# The Arts and Crafts Movement in America

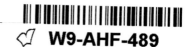 

The Art Museum, Princeton University
21 October—17 December 1972

The Art Institute of Chicago
24 February—22 April 1973

Renwick Gallery of the National Collection of Fine Arts,
Smithsonian Institution
1 June—10 September 1973

# The Arts and Crafts Movement in America 1876-1916

An exhibition organized by the Art Museum, Princeton University, and The Art Institute of Chicago

Edited by Robert Judson Clark

With texts by the editor and Martin Eidelberg, David A. Hanks, Susan Otis Thompson, and others

Distributed by Princeton University Press

Distributed by Princeton University Press, 41 William Street,
Princeton, New Jersey 08540

Library of Congress Card No. 72-77734
ISBN 0-691-00294-0 (pbk.)
Eighth printing, in a new format, 1992
15   14   13   12   11   10   9   8

Princeton University Press books are printed on acid-free
paper, and meet the guidelines for permanence and durability
of the Committee on Production Guidelines for Book Longevity
of the Council on Library Resources

Printed in the United States of America

# Contents

## Foreword

Our three museums sponsor with great pleasure the pioneer exhibition *The Arts and Crafts Movement in America, 1876–1916,* which for the first time presents a comprehensive survey of one of the most important movements in late nineteenth-century America.

We are extremely grateful to the organizer of the exhibition, Robert Judson Clark, Assistant Professor in the Department of Art and Archaeology, Princeton University, without whom this exhibition would not have been possible. He has been fortunate in his three collaborators: David A. Hanks, Martin Eidelberg, and Susan Otis Thompson.

We would like to thank all of the lenders, particularly the private collectors who have so generously agreed to part with their objects for one year.

David W. Steadman
*Acting Director*
*The Art Museum, Princeton University*

John Maxon
*Associate Director*
*The Art Institute of Chicago*

Joshua C. Taylor
*Director*
*National Collection of Fine Arts*

# Preface to the Twentieth-Anniversary Edition, 1992

There has been great popular demand for another printing (the eighth) of this catalog. But there has also been an insistence (from booksellers and others) that it appear in a more manageable size. It must be emphasized that this is not a revised edition of the 1972 volume. The illustrations and texts are merely recast in a new format; they are old wine in a new bottle. Other than these few words, the only addition is a supplemental bibliography, which reflects the variety of publications—exhibition catalogs, monographic studies, critical and synthetic essays, and even some revisionist views—that have appeared since "The Arts and Crafts Movement in America, 1876–1916" toured from Princeton to Chicago, and on to Washington, D.C., in 1972–1973.

Twenty years ago, there were very few private or public collections of American Arts and Crafts objects for us to search among, and printed references were almost as difficult to find. Nevertheless, our goal was to put together an ambitious, although necessarily tentative, view of this fascinating period of American decorative arts. If we were to do a similar work now, we would have not only a much greater wealth of "discovered" objects from which to choose, but also much more definitive research by others to guide and inspire us. Yet how much of this activity would have occurred without the so-called "Princeton exhibition" of a generation ago?

The production of this twentieth-anniversary edition was coordinated by Elizabeth Powers of Princeton University Press. The pages were reformatted by Carmina Alvarez, and the cover, with its full-color reproduction of what has become a principal icon of the American movement, was designed by Donald Hatch. The new bibliography was prepared with the assistance of Amy Ogata. To all of these persons I record my gratitude. I also want to thank, again, the coauthors—Martin Eidelberg, David A. Hanks, and Susan Otis Thompson—who made the original endeavor a memorable scholarly adventure.

Robert Judson Clark

# Acknowledgments

This project was first proposed in November 1970 as a small exhibition to be prepared by members of a senior seminar at Princeton. *19th-Century America* had recently closed at the Metropolitan Museum of Art, and a special fascination with the decorative arts of the period between the Civil War and World War I was the impulse. During the months that followed, the proposal acquired a more ambitious format, with the seminar achieving graduate status, and an illustrated catalogue, as well as a symposium, being added to the assignment. As word of the intended exhibition spread, we were pleased to have inquiries from several museums from Massachusetts to California regarding possible participation. It became a traveling show when we accepted the welcome cooperation of the first two museums that had contacted us: The Art Institute of Chicago, and the Renwick Gallery of the National Collection of Fine Arts, Smithsonian Institution. For their interest and help, both financial and scholarly, we are extremely grateful.

With this new scope, a more definitive effort was outlined. In addition to the several scholars who had already been asked to contribute individual essays, David A. Hanks, assistant curator of American Decorative Arts at The Art Institute of Chicago, agreed to gather and discuss the material representing Chicago and the Midwest. Professor Martin Eidelberg of the Department of Art, Rutgers University, accepted an invitation to organize the section of art pottery. Professor Susan Otis Thompson of the School of Library Service, Columbia University, contributed the material on the Arts and Crafts book. It has been a special pleasure to work with these collaborators, who have helped with each other's material at various points along the way.

Sincerest thanks are extended the lenders to this exhibition, who often provided important information and unforgettable hospitality. Staff members of various museums and libraries have shown innumerable kindnesses and given valuable advice. A partial list of the above individuals must be attempted here, because of special favors: Mrs. Sheila Machlis Alexander, Mrs. Marilynn Johnson Bordes, Mr. Simeon Braunstein, Miss Hazel Bray, Mr. Larry Curry, Mr. Jack Erickson, Mr. Paul F. Evans, Mr. and Mrs. Cyril Farny, Professor David Gebhard, Mr. and Mrs. Charles F. Hamilton, Mrs. Jethro Hurt, Mr. and Mrs. Robert A. Hut, Professor Edgar Kaufmann, jr., Dr. and Mrs. Robert Koch, Mr. Robert Lauch, Mr. and Mrs. Terence Leichti, Dr. Carol Macht, Miss Jean Mailley, Mr. Randell L. Makinson, Mr. and Mrs. James M. Marrin, Mr. and Mrs. Robert Mattison,

Mr. John Maxon, Mr. Warren C. Moffett, Mrs. Lillian Nassau, Mrs. Caroline Shine, Professor James H. Stubblebine, and Miss Tina Uccifferrie.

The several photographers, especially Richard Taylor, performed heroically in the face of deadlines. Lynne Geison, Macie Green, and Kasey Grier helped at various stages with typing and research. Virginia Wageman, the publications editor at The Art Museum, has overseen the copy editing and production, with the assistance of Mary Laing, fine arts editor at Princeton University Press. James Wageman designed these pages. Robert Lafond, registrar at The Art Museum, has assumed innumerable responsibilities.

Princeton's share of the cost of the catalogue was made possible by grants from the National Endowment for the Arts and the Publications Fund of the Department of Art and Archaeology, Princeton University. For this assistance we are grateful.

The organizers of the exhibition have hoped for a broad range, but are aware that vast areas have been left untapped because of time, space, and expense. Some lapses were agreed upon from the beginning. For instance, there are no examples of Louis C. Tiffany's glass vases and bowls, for these have already received considerable attention in previous exhibitions. It was decided, instead, to devote this space to the first comprehensive display of American art pottery. Its large representation in this show reflects similar situations at most Arts and Crafts exhibitions around the turn of this century. Experiments in art pottery provided the beginning, and the most consistent stylistic development, of the Arts and Crafts movement in America.

RJC

# Lenders to the Exhibition

Albright-Knox Art Gallery, Buffalo

The Art Institute of Chicago

The Art Museum, Princeton University

Mr. and Mrs. Victor H. Bacon II,
Ocean City, New Jersey

Robert W. Blasberg, Port Jervis, New York

Mr. and Mrs. Ted Bloch, Glencoe, Illinois

Nancy Hubbard Brady, East Aurora, New York

Simeon Braunstein, Malden, Massachusetts

Brooklyn Museum

Chicago Historical Society

Chicago School of Architecture Foundation

Cincinnati Art Museum

Cliff Dwellers Club of Chicago

College of Environmental Design,
University of California, Berkeley

Columbia University Libraries, New York

Cooper-Hewitt Museum of Decorative Arts
and Design, Smithsonian Institution, New York

Detroit Institute of Arts

Joseph R. Dunlap, New York

Paul F. Evans, Mill Valley, California

Everson Museum of Art, Syracuse

Mr. and Mrs. Cyril Farny,
Morris Plains, New Jersey

Carol Ferranti Antiques, New York

Martha Field, Chicago

The Fortnightly of Chicago

Gamble House, Greene and Greene Library,
Pasadena

J. Herbert Gebelein, Boston

David Gebhard, Santa Barbara

Mr. and Mrs. Julius Gold,
Fairfield, Connecticut

Mrs. Robert D. Graff, New York

Grolier Club, New York

Mr. and Mrs. Charles F. Hamilton,
East Aurora, New York

Marilyn and Wilbert R. Hasbrouck,
Palos Park, Illinois

Elbert Hubbard Library-Museum,
East Aurora, New York

Dr. and Mrs. Ernest Kafka, New York

Edgar Kaufmann, jr., New York

Mr. and Mrs. Roger G. Kennedy, New York

Dr. and Mrs. Robert Koch,
South Norwalk, Connecticut

Mr. and Mrs. Walter K. Krutz,
Lombard, Illinois

Ethel and Terence Leichti, Los Angeles

Jeannette and Hugh F. McKean,
Winter Park, Florida

Macklowe Gallery, New York

Mr. and Mrs. James M. Marrin, Pasadena

Mr. and Mrs. Robert Mattison, Berkeley

Metropolitan Museum of Art, New York

Mr. and Mrs. Warren C. Moffett,
East Aurora, New York

Paul Morrissey, New York

Museum of Fine Arts, Boston

Museum of Modern Art, New York

Mr. and Mrs. Hyman Myers,
Merion Station, Pennsylvania

Lillian Nassau, Ltd., New York

National Museum of History and Technology,
Smithsonian Institution, Washington, D.C.

Mr. and Mrs. Walter A. Netsch, Jr., Chicago

Newark Museum

Oakland Museum

James F. O'Gorman,
Bay View, Massachusetts

Campbell G. Paxton, Mentor, Ohio

Philadelphia Museum of Art

Princeton University Library

Roland Rohlfs, Manhasset, New York

Tim Samuelson, Chicago

Mr. and Mrs. George ScheideMantel,
East Aurora, New York

Thomas L. Sloan, Princeton, New Jersey

Josephine S. Starr,
Northampton, Massachusetts

Mrs. Theodore D. Tieken, Chicago

Eleanor McDowell Thompson, New York

Ray Trautman, New York

University of Chicago

Robert W. Winter, Pasadena

Mr. and Mrs. Joseph Zwers, Chicago

and six anonymous lenders

# Introduction

It was not until 1888 that the words "Arts and Crafts" were officially joined. In that year, the Arts and Crafts Exhibition Society was founded in London by young members of the Royal Academy who were frustrated by the institutional definition of art in terms of the fine arts only, leaving the applied and decorative arts in a limbo of second-class citizenship. T. J. Cobden-Sanderson suggested the name of that new society, which in turn gave its name to the whole British movement of renewal in the decorative arts—a movement that had been gathering force since the 1860s.

Usually associated with the activities of William Morris, the Arts and Crafts movement actually had its roots much earlier in the century. Thomas Carlyle had warned of the dangers of the Industrial Revolution and its effects on the human soul. Division of labor deprived the worker of the pleasures of guiding his product from conception to completion; machines had replaced the traditional standards of beauty with those of economy and profit. From Carlyle through John Ruskin to William Morris a sincere distrust of the modern age was the legacy. Seeking regeneration and renewal, they retreated to the glories of the medieval world.

The United States had no figures comparable to these three British thinkers and artists. Horatio Greenough was a classicist with ideas that appealed to later generations of functionalists; Henry Adams understood Ruskin, and was a great influence on his friends Henry Hobson Richardson and John La Farge. But our conscience here was not as heavy, and our reactions were less obvious at first.

In 1876 the world was invited to Philadelphia to help the United States celebrate a century of independence. Only on a political or industrial scale was this independence thoroughly convincing. Culturally and artistically, America was still in adolescence. Visitors were generally awed by the mighty Corliss engine, while the more sensitive viewers and critics were often horrified by furniture exhibits that showed a taste for grandeur and no pride in craftsmanship. When Oscar Wilde came to this country on a lecture tour in 1882–83, he was rather patronizing. He said, "I find what your people need is not so much high, imaginative art, but that which hallows the vessels of every-day use . . . the handicraftsman is dependent on your pleasure and opinion. . . . Your people love art, but do not sufficiently honor the handicraftsmen" (*Decorative Art in America*).

By the late 1870s, however, the furniture industry in New York had made great strides in emulation of the art furniture of England. With Henry Hobson Richardson's adoption

in the mid-1870s of the Queen Anne style, avant-garde architectural tastes were again aligned with the mother country. Our own Arts and Crafts movement was underway.

This important era of development in American decorative arts can be divided into three stylistic periods, which correspond to major expositions held in the United States:

*1876–93* This was a time of nationalism and industrial expansion. Tastes for things British and oriental were nevertheless the decisive influences.

*1893–1901* With artistic self-confidence won at the Columbian World's Exposition in Chicago, the United States proceeded on two architectural paths—a new academicism, and an expansion of trail-blazing developments in building techniques. There were some parallels to the international wave of Art Nouveau, which did not encounter abundant acceptance here, other than in the architectural ornament of Louis Sullivan and the exquisite objects produced by Louis C. Tiffany. In this period, the first of dozens of arts and crafts societies were founded in this country.

*1901–16* The years between the Pan-American Exposition and the outbreak of World War I are often referred to as those of the "Craftsman Movement," for the *Craftsman* magazine was the chief spokesman for a generation of designers who established a severe, geometric style of furniture and ornamentation. With the rise of the Prairie school, a great new American architecture was born.

The terminal date of 1916 is suggested not merely because it rounds out the four decades that followed the Philadelphia Centennial. In December 1916, the *Craftsman* ceased publication. It was by then a superseded monthly that had not adapted itself well, or else soon enough, to the genteel historicism that was invading architecture and furnishings. Then, within a few months we were at war. When things again stabilized in the 1920s, we were at last in the twentieth century.

# Chronology

| | |
|---|---|
| 1876 | Centennial Exposition, Philadelphia |
| 1877 | M. Louise McLaughlin discovers secret of Limoges underglaze painting. New York Society of Decorative Art founded, 24 February |
| 1879 | Louis C. Tiffany and Company, Associated Artists, organized in New York. Women's Pottery Club started in Cincinnati |
| 1880 | Rookwood Pottery founded in Cincinnati |
| 1882 | H. H. Richardson visits William Morris at Merton Abbey |
| 1882–83 | Oscar Wilde tours and lectures in the United States |
| 1883 | Laura A. Fry introduces airbrush for painting backgrounds of pottery |
| 1886 | H. H. Richardson dies, 27 April |
| 1891 | Chelsea Pottery opened in Chelsea, Massachusetts |
| 1892 | *A Day at Laguerre's* published by the Riverside Press, Cambridge, Massachusetts |
| 1893 | World's Columbian Exposition, Chicago. Frank Lloyd Wright begins independent architectural practice. Charles Sumner Greene and Henry Mather Greene arrive in Pasadena |
| 1894 | Elbert Hubbard visits William Morris and sees the Kelmscott Press at Hammersmith. Underglaze decoration of pottery begins at Zanesville, Ohio, in imitation of Cincinnati wares |
| 1895 | Grueby Faience Company organized in Boston. Newcomb College established a pottery studio in New Orleans. Chalk and Chisel Club organized in Minneapolis; name changed in 1899 to Minneapolis Arts and Crafts Society. Samuel Bing publishes *La Culture artistique en Amérique* |

| | |
|---|---|
| 1896 | *The Song of Songs*, first book of the Roycrofters, completed in January. *The Altar Book* published by the Merrymount Press, Boston. First issue of *House Beautiful* published in Chicago, December. Deerfield Society organized in Deerfield, Massachusetts. Opening of Dedham Pottery in Dedham, Massachusetts |
| 1897 | First major Arts and Crafts exhibition in this country held at Copley Hall, Boston, April. Boston Society of Arts and Crafts founded, 28 June. Chicago Arts and Crafts Society founded, 22 October |
| 1898 | Gustav(e) Stickley Company founded in Syracuse (Eastwood), New York, May. Stickley travels to Europe, where he meets Charles F. A. Voysey, C. R. Ashbee, and Samuel Bing, among others. William H. Grueby introduces mat glazes for pottery |
| 1899 | Adelaide A. Robineau begins publication of *Keramic Studio* in Syracuse. Roycroft furniture first mentioned in the *New York Sun*, 29 October. Industrial Art League founded by Oscar Lovell Triggs in Chicago; disbanded in 1904 |
| 1900 | Guild of Arts and Crafts of New York organized, January |
| 1901 | Pan-American Exposition, Buffalo. Frank Lloyd Wright delivers address, "The Art and Craft of the Machine," to the Chicago Arts and Crafts Society at Hull House, 6 March. Artus Van Briggle begins commercial production in Colorado. Hingham Society of Arts and Crafts organized in Hingham, Massachusetts. |

| | |
|---|---|
| | Rose Valley Association incorporated at Moylan, near Philadelphia. *House and Garden* first published in Philadelphia. Appearance of the *Craftsman*, published in Syracuse, October |
| 1901–02 | The Bradley House featured as installments in *Ladies' Home Journal*, November through August |
| 1902 | After using several variations, the name of Louis C. Tiffany's firm officially changed to Tiffany Studios. *Handicraft* first published in Boston, May. William Morris Memorial Room installed by the Tobey Furniture Company, Chicago. Handicraft Guild founded in Minneapolis. Society of Arts and Crafts founded in Grand Rapids |
| 1903 | William Morris Society founded in Chicago, 7 May. Dard Hunter joins the Roycrofters in East Aurora, June. Rose Valley Association begins publication of the *Artsman*. Pewabic Pottery founded in Detroit |
| 1904 | Louisiana Purchase International Exposition, St. Louis. Harvey Ellis dies, 2 January. Artus Van Briggle dies, 4 July. Ernest A. Batchelder moves to California. Handicraft Club organized in Providence, Rhode Island, 25 October |
| 1905 | Tiffany pottery first sold to the public. Society of Printers founded in Boston, February |
| 1906 | Furniture Shop established by Lucia and Arthur F. Mathews in San Francisco |
| 1907 | National League of Handicraft Societies organized in Boston, 21–23 February |
| 1908 | Hugh C. Robertson dies. |

| | |
|---|---|
| | Grueby Faience Company goes bankrupt. |
| | Dirk Van Erp opens his Copper Shop in Oakland; moves to San Francisco two years later |
| **1909** | Only issue of *Arroyo Craftsman* published in Los Angeles, October |
| **1910** | Newcomb College Pottery begins to use mat glaze. First kiln fired at University City, Missouri. |
| | Fulper Pottery Company, Flemington, New Jersey, introduces line of art pottery. |
| | Frank Lloyd Wright's *Ausgefuehrte Bauten und Entwuerfe* published in Berlin |
| **1911** | *Frank Lloyd Wright: Ausgefuehrte Bauten*, with an introduction by C. R. Ashbee, published in Berlin |
| **1913** | Elsie de Wolfe writes *The House in Good Taste* |
| **1915** | Panama-Pacific International Exposition, San Francisco. |
| | Panama-California Exposition, San Diego. Enterprises of Gustav Stickley declared bankrupt, 24 March. |
| | Alice and Elbert Hubbard perish on the *Lusitania*, 7 May |
| **1916** | Charles Sumner Greene moves from Pasadena to Carmel, California. |
| | Final issue of the *Craftsman*, December. |

## Major figures

Ernest A. Batchelder   1876–1957

Charles F. Binns   1857–1934

Will Bradley   1868–1962

Theophilus A. Brouwer, Jr.   1865–1932 ?

Thomas Maitland Cleland   1880–1964

Charles A. Coolidge   1858–1936

W. A. Dwiggins   1880–1956

Harvey Ellis   1852–1904

George Grant Elmslie   1871–1952

Laura A. Fry   1857–1943

William H. Fulper   1872–1928

Frances M. Glessner   1848–1932

Bertrand Grosvenor Goodhue   1869–1924

Frederic W. Goudy   1865–1947

Charles Sumner Greene   1868–1957

Henry Mather Greene   1870–1954

William H. Grueby   1867–1925

Christian Herter   1840–1883

Elbert Hubbard   1856–1915

Dard Hunter   1883–1966

Robert R. Jarvie   1865–1941

Jewett N. Johnston   1005–1962

John La Farge   1835–1910

M. Louise McLaughlin   1847–1939

George W. Maher   1864–1926

Arthur F. Mathews   1860–1945

Lucia K. Mathews   1870–1955

John Henry Nash   1871–1947

George E. Ohr   1857–1918

Mary Chase Perry   1868–1961

William L. Price   1861–1916

Will Ransom   1878–1955

Frederick H. Rhead   1880–1942

Henry Hobson Richardson   1838–1886

Hugh C. Robertson   1845–1908

Adelaide Alsop Robineau   1865–1929

Bruce Rogers   1870–1957

Charles Rohlfs   1853–1936

Carl Purington Rollins   1880–1960

Isaac Scott   1845–1920

Ellen Gates Starr   1859–1935

Gustav Stickley   1857–1942

Maria Longworth Nichols Storer   1849–1932

Louis H. Sullivan   1856–1924

Louis C. Tiffany   1848–1933

Oscar Lovell Triggs   1865–1930

Joseph Twyman   1842–1904

Daniel Berkeley Updike   1860–1941

Artus Van Briggle   1869–1904

Dirk Van Erp   1860–1933

Charles Volkmar   1841–1914

Frederick E. Walrath   ca. 1880–ca. 1920

Samuel A. Weller   1851–1925

Clara Barck Welles   1868–1965

Candace Wheeler   1827–1923

Ellsworth Woodward   1861–1939

Frank Lloyd Wright   1867–1959

# 1 The Eastern Seaboard

# 1 The Eastern Seaboard

## Robert Judson Clark and others

The fame of Philadelphia as an intellectual and cultural center suffered such a decline after the Jacksonian years that it is unlikely that an international exposition would have taken place there in 1876, had the historical occasion being celebrated not occurred there a century before. Nevertheless, Philadelphia maintained a vigorous Academy of Art during the 1870s and 80s, and the group of architects gathered around Wilson Eyre adapted their buildings from good English sources, giving them crafted interiors and picturesque exterior compositions. The *Ladies' Home Journal,* which had a decided effect on household taste at the turn of the century, was very much a Philadelphia institution. It was joined in 1901 by *House and Garden,* which had a more architectural orientation. Edwin A. Barber was forming an important collection of art pottery at the Pennsylvania Museum, and wrote the first history of this craft in America. Not far away, the workers in Rose Valley, Pennsylvania, were carving quasi-Gothic furniture in a communal effort, as though transferred from the pages of William Morris's *News from Nowhere.* The work sold by the Quaker Shops in Philadelphia, however, was actually more in the spirit of the reform aesthetic of the time.

Just as the financial and intellectual focus had shifted from Philadelphia to New York in the mid-nineteenth century, so had the artistic one, generally speaking. The National Academy of Design had been established in New York early in the century, and the best American furniture of the post-Civil War period was made in Manhattan workshops. The country's greatest decorating firm was headed by Louis Comfort Tiffany, who continued to attract the attention of the world to his studios for the next several decades. The three major museums in the New York area at the time, the Metropolitan Museum of Art and its counterparts in Brooklyn and Newark, had periodic exhibitions of the applied arts, American and foreign, and were collecting substantial representations of what was being designed and made in this country.

In the late 1890s there was a rapid proliferation of arts and crafts organizations, following within a decade the founding of the influential Arts and Crafts Exhibition Society of London in 1888. The Boston area, which had been the scene of new developments in domestic architecture since the 1870s, now experienced a revival of fine silversmithing

and the founding of the Boston Arts and Crafts Society in June 1897. *Handicrafts* magazine was published by the society, beginning in May 1902—only to disappear in 1904, and then to be revived as a more nationally oriented monthly in 1910–12. It was also in Boston that the Society of Printers was founded in 1905. During this period, citizens inland from Boston organized their own arts and crafts groups; but, as in Deerfield and Hingham, they were often more an emanation of the Colonial revival, which had taken firm root in New England. However, it was in the Boston area that the first concentration of art potteries east of Ohio occurred.

After the turn of the century, activity intensified in upper New York State. In this land of the Chautauquan movement, there were several individuals and groups whose names stand for many of the finest accomplishments, or at least for some of the most interesting episodes, in the American Arts and Crafts movement. Charles Rohlfs worked in Buffalo, where he made furniture that was exhibited at the world's major fairs, winning critical acclaim in international journals. At the Buffalo Arts and Crafts Shop was Paul J. Wilhelm, who worked with copper, silver, and enamels. Nearby in East Aurora, Elbert Hubbard propagandized while encouraging his many craftsmen. Due eastward, Gustav Stickley guided his Craftsman Workshops in Syracuse, and edited the *Craftsman*, which soon established itself as the best survey of what was happening in the workshops and studios across the country between 1901 and 1916.

## Isaac E. Scott

Born near Philadelphia, Scott was listed in that city's directories for 1867 and 1869. His name is found in the Chicago directories from 1873 to 1883. During this time, he received several commissions to design furniture for the John J. Glessners, who then lived on West Washington Boulevard in Chicago. When they moved to their new house on Prairie Avenue, designed in 1886 by Henry Hobson Richardson, the Scott pieces went with them. Scott became a close friend of the family, and even after leaving Chicago for New York and Boston, he visited the Glessners at their summer home in New Hampshire, where he tutored the children in matters of the arts. A master of many crafts, Scott produced cabinetry of exceptional quality.   DAH

### 1 Bookcase
Designer: Isaac E. Scott, 1875
Walnut, with inlays of various woods
Height: 86¼", width: 70¼", depth: 14½"

Of the known pieces of Scott's furniture, this is the most ambitious. Its style is derived from contemporary English reform furniture which, in turn, was often inspired by north Italian medieval models. An entry of February 1870 in Mrs. Glessner's diary probably refers to this piece. "Had bought first bookcase about Christmas, 1875, but didn't get it until end of Jan'y."   DAH

Chicago School of Architecture Foundation, gift of Mrs. Charles F. Batchelder

**2 Desk**
Designer: Isaac E. Scott, 1879
Walnut
Height: 46½", width: 30", depth: 25"

Another entry in Mrs. Glessner's diary, November 1879, noted that Scott returned early that month from Boston, where he had been making vases for the family (see entry 170). Upon his return, the Glessners requested several additional pieces of furniture—including a small desk, which is probably the one illustrated here. Particularly noteworthy are the details of the side panels that show Scott's ability as designer as well as master carver.   DAH

Chicago School of Architecture Foundation, gift of Mrs. Charles F. Batchelder

2 (detail)

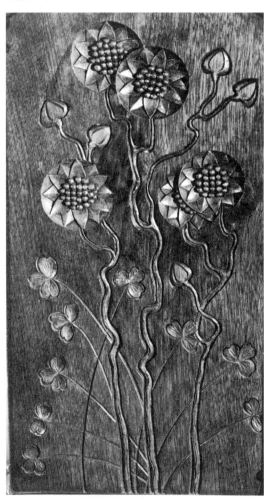

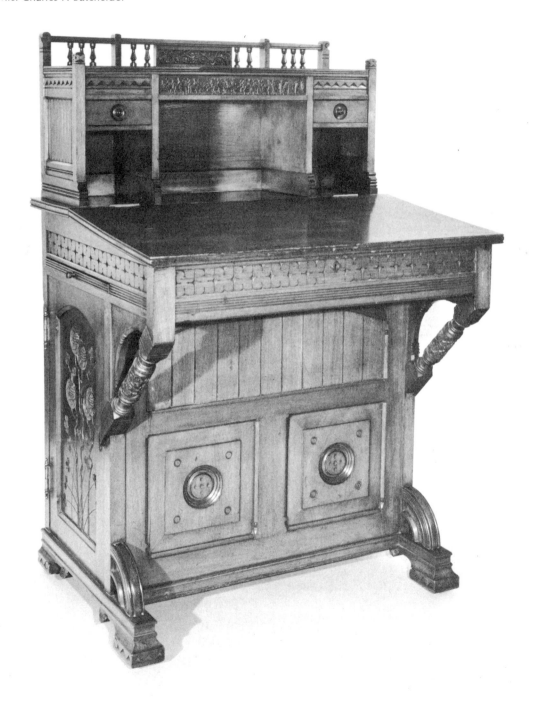

## Herter Brothers

By the 1880s, the United States had produced some great architects of its own. But foreign-born designers and craftsmen still held considerable command in the field of furniture and interior decoration. The leader in New York, at least until the rise of Louis C. Tiffany and his associates, was the firm of Christian Herter, known as Herter Brothers. Although Herter was born in Germany and trained in France, his "art furniture" of the late 1870s onward paralleled reform movements in England, with many references to the Orient. The furniture and interiors by Herter Brothers were catholic and exotic—and always exquisitely crafted.

**3 Table**
Herter Brothers, New York, ca. 1880
Ebonized cherry wood, carved and gilt, with marquetry of lighter wood
Height: 29¼", width: 46½", depth: 28¼"

Closely related in style and execution to several pieces of furniture by the Herter Brothers now in the Metropolitan Museum of Art, the table top is inlaid with two panels of cherry blossoms and leaves, while the legs are carved with oriental poppy blossoms and buds. Typical of the inventive nature of "art furniture" at this time, the stamens of the blossoms on the legs are formed by the overlapping heads of brass nails driven into the wood. The combination of black and gold, as well as the specific floral motifs, are wholly Japanese; but the thin engraved lines and the lathed spindles are more in the spirit of Eastlake. The undersides of the drawers are crayoned 5 and 6, indicating that at least two other examples of this table were made at the same time.   ME

Private collection

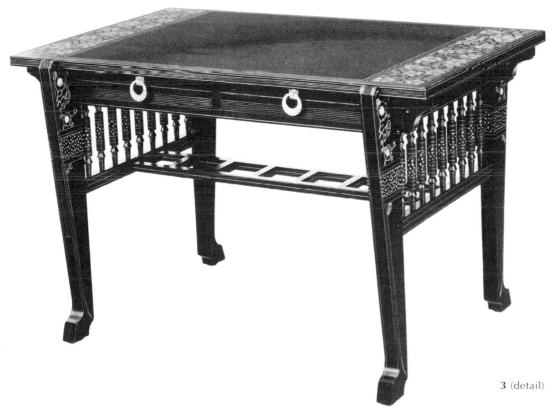

3 (detail)

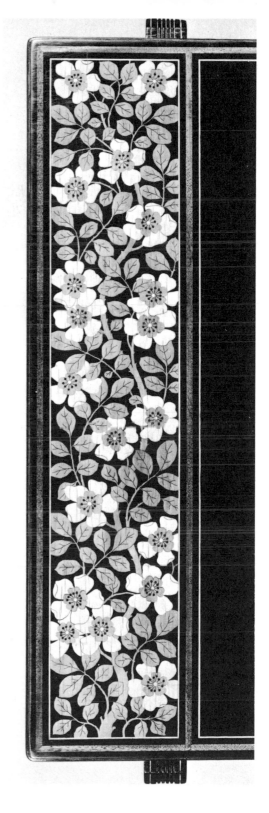

## Office of Henry Hobson Richardson

H. H. Richardson's place in the history of American architecture has been assured largely through the public buildings he designed in a personal and robust interpretation of the Romanesque revival. Yet his domestic buildings, in which he combined elements of the Queen Anne mode with American vernacular building materials, are of almost equal importance. For in the 1870s Richardson put aside his French predilection for Mansard roofs and classical cornices and looked to the work of Richard Norman Shaw. At the time of this important shift toward a British orientation, Richardson's interiors emerged as some of the best domestic spaces of their time, and were appointed with careful attention to detail and craftsmanship. Custom furniture was designed for some of them. Richardson seems to have been greatly influenced by British architectural magazines, as well as by Talbert's *Gothic Forms Applied to Furniture* (1867) and Eastlake's *Hints on Household Taste* (1868), both of which appeared in several American editions. There were also personal contacts with English artists, including William Morris, whom Richardson met on a trip to England in 1882.

Whether planned personally by Richardson, or by his staff with his approval, the public or private interiors were well integrated with the architectural totality of his buildings. The furniture and woodwork were produced by various firms in the Boston area. Soundly constructed and often large in scale, his furniture was simple in outline and graceful in effect. The pieces could be elaborately carved, like those in the Court of Appeals in Albany; or where a limited budget prevailed, more severe pieces were provided, as in the Winn Memorial Library at Woburn, Massachusetts. Later, as seen in some of the chairs for the Converse Memorial Library in Malden, Massachusetts, the influence of an intensifying interest in the art of this country's own Colonial period made its mark on Richardson's work.   HJI

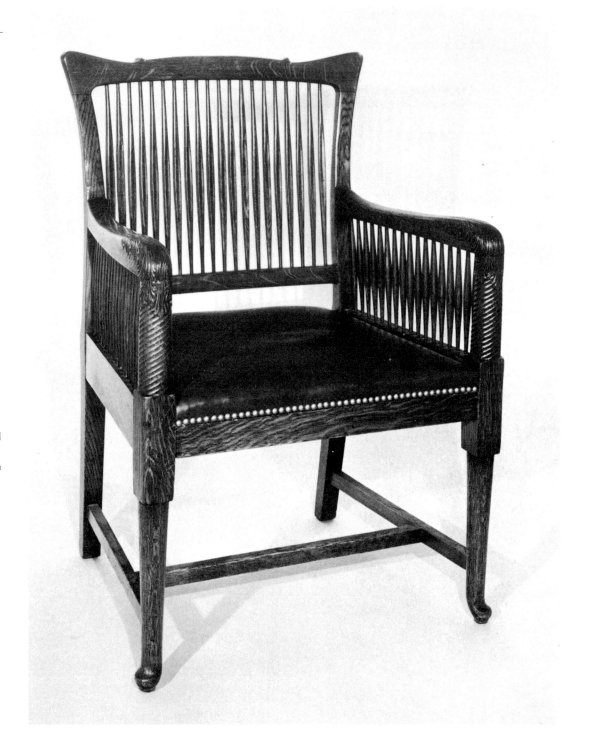

**4 Armchair**
Designer: Charles A. Coolidge, 1887
Maker: A. H. Davenport, Boston
Oak
Height: 39½", width: 26", depth: 21¾"

When Richardson died in 1886 before the completion of the John J. Glessner house in Chicago, his successors, under the direction of Charles A. Coolidge, completed the interior and some of its furniture, including a large library desk, a sideboard, dining table, armchairs, and side chairs. They were made by the firm of A. H. Davenport, who made other pieces for the Glessners after the designs of Francis Bacon. Of simpler concept than the well-known furniture Richardson designed for the Court of Appeals chamber at the New York State Capitol in Albany, this armchair reflects both the Romanesque and the American Colonial revivals; the spindles, for example, are reminiscent of the Windsor chair.   DAH

Chicago School of Architecture Foundation

**John La Farge**

With due acknowledgment of La Farge's contributions in the field of easel painting, it may be said that his part in the history of American decorative arts was even greater. For although he was a fine watercolorist and important early painter of murals, his developments in the field of ornamental glass were crucial. On a visit to France in 1872 he had studied the qualities of medieval windows, and by 1887 was experimenting with new means of expression in glass. In contrast to older methods of coloring in which pot-metal glass was stained or painted, La Farge developed a technique of producing what became known as "opalescent" glass, in which thin layers of glass of various colors were pressed together almost to the point of crushing and then fused by firing. This increased the range of coloristic effects and caused widespread imitation of his work. La Farge believed that the artist who made the initial design for an ornamental window should maintain supervision over all subsequent processes necessary for completion, and he produced windows superior to contemporary work in colored glass being done in France and England. He even surpassed the efforts of Edward Burne-Jones and other Pre-Raphaelites, some of whom he had met during a trip to England in 1873, where he also encountered William Morris. Almost all of La Farge's glasswork was in the form of windows, among which were panels for H. H. Richardson's Trinity Church in Boston, his Crane Library in Quincy, Massachusetts, and the William Watts Sherman house in Newport, Rhode Island.   HJI

## 5 Window

Designer: John La Farge, ca. 1877
Leaded glass
Height: 5' 5½", width: 24"

This was the center of a three-panel window with transoms, executed by John La Farge for the front wall of the large living hall of the William Watts Sherman house, Newport, Rhode Island, designed by H. H. Richardson. The date of 1877, suggested by Barbara Weinberg in her recent dissertation on La Farge's decorative work, follows the date of completion of the house by about two years. The floral motif was one of La Farge's favorites and appears often in other windows he made, as well as in his oil paintings. This set was an early work in La Farge's large output of colored glass windows. He had begun to experiment in glass only two years earlier. The etching of details was still part of his technique, although that would soon be abandoned. Some of the colors are unusual—acidic hues of yellow, orange, and red—and the background, intensifying the effect of the flowers through complementaries, is dominated by a multiplicity of blues. The bamboo-like strips at the bottom of the panel owed something to La Farge's interest in the Orient. The window, the first and most successful of several windows he made for this house, is also the earliest one that he did in collaboration with Richardson for a domestic context.   HJI

James F. O'Gorman

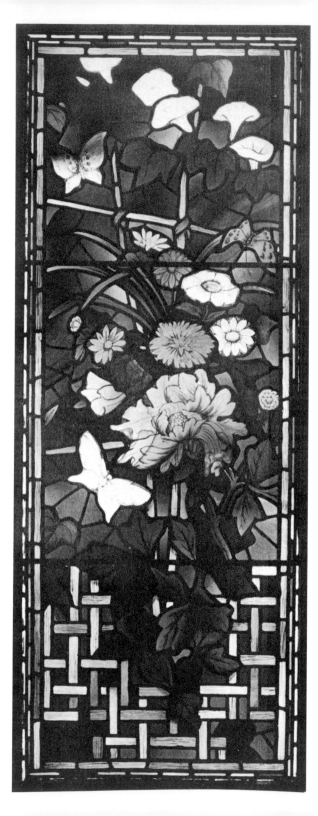

## Louis C. Tiffany
## Associated Artists
## Tiffany Studios

The foremost American designer of art objects and decorations for the carriage trade in the opulent years of the turn of the century was Louis Comfort Tiffany, son of the founder of Tiffany and Company, jewelers. Tiffany began his studies as a painter with George Inness in 1866, and a selection of his paintings was included in the Philadelphia Centennial Exposition. In that same year, 1876, Tiffany created his first opalescent, ornamental glass window, thus beginning what was to become his most significant contribution to the American decorative arts, and entering into rivalry with another painter and designer, John La Farge.

Tiffany began working with mosaics as early as 1879, the year in which Louis C. Tiffany and Company, Associated Artists, was established in New York. This short-lived collaborative effort involved the talents of Tiffany, Lockwood de Forest, Samuel Colman, and Candace Wheeler. The firm worked together in the spirit of [William] Morris and Company, receiving several prestigious commissions for interiors in New York and the assignment to redo the public rooms of the White House during the administration of Chester A. Arthur. The association did not survive the mid-1880s, however, and Tiffany continued to experiment independently with his great obsession, glassmaking. Like La Farge, he was dedicated to an understanding of technical processes, through which he discovered methods of making opalescent and iridescent glass. After many years of experimenting, he patented his famed Favrile glass in 1894.

By the end of the century, Tiffany's designers and craftsmen were producing, in addition to vases and windows, an incredible array of lamps with leaded-glass shades. Other products associated with the name of Louis C. Tiffany appeared after the name of the firm was officially changed to Tiffany Studios in 1902, marking the beginning of a decidedly more commercial phase of operations. Among the items produced by Tiffany Studios were desk accessories in bronze or combinations of metal and glass, in a considerable range of styles. Tiffany's own interest, however, remained in ornamental windows, each of which he personally supervised—according to a catalogue issued by the studios in 1913. His designs and techniques in all media revealed a knowledge of the decorative arts of many cultures. His taste, however, remained that of the late nineteenth century. The Tiffany Studios survived the initial wave of the financial disaster in 1929, but was forced to declare bankruptcy in 1932—one year before the death of the founder, who had retired several years earlier.
TLS

**6 Window**
Associated Artists, New York
Designer: Louis C. Tiffany, ca. 1879–81
Leaded glass, with a design of squashes and leaves on a trellis, in tones of yellows and greens
Height: 32¼", length: 42¼"

This is one of a pair of windows that must be counted among the earliest of Tiffany's decorative glass windows. Their provenance poses a problem. This window is identical in design to one that was used as a transom in the George Kemp house in New York, Tiffany's first commission for a complete interior, which was executed in 1879 (illustrated in George W. Sheldon, *Artistic Houses*, 1883–84). Ordinarily it could be assumed that this is the window from the Kemp house. However, the pendant to this panel, of the same measurements and similar design, except that the motif is an eggplant vine, appears to be the one that was in

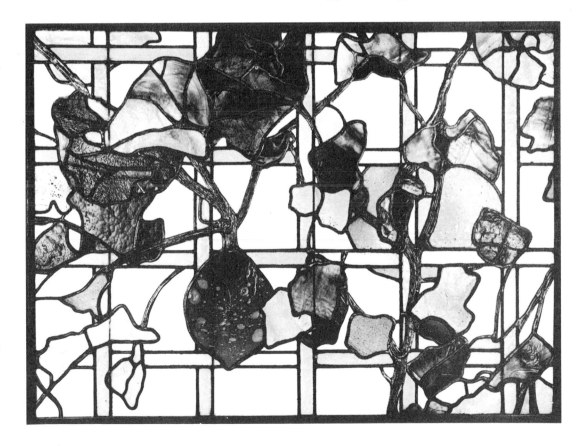

the dining room of Tiffany's own home in the Bella Apartments (illustrated in *Our Continent,* 29 March 1882, p. 100). Thus the question arises whether Tiffany may have made two sets of windows, one for Kemp and one for himself. The designs were suitable for either setting, since in the Kemp house the dining room was decorated with a frieze of gourds, pumpkins, and other autumnal fruit, while in Tiffany's home a large painting of pumpkins and corn hung over the mantel and gourds decorated one wall.

Whatever the answer, the early date of this window is manifest in the simplicity of colors and execution. From the very beginning, Tiffany avoided the process of staining the glass. Rather, he relied on the variations of coloring and thickness of the glass itself to achieve the desired effects of modeling. Moreover, he utilized the leading to emphasize the strong, linear contours that contribute to the success of this design.   ME

Jeannette and Hugh F. McKean

**7 Textile**
Associated Artists, New York
Designer: Candace Wheeler, ca. 1885
Maker: Cheney Brothers
Silk, warp twill patterned *chiné à la branche*
Height: 29", width: 25" (full loom width)

As part of the activities of the Associated Artists, Mrs. Wheeler designed textiles such as this and the following silk, which were executed by the firm of Cheney Brothers. As always, her work emphasized the luxury of the material. The unusual technique employed here of *chiné à la branche* involves tying the warp in bunches and dyeing it before the fabric is woven. The resulting pattern, which in this case is of water lilies, has a softened sense of line which is well complemented by the misty color scheme of ash rose, muted blue-green, and olive green on a green-tinged cream ground. The free, open rhythm of the looped stems is typical of the 1880s and, to a limited degree, can be looked upon as one of the precursors of the Art Nouveau of a decade later.   ME

Metropolitan Museum of Art, gift of
Mrs. Boudinot Keith

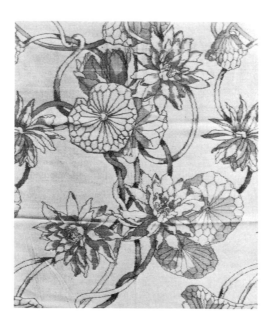

**8 Textile**
Associated Artists, New York
Designer: Candace Wheeler, ca. 1885
Maker: Cheney Brothers
Silk, satin patterned with disks in tabby binding
Height: 24½", width: 19¾"
Mark: *aa of ny*, in weft floats in the twill selvage

This design, both in terms of its decorative motif and in the play of brilliant gold against the deep blue ground, was strongly inspired by Japanese art. The weaving of the Associated Artists' initials in the border is typical of the luxury to which Mrs. Wheeler was accustomed, for not only is it to be read from the reverse side of the fabric but, after all, it was a section that would probably never be displayed. Even more curious is the fact that the letters are Gothic, which, when seen against this most Japanesque of textiles, recalls how freely historic styles were combined at this time.   ME

Metropolitan Museum of Art, gift of
Mrs. Boudinot Keith

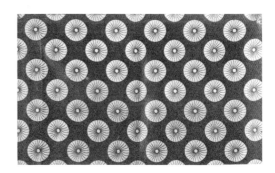

**9 Hanging shade**

Tiffany Studios, New York, ca. 1900–10
Leaded green marbelized glass, set with opalescent glass "stones," and metal filigree with a pattern of conventionalized flowers
Height: 11⅞" (without chain), diameter: 29½"

From the beginning of his career, Tiffany was intrigued by the effects of nature and often incorporated them or imitated them in his work. This frequently occurred in his lamps, where real stones and glass "jewels" were used separately or in interesting combinations to catch the sparkle of light. Tiffany studded this shade with large, rough-hewn pieces of glass that give a lusterous contrast to the polished panels of glass and the metal surfaces.   ME

Philadelphia Museum of Art, gift of Mr. and Mrs. Thomas E. Shipley, Jr.

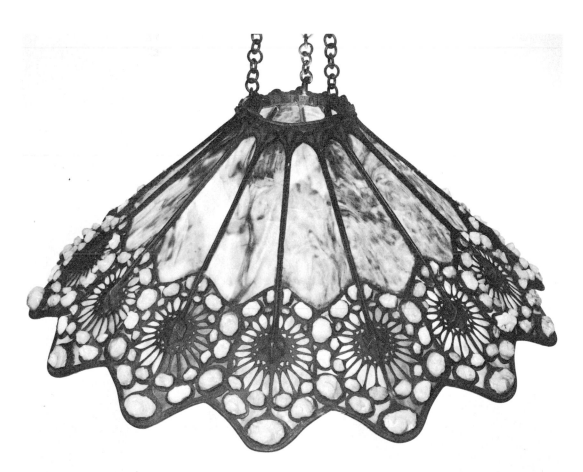

**10 Lamp**
Tiffany Studios, New York, ca. 1900–10
Leaded glass, glass mosaic, and bronze, the glass in
tones of yellow, gold, red, green, and blue
Height: 26"
Mark: *S629*, impressed under one foot

Nationalism and the Arts and Crafts movement
went hand in hand. Tiffany, like so many of his
contemporaries, encouraged the use of American
materials and American motifs. In addition to
native plants and animals, he was interested in the
art of the American Indians, as is shown in this
lamp where the patterns formed by the tesserae
imitate an Indian woven basket. This effect is
found in other Tiffany products and, in fact,
Tiffany Studios issued a brochure on the subject of
American Indian art in 1909 when they introduced
a desk set with Indian patterns. Tiffany's interest
was by no means anthropological, and thus on
this lamp Indian motifs are combined with a
Roman type of claw foot. Although presently
electrified, the lamp originally used kerosene fuel,
which explains the heavy proportions of the
drum base.   ME

Lillian Nassau, Ltd.

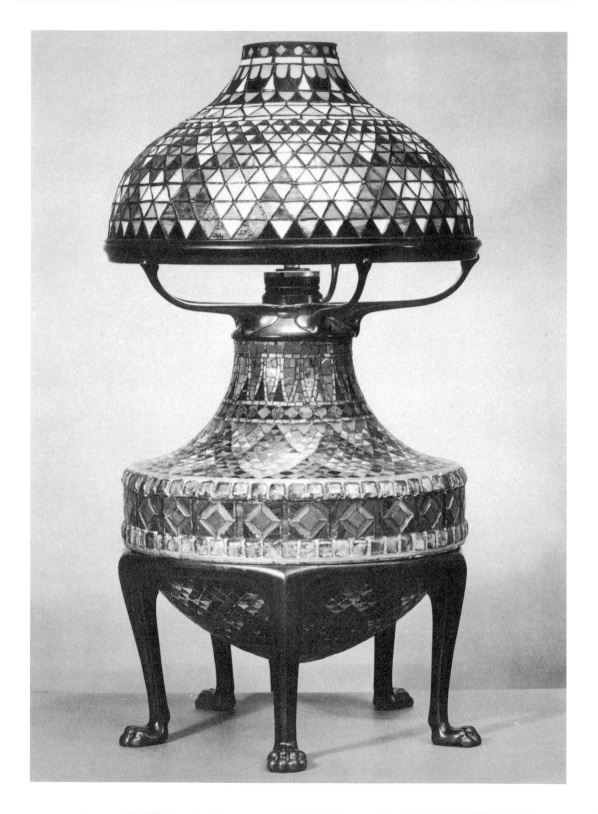

**11 Inkwell**
Tiffany Studios, New York, ca. 1900–02
Bronze, with cast relief design of three scarabs
supporting a ball, green patina
Height: 4"
Mark: impressed cypher of conjoined *TGDCO,
TIFFANY STUDIOS/NEW YORK, 29234*

This model appears in the 1906 price list: "857.
INKSTAND, Metal, 3 Scarabs. . . . 25.00." Its
design ingeniously uses the Egyptian motif of the
sacred scarab beetle pushing a dung ball, a symbol
of the generative force of the universe. Scarabs
and other Egyptian motifs were in general favor at
the turn of the century; but they had special
appeal for Tiffany who was attracted to the
splendors of the Near East and who had visited
Egypt as early as 1870. When this model was
produced, Alvin J. Tuck was the chief designer and
supervisor in Tiffany's metal shop.   ME

Carol Ferranti Antiques

**12 Pen tray**
Tiffany Studios, New York, ca. 1900–19
Bronze, set with mosaic of gold iridescent glass;
red patina
Length: 8", width: 3⅛"
Mark: impressed *2890*

The fluid patterns found in Tiffany's Favrile glass
as early as 1894 foreshadow the whiplash line
associated with Art Nouveau. This curvilinear
tendency was intensified just before and after the
turn of the century, when Tiffany and his artists,
very much aware of European developments,
consciously produced designs that were whole-
heartedly Art Nouveau. The style was applied to
small, single objects such as this pen tray; but
Tiffany almost never conceived large-scale under-
takings, such as interior decoration, in the Art
Nouveau mode. This particular item appears in the
1906 price list: "1001. Pen Tray, Metal and
Mosaic, swirl. . . . 5.00."   ME

Dr. and Mrs. Robert Koch

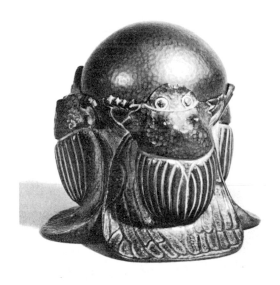

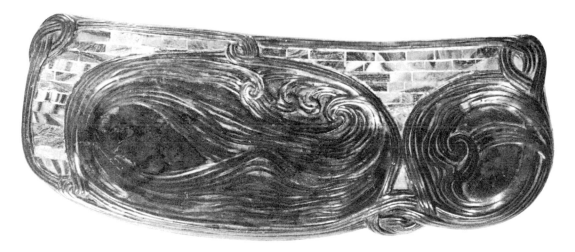

**13 Plaque**
Tiffany Studios, New York, ca. 1902–10
Glass mosaic in iridescent tones of blues set in
bronze frame
Diameter: 7¼"
Mark: impressed *TIFFANY STUDIOS*

The dragonfly motif had international currency at
the turn of the century. It seems to have had a
special attraction for Tiffany, who captured so well
its shimmering iridescence and fragility. This
mosaic disk, which could be hung, is similar
to one that Tiffany exhibited at the Turin Expo-
sition of 1902.   ME

Dr. and Mrs. Robert Koch

**14 Cigar box**
Tiffany Studios, New York, ca. 1902–10
Bronze, with cast relief pattern of conventionalized
flowers and circles; cedar wood lining
Height: 2¾", width: 9", depth: 6"
Mark: impressed *TIFFANY STUDIOS/NEW
YORK/10031*

Although cast in bronze, this box has the sem-
blance of a handcrafted object, with all the
delightful irregularities of modeling we might
expect from such a work. Tiffany cultivated this
natural look as the following story indicates. One
of the artists, who had little training in metals,
devised a way of cushioning the sheet of metal
on which she worked her repoussé. She told how
Mr. Tiffany preferred the effects she achieved
to those of a professionally trained English chaser

working next to her. In the same vein, Tiffany oft
carried pieces of Japanese metalware in the pock
of his vest which, as occasion prompted, he took
out as examples of the type of soft finishing or
contour he desired. It was in these ways that he
guided the eyes and hands of his many
craftsmen.   ME

Edgar Kaufmann, jr.

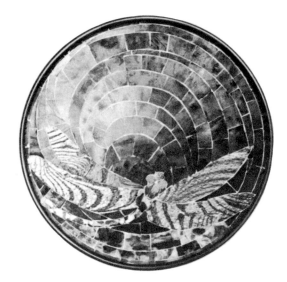

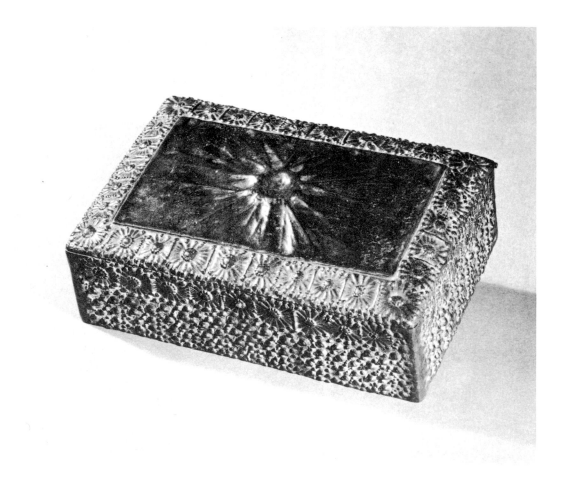

**15 Bowl**
Tiffany Studios, New York, ca. 1899–1910
Maker: Julia Munson
Copper repoussé with design of plums, branches, leaves; iridescent enamels in tones of purple, brown, orange, and green
Height: 6⅛", diameter: 9½"
Marks: impressed *SG 44*, incised in script
*Louis C. Tiffany*

Tiffany began experiments with enamels in the late 1890s in his home on 72d Street, using a small staff headed by two young women, Patty Gay and Julia Munson. The latter, in 1969, believed she was the maker of this bowl. When Tiffany undertook this work, the possibilities of the medium had already been explored with great success, most notably by Alexander Fisher in England and, more apropos for Tiffany, by René Lalique in France. Like Lalique, Tiffany sought to exploit the fire and depths of enamels in an attempt to rival the effects of precious stones. Tiffany used judicious combinations of opaque and translucent enamels, applying them in several layers and firing each separately, thus bringing them into a soft harmony of colors. Frequently, as with this bowl, the final surface was iridized, giving it the vibrant quality of a prismatic gemstone.   ME

Metropolitan Museum of Art, gift of the Louis Comfort Tiffany Foundation

**16 Box**
Tiffany Studios, New York, ca. 1900
Wood, carved and stained with a decorative pattern of flowers and leaves, inset with orange and yellow glass
Height: 2⅝"
Mark: incised *TIFFANY STUDIOS/NEW YORK*

At the turn of the century, Tiffany Studios began working with a wide variety of materials: enamels, pottery, and wood. Only a few examples of carved wood are known, suggesting that this was a short-lived experiment. The conception of this box, however, is totally in accord with the other products of Tiffany Studios. The decoration is formed from a natural motif, perhaps, in this instance, the cowslip plant. And, as might be expected, color is a chief concern, the effect being achieved through the staining of the wood and the ingenious use of Favrile glass to supply the natural color of the flowers and buds.   ME

Metropolitan Museum of Art, gift of the Louis Comfort Tiffany Foundation

## 17 Window

Tiffany Studios, New York, ca. 1910–19
Leaded glass, with a landscape design rendered
primarily in tones of green, blue, red, and yellow
Height: 50", width: 80½"
Marks: left panel, lower left corner in cameo
relief, *Louis C. Tiffany N.Y.*; middle panel, lower
left corner in cameo relief, *Louis C. Tiffany;*
right panel, lower right corner in cameo relief,
*Louis C. Tiffany N.Y.*

These three panels formed a window that was
installed in the Newark, New Jersey, house of
Carey Ballantine in the early 1920s. As part of his
inherent love for nature, Tiffany promoted the
use of floral and landscape themes for both
ecclesiastical and domestic settings. Not only did
their color enrich the environments but, as a
solution to one of the new problems of urban life,
they masked unpleasant views. Tiffany considered
himself primarily a colorist, and this is apparent
here. The richness of this landscape scene is
enhanced by the brilliance of the flowering trees
and iris, by the contrasts of green cypress and
white birch, and by the red and orange sunset. In
contrast to the simplicity of his earlier window
(see entry 6), the glass used for these panels shows
a bewildering variety, which is perhaps not so
surprising since already before 1900 Tiffany kept
between two and three hundred tons of glass in
store, with approximately five thousand different
colors and types. Most of the glass in this window
is marbelized or mottled; some of it, while still
molten, was rolled in fragments of other colors. In
some, filaments of other colors were poured
on in random patterns. Moreover, layers of glass
have been superimposed upon each other to
heighten the subtlety and brilliance of the color.
Actually, a great deal of responsibility fell upon the
shoulders of the artist who was charged with
the selection, cutting, and assembling of the glass;
but all work, from the cartoon to the finished
product, was carefully supervised by Tiffany
himself.   ME

The Art Museum, Princeton University, gift of
Norman A. Ballantine

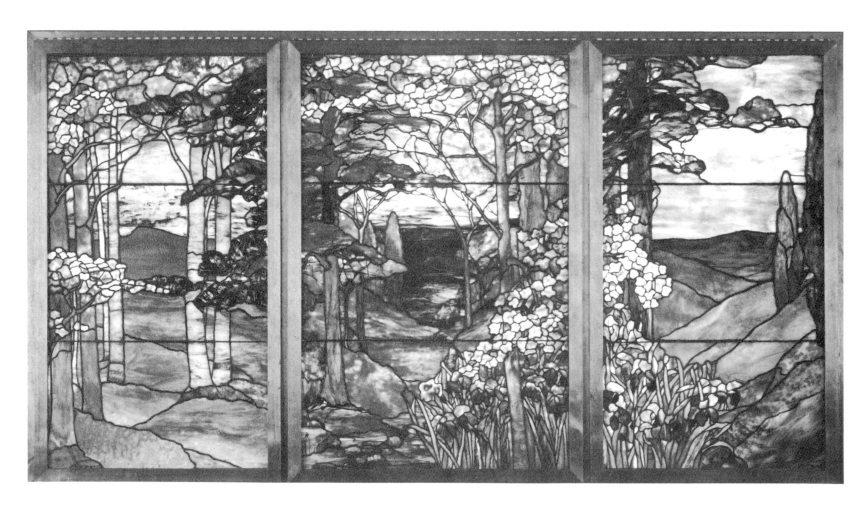

## Gorham Manufacturing Company

The founder of this Providence, Rhode Island, firm was Jabez Gorham, who, after a seven-year apprenticeship, formed a partnership in about 1818, which eventually lead to the formation of Gorham & Company in 1852. Known as Gorham Manufacturing Company after 1863, it was one of the first silver manufacturers to employ methods of mass production in making its wares. However, the firm continued to use handicraft techniques in some of its lines, such as Martelé, which was first sold around 1900. The company's chief designer at the time was William C. Codman, who had worked for Cox and Son in London before coming to Providence in 1891.   DAH

**18 Bowl**
Designer: probably William C. Codman, ca. 1912
Silver, gilt
Height: 5¼", diameter: 11¼"
Mark: *Martelé/9585/VPC/SPAULDING & CO./CHICAGO*, and Gorham hallmarks, stamped on bottom
Inscription: *MJR/JUNE 12-1912*, engraved on bottom

Purchased at Spaulding & Company in Chicago, this piece was presented to Marjorie J. Robbins in 1912. It represents Gorham's Martelé line, which was closely related to French Art Nouveau.   DAH

Mrs. Robert D. Graff

**19 Three-handled cup**
Silver
Height: 9¾"
Marks: *STERLING/A327/7 pint,* and Gorham hallmarks, stamped on bottom

Intended as a bridal or toasting cup, it has a rather traditional basic shape in smooth silver. But to this have been added handles and spreading details in quite realistically portrayed thistles, making an interesting comparison with the portiere designed in 1901 by George W. Maher (see entry 82).

Mr. and Mrs. Victor H. Bacon II

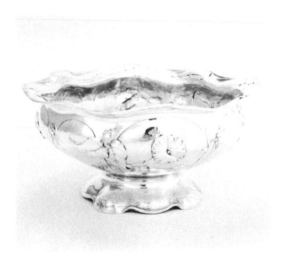

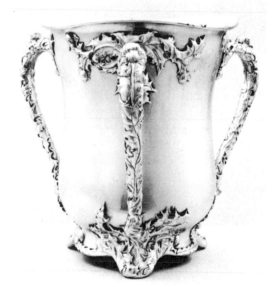

**20 Cigar box**
Silver, with lining of Spanish cedar
Height: 4⅞", width: 7¾", depth: 4⅜"
Marks: *GORHAM/STERLING,* on bottom
Inscription: *L. W.,* in panel on lid

In contrast to the more naturalistic decoration of
the preceding two pieces, this box bears con-
ventionalized tree motifs which function as borders
for the sides and top. It therefore represents the
severe, geometric phase of Art Nouveau, which was
the mature, late style of the Arts and Crafts
movement. The central quatrefoil on the front is
a movable latch.

Mr. and Mrs. Victor H. Bacon II

### Elizabeth E. Copeland

Born in Boston, Elizabeth Copeland was known
for her enameling and silverwork. She studied
in London before returning to Boston, where she
was associated with the Handicraft Shop. In
1916 she was awarded a medal for excellence by
the Society of Arts and Crafts, Boston. She
exhibited in arts and crafts exhibitions throughou
the country.   DAH

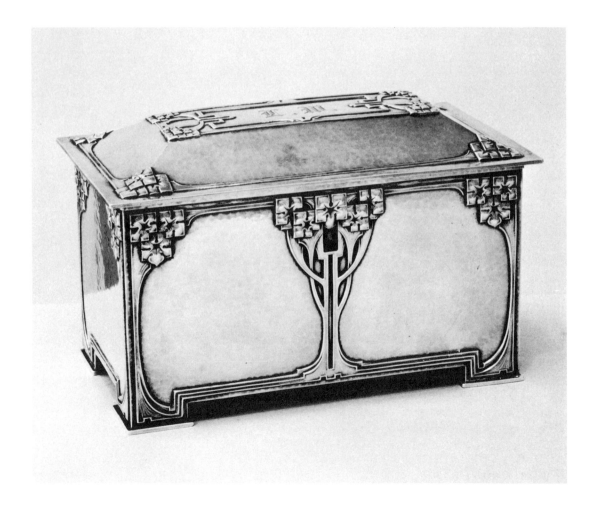

**21 Box**
Designer and maker: Elizabeth E. Copeland, ca.
1907–08
Silver with enamels
Height: 2⅛", width: 5⅛", depth: 3⅜"
Mark: *EC*, scratched on left rear corner of base

Typical of Miss Copeland's work is the primi-
tivistic impression given by her forms, enlivened by
the colorful enamels in suggestions of natural
motifs.

J. Herbert Gebelein

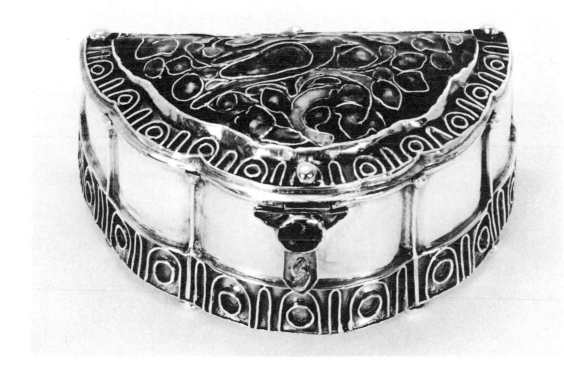

## Art Workers' Guild

Long before the Handicraft Club was founded in
Providence, Rhode Island, a group of three men
who had collaborated on architectural decoration
and other projects in the mid-1880s began calling
themselves the Art Workers' Guild, a name used by
a much more famous group in London, organized
in 1884. Members in Providence were the painters
Sydney R. Burleigh and Charles W. Stetson,
along with John G. Aldrich, an industrialist who
was especially interested in the fine arts and handi-
crafts. The most important example of their
mutual efforts is the Fleurs de Lys Studios building
of 1885 in Providence, which has been published
by Edgar Kaufmann, jr. (*Journal of the S. A. H.,*
December, 1965). They also did silverwork, panel
paintings, and furniture, often in collaboration.

**22 Cabinet**
Art Workers' Guild, Providence, R.I., ca. 1894
Painted wood with columns of mahogany; framed
paintings, oil on canvas mounted on composition
board
Height: 58", width: 63½", depth: 7½"

Made for Mrs. Sydney R. Burleigh about 1894, the
shallow cabinet was undoubtedly intended for a
hallway. The lower section with its recessed
panels and engaged colonettes is quite traditional;
similar classical details would reappear in the
work of the Englishman Ambrose Heal in the
1920s. The polychromed carvings, attributed to
Burleigh, are confined to areas between the
hinged doors that contain panels painted on both
sides by Stetson. "Illuminated" cabinets were a
specialty of William Morris and his associates; this
descendent, however, is much simpler in scheme.
The use of ivory paint would have pleased Elsie
de Wolfe two decades later.

Edgar Kaufmann, jr.

## Rose Valley Association

The Rose Valley community was founded in 1901 by William L. Price, the Philadelphia architect who designed the home of Edward Bok, editor of *Ladies' Home Journal*. The community was located in a valley fourteen miles southwest of the center of Philadelphia, with shops set up in abandoned mill buildings. The parallel with C. R. Ashbee's Guild of Handicraft and its move in 1902 to Chipping Campden was noticed by at least one contemporary writer (*House Beautiful*, November 1906). Financial backing came from nearby Swarthmore College and from the Fels brothers. There were workshops for pottery and furniture making, as well as a Village Press, which published the *Artsman* from 1903 to 1907. According to George Thomas, craftsmen were brought from Switzerland to train the resident-workers. A salesroom was maintained in Philadelphia as an outlet for the products made in the community, which went bankrupt in 1909.

**23 Book stand**
Rose Valley Association, Moylan, Pa., before 1909
Designer: William L. Price
Oak
Height: 43", width: 20", depth: 15"
Mark: *ROSE VALLEY SHOPS*, on underside of leg

Designed by Price for his own architectural office in Philadelphia, the stand shows the generally medieval character of most Rose Valley furniture. The carved details are especially well conceived and executed.

Mr. and Mrs. Hyman Myers

## Charles Rohlfs

For Charles Rohlfs, furniture making was a third career. Born in New York City in 1853, and trained at Cooper Union, he was working as a designer of cast-iron stoves by 1872. Five years later he made his theatrical debut with the Boston Theater Stock Company, and soon was a renowned professional actor, appearing often in Shakespearian roles. In 1884 he married the novelist Anna Katherine Green, whose book *The Leavenworth Case* he helped adapt for the stage. He played the role of its leading character during the 1891–92 season. Curiously, Mrs. Rohlfs had married him with the stipulation that he give up acting, so he gradually turned to his favorite hobby, woodworking.

By 1890, Rohlfs was making plain oak pieces with unusual details, which had many characteristics in common with the style later known as Mission. Opening a small workshop in Buffalo, he never employed more than eight assistants even at the peak of his popularity. Rohlfs made single custom pieces, and also supervised the decoration of office suites and domestic ensembles. He was once commissioned to design several pieces of furniture for Buckingham Palace, although these were done in a style hardly recognizable as his work. He was elected to membership in the Royal Society of Arts in London, largely because of his impressive representation at the International Exhibition of Modern Decorative Arts in Turin, 1902. Rohlfs also showed furniture at the Buffalo Exposition in 1901 and at St. Louis in 1904. The Austro-German press was especially enthusiastic about his work.

Rohlfs often lectured in East Aurora as a guest of Elbert Hubbard and the Roycrofters, and once wrote an article for *House Beautiful* on "The Grain of Wood" (February 1901). In 1910 he helped design his own house on Park Street in Buffalo, the exterior of which bears a strong resemblance to the work of the British domestic revival of the preceding decade. He retired in the mid-1920s.

**24 Chest of drawers**
Designer: Charles Rohlfs, ca. 1900
Fumed oak
Height: 65½", width: 31½", depth: 16"

Intended for use in Rohlfs's home, this chest is a simpler version of a famous piece shown at the Buffalo Exposition of 1901 (*Kunst und Kunsthandwerk,* March 1902), and again in Turin and St. Louis. It was advertised in 1907 as available on special order for eighty-five dollars. Rohlfs's son recalls that his father once explained how his carved ornament was inspired by the smoke curling from his pipe. Often the design followed patterns suggested by the grain of the wood. Some of Rohlfs's early panels resemble the broomcorn designs of 1887 by Edward Colonna.

Roland Rohlfs

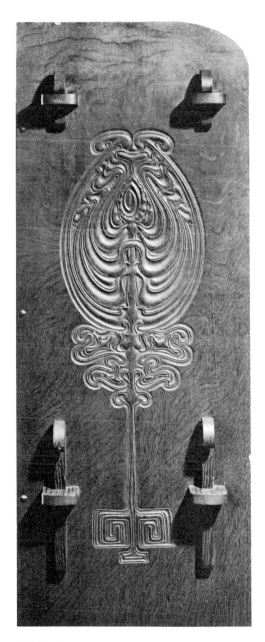

24 (detail)

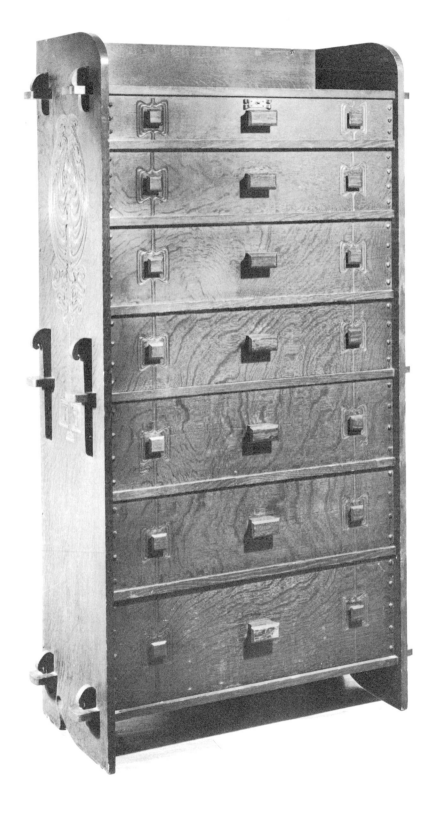

**25 Chair**
Designer: Charles Rohlfs, ca. 1898
Oak
Height: 54", width: 17½", depth: 16¼"

Designed for Rohlfs's own residence, this was a "fancy chair" for the living room. One of the few American furniture designers who worked successfully in an Art Nouveau mode, Rohlfs possibly gleaned some inspiration from the ornament of Louis Sullivan's Guaranty Insurance Building in Buffalo. Despite the frenzied elaboration of the back of the chair, the whole is conceived as a series of perforated planes. Rohlfs always did the designing, but often delegated the carving to his assistants. George Thiele was the carver in this instance. The upholstery is not original.

Roland Rohlfs

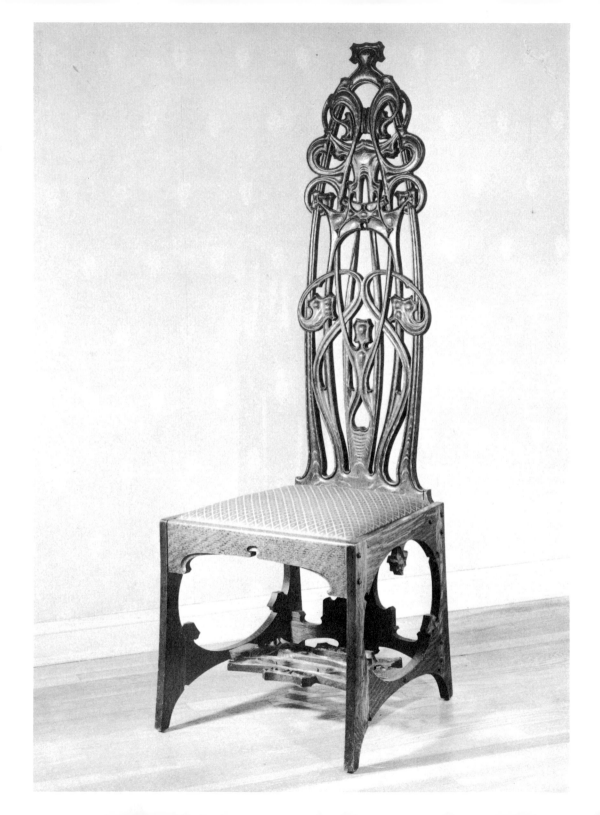

**26 Rocker**
Designer: Charles Rohlfs, 1902
Fumed oak with white paint rubbed into grain
Height: 33¼", width: 23¼", depth: 26¼"
Mark: *R/1902,* carved on rear apron

Because this was made for a customer rather than
for his own use, it bears the once-famous Rohlfs
shopmark, an *R* enclosed in the rectangular
frame of a wood saw, with the date below it.
This mark was usually incised, but sometimes
burned into his furniture. In his advertising bro-
chure of 1907, Rohlfs wrote, "Pardon me for
adding that my work is considered to be artistic to
a degree by competent critics."

Paul Morrissey

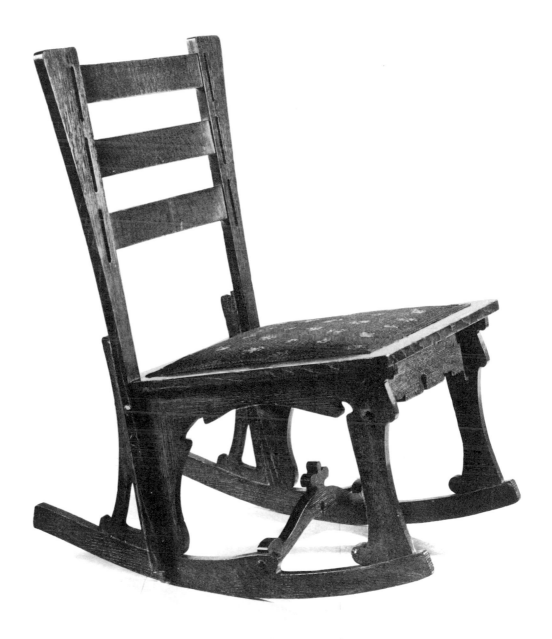

### 27 Footstool

Designer: Charles Rohlfs, ca. 1901
Fumed oak
Height: 16½″, width: 18⅛″, depth: 9⅛″
Mark: *R,* burned into apron

The charm of this piece is not only in its jaunty profile, but also in the fact that it is a *rocking* footstool.

Roland Rohlfs

### 28 Table

Designer: Charles Rohlfs
Oak
Height: 30″, diameter: 30″

Made for Rohlfs's own home in Buffalo, this is one of his simplest designs. The hinged top opens for storage of linens.

Roland Rohlfs

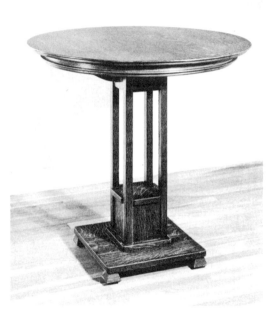

### 29 Candelabrum

Designer: Charles Rohlfs, 1903
Oak
Height: 17¼″, width: 21¾″, depth: 4½″
Mark: *R/1903,* burned into underside of base

The stile and rail construction encloses panels pierced with a conventionalized plant design. Originally, the two wooden disks held copper bobeches for large carriage candles. Wire masts supported movable shades of translucent shells found in the China Sea. A matching single candle-holder was advertised by Rohlfs in 1907 for two dollars and fifty cents.

Brooklyn Museum, gift of Mrs. C. Cojean

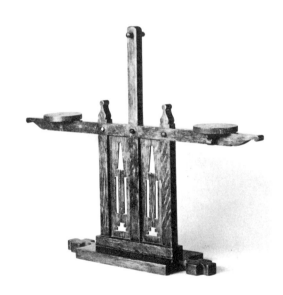

## Will H. Bradley

Will H. Bradley, renowned during the 1890s for his book illustrations and posters in the Art Nouveau mode, considered himself not only a graphic designer but also an American exponent of the Arts and Crafts movement who sought to make everyday life more beautiful. In 1896 he established the Wayside Press in Springfield, Massachusetts, where, according to the *Echo* of 1 February 1896, he hoped to produce not only a magazine, *Bradley: His Book,* but also "pictures, books, tapestries . . . wallpapers, and all kinds of mural decorations, including fabrics." Suggestions for household decoration were to be included in *Bradley: His Book,* which would also sponsor contests to encourage aspiring artist-craftsmen in this country, as the *Studio* was doing in England. It was also reported that Bradley proposed to organize a school of design where instruction would be given "in various kinds of decorative art" (*Poster Lore,* February 1896). Most of these plans were never realized. But when Bradley displayed examples of his work at the first Boston Arts and Crafts Exhibition in April 1897, the *Boston Globe* commented that he was "a many-sided genius [who] seems to be equally at home designing an initial or a font of type or a poster, and he also designs furniture—in fact there appears to be no limit to his ambition."

Bradley's skill as a printer and typographer won him in 1900 the commission to prepare a new editorial prospectus for the *Ladies' Home Journal.* Thus began a long friendship with the editor, Edward Bok, who in the mid-1890s had undertaken a campaign to promote good domestic architecture in this country through a series of projects for moderately priced homes featured in his magazine. These were designed by some of America's leading architects—Frank Lloyd Wright, Robert Spencer, and Ralph Adams Cram, among others. Bok soon asked Bradley to prepare a series of interiors, which appeared in *Ladies' Home Journal* from November 1901 to August 1902, the last installment being suggestions for the exterior of the "Bradley house," as it was known.

The series was introduced with an explanation: "Mr. Bradley will design practically everything shown in the pictures. It is not his hope that anyone will build a house completely as he designs it: he hopes rather to influence through individual suggestions—through pieces of furniture, draperies, fireplace accessories, wall-paper designs, all of which can be independently followed and detached from his entire scheme." Although Bradley expected his suggestions to be taken selectively, a striking feature of his scheme is the cohesiveness of the total design. The floor plan, although not entirely coherent as architecture, was arranged to permit an open flow of light and air between the rooms. Bradley related each piece of furniture to the individual room for which it was designed and to the house in general by emphasizing the structural and decorative elements of the furniture, the walls, and the beamed ceilings, and by repeating throughout the interior warm, earth colors— yellows, greens, and umbers. The Bradley house, with its low ceilings, intimate inglenooks, window seats, and decorative friezes, was conceived as a cozy suburban home.

Bradley must have been fully aware of the work of his contemporaries who were interested in the country dwelling and its furnishings, especially M. H. Baillie Scott and C. F. A. Voysey in England, and Frank Lloyd Wright in America. Although he seems to have been influenced by all three of these artist-craftsmen, the pictorial elements in his furniture and interior decoration place him closer to Scott than to Wright. Bradley's ornament also reflects his own style of illustration at the turn of the century, which was characterized by his use of rectilinear composition, strong outlines, and watercolor wash.

The *Ladies' Home Journal* series, particularly the design for the nursery, was well received by the public, and Bok commissioned Bradley to design several more houses. Although probably completed in 1902, they were not published until February, April, and June 1905. Bok also encouraged Bradley to open a shop for the design of furniture and other handicrafts at Rose Valley, near Philadelphia, and to assume the art editorship of *House Beau-*

*tiful,* which Bok considered buying. Bradley declined these offers and returned to his freelance work. Nevertheless, his architectural interests were exercised in three houses he designed for his family: one in Concord, Massachusetts (1902), and two in Short Hills, New Jersey (ca. 1910 and the early 1920s). None of the Bradley house furniture is known to have been executed, except for several pianos built by Chickering & Sons, Boston. according to Bradley's drawings  RWW

**30 Chest**

For the living room or hall, *Ladies' Home Journal,*
March 1902
Designer: Will H. Bradley, 1901
Watercolor and ink on paper
Height: 8⅛″, width: 4⁷⁄₁₆″
Signed: *W. B.,* lower right corner

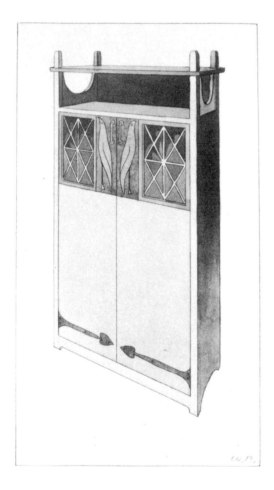

This and the following five drawings are a few of
the incidental furniture designs that were arranged
around the interior view of each room presented
in the *Ladies' Home Journal* series. They were
intended as alternate or supplementary suggestions.
Bradley later recalled, "I added dozens of sug-
gestions for individual pieces of furniture—this
being the 'Mission' period when such designing
required no knowledge of period, only imagina-
tion." He often designed furniture with projecting
vertical extensions, similar to the work of C. F. A.
Voysey, Baillie Scott, and some of their followers,
such as A. Wickham Jarvis and Walter Cave.
The bird motif may have been inspired by Voysey,
although Bradley had used comparable decoration
in his illustrations since 1897.   RWW

Metropolitan Museum of Art, gift of
Fern Bradley Dufner

**31 Cabinet**

For the living room or hall, *Ladies' Home Journal,*
March 1902
Designer: Will H. Bradley, 1901
Watercolor and ink on paper
Height: 9⅛″, width: 4⅛″
Signed: *W. B.,* lower right corner

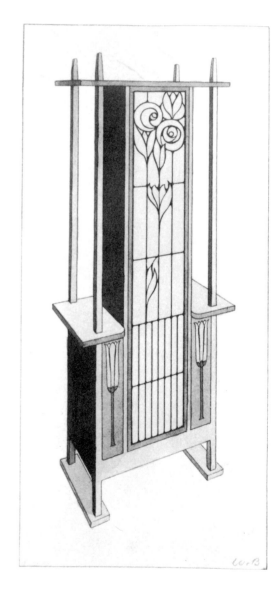

Bradley, influenced by Voysey and Scott, often designed furniture with an open framework that defined but did not enclose space. His interest in decorative glass may have been inspired by similar ornamental doors on cabinets by the Scottish designers C. R. Mackintosh, Herbert McNair, and Talwin Morris.   RWW

Metropolitan Museum of Art, gift of
Fern Bradley Dufner

## 32 Cabinet

For the living room or hall, *Ladies' Home Journal,* March 1902
Designer: Will H. Bradley, 1901
Watercolor and ink on paper
Height: 7¼", width: 3⁷⁄₁₆"
Signed: *W. B.,* lower right corner

The cabinet is reminiscent of the heavy, solid furniture with turned elements that Baillie Scott designed for an artist's house, published in the *Studio,* October 1896. The heart motif seen here in the hinges was a favorite of Scott and Voysey. RWW

Metropolitan Museum of Art, gift of
Fern Bradley Dufner

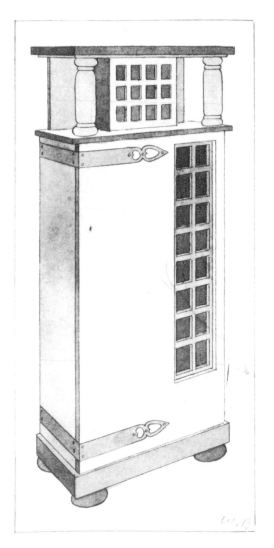

## 33 Chair

For the nursery, *Ladies' Home Journal,* February 1902
Designer: Will H. Bradley, 1901
Watercolor and ink on paper
Height: 5½", width: 3⁵⁄₈"
Signed: *W. B.,* lower right corner

This austere chair exceeds the demands for simplicity espoused by Baillie Scott and Charles Voysey, and is in sharp contrast to most of the other designs in Bradley's *Journal* series. It may be indebted to William Martin Johnson's unorthodox, English-inspired furniture published by the *Journal* in 1900; it also resembles some later Prairie school pieces (see entry 83).   RWW

Metropolitan Museum of Art, gift of
Fern Bradley Dufner

### 34 Chest

For the living room or hall, *Ladies' Home Journal,*
March 1902
Designer: Will H. Bradley, 1901
Watercolor and ink on paper
Height: 8⅝", width: 3¹⁵⁄₁₆"
Signed: *W. B.,* lower right corner

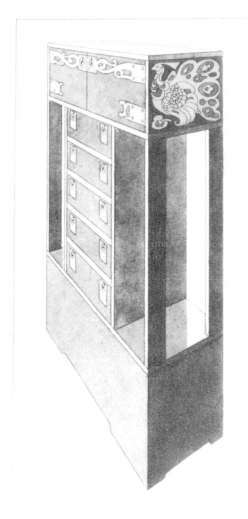

Bradley experimented here with the decorative
possibilities of metalwork, following the example
of many British designers. Current periodicals had
paid particular attention to the repoussé work
of Mackintosh, McNair, and the Macdonald sisters.
The peacock on the side of the chest was a motif
that Bradley, along with other Art Nouveau
artists, had used often throughout the
1890s.   RWW

Metropolitan Museum of Art, gift of
Fern Bradley Dufner

### 35 Cabinet

For the living room or hall, *Ladies' Home Journal,*
March 1902
Designer: Will H. Bradley, 1901
Watercolor and ink on paper
Height: 6½", width: 2½"
Signed: *W. B.,* lower right corner

Bradley again emphasized the ornamental possi-
bilities of custom hinges on this cabinet, reflecting
the rule proposed by Baillie Scott that "construc-
tion is decorative and decoration constructive."
This particular leaf motif was a Bradley favorite in
the 1890s. He apparently intended the cabinet
to be stained green, a finish popular with Scott
and Voysey.   RWW

Metropolitan Museum of Art, gift of
Fern Bradley Dufner

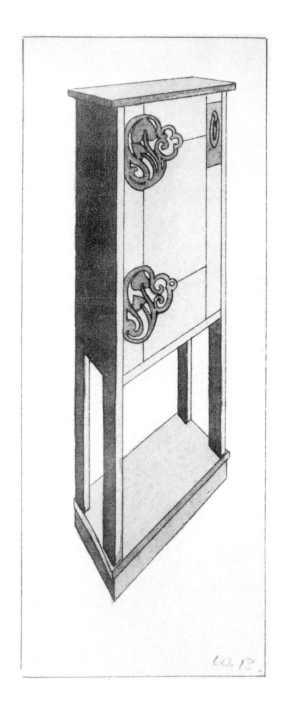

## Harvey Ellis

Harvey Ellis began his professional career as a draftsman in Albany as early as 1873–74. After a short period in the office of an engineer in New York City, Ellis returned to Albany, where he worked for H. H. Richardson on designs for the completion of the state capitol building. Returning to his hometown of Rochester in 1879, Ellis worked with his brother Charles for the next five years in an architectural practice about which little is known. By the mid-1880s, Ellis's exquisite renderings began to appear in the Midwest, labeled with the names of such architects as Leroy S. Buffington, Minneapolis, and George R. Mann of St. Louis and St. Joseph, Missouri. Although Ellis was rarely sober and almost always penniless, he was sought after by many architects, who recognized in his renditions of the Romanesque revival a talent superior to their own.

His way of life changed drastically in the mid-1890s, when he temporarily gave up drinking and returned once again to work with his brother in Rochester. It was during this period that his designs began to show inspiration from the British Arts and Crafts movement. For example, three drawings for houses published in the 1901 catalogue of the Chicago Architectural Club exhibition were in the style of M. H. Baillie Scott. Ellis also turned more and more to painting, his canvases usually evoking a mystical symbolism, but sometimes showing an affinity for the two-dimensional graphic style of the period.

In April 1903, Ellis began to work for Gustav Stickley's United Crafts in Syracuse. The July 1903 issue of the *Craftsman* contained his first contributions to that magazine, which featured his work until shortly after his death in January 1904. In that half year, the *Craftsman* had its first real moments of greatness, for Ellis revealed a full awareness of current developments in Europe as well as an appreciation of American traditions. He also designed a line of inlaid furniture for Stickley, which was advertised as being "lighter in effect and more subtle in form than any former productions of the same workshops."

This promising new phase of Ellis's career was cut short just as the readers of the *Craftsman* were growing used to his sensitive drawings in each issue. Stickley reported: "In the death of Mr. Harvey Ellis, which occurred on January 2, the *Craftsman* lost a valued contributor to its department of architecture. Mr. Ellis was a man of unusual gifts, possessing an accurate and exquisite sense of color, a great facility in design and a sound judgment of effect. These qualities were evidenced in his slightest sketches, causing them to be kept as treasures by those fortunate enough to acquire them" (*Craftsman*, February 1904).    KIG

**36 Window**
Designer: Harvey Ellis, 1897
Leaded glass
Height: 18½″, width: 70½″

The Junius Judson house in Rochester was re-modeled by Charles and Harvey Ellis in 1897, at which time this window was designed by Harvey. The knightly procession toward a castle with a setting sun in the background has a storybook quality not unlike Ellis's design for a tapestry and his illustrations for "Puss and Boots," published in the July and August 1903 issues of the *Craftsman*.

Mr. and Mrs. Roger G. Kennedy

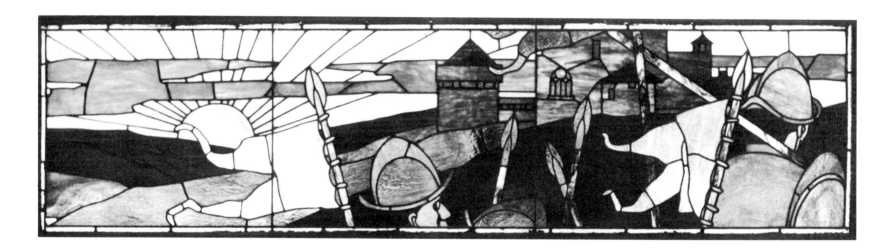

**37 Side chair**
United Crafts, Syracuse, N.Y., 1903
Designer: Harvey Ellis for Gustav Stickley
Oak, with inlays of darker woods, copper, and
pewter
Height: 42½", width: 17", depth: 19¾"
Mark: red decal, *Als ik kan/Stickley,* on inside of
rear leg, above stretcher

This is one of the chairs of a new line of inlaid
furniture advertised in the *Craftsman* in July 1903
and pictured in the January 1904 issue. The gentle
curve of the apron, the elegant, distended stiles,
and the details of the splats are evidence of
Ellis's hand. The inlaid designs are closely related
to work of the Glasgow School, consisting of "fine
markings, discs, and other figures of pewter and
copper, which, like the stems of plants and ob-
scured, simplified floral forms, seem to pierce the
surface of the wood from beneath" (*Craftsman,*
January 1904). The line was discontinued soon after
Ellis's death, probably because of its expense.
Stickley recalled that his workshops had "used an
occasional touch of ornamentation, but gradually
left off all decoration as the beauty of pure
form developed, and any kind of ornament came
more and more to seem unnecessary and intrusive"
(*Chips from the Craftsman Workshops,* 1907).

Private collection

**37** (detail)

**38 Writing table**
United Crafts, Syracuse, N.Y., 1903
Designer: Harvey Ellis for Gustav Stickley
Oak, with inlays of various woods, copper, and pewter
Height: 30", width: 29¾", depth: 18"
Mark: red decal, *Als ik kan/Stickley,* underneath drawer area

A similar table, but with two drawers, was shown in Ellis's drawing of the north wall of a child's bedroom featured in the July 1903 issue of the *Craftsman.* The complicated inlays on the legs are conventionalized floral motifs with vignettes of Viking ships.

Private collection

## Gustav Stickley

The oldest of six brothers born in Osceola, Wisconsin, Gustav Stickley was trained by his father as a stonemason. As a young man, however, he found himself making chairs for an uncle in Brandt, Pennsylvania. Introduced to the writings of Ruskin, he began thinking in terms that later made him one of the leading exponents of Arts and Crafts ideals in America.

Stickley's activities up to the year 1898 were numerous and are difficult to plot in chronological order. He was usually in partnership with various relatives in furniture manufacturing—making chairs in eclectic styles or else Colonial reproductions. In 1898, he bought out his partner Elgin A. Symonds, forming the Gustave Stickley Company in Eastwood, a suburb of Syracuse, New York. Stickley made an extended trip to Europe that year, visiting Charles F. A. Voysey and other leaders of design in England and on the Continent. From that point onward, his work seldom had historical references. A line of simple furniture constructed of plain boards and revealing some hints of Art Nouveau was shown by him at the June 1900 furniture exhibition in Grand Rapids (House Beautiful, October and December 1900, the latter a Tobey Furniture Company advertisement with no mention of Stickley).

That year, 1900, two of his brothers left his workshop and formed the L. & J. G. Stickley Company in nearby Fayetteville. Their parallel efforts, and those of other manufacturers capitalizing on the sudden popularity of this simple "revolutionary" furniture style, caused something of a crisis for Stickley. He now found it necessary to emphasize his trade name, Craftsman, and the device with which he labeled his work, a joiner's compass with the words Als ik kan, borrowed from Jan Van Eyck via William Morris. Stickley showed a major selection of his new furniture at the Pan-American International Exposition in Buffalo, 1901, sharing space with the Grueby Faience Company of Boston. That same year, he introduced a semi-cooperative scheme in his business, calling it the United Crafts. The venture was not entirely successful, and the name was dropped in 1904, at about the time he changed the spelling of his first name from Gustave to Gustav.

In October 1901 appeared the first issue of the Craftsman, a small monthly that Stickley at first distributed with the help of his wife and daughters. The initial force behind this publication was Irene Sargent, a professor of art history and romance languages at Syracuse University. With homage to Morris and Ruskin, the Craftsman gradually became a forum for views on current movements in the arts and an effective vehicle for spreading the taste for Stickley's own furniture and his ideas about architecture and even city planning. He attracted some admirable talents as collaborators, chiefly Harvey Ellis, whose association was cut short by death in January 1904. Quite possibly at the suggestion of Ellis, Stickley established the Craftsman Home-Builders' Club in late 1903. Thereafter, monthly suggestions for simple, tasteful houses were featured in the magazine, with plans and specifications available on request.

A Stickley empire was obviously in the making, and in 1905 his editorial and executive operations were moved to New York City, the workshops remaining in Eastwood. As if to compensate for this removal from the scene of his most important activity, furniture making, he purchased land near Morris Plains, New Jersey, where a model farm and small family community was planned and partially realized. Meanwhile, Craftsman furniture had become popular across the country, and franchises existed from Boston to Los Angeles. In 1913, the year in which Elsie de Wolfe was writing and lecturing against almost everything that Stickley stood for, he purchased a large building in Manhattan, where showrooms, offices, and a restaurant were installed. It was an ambitious move at least a half dozen years too late. In April 1915 bankruptcy was declared. During the next several months, new lines of furniture were introduced; some had vague recollections of eighteenth-century forms, while others featured bright new colors as an alternative to the consistent production of oak that had made Stickley famous. Mary Fanton Roberts, who had served for several years as managing editor, guided the Craftsman magazine to its quiet demise in December 1916, only to revive its format and message in a short-lived likeness that she called the Touchstone. Shock and disillusionment left Stickley powerless to make a comeback of any kind, and he died quite forgotten in 1942.

### 39 Folding screen
Craftsman Workshops, Syracuse, N.Y., 1905
Oak, burlap, and linen
Height: 58", width: 54"

Two versions of this folding screen were announced in the "Home Department" of the February 1905 issue of the Craftsman. Both designs were based on the motif of the rose, which was then a favorite flower for conventionalized decoration both in this country and Europe. With pride in both conception and execution, the editor described the colors and fabrics: "The soft olive green of the panel color suggests the deep tones of the hazel wood of which the frame is made, and in contrast we have introduced, as the appliqué of the rose form, a bloom linen of richest gold—this again finding a place in the little space enclosed at the base of the stem lines. The tapering leaves of the rose, singularly decorative in line, are carried out in an appliqué of this clear green and outlined in a golden brown which also is again repeated in the stem lines, and the markings of the petal forms of the flower." Available with framing in a variety of woods, this one of oak was chosen for an upstairs bedroom of the Gamble house in Pasadena. Its colors have changed drastically because of prolonged exposure to sunlight. According to Stickley's 1906 catalogue, the price was twenty dollars.

Gamble House, Greene and Greene Library

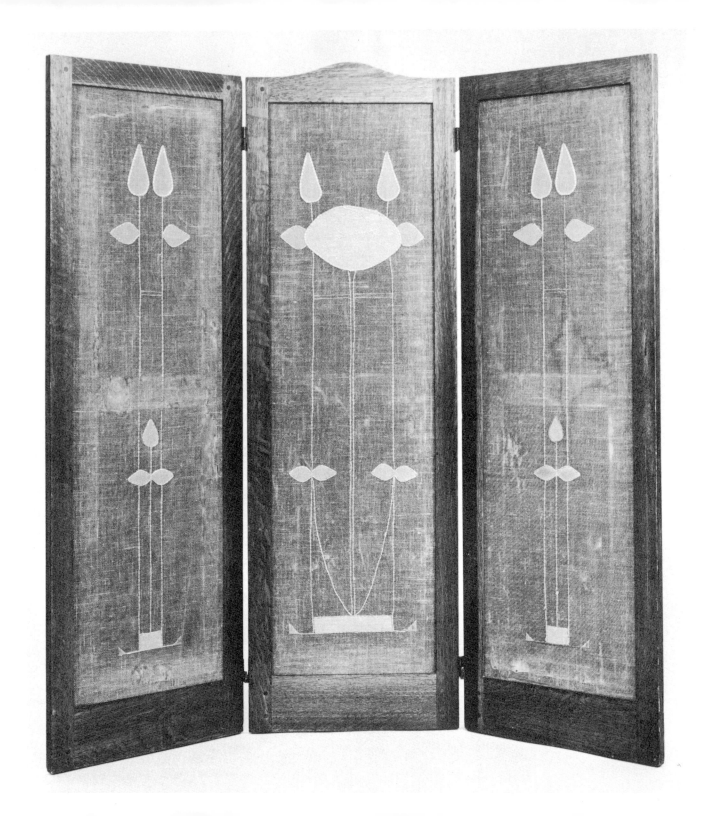

**40 Armchair**
United Crafts, Syracuse, N.Y., after 1901
Oak, with leather seat
Height: 37", width: 20", depth: 19"
Marks: red decal, *Als ik kan/Stickley,* and paper label

In his book *Craftsman Homes* (1909), Stickley singled out this chair and proclaimed that no better example of the Craftsman style could be found. Shown at the Buffalo Exposition in 1901, it was originally made with a rush seat. The text of a later advertisement for a Stickley chair (March 1907) applies here also: "The piece . . . is first, last and all the time a *chair,* and not an imitation of a throne, nor an exhibit of snakes and dragons in a wild riot of misapplied wood-carving. The fundamental purpose in building this chair was to make a piece which should be essentially comfortable, durable, well proportioned and as soundly put together as the best workmanship, tools and materials make possible."

Ethel and Terence Leichti

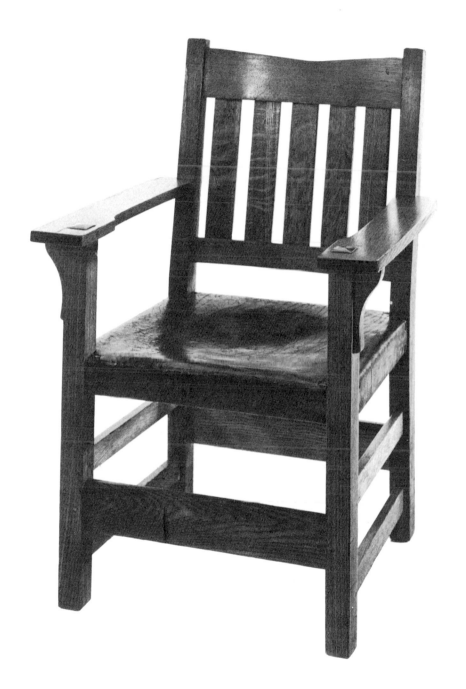

**41 Side chair**
United Crafts, Syracuse, N.Y., after 1901
Oak, with leather seat
Height: 36″, width: 16″, depth: 16″
Mark: red decal, *Als ik kan/Stickley*

Ethel and Terence Leichti

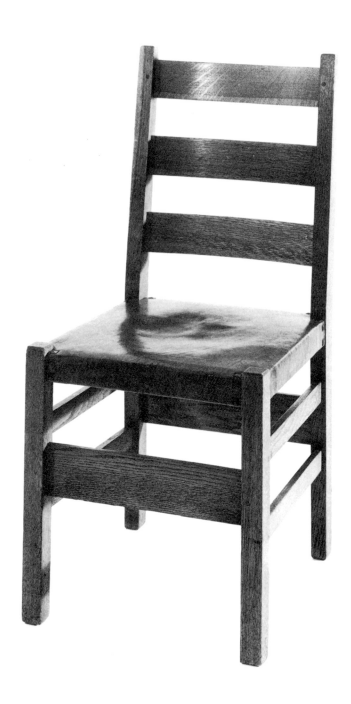

**42 Settle**
Craftsman Workshops, Syracuse, N.Y., ca. 1908
Oak, with leather cushion
Height: 39", width: 71¼", depth: 28"

The movable settle, with slats and sometimes soft cushions, was an important item in any avant-garde catalogue at the turn of the century. This number first appeared in Stickley's 1909 catalogue, and was priced at fifty dollars. It is severe, even relentless in the insistence on rectilinearity and forthright construction. Stickley wrote about his love of the straight line and of oak: "When I first began to use the severely plain, structural forms, I chose oak as the wood that, above all others, was adapted to massive simplicity of construction. The strong, straight lines and plain surfaces of the furniture follow and emphasize the grain and growth of the wood, drawing attention to, instead of destroying, the natural character that belonged to the growing tree" (Binstead, *The Furniture Styles,* 1909).

The Art Institute of Chicago, gift of Mr. and Mrs. John J. Evans, Jr.

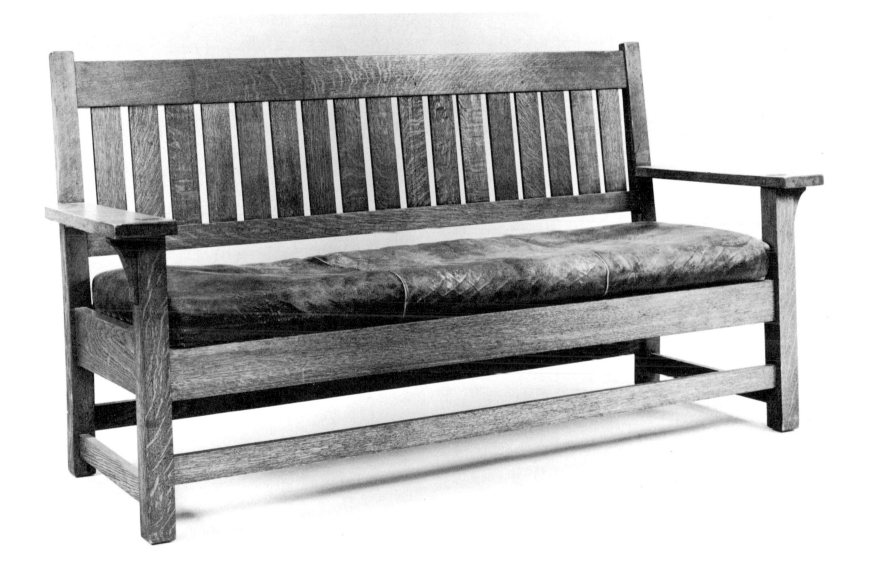

**43 Bookcase**
Craftsman Workshops, Syracuse, N.Y., ca. 1904
Oak, with copper hardware
Height: 56", width: 48", depth: 13"

As necessary for the American bungalow as the
Morris chair and the library table, bookcases were
offered in a variety of sizes by Stickley and his
many competitors. Enclosed shelves were often
built on either side of the fireplace, or as perma-
nent dividers between the living and dining rooms.
The Craftsman Workshops occasionally executed
such custom work. But for those who ordered
Craftsman furniture through catalogues, this was a
handsome purchase for thirty-seven dollars and fifty
cents (1906). It was first advertised in the *Craftsman*
of February 1905.

Ethel and Terence Leichti

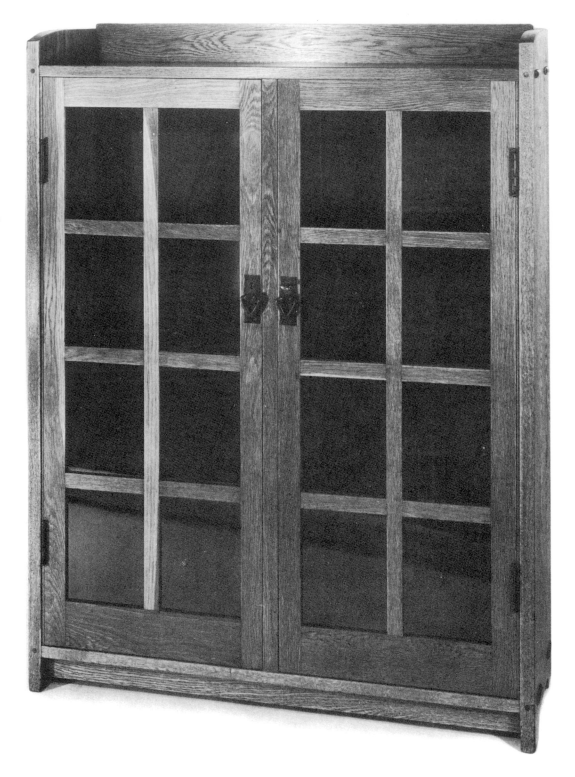

**44 Library table**
Craftsman Workshops, Syracuse, N.Y., 1906
Oak, with leather covering on top
Height: 29", diameter: 48"

Stickley's library tables were generally rectangular, with two or three drawers and a shelf below. He also advertised a round table, and this hexagonal model, first shown in his magazine of October 1906. The table shown was used in his own house at Craftsman Farms, Morris Plains, New Jersey, where it stood in front of a large fireplace at the south end of the long living room (*Craftsman*, November 1911).

Mr. and Mrs. Cyril Farny

**45 Serving table**
Craftsman Workshops, Syracuse, N.Y., before 1909
Oak, with copper hardware
Height: 39", width: 48", depth: 20"
Mark: *Als ik kan/Stickley*, burned in drawer

This appears in the 1909 catalogue of Craftsman furniture, but is surely a design of a slightly earlier date. The center drawer was lined with "ooze leather" for silverware.

Ethel and Terence Leichti

**46 Wall plaque**
Craftsman Workshops, Syracuse, N.Y., before 1906
Hammered copper
Diameter: 15⅛"
Mark: *Als ik kan/Stickley,* impressed on back

At the Arts and Crafts exhibition held in the Crafts-
man building at Syracuse in the spring of 1903,
Stickley showed many examples of English wares,
including some metalwork by the Art Fittings Com-
pany of Birmingham. Duplicates of them were
soon featured in his catalogue: imported and
marked with his own device. This repoussé plaque,
although similar to the Birmingham pieces, seems
to have been designed and made in this country
for Stickley's distribution. Illustrated in Stickley's
*Craftsman's Story* of 1905, its design was adapted
from a favorite motif of Harvey Ellis.

Ethel and Terence Leichti

**47 Candlestick**
Craftsman Workshops, Syracuse, N.Y., ca. 1913
Copper
Height: 9", diameter, 7"
Mark: *Als ik kan/Stickley,* impressed on bottom

First listed in the September 1913 Craftsman cata-
logue, the candlestick bears the artificial patina
characteristic of Stickley's later metalwork.

Private collection

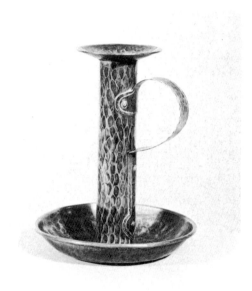

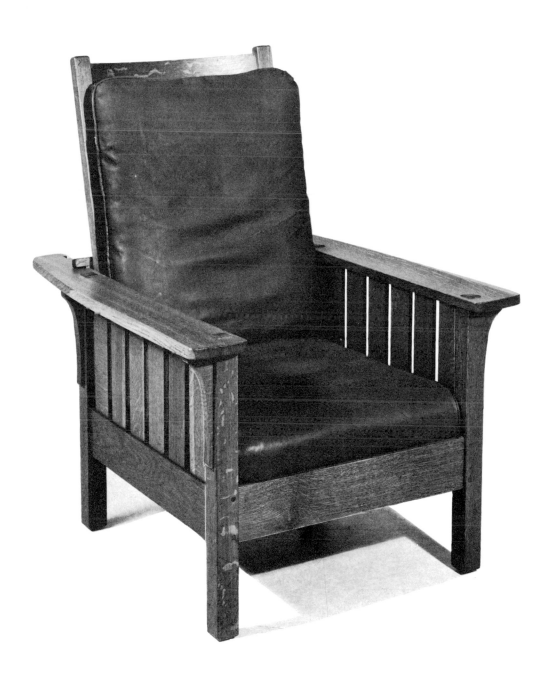

## L. & J. G. Stickley Company

The Stickleys were a veritable dynasty of furniture makers. A desk and chair by two of Gustav's brothers are shown elsewhere in this catalogue (see entry 105). After working for their older brother for several years, two more brothers, Leopold and J. George, opened a factory at Fayetteville, New York, in 1900 under the name L. & J. G. Stickley Company. A large catalogue that they issued in 1910 received praise in the *American Printer* of January 1911 for its handsome layout and fine printing. Their furniture designs were similar to those of Gustav Stickley, except that they were sometimes slightly more crude, or used inferior pieces of oak. Veneers and laminated members were not uncommon. Nevertheless, the finish was always superb, and occasionally a piece was marketed that could stand well beside the products made in nearby Eastwood. L. & J. G. Stickley executed the furniture designed by Frank Lloyd Wright for the Bradley and Hickox houses in Kankakee, Illinois, 1900.

### 48 Reclining chair

Oak, with leather-covered cushions (not original)
Height: 42¼" width: 31½", depth: 35"
Mark: red decal, *L. & J. G. Stickley/Handcraft,* on handscrew (shopmark)

The so-called Morris chair is one of the important symbols of the Arts and Crafts movement in America. This design was pictured in the 1910 catalogue of the firm of Leopold and J. George Stickley. After the bankruptcy of their brother Gustav, they purchased his factory in Eastwood (Syracuse) and ran a parallel business known as Stickley Manufacturing Company, Inc. By the time of the First World War, L. and J. G. Stickley were producing furniture based on historical models. The firm is still operating, and is famous for its American Colonial reproductions in cherry wood.

Private collection

## The Roycrofters

Elbert Hubbard had charisma. It contributed to making him a brilliant salesman, the hub about which the Roycroft community turned, and established him as a cultural messiah to thousands of Americans. Born in Bloomington, Illinois, in 1856, Hubbard peddled soap for almost twenty years. Selling his partnership in the Larkin Soap Company in 1893, he settled in East Aurora, New York, near Buffalo. He visited the Kelmscott Press in 1894, met William Morris, and fell under the great man's spell. Back home, Hubbard bought a small press and published *The Song of Songs* (1895–96), the first book with the Roycroft colophon. Taking his inspiration from Morris, and the name of his press from a pair of seventeenth-century English bookbinders, he was soon publishing his little magazine, the *Philistine*, and began printing his series of *Little Journeys*—prose "visits" with famous people ranging from Socrates to Thorwaldsen—and assorted other titles in rapid succession.

The press soon begat a bindery, which produced elaborate designs in high-relief molded leather, as well as the more typical limp chamois bindings. The bindery eventually begat a leather shop, which made beautifully crafted table mats, boxes, purses, and wallets. In 1901, the Roycroft book catalogue mentioned a line of furniture, including a Morris chair. The pieces were simple and heavy, of oak and mahogany, and owed much to the prevalent Mission style. The pieces were proudly emblazoned with the orb-and-cross mark or with the Roycroft name.

Roycroft was an artistic community within East Aurora, and its enterprises included the Roycroft Inn for guests, opened in 1903, as well as the various workshops. Local residents were employed, but significantly large numbers of people came to East Aurora from across the country to find work. An apprentice system was set up, and workers learned various crafts, migrating from shop to shop. The cultural life included lectures, frequently by Hubbard, concerts, and organized sports. While Hubbard wrote, edited his magazines, and made lecture tours, his admirable wife Alice kept the books and supervised the business.

Among the talented young people who gravitated to East Aurora was Dard Hunter, who was later to become a leading authority on papermaking. At nineteen, as a student at Ohio State University, Hunter was intrigued by a copy of the *Philistine*, and in June 1903, went to East Aurora seeking a job. There he encountered incunabula and Kelmscott Press books, read the international art and design periodicals on hand, and worked at designing furniture, metal objects, leaded glass, and finally books. Soon he had his own studio supplied by Hubbard. A trip to Vienna in 1908 helped refine his style; but even his earliest efforts showed him to be the most sophisticated and original Roycroft designer. Through his friendship with Karl Kipp, head of Hubbard's copper shop, Viennese influence was also introduced into some of the finest Roycroft metalwork. In 1910 Hunter went to Vienna again, and did not return to Roycroft, although his magazine and book designs were often reused there.

After the Hubbards disappeared on the *Lusitania* in 1915, the Roycroft Shops continued under the direction of Bert Hubbard, only to fall victim to the Depression and to be sold at auction in 1938. Elbert Hubbard, the "Fra," was neither artist nor designer, but his personality drew people to Roycroft and held it together. At their best, the Roycroft Shops produced handsome objects of fine workmanship. Never before had mass advertising been used to make people conscious of books, simple furniture, and small household items as objects of aesthetic value. The diligent, self-sufficient quality of the Roycroft community expressed well the ideals of the Arts and Crafts movement, and Elbert Hubbard popularized a sincere, if sometimes plebeian, version of the ideals of William Morris. MLG

**49 Chair**
Roycroft Shops, East Aurora, N.Y., ca. 1905–12
Oak
Height: 46½", width: 18¾", depth: 19"
Mark: *Roycroft*, carved on front of rail

Listed as a desk chair in the 1912 Roycroft furniture catalogue, this is similar to a chair exhibited at the Providence (Rhode Island) Art Club in 1901. The latter piece, of a more ponderous scale and with a single wide splat in the back, was described by a reviewer as "honest and simple enough in construction but somewhat too austere in design, and altogether too massive to be pleasing" (*House Beautiful*, June 1901). The manufacture of furniture by the Roycrofters seems to have come about almost by accident. Some pieces were made by local carpenters for the new Roycroft Inn; guests saw them and ordered duplicates. This was mentioned in the *New York Sun* of 29 October 1899, which article was reprinted in the 1900 Roycroft book catalogue. The catalogue of the following year listed eleven pieces that were available. By 1905, a separate furniture catalogue was issued in which the term Aurora Colonial Furniture was used. The introduction reads: "It is simple, solid, substantial, severe and rarely beautiful. It is distinguished—it has as much personality as a Rookwood vase—combines great strength with grace of outline and purity of design. . . . A room furnished roycroftie is a constant delight to the owner and the occupant."

Robert W. Blasberg

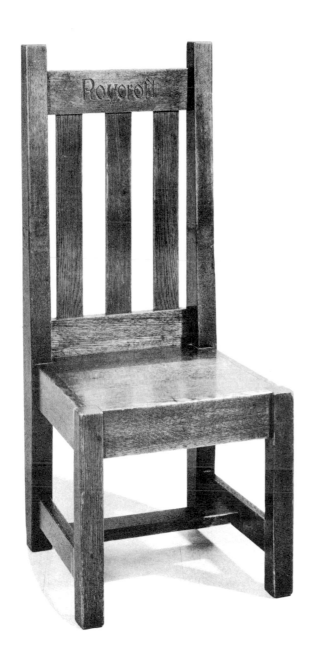

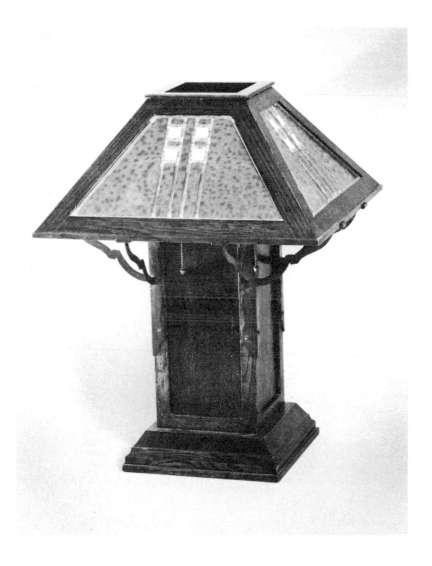

**50 Lamp**
Roycroft Shops, East Aurora, N.Y., after 1903
Designer: Dard Hunter
Wood, hardware, and leaded glass in green and white
Height: 25½″, width: 18⅝″, depth: 18⅝″

Several versions of this lamp, with varying patterns of glass, are seen in photographs taken at the Roycroft Inn and in the Hubbards' office.

Mr. and Mrs. George ScheideMantel

**51 Lamp**
Designer: Dard Hunter, ca. 1903–08
Copper base, with leaded-glass shade in greens and pink
Height: 23", diameter of shade: 17½"
Mark: *H* with a tangent *D* on either side, repeated in leaded-glass rose motif

Dard Hunter undoubtedly designed this lamp before his departure for Vienna in 1908. It is shown on a table in the salon of the Roycroft Inn in a photograph published in 1912. It was also used on the library table of the Hubbards' own home. After Hunter visited Europe a second time in 1911, he returned to East Aurora, but not to the Roycroft Shops, setting up the Dard Hunter School of Handicraft, with courses in leaded art glass and jewelry making (*Craftsman*, October 1911, p. 8a). This venture was short lived.

Nancy Hubbard Brady

**52 Bookends**
Roycroft Shops, East Aurora, N.Y., ca. 1913
Designer: Karl Kipp
Copper
Height: 5⅝", width: 5½", depth: 5⅝"
Mark: *R*, in orb with cross

Elbert Hubbard wrote to Lyman Chandler on 4 March 1903: "The Roycroft began as a joke, but did not stay one: it soon resolved itself into a Commercial institution" (letter in the possession of Simeon Braunstein). By 1909, the Roycroft catalogues featured extensive lines of leatherwork and copper wares, as well as furniture. Karl Kipp, who had been a banker, came to East Aurora in September 1908 and worked in the bindery. Soon he organized the Roycroft Copper Shop, which at times employed as many as thirty-five men. Kipp conceived each design and then turned the prototype over to an assistant, who made the special tools to execute the details more rapidly. These bookends in the poppy pattern were advertised in the *Fra*, July 1913

Dr. and Mrs. Robert Koch

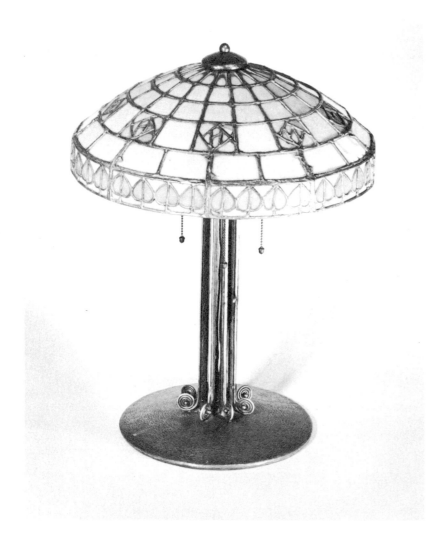

**53 Bookends**
Roycroft Copper Shop, East Aurora, N.Y., ca. 1909
Copper
Height: 6½", width: 4", depth: 4⅞"
Mark: *R*, in orb with cross

Because the origin of all Roycroft activities was in
the realm of books, bookends were an appropriate
feature of the line of metalware made by Hubbard's
craftsmen. This is an unusual design, not recalled
by any of the surviving Roycrofters. It was perhaps
a unique pair, an experiment with a pictorial sub-
ject. The gnarled tree is similar to one drawn by
Harvey Ellis and published in the *Craftsman*, August
1903 (p. 371). But the bookends date sometime
after 1909.

Mr. and Mrs. James M. Marrin

**54 Inkwell**
Roycroft Copper Shop, East Aurora, N.Y., ca. 1916?
Designer: Karl Kipp
Brass-plated copper
Height: 2½", width: 4¼", depth: 4¼"
Mark: *R*, in orb with cross, stamped on bottom

A desk set with this inkwell was pictured in the
October 1916 issue of the *Fra*. By that time, the
Roycrofters were making very few pieces of furni-
ture, for visitors wanted more portable souvenirs.
Small metal items and leather goods were selling
well.

Simeon Braunstein

**55 Smoking set**
Roycroft Copper Shop, East Aurora, N.Y., ca. 1909?
Copper
Height: 4″, width: 14″, depth: 6″
Mark: *R*, in orb with cross, in central indentation of tray

Although Hubbard continually spoke out against smoking, his coppersmiths produced a variety of smoking sets, of which this is the most unusual. It is curious to note that an almost identical design was published in the *Craftsman,* November 1909, as a suggestion for home craftsmen.

Elbert Hubbard Library-Museum

**56 Tray**
Roycroft Copper Shop, East Aurora, N.Y., ca. 1917
Designer: Karl Kipp
Maker: Leon W. Varley
Length: 22″, width: 10″
Mark: *R*, in orb with cross, on bottom

As was the usual practice with such objects, the tray was formed over a specially cut maple block.

Mr. and Mrs. George ScheideMantel

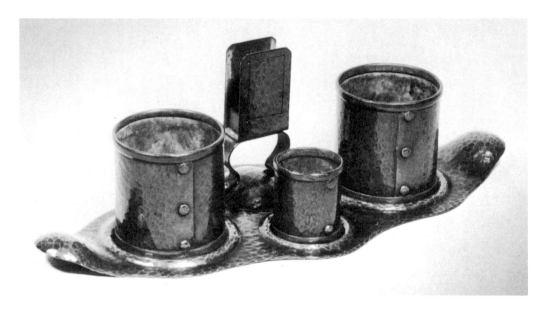

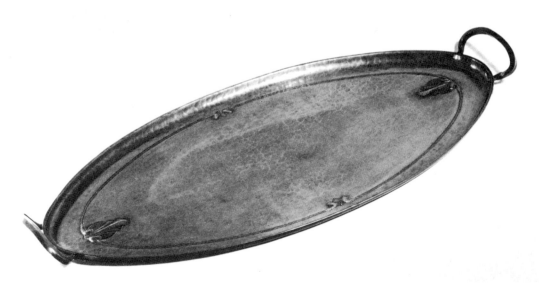

50

**57 Candlesticks**
Tookay Shop, East Aurora, N.Y., ca. 1912–13
Designer: Karl Kipp
Copper
Height: 10½″, diameter: 5¾″
Mark: *KK,* in circle stamped on base

By early 1912, Karl Kipp had left the employ of
Hubbard and established his own workshop in East
Aurora. The Tookay Shop (KK) was advertised reg-
ularly in the *Craftsman,* starting in March 1912
(p. 8a). Kipp continued many of the designs he
had conceived for the Roycrofters, although this
pair of candlesticks seems to have been made only
in the period of Kipp's independent venture. After
the deaths of Alice and Elbert Hubbard in May
1915, Bert Hubbard enticed Kipp back to the Roy-
croft workshop.

Mr. and Mrs. Walter K. Krutz

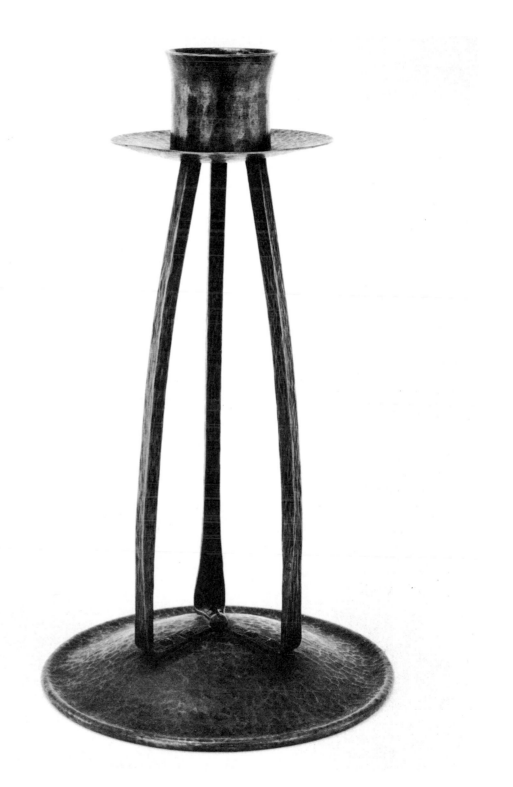

**58 Vase**
Roycroft Copper Shop, East Aurora, N.Y., 1911
Designer: Karl Kipp
Copper, with details of German silver
Height: 7½", diameter: 4¼"
Mark: *R*, in orb with cross on base

This vase did not appear in the 1910 Roycroft cata-
logue, but was featured as a suggested Christmas
gift in the November 1911 *Fra*. It is one of the most
simple, straightforward designs by Kipp: a heavy
copper pipe with a tooled texture, lateral "but-
tresses," and four attached squares of German
silver. There is influence from Vienna here, trans-
mitted by Dard Hunter.

Private collection

**59 Fern dish**
Tookay Shop, East Aurora, N.Y., 1912–15
Designer: Karl Kipp, 1911 (prototype)
Copper and brass
Height: 4½", diameter: 6½"
Marks: *KK*, in circle; *Karl/Kipp/Hand/Wrought/East
Aurora, N. Y.* and *R*, in orb with cross

Again, the Viennese *Quadrat-Motif* appears in the
brass banding of this copper planter. This model was
first shown in the November 1911 issue of the *Fra*.
The double markings indicate that this was in Kipp's
Tookay Shop when he moved back to Roycroft.
It was remarked for sale there.

Mr. and Mrs. George ScheideMantel

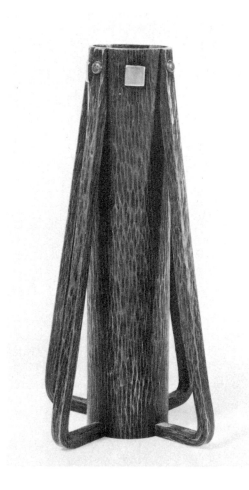

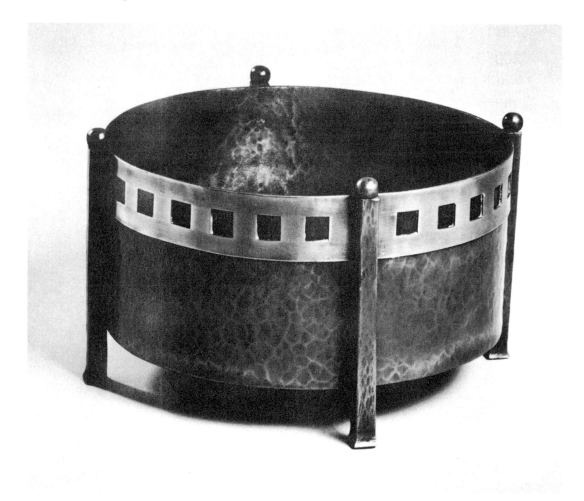

**60 Nut spoon**
Roycroft Copper Shop, East Aurora, N.Y., ca. 1910
Designer: Karl Kipp
Copper
Length: 7⁹⁄₁₆", width: 3¾"
Mark: *R*, in orb with cross, stamped on rear of
upper portion of handle

Although usually sold with a nut set, the spoon was
also available separately. The perforated details of
the end of the handle place it in the 1910-11
period of the Copper Shop. It was, in fact, pictured in the 1910 Roycroft catalogue.

Mr. and Mrs. James M. Marrin

**61 Hatpins**
Roycroft Copper Shop, East Aurora, N.Y.
Designer: probably Karl Kipp
Copper
Length: 8" and 9", heads: 1½" square
Mark: *R*, in orb with cross (on head of one pin)

The choice of designs in hatpins(!) emphasizes the
range of objects and variations available from the
Roycroft Shops.

Mr. and Mrs. Warren C. Moffett

**62 Manicure case**
Roycroft Leather Shop, East Aurora, N.Y.
Designer: Frederick Kranz
Leather
Length: 6", width: 4"
Mark: *R*, in orb with cross, stamped on inside
corner

Frederick Kranz came to East Aurora from Germany, via Philadelphia. Hubbard met him on a
lecture trip and invited him to join the Roycrofters
to expand the leather shop there—an operation
that had grown out of the activities of the bindery.
Hubbard commented in the 1909 leather catalogue: "The Germans lead the world in craftsmanship, just as they have in musical composition. The
Roycrofters imported the Germans—the Teutons
did the rest."

Simeon Braunstein

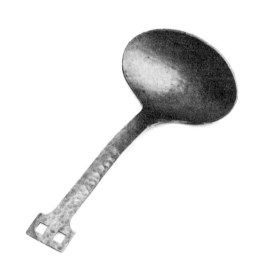

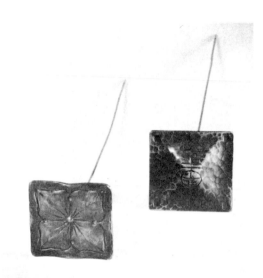

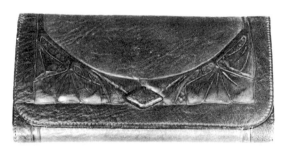

**63 Wastebasket**
Roycroft Leather Shop, East Aurora, N.Y., ca. 1909-10
Designer: Frederick Kranz
Leather on heavy pasteboard
Height: 14", diameter: 8¾"
Mark: *R,* in orb with cross on bottom

A similar leather wastebasket was shown in the 1909 Roycroft catalogue of leather goods.

Mr. and Mrs. Charles F. Hamilton

**64 Frame**
Roycroft Leather Shop, East Aurora, N.Y.
Designer and maker: Frederick Kranz
Leather
Height: 11", width: 7"

A leather frame of the same shape but with different details appeared in the November 1911 issue of the *Fra.*

Mr. and Mrs. George SheideMantel

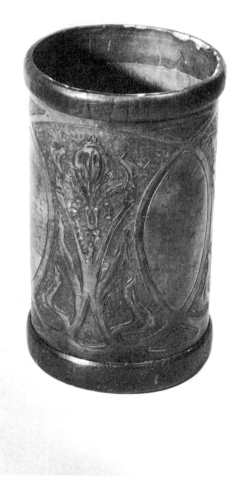

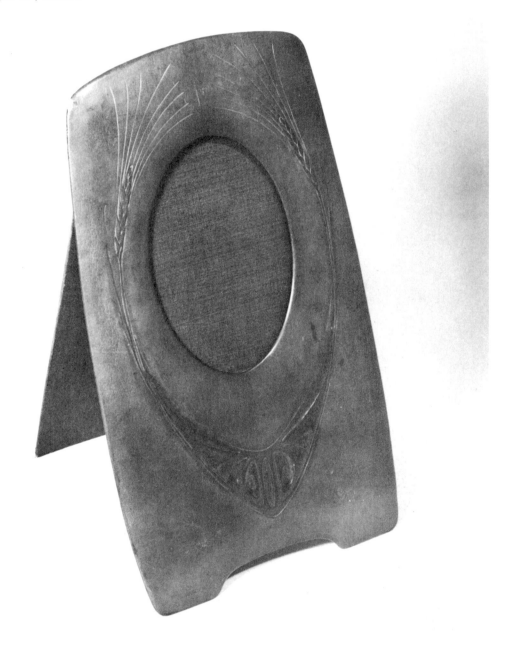

## Wallpaper industry

One of William Morris's most significant contributions was the principle of designing flat patterns for flat surfaces. He worked with rugs, decorative fabrics, and wallpapers. In this country, the wallpaper industry reflected his innovations, and even produced some handsome Art Nouveau designs.

**65 Wallpaper**
York Wall Paper Company, York, Pa., after 1895
Paper, printed in various shades of blue
Height: 38⅝", width: 19½"
Mark: *Y.W.P. Co.*, printed on right selvage

Although much simpler in its pattern, this design is an obvious emulation of the few papers Morris designed during the last years of his life, when his attention was diverted by activities of the Kelmscott Press.

Philadelphia Museum of Art, gift of the Horace M. Pryor Company

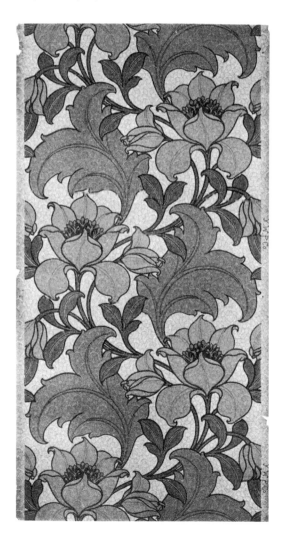

**66 Wallpaper**
M. H. Birge and Sons, Buffalo, N.Y., 1904
Embossed heavy paper, with design in silver, blue,
and red on olive ground
Height: 26¾", width: 21¾"
Marks: *8166 EA* printed, and *EA* written, on verso

M. H. Birge was one of the leading manufacturers
of artistic wallpaper in this country well before the
turn of the century. Among its specialties was a
line of embossed papers imitating stamped cordo-
van leather and a "half-bronze" effect, called
"Scintillaire." Shortly after 1900, Birge introduced
a series of Art Nouveau designs that were produced
using the same embossed and metallic effects as
before. This particular design (Birge number 8166)
appears in the company's 1904 catalogue. It was
offered in a wide variety of colors, including various
tones of brown leather, red, and green. The wood
block from which this pattern was printed was for-
merly in the collection of the designer Edward
Wormley (R. Koch, *Louis C. Tiffany, Rebel in Glass*,
p. 216). The processes at the Birge factory were
discussed in *Brush and Pencil*, July 1905; a later
visit to the premises was reported by Elbert Hub-
bard II in *Roycroft*, July 1923.   ME

Private collection

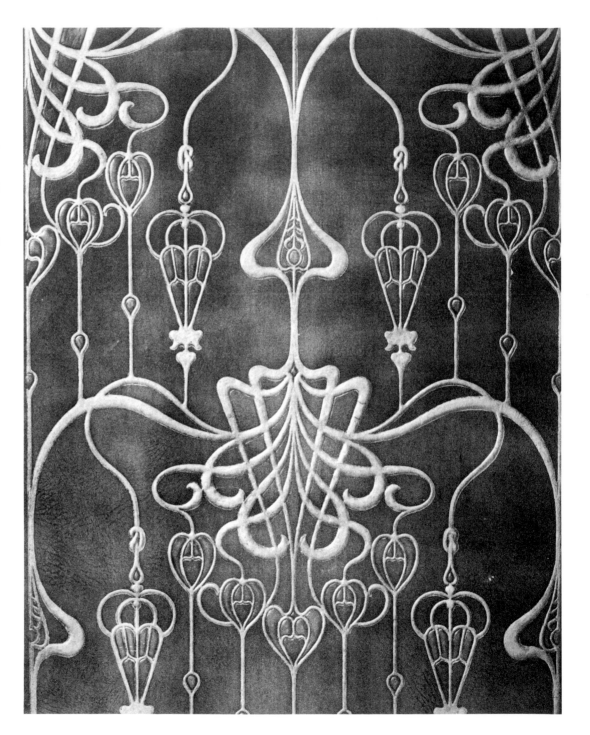

**67 Chair**
Oak, with panels of leaded glass in blue and green
Height: 60″, width: 18½″, depth: 17½″

The tall-backed chair was almost an international phenomenon at the turn of the century. Seldom comfortable, it seems to have descended from the Victorian combination of hat rack and hall seat— especially when made in single versions rather than as dining room chairs. This example, which is traceable to Connecticut but was not necessarily made there, is surely American, simply because of its unusual, unabashed combination of forms and motifs. The tops of the three long slats have been divided into thirds, the central section replaced by panels of leaded glass in a conventionalized floral pattern, or perhaps a reference to the popular peacock feather.

Private collection

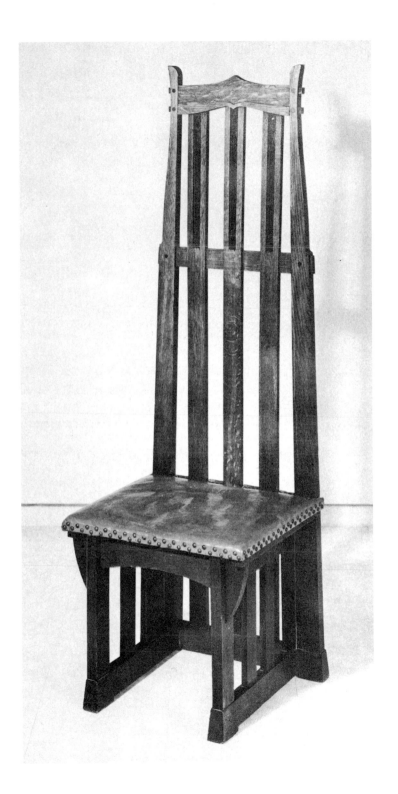

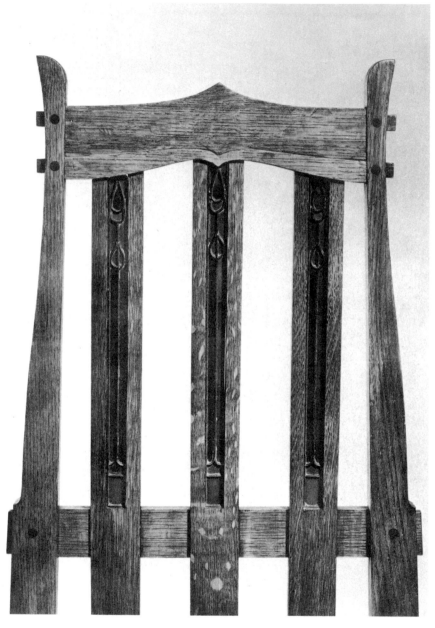

**67** (detail)

Cotton, wool, and soft wood paper fibers; plain weave
Height: 82¾", width: 46⅞"

Although this rug comes from a summer residence in New Hampshire that was furnished with many pieces of Gustav Stickley's Craftsman furniture, the rug does not seem to have been ordered from his catalogues. At least it does not appear in the Stickley brochures, nor in advertisements in the *Craftsman* that showed rugs and carpets made especially for Stickley's distribution. The severe geometry of its design is typical of the conventionalized patterns of the first decade of the century, and may have been influenced by the new interest in American Indian art.

The Art Institute of Chicago, gift of Mr. and Mrs. John J. Evans, Jr.

**69 Window**
Leaded glass in orange, amber, green, and variegated tones, with areas of colorless obscure glass in three textures
Height: 22", width: 14"

From a demolished house in northern New Jersey, this small and inexpensive panel illustrates the manner in which the fashion for leaded-glass windows was made accessible to all. Although it was intended to work as a unified composition, the tulip panel seems quite British, while the lower section has a Germanic flavor. The unresolved combination is not without a certain modest charm.

Private collection

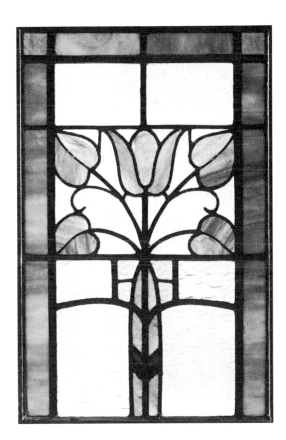

**70 Pillow cover**
Linen with cotton embroidery
Height: 17½", width: 17"

Mr. and Mrs. James M. Marrin

**71 Flagon**
Copper and brass
Height: 13¼", diameter: 4⅞" (base)
Mark: eagle impressed on bottom

The eagle is similar to marks used in the Boston area by pewter craftsmen around 1900–10.

Private collection

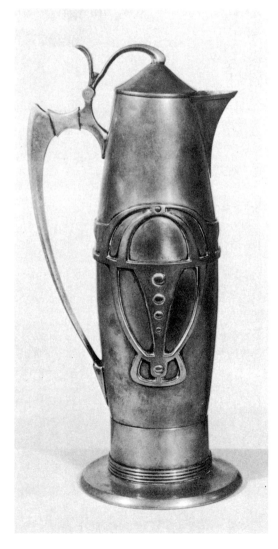

**72 Table mat**
Tooled leather, slightly dyed
Diameter: 23½″

Private collection

**73 Table mat**
Tooled leather, dyed black and red
Diameter: 22½″

The two mats (entries 72 and 73) offer an instructive comparison between the curvilinear aesthetic of Art Nouveau, including the popular motif of the water lily, and a more rigid scheme adapted from the checkerberry, more typical of the mature style toward 1910.

Mr. and Mrs. James M. Marrin

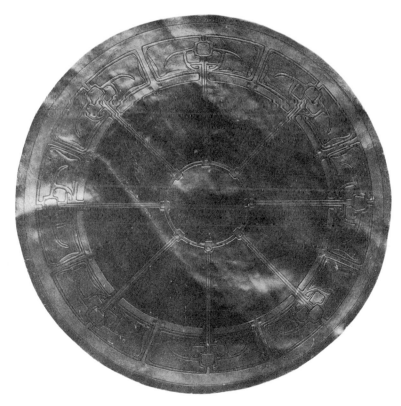

# 2   Chicago and the Midwest

## 2　Chicago and the Midwest

David A. Hanks

Chicago was one of the most important centers of the Arts and Crafts movement in America. Within a decade of the great fire of 1871, craftsmen such as Isaac Scott were doing work in Chicago equal to that of contemporaries who had exhibited at the Philadelphia Centennial Exposition. The founding of the Chicago Arts and Crafts Society in 1897 at Hull House marked a crystallization rather than the beginning of the movement in the Midwest. The culmination was the architecture and decorative arts of what is now known as the Prairie school.

The Midwestern movement was patterned after that in England, and there were numerous direct connections. Not only did Chicagoans such as Jane Addams and Ellen Gates Starr go to England, but distinguished English leaders of the Art and Crafts movement came to Chicago. Walter Crane, for example, lectured at The Art Institute and helped organize an exhibition of his work there in 1892. C. R. Ashbee visited Chicago twice, and later wrote the foreword to Wright's work published in Germany in 1911. One Englishman, Joseph Twyman, came to Chicago and stayed, championing the cause of William Morris in lectures and articles.

William Morris was well known to the intellectual and social elite among Chicagoans in the 1880s and 90s. Fabrics, wallpapers, and furniture designed by Morris were available at Marshall Field & Company and the Tobey Furniture Company. The latter organized an exhibition of his fabrics in 1902, and a "Morris Memorial Room" was installed for the occasion by Joseph Twyman. "A unique Arts and Crafts Exhibition of special interest to the admirers of William Morris is held in Chicago, in the form of a Morris room, and is furnished with products of Morris' own establishment and other articles conforming to his ideas," reported *House Beautiful*.

In 1903, Twyman organized the William Morris Society. Evidence of the strength of the Arts and Crafts movement in Chicago was the number of such organizations. In addition to the Arts and Crafts Society and the Morris Society, there was the Industrial Art League, founded in 1899 by Oscar Lovell Triggs (continued until 1904). In 1902, its membership numbered over four hundred. Its National Advisory Board included Augustus St. Gaudens and John La Farge. There was also the Illinois Art League, which was a local chapter of the Industrial Art League. Its purpose was to provide workshops, give instruction in the arts and crafts, to establish industrial art libraries and museums in Illinois, and to promote the arts and crafts through publications.

A number of Chicago arts and crafts groups had workshops and salesrooms in the Fine Arts Building at 408 South Michigan Avenue. Here could be found the Kalo Shop, the Artists' Guild, and the Wilro Shop. Other similar Chicago enterprises included the Craftery, the Krayle Shop, the Atlan Ceramic Club, and the Swastica Shop. There were, of course, many other craftsmen working on their own.

The role of The Art Institute in the Chicago movement was of great importance, particularly because of the annual exhibitions organized by the museum from 1902 through 1921. Bessie Bennett, the first curator of the Department of Decorative Arts, was an accomplished practitioner herself, and she frequently included her own work in the craft exhibitions she organized at The Art Institute. The Chicago Architectural Club had rooms at The Art Institute and held exhibitions there from 1888 to 1928; decorative crafts were frequently included. The Society of Decorative Arts of The Art Institute (now known as the Antiquarian Society) maintained a sales gallery at the Institute and sold work by members, or objects donated by them, for the benefit of the society.

Although Chicago was the most important regional focus, it was not, of course, the only city in the Midwest where such activities were taking place. Minneapolis, Cincinnati, Dayton, Detroit, Cleveland, and St. Louis were also active centers. It is interesting to note a few of the arts and crafts societies in these other areas. In 1895, for example, the Chalk and Chisel Club was organized in Minneapolis. It claimed to be the oldest arts and crafts group in the United States, later becoming the Minneapolis Arts and Crafts Society. In Grand Rapids, Michigan, there was the Society of Arts and Crafts, founded in 1902 under the directorship of Forrest Emerson Mann. The Ceramic Department of the People's University, American Woman's League, University City, was eventually organized in St. Louis. In fact, most of these Midwestern cities had art schools featuring programs in the arts and crafts: the School of Fine Arts, Washington University, St. Louis, and the School of The Art Institute of Chicago, to name only two.

In addition to the arts and crafts organizations and shops, there were a number of periodicals published in Chicago that were influential in the movement: *House Beautiful*, founded in 1896; *Common Clay*; *Ornamental Iron*, 1893–95; *Inland Architect and News Record*, 1883–1908; *Western Architect*, 1902–31; *Fine Arts Journal*, 1899–1919; *Forms and Fantasies*, 1898–99; and *Builder and Woodworker*, 1868–95.

The decorative designs of the Prairie school architects were an outgrowth of the Arts and Crafts movement—ideologically and stylistically. From the larger movement the Prairie architect derived an emphasis on unity of exterior and interior, the respect for natural materials, a desire for simplicity, the interest in Japanese art, and a geometric, rectilinear style. In addition to the influences from abroad there were those from the East

coast, particularly the work and writings of Gustav Stickley and Elbert Hubbard. Stickley's Craftsman furniture was frequently recommended by Prairie architects, especially for their clients' secondary rooms. It was therefore not surprising to find in a bedroom at the Henry B. Babson house a bed designed by Elmslie along with chairs and tables from Stickley's workshop near Syracuse. The furniture Wright designed for the Bradley house in Kankakee was made by L. and J. G. Stickley in Fayetteville, New York. The compatability was no coincidence, for Craftsman furniture and the Prairie house derived from the same philosophical sources.

## Office of Louis H. Sullivan

Although Frank Lloyd Wright was the major figure of the Prairie school, Louis Sullivan was its source. Trained briefly at the Massachusetts Institute of Technology and at the Ecole des Beaux-Arts in Paris, Sullivan settled permanently in Chicago in 1875. Joining in partnership with Dankmar Adler, his creative imagination found full expression. In the mid-1880s, Boston-based H. H. Richardson was becoming the leading figure in Midwestern architecture, with substantial commissions in Chicago and St. Louis. But his death in 1886 cleared the way for Sullivan, who borrowed many exterior forms from Richardson, made them more severe, and then enhanced them with an architectural ornament that was the finest, most vigorous counterpart of European Art Nouveau this country produced. It was as though the stark forms he wrought needed to be softened, or enlivened, with the crafted touch of recognizably human creation, lest the relationship to the late Victorian pedestrian be lost.

Sullivan's ornament was tightly conceived and intensely elaborated, reflecting his own complicated personality. He later called it a "system of architectural ornament," and the system was passed on to collaborators and assistants with varying degrees of success. His best student in this regard was George Grant Elmslie, whose drafting ability equaled Wright's in those years.

Sullivan also worked with others outside of his office when large decorative schemes for interiors were needed. His favorite collaborator was Louis J. Millet. Millet was born and educated in New York City before receiving additional training in Paris at the Ecole des Beaux-Arts and in the architectural section of the Ecole des Arts Décoratifs. From 1881 through 1899, Millet was in partnership with George L. Healy. Both men were friends of Sullivan; the three had known each other in Paris. Healy and Millet were chosen to execute the interiors of Adler and Sullivan's Auditorium Building, McVicker's Theater, and the Chicago Stock Exchange. From about 1891 until 1918, Millet was an instructor of decorative design and architecture at the School of The Art Institute of Chicago. He was appointed chief of mural and decorative painting for the Louisiana Purchase International Exposition, 1904, in St. Louis.   RJC, DAH

### 74 Section of stenciled frieze
Designers: Louis J. Millet and Louis H. Sullivan, 1894
Oil on canvas
Length: 10' 11", height: 57¼"

As in the Auditorium Building, Sullivan included rich stenciled designs as the key decorative ornament of the Chicago Stock Exchange. This section of a frieze was part of a series of stenciled designs that, along with the leaded-glass windows, made this public room one of the richest of its period. Sullivan probably sketched the design, leaving the choice of colors and the execution to Millet.

The Art Institute of Chicago, gift of Mr. and Mrs. Arthur D. Dubin

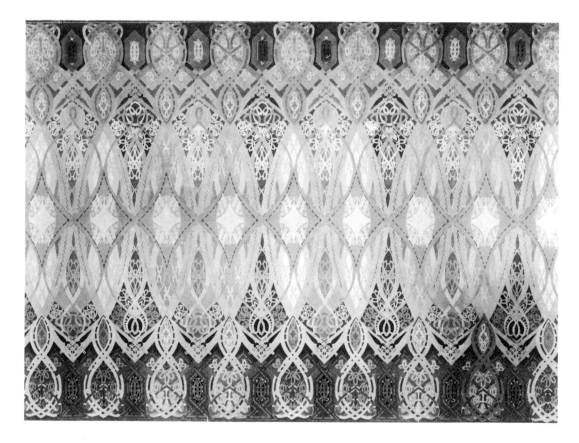

**75 Medallion**
Designer: George Grant Elmslie for
Louis H. Sullivan, 1899
Cast iron, bronze plated
Diameter: 23⅝"

This ornamental medallion was for the elevator
doors of the Schlesinger and Mayer Department
Store (now Carson, Pirie, Scott & Company), in
Chicago, designed by Louis Sullivan. As chief drafts-
man for Sullivan, Elmslie conceived most of the

exterior and interior ornament for this building. The
metalwork was cast by Winslow Brothers.

The Art Institute of Chicago, gift of the Graham
Foundation for Advanced Studies in the Fine Arts

## George Grant Elmslie

Born on a farm in Scotland, Elmslie came with his parents to the United States in 1884. He started work with J. L. Silsbee in 1887, at the same time that Frank Lloyd Wright and George Maher were in the office. In 1889, Elmslie began to work for Adler and Sullivan, becoming chief designer in 1895. From 1909 to 1913 he was in partnership with William Gray Purcell and George Feick, and with Purcell alone until 1922. After joining this firm, Elmslie moved to Minneapolis, but returned to Chicago in 1912.

Elmslie, after being in the shadow of Sullivan and Wright, is today more widely recognized as an important designer on his own. As with other Prairie school architects, Elmslie's designs were derived from the Arts and Crafts movement; he was concerned with creating an interior that was harmonious with the whole. Although Wright was a strong influence, Elmslie developed his own vocabulary and theories at the same time. Elmslie's furniture is less rectilinear and geometric and reveals the influence of Sullivan in the flowing and rich ornamental details. One of the earliest known interiors by Elmslie is that of the Henry B. Babson house (1907), Riverside, Illinois, which actually bore the name of Sullivan.

Several motifs appear consistently in Elmslie's ornament, whether in terra-cotta, stencils, leaded glass, or in the cutout designs of backs of chairs. Elmslie explained their use: "These motifs are designed as an organic part of a structure, an efflorescence of the idea represented in the building itself. . . . The ornaments themselves represent the expansion of a single germinal idea and may be severe, restrained, simple or as elaborately evolved as desired for place and circumstance. After the motif is established the development of it is an orderly procession from start to finish. It is all intensely organic, proceeding from main motif to minor motifs, interrelating and to the last terminal, all of a piece . . ." (*Western Architect,* January 1913).

**76 Side chair**
Designer: George Grant Elmslie, 1909
Oak, with leather upholstery
Height: 50", width: 20⅜", depth: 21¼"

Similar in style to a number of other Elmslie dining chairs, this example (number three of a set) was made for the Charles A. Purcell house, River Forest, Illinois. The handsome geometric design of the splat is cut out of laminated wood and tapers toward the bottom. The leather upholstery is original.

Mr. and Mrs. Joseph Zwers

**77 Window**
Designer: George Grant Elmslie, 1911
Leaded glass
Height: 63", width: 15"

Designed for the house of Dr. J. C. Cross of
Minneapolis, the window shows Elmslie's charac-
teristic motifs in the stylized floral design.

Metropolitan Museum of Art, gift of Roger G.
Kennedy

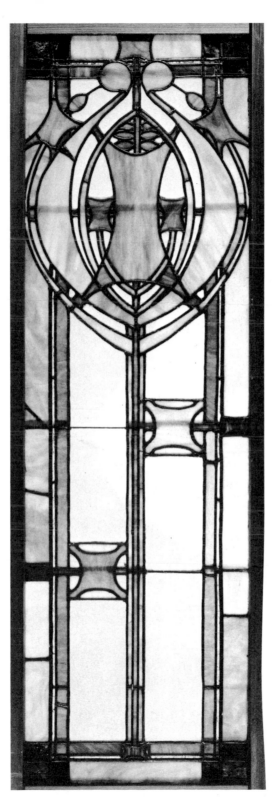

**78 Table cover**
Designer: George Grant Elmslie, 1910
Linen, plain weave, embroidered with two shades
of blue and green silk floss
Length: 21½", width: 20½"

This textile is one of a series that Elmslie designed
for his own house in Minneapolis. The embroidery
was done by his wife Louise Elmslie.

David Gebhard

### 79 Tall clock
Designer: George Grant Elmslie, 1912
Mahogany with brass inlay
Height: 88″, width: 24¾″, depth: 15½″

This clock was the result of a commission given the firm of Purcell, Feick and Elmslie for the Henry B. Babson house, Riverside, Illinois. Although the house was nominally designed by Louis Sullivan in 1907, a large part of the scheme was by Elmslie who was then working for Sullivan. In 1912, Elmslie and his firm made additions to the house, including eight pieces of furniture of which this was part. The clock was pictured in situ in the *Western Architect* of July 1915. Its face was modeled by Kristian Schneider; the hands were made according to Elmslie's designs by Robert Jarvie of Chicago. The works and nine chimes were imported from Germany.

The Art Institute of Chicago, gift of Mrs. Theodore D. Tieken

### 80 Andirons
Designer: George Grant Elmslie, 1912
Bronze
Height: 10½″, width: 7½″, depth: 7½″

Also designed for the Babson house, these andirons were pictured in the *Western Architect*, July 1915, along with two other sets. The caption for these indicates that they were intended for the living room hearth. They were cast in a sand mold, traces of which remain. The iron log-rests are not shown.

The Art Institute of Chicago, gift of Mrs. George A. Harvey

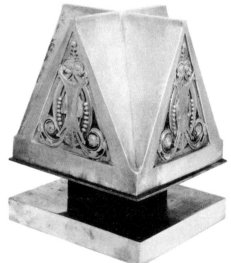

**81 Rug**
Designer: George Grant Elmslie, 1907
Wool
Length: 12′ 7″, width: 3′ 9″

One of a number of rugs designed for the
Babson house, this rug has a cut pile in brown,
green, turquoise, blue, and white in a design of
repeat center medallions. Knotted by hand, it was
probably made in Europe.

Mrs. Theodore D. Tieken

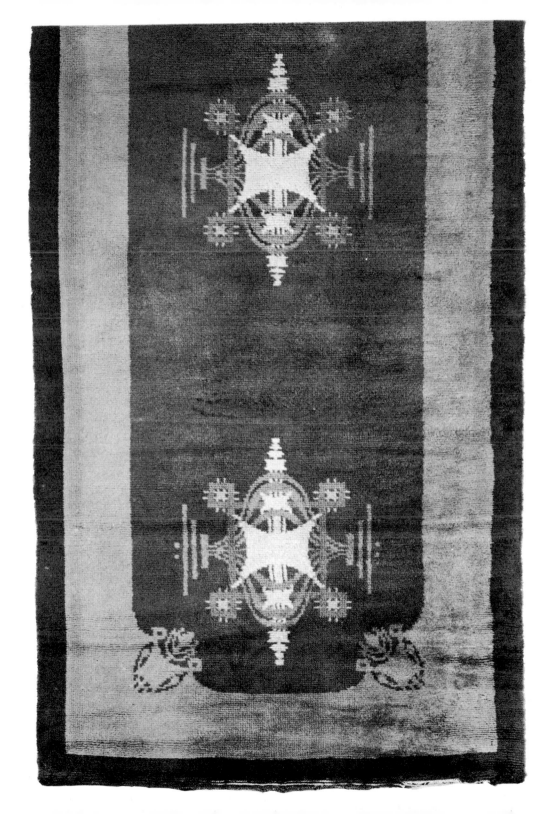

## George Washington Maher

A native of Mill Creek, West Virginia, George Maher moved with his family to New Albany, Indiana, and then to Chicago when he was still young. Apprenticed at thirteen to the Chicago architectural firm of Bauer and Hill, he then transferred to the office of J. L. Silsbee, where Frank Lloyd Wright and George Grant Elmslie were fellow draftsmen. In 1888, Maher began his own practice.

Two distinct influences can be seen in Maher's early work: that of J. L. Silsbee and that of his travels in Europe in 1892 and 1898, when he encountered the important innovations in modern Europe architecture. He also saw the work of the Germans at the Louisiana Purchase Exposition at St. Louis, 1904.

Typical of the Prairie school architects, Maher attempted a visual unity, and his theory of the rhythm motif was a means to achieve this end. Maher explained: "These buildings are in the main designed on the motif rhythm theory. The fundamental principle being to receive the dominant inspiration from the patron, taking into strict account his needs, his temperament, and environment, influenced by local color and atmosphere in surrounding flora and nature. With these vital impressions at hand, the design naturally crystallizes and motifs appear which being consistently utilized will make each object, whether it be of construction, furniture or decoration, related . . ." (Architectural Record, June 1907).

Maher did not design furniture for all of his houses. With major commissions, however, he conceived the complete interior and used these special motifs to achieve coordination. Examples of these motifs are the lion in the John Farson house, Oak Park (1897), the thistle in the James A. Patten house, Evanston (1901), and the hollyhock in the Harry Rubens house, Glencoe (1902–03). These interiors are distinctly European in feeling and give the impression of being an intermediate state between the Victorian and modern periods. The Ernest Magerstadt house of 1908, on the other hand, is more typical of the Prairie school style, the abstract motifs creating a convincing unity rather than merely supplying a repeated image. Here one sees the influence of Wright.

## 82 Portiere

Designers: George W. Maher and Louis J. Millet, 1901
Cotton and silk velvet with design appliquéd in cotton damask
Height: 80¼", width: 47⁷⁄₁₆"

For the James A. Patten house, Evanston, Illinois, Maher used the thistle as the unifying decorative motif. " . . . it has refinement of outline and a strong organic growth which could be most readily accommodated to the various materials that are employed in the construction of the building," Maher explained. The Patten house was illustrated in several contemporary periodicals, including the *Inland Architect and News Record* for August 1903, which said: "Among the contractors who have assisted in making this residence a complete exponent of a new thought in design, it is appropriate to mention Louis J. Millet, whose correct taste as a decorative artist is often sought where the highest skill is required for such work." It is likely that Millet contributed to the design, as well as supervised the work.

The Art Institute of Chicago, gift of the Antiquarian Society, through the David A. Hanks Fund

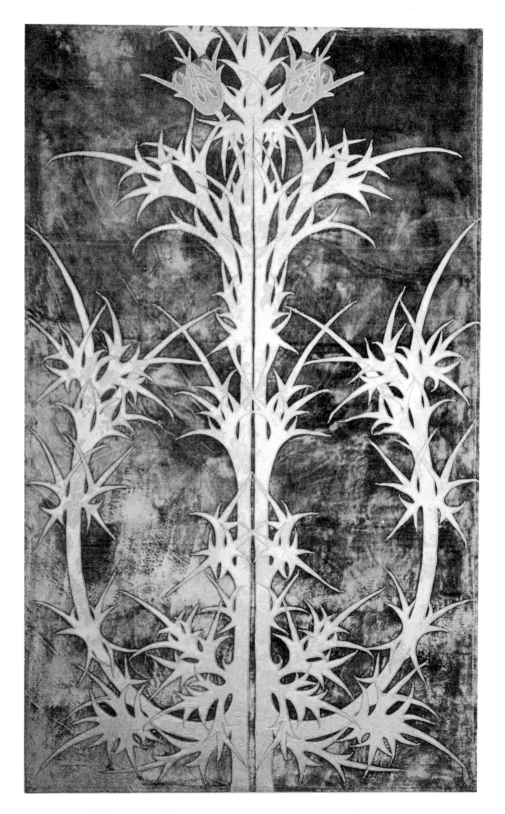

**83 Side chair**
Designer: George W. Maher, 1908
Oak
Height: 36″, width: 17¼″, depth: 19½″

Designed for the Ernest J. Magerstadt house,
Chicago, this chair in a severely geometric style
shows Maher's change, under the influence of
Wright and European architects, from the elaborate
style of the Farson house furniture to a more
severe design. This is one of a group of chairs
made for the dining room, which was illustrated
in the June 1908 issue of *Inland Architect and News
Record* (plate *VIII*). The chair was originally uphol-
stered in leather and stained a lighter tone.

Martha Field

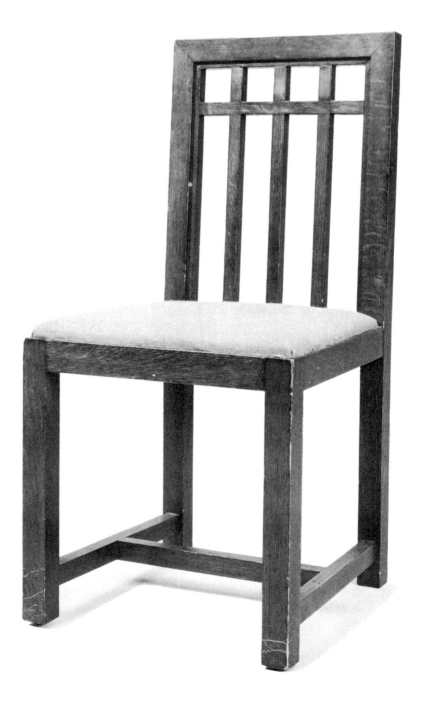

## Frank Lloyd Wright

In 1887, Frank Lloyd Wright left Madison, Wisconsin, for Chicago, where he was employed by J. L. Silsbee for about five months. From 1888 to 1893, Wright was chief draftsman for Adler and Sullivan, after which time he practiced on his own. His studio in Oak Park became the center of his activity, and it was where his assistants were trained in the ways of the developing Prairie school. Wright's departure for Europe in 1909 marked the end of his first great period of accomplishment.

Wright's ideas about architecture and the decorative arts were derived from the Arts and Crafts movement, to which his early work was in turn a substantial contribution. Wright's concept of unity of exterior and interior and his incomparable sense of space required corresponding innovations in interior design. He wrote in 1908, "The most truly satisfactory apartments are those in which most or all the furniture is built in as a part of the original scheme. The whole must always be considered as an integral unit" (*In the Cause of Architecture*). The use of built-in furniture was a means of controlling the total scheme.

One of the most important influences on Wright was the architecture of Japan. Wright had admired Japanese art and architecture even before his first visit to Japan in 1905. This is seen not only in the forms of his furniture but also in the respect for materials that characterize Wright's work. He wrote: "Bring out the nature of the materials, let this nature intimately into your scheme. Strip the wood of varnish and let it alone; stain it."

Wright's emphasis on simplicity is also typical of the late Arts and Crafts aesthetic. Wright said about William Morris and simplicity: "That he [Morris] miscalculated the machine does not matter. He did sublime work for it when he pleaded so well for the process of elimination its abuse had made necessary; when he fought the innate vulgarity of theocratic impulse in art as opposed to democratic; and when he preached the gospel of simplicity" (Hull House lecture, 1901).

Not all of Wright's furniture was designed to be built-in, but even the movable pieces were carefully designed for a specific location to create a balanced and unified composition. Wright's furniture was often criticized for its lack of comfort: "Those roomy, barrel-shaped chairs were not designed for comfort. Each persisted in catching one at the wrong angle and making one feel as if caught in some fiendish instrument of torture" (*Fine Arts Journal* [1901–03]). The furniture, however, must be regarded as architectural sculpture rather than merely utilitarian objects—a part of a larger sculptural whole. As such, the furniture can take on symbolic significance that a decorative object does not usually convey. For example, the Robie dining room ensemble not only was designed visually to create vertical and horizontal accents in the room, but also to express the idea of what it means to be a family gathered together at meals—a formal and significant occasion for Wright.

Wright's basic vocabulary in furniture design seems to have been developed early and can be seen in the furniture he designed for himself soon after 1895. Early furniture designs can also be seen in a drawing for the Isadore Heller house, Chicago, around 1897. Like his architecture, the chairs and tables here are rectilinear in form, and the use of splats is characteristic of much of his furniture, as are the flaring feet. The proportions, including high backs for side chairs, the positioning of crest rail, and the placing of stretchers were to vary.

George M. Niedecken of Niedecken-Walbridge Company, Milwaukee, Wisconsin, made most of Wright's early furniture. The varying quality of craftsmanship, however, would point to Wright's having furniture made by other firms as well, for example, John W. Ayres, who made furniture to Wright's designs for the Hickox house, Kankakee, that was exhibited in the 1902 exhibition of the Chicago Architectural Club. Niedecken was a capable designer in his own right and was responsible for the design and execution of a number of pieces of furniture, such as those for the D. M. Amberg house, Grand Rapids, Michigan. Niedecken's own designs are pictured in the *Western Architect,* and his article "Relation of Decorator, Architect and Client" demonstrates that his designs were similar to Wright's and may have been influential in the latter's own conceptions. In the December 1913 issue of *Western Architect,* Niedecken's firm advertised itself as: "Specialists in design and execution of interior decorations and mural paintings. Makers of special furniture—Art Glass—Electric Fixtures." Niedecken argued for professional standing for the interior decorator.

Wright was famous for his early acceptance of the machine, as indicated in his famous lecture delivered at Hull House in 1901, "The Art and Craft of the Machine." Certainly the flat, straight surfaces of Wright's designs lent themselves to machine production. However, even his most crudely constructed furniture could not, of course, be made entirely by machinery. It does, nevertheless, give the *impression* of being amenable to machine production. Wright's words indicated an ideal rather than actual practice.

**84 Vase**
Designer: Frank Lloyd Wright, 1893–1902
Copper
Height: 28", width 4¼" (at base)
Mark: *John Lloyd Wright Collection, #65,* on base

One of a pair that originally decorated Wright's private octagonal library in Oak Park, the vase came from the architect's son to the present owner.

Edgar Kaufmann, jr.

**85 Section of entrance gate**
Designer: Frank Lloyd Wright, 1895
Wrought iron
Height: 98", width: 49½"

This section of ironwork is from the entrance gate of the Francis Apartments, Chicago, designed by Wright in 1895. The building was demolished in 1971; of the four sections of the gate this is the only one to have survived. It is interesting to compare this early example of Wright's metalwork with the later, simpler fence done for the Larkin Building in Buffalo, and with the gate to the Waller property in River Forest. "From the very beginning my T-square and triangle were easy media of expression for my geometric sense of things," he explained.

The Art Institute of Chicago, gift of the Graham Foundation for Advanced Studies in the Fine Arts

**86 Lamp**
Designer: Frank Lloyd Wright, ca. 1898–99
Copper
Height: 28", width: 1⅞" (at base)

The octagonal base of the lamp with stylized trees was hammered by hand in the Arts and Crafts manner. It was pictured in the 1902 Chicago Architectural Club catalogue, along with the vase and urn shown in entries 84 and 87. The shade has been reproduced from this original illustration. Wright gave the lamp to the Chicago architect W. Bryce Mundie; the present owners acquired it from Mundie's son-in-law.

Marilyn and Wilbert R. Hasbrouck

**87 Urn**
Designer: Frank Lloyd Wright, ca. 1898–99
Copper with galvanized tin insert
Height: 18½", width: 18½"

Mark: *E. C. Waller,* in pencil on inside of container

This urn is one of a pair made for the Edward C.
Waller house, which was remodeled by Wright.
At least six more of these urns are known to have
been made, two for Browne's Bookstore, two for
Wright's own studio, and two for the Avery
Coonley house. One of these urns was shown in
the exhibition of the Chicago Architectural Club
in 1902. It was listed as "Repoussé copper bowl.
Made by James A. Miller." Miller had advertised
in the 1896 catalogue of the Architectural Club:
"James A. Miller and Brother, Roofers in Slate,
tin, and iron, and makers of cornices, bays,
skylights, etc. in copper and galvanized iron.
Special attention given to first class work and
large contracts."

Marilyn and Wilbert R. Hasbrouck, Chicago

**88 Armchair**
Designer: Frank Lloyd Wright, 1904
Oak
Height: 32", width: 23", depth: 23"

This chair was designed for the Darwin R. Martin
house in Buffalo. Its inspiration may have been a
chair by Leopold Bauer that was published in
*Das Interieur,* 1900 (p. 171). Wright repeated the
design with slight modifications for the S. C.
Johnson house, Racine, Wisconsin, in 1937.

Albright-Knox Art Gallery, gift of Darwin R. Martin

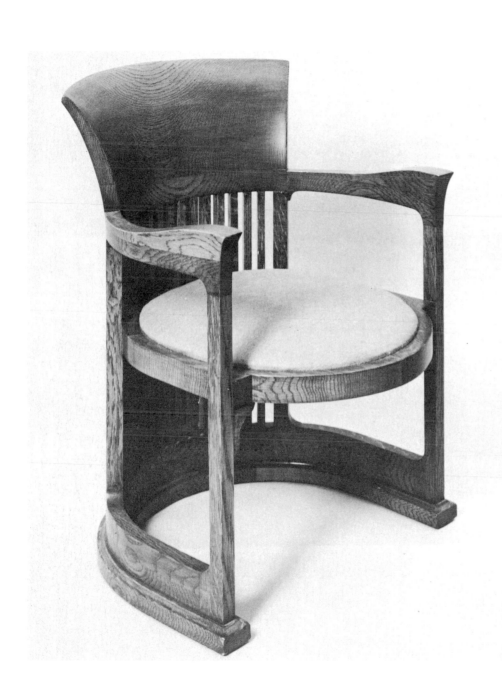

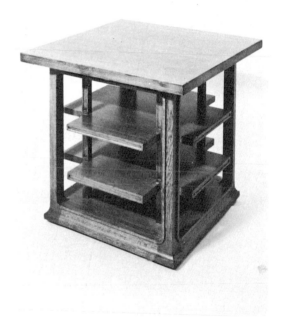

**89 Table**
Designer: Frank Lloyd Wright, 1904
Oak
Height: 26¼", width: 27", depth: 27"

The Darwin R. Martin house, Buffalo, was one of
Wright's early masterpieces. The furniture was of
equal quality, conceived with graceful curves
contrasting with severe rectilinear elements.

Albright-Knox Art Gallery, gift of Darwin R. Martin

**90 Armchair**
Designer: Frank Lloyd Wright, 1908
Oak
Height: 34½", width: 30⅛, depth: 23⅞"

At least three of these armchairs were designed by
Wright for the Ray W. Evans house, Chicago, in
1908. The Wasmuth publication of 1911 shows one
of them in the Evans living room.

The Art Institute of Chicago, gift of Mr. and Mrs.
F. M. Fahrenwald

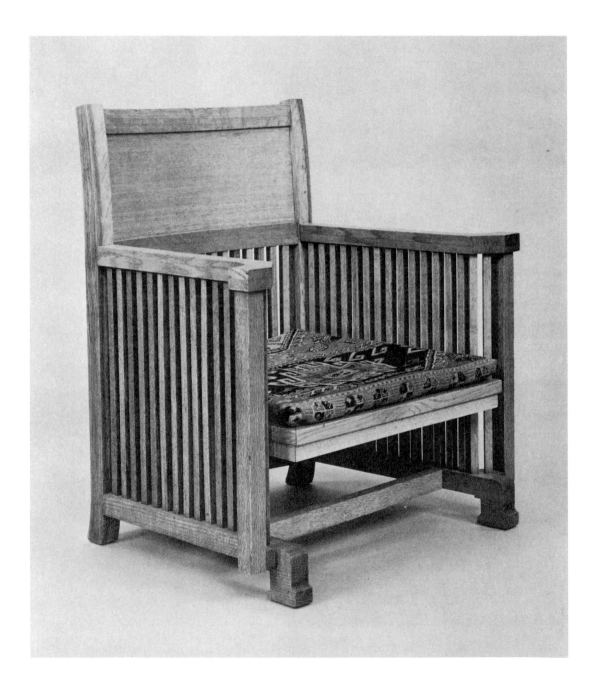

**91 Side chair**
Designer: Frank Lloyd Wright, 1908
Oak
Height: 39⅜", width: 15", depth: 17½"

One of the most beautiful of Wright's early
houses was that for Isabel Roberts. This chair was
one of the group of chairs designed for the
dining and living rooms. Miss Roberts was for
many years a secretary and bookkeeper in
Wright's studio, and apparently contributed some
of the details for her house.

Chicago School of Architecture Foundation

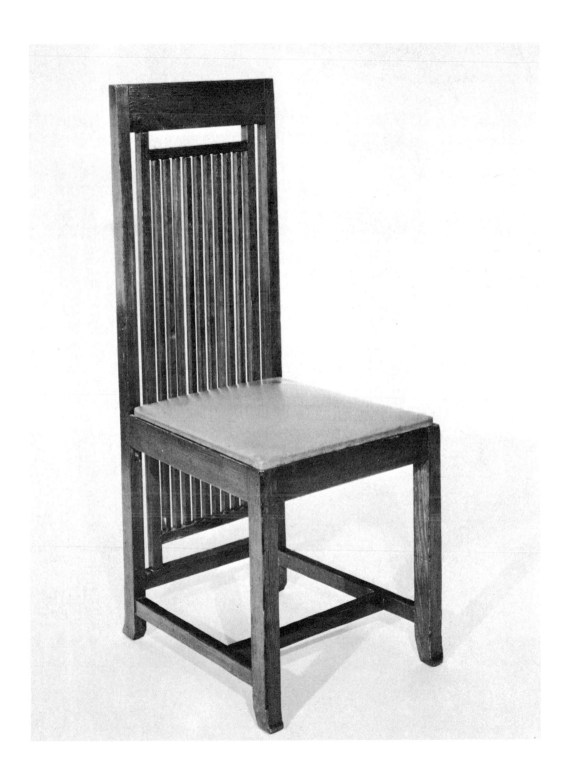

**92 Tall lamp**
Designer: Frank Lloyd Wright, 1911 (1915–16)
Oak
Height: 65⅛", width: 10⅛", depth: 14⅛"

Sherman M. Booth was Wright's lawyer and close
friend. Wright designed a house and furniture
for him in 1911. The house was not built until
1915–16, and was done without Wright's super-
vision. Execution of this and at least five other
lamps date from the late building period.

Mr. and Mrs. Ted Bloch

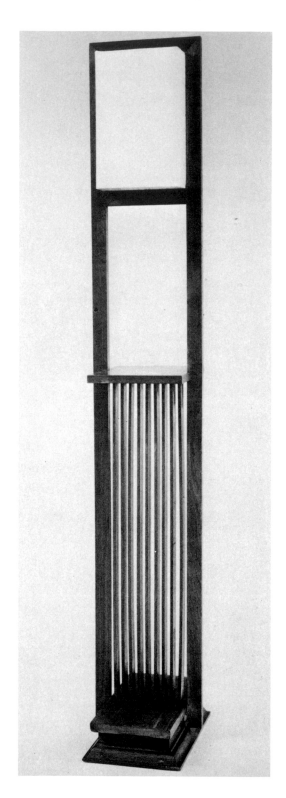

**93 Dining table and six side chairs**
Designer: Frank Lloyd Wright, 1908
Oak
Table: height: 55½", width: 58¾", length: 95½"
Chairs: height: 52⅜", width: 17", depth: 19¾"

Designed for the Frederick C. Robie house, Chicago,
this dining room furniture is among Wright's
most famous ensembles. Because Wright left
Chicago before the house was completed, it is
possible that Marion Mahoney had something
to do with the interior details and furnishings.
However, if she did, it was done in the master's
style, and suggests how capable Mahoney was as
Wright's executing hand. The table was dras-
tically altered in subsequent years. The four piers
with lamps have been reconstructed from drawings
photogrammetrically plotted from original
photographs of the set.

University of Chicago

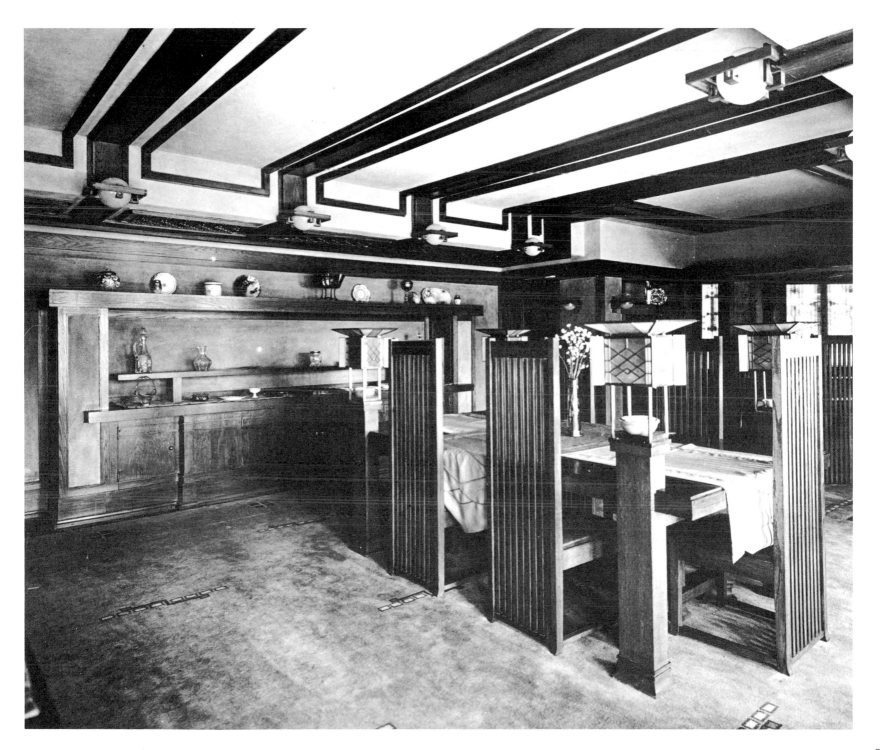

**94 Candlesticks**
Designer: Frank Lloyd Wright, 1909
Brass
Height: 8″, width: 3⅞″

Since these candlesticks were acquired from the
J. Kibben Ingalls house, River Forest, it is likely
that they were designed for it. The geometric
shapes echo the abstract design of the interior
of the house. It is likely that they were cast by
Winslow Brothers of Chicago.

Tim Samuelson

**95 Window**
Designer: Frank Lloyd Wright, 1904
Leaded glass
Height: 41½″, width: 26¼″

Designed for the Darwin R. Martin house, this win-
dow features a highly abstracted version of the
Tree of Life, a popular motif at the turn of the
century. It is one of the finest of Wright's early
decorative windows.

The Art Institute of Chicago, gift of Mrs. Philip
K. Wrigley through the Antiquarian Society

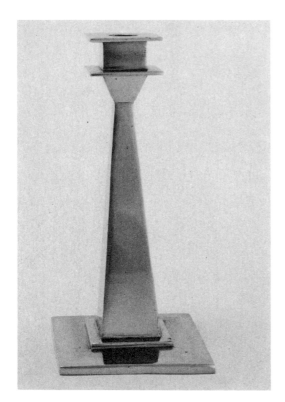

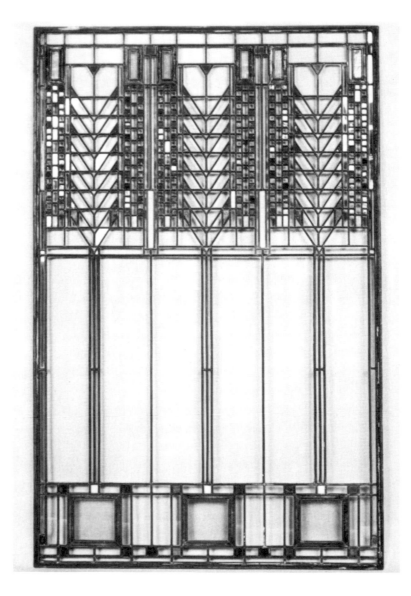

**96 Window**
Designer: Frank Lloyd Wright, 1912
Leaded glass
Height: 62", width: 13⅝"

This panel was one of the narrow side windows
from the front of the Avery Coonley playhouse.
These windows are some of Wright's most im-
portant single decorative efforts, for they relate to
nonobjective experiments in European painting
at the time, and hold their own well with Art Deco
schemes of the next decade.

Mr. and Mrs. Walter A. Netsch, Jr.

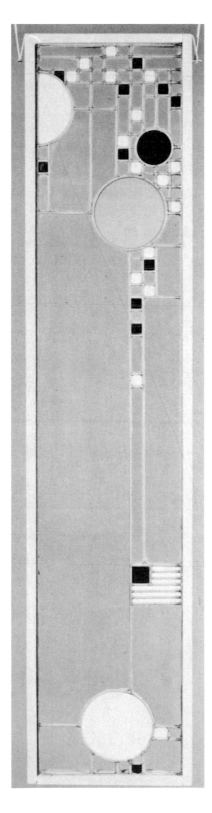

**Robert R. Jarvie**

Born of Scottish parents in Schenectady, New York,
Robert Jarvie was listed as a silversmith in the
Chicago directories from 1893 to 1917. The Jarvie
Shop, of which he was president, was first listed
in 1905. A founding member of the Cliff Dwellers
Club, Jarvie was long active in it. He advertised
frequently in the *Craftsman, House Beautiful, Fine
Arts Journal, and Arts and Decoration*. Although
he was particularly well known for his copper
candlesticks, he is in the top rank of twentieth-
century American silversmiths. He exhibited at The
Art Institute of Chicago and his work was known
and respected in the East. Arthur G. Leonard,
president of the Union Stockyard Company,
Chicago, admired Jarvie's work, and in 1912 in-
vited him to move into the "Old English Cottage,"
at 842 Exchange Avenue, and to design trophies
that were awarded in great numbers to cattle
raisers at shows in Chicago and at fairs in neighbor-
ing states. Some of these trophies were exhibited
at The Art Institute.

**97 Punch bowl**
Designer and maker: Robert Jarvie, 1910
Silver
Height: 10¼", diameter: 16⅜"
Mark and inscription: *THE-CLIFF-DWELLERS/
Jarvie/1910/Chicago/PRESENTED BY/CHARLES-
L-HUTCHINSON,* on bottom of bowl

Evelyn Marie Stuart wrote in the December 1911
issue of *Fine Arts Journal:* "One of the most in-
teresting features of arts and crafts in Chicago
and the west has been the adaption of strictly
American motifs in design, suggestions borrowed
from the aboriginal Americans. Such is the spirit
of the exquisite punch bowl wrought in silver
by Robert Jarvie and presented by Charles L.
Hutchinson to the Cliff Dwellers Club of Chicago,
an organization of painters, writers, musicians,
craftsmen, and artists generally." Jarvie obtained

a plaster cast of an original American Indian
bowl from the Field Museum of Natural History
and adapted the design for the silver bowl. Miss
Stuart praised the surface of Jarvie's silverwork
for its "medium finished surface, neither polished
to the brilliancy of a mirror, nor broken into a
series of unmistakable dents." The modern crafts-
man, she maintained, should, just as his predeces-
sor of the eighteenth century, hide, as far as
possible, the impressions of the hammer blows.
The October 1903 issue of the *Craftsman* extolled
the virtue of the North American Indian decorative
motifs, which "offer rich opportunities in both
symbolism and ornament. These motifs . . . are
worthy to be ranked with the Briton and Celtic
systems."

Cliff Dwellers Club of Chicago

**98 Trophy**
Designer and maker: Robert R. Jarvie, 1912
Silver
Height: 15⅜" (with lid), diameter: 10"
Inscription: *AERO AND HYDRO/TROPHY/FOR/
HYDROAEROPLANE/EFFICIENCY,* engraved on side
of bowl; *WON BY,* on back
Mark: *Jarvie/Chicago/STERLING/1057,* engraved
and stamped on bottom of base

"To encourage the development of the hydro-
aeroplane, or aero-hydroplane, as it is sometimes
termed, and at the same time to provide an
annual event to encourage competition among
operators of this type of flying machine, *Aero
and Hydro* has offered the Aero Club of Illinois
a trophy, to be known as the efficiency trophy for
air and water craft. The gift has been accepted by
the club and will be competed for the first time
this year during the hydroaeroplane meet to be held
just off Grant Park, Chicago, September 17 to 21,
probably on September 19" (files of the Chicago
Historical Society). A letter of 3 September 1912 to
Jarvie from the magazine *Aero and Hydro* out-
lines the commission, which specified using a
model of a flying boat made by the Curtiss Aero-
plane Company. The trophy was exhibited in the
1912 Art Crafts Exhibition at The Art Institute.

Chicago Historical Society, gift of the Aero Club
of Illinois

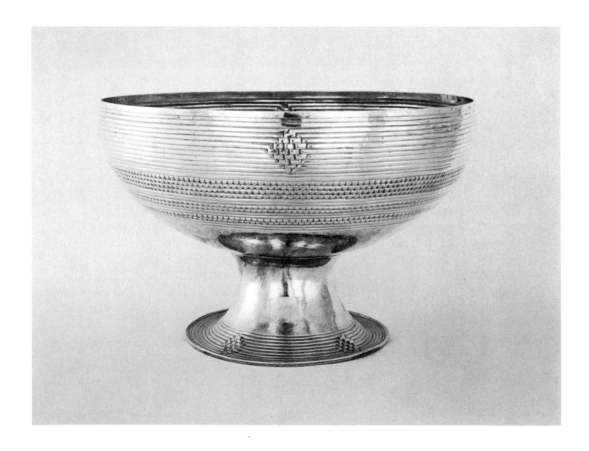

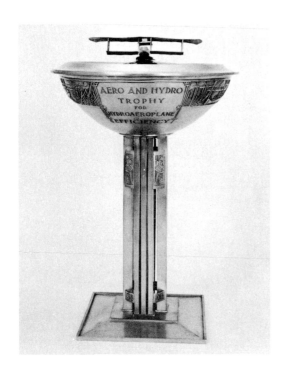

**100 Candlestick**
Designer: Robert R. Jarvie, ca. 1901
Brass, copper plated
Height: 13½", diameter: 5¾" (base)
Mark: *Jarvie,* in script, with letter *B*

The *Craftsman* of December 1903 explained Jarvie's
success: "Mr. Jarvie earned for himself the sobriquet
of 'The Candlestickmaker.' Nearly all this work is
of cast brass or copper, brush polished, a process
which leaves the metal with a dull glow. Some
pieces are cast in bronze and their unpolished
surfaces are treated with acids which produce an
exquisite antique green finish. . . . The charm of
these candlesticks is in their simplicity and purity of
form. The graceful outlines and soft lustre of the
unembellished metal combine to produce dignity
as well as beauty, and the possessor of one of the
Jarvie candlesticks must feel that nothing tawdry
or frivolous can be placed by its side."

Ethel and Terence Leichti

**101 Candlestick**
Designer: Robert R. Jarvie
Brass, copper plated
Height: 10⅛", diameter: 5¼" (base)
Mark: *Jarvie,* in script, bottom of base

Ethel and Terence Leichti

**99 Candlestick**
Designer: Robert R. Jarvie, ca. 1901
Brass
Height: 12", diameter: 5⅞" (base)
Mark: *Jarvie,* in script, and Greek letter *delta,*
bottom of base

The Jarvie Shop was especially well known for its
candlesticks, three of which are shown here.
Jarvie advertised candlesticks like these in *House
Beautiful* beginning in late 1901. He exhibited them
at The Art Institute of Chicago from 1903 to 1905.

Ethel and Terence Leichti

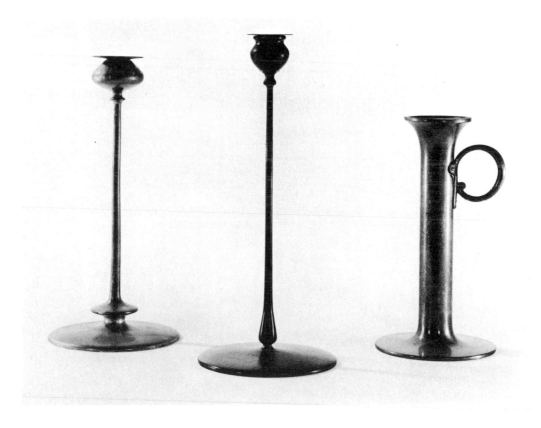

## The Kalo Shops

The Kalo Shops were started by Clara Barck Welles at Park Ridge, Illinois, in 1900; the salesroom was at Michigan Avenue and Adams Street in Chicago. In 1914 the store moved to 32 North Michigan Avenue, with workshops overlooking Grant Park. The shop was moved to the Fine Arts Building in 1918, joining numerous other crafts shops there. Mrs. Welles retired in 1940, after which the shop was run by Robert R. Bower. The establishment closed in 1970 because of the deaths of Daniel H. Pederson and Yngre H. Olsson, Kalo's finest silversmiths in its later period. The designs initiated by Mrs. Welles were continued through the years, the craftsmen following her outline drawings. Distinguished for its classic simplicity and always beautifully crafted, Kalo silver was popular with several generations of Chicagoans. Admired in her own time, Mrs. Welles exhibited often at The Art Institute and major museums in the East.

**102 Water pitcher**
Designer: probably Clara B. Welles, 1901–14
Silver
Height: 8¾", width: 7¹¹⁄₁₆" (including handle)
Mark: *STERLING/HAND BEATEN/AT/KALO SHOPS/ PARK RIDGE/ILLS./9319,* impressed on bottom

The joining of the handle to the body of this pitcher is particularly well designed and executed.

Private collection

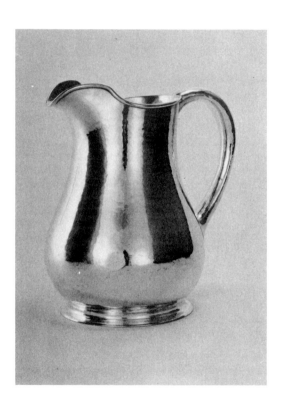

**103 Beaker**
Designer: Clara B. Welles, 1900–14
Silver
Height: 3", diameter: 2¾" (at lip)
Mark: *STERLING/HAND BEATEN/AT/KALO SHOPS/ PARK RIDGE/ILLS./ 4323,* stamped on bottom

The simplicity of this design demonstrates the reform tenets of Clara Welles and her Kalo Shops.

Private collection

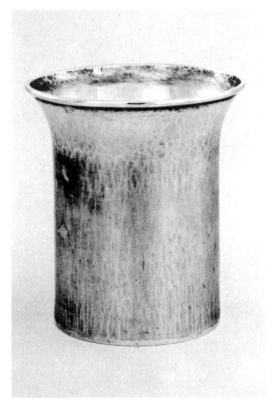

90

## Frances M. Glessner

Born in Urbana, Ohio, Frances Macbeth married John J. Glessner in 1870. She was a social leader in Chicago in the 1880s, well known for her Monday Morning Reading Classes. Although various crafts such as silvermaking and needlework were fashionable for women at the time, the Glessners' friendship with Isaac Scott (see entries 1 and 2) probably encouraged her own interests. The Glessner house reflected enthusiasm for the Arts and Crafts movement, for it contained fabrics and a rug by William Morris and furniture by Herter Brothers of New York, as well as by Scott.

**104 Sweetmeat dish**
Designer and maker: Frances M. Glessner, 1905
Silver
Height: 2¼", width: 6⅞", depth: 6⅞"
Inscription: *MADE FOR/THE FORTNIGHTLY OF CHICAGO/BY/FRANCES M. GLESSNER,* engraved in script underneath rim of dish
Mark: *G,* superimposed with a bee, on bottom

On 17 December 1905, Mrs. Glessner noted in her diary: "Thursday I went to the Fortnightly and took a silver dish of my own make as a present." Mrs. Glessner made the dish under the instruction of Mr. Fogliata, the master of metalwork at Hull House, Chicago. She may have made it there, or at her house at 1800 Prairie Avenue, where the conservatory had been converted for use as a metal shop. The quality of craftsmanship attests to Fogliata's ability as a teacher at a time when handicrafts at home were widespread, and skill at various crafts a prerequisite for prominent women.

The mark of a *G* superimposed with a bee was Mrs. Glessner's ingenious use of her initial with reference to her interest in bee-keeping at her summer house in New Hampshire.

The Fortnightly of Chicago

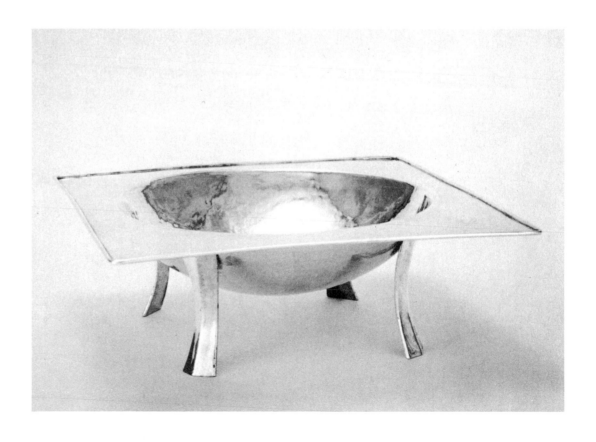

## The furniture industry in Grand Rapids, Michigan

Known as the "Furniture Capital of the United States," Grand Rapids was influencing, or at least responding to, domestic tastes before the 1876 Centennial Exposition made its wares famous. Machine production was used to supply period reproductions or current modes. Several companies came forth with commercial versions of Arts and Crafts furniture for the catalogue trade from about 1900 to the First World War.   RJC

**105 Writing desk and chair**
Stickley Brothers Company, Grand Rapids, Mich., 1906
Mahogany, with brass hardware
Desk: height: 36", width: 36", depth: 23¼"
Chair: height: 38¼", width: 16⅜", depth: 16"
Mark: paper label, *MADE BY/STICKLEY BROTHERS CO./GRAND RAPIDS, MICH.,* under drawer area; chair has partial label under seat

Two of Gustav Stickley's younger brothers, George and Albert, moved to Grand Rapids in 1891, founding the Stickley Brothers Company. At the turn of the century their production closely resembled the oak furniture made famous by their eldest brother; but it was always inferior in design and in choice of woods and finishes. When the firm sought more independent designs, some worthwhile pieces were produced, such as this writing desk and chair of mahogany. The set was not in the Stickley Brothers catalogue of January 1906, but did appear in the supplement issued in July of that year (number 6810). It closely parallels certain inexpensive lines of Arts and Crafts furniture made in England at the same time, which were often called "cottage furniture." Stickley Brothers added the phrases "Quaint Furniture," and "Arts and Crafts" to their trade name during this period.   RJC

Private collection

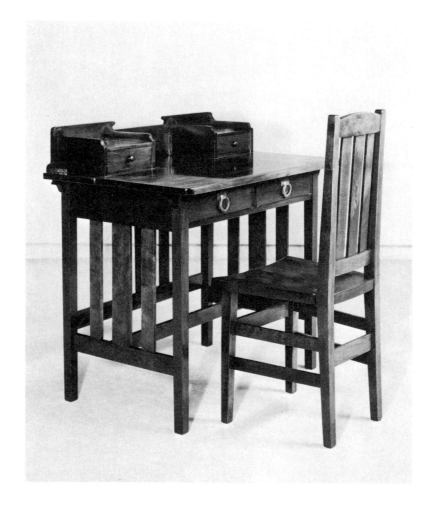

**106 Plant stand**
Charles P. Limbert Company, Grand Rapids and
Holland, Mich., 1912
Oak
Height: 18", width: 15¹⁵⁄₁₆", depth: 15¹⁵⁄₁₆"
Mark: paper label, *LIMBERT'S/ARTS CRAFTS/
FURNITURE/TRADE MARK/MADE IN/GRAND
RAPIDS/MICHIGAN*, on underside of top

With salesrooms in Grand Rapids, and a factory in
nearby Holland, Michigan, the Charles P. Limbert
Company advertised its line of "Limbert's Holland
Dutch Arts and Crafts Furniture" before World
War I. Their catalogues featured a fascinating con-
glomeration of oak pieces, many of them derived
from Gustav Stickley and similar craftsmen, but
with occasional details showing awareness of Con-
tinental work exhibited at the world's fairs and
published in European magazines. Some pieces
were inlayed with ebony in conventionalized pat-
terns, while others were extremely simple. The
plant stand was one of the company's most
sophisticated productions, strongly indebted to
Charles Rennie Mackintosh. It was first included
in Limbert's 1912–13 catalogue (number 234). RJC

Mr. and Mrs. James M. Marrin

# 3 The Pacific Coast

# 3   The Pacific Coast
Robert Judson Clark

At the time of the 1876 Centennial Exposition in Philadelphia, California was beginning to overcome its reputation as the Bonanza capital of Gold Rush days and to assume the stance of a cultural outpost of some significance. This was possible largely because of the completion of the transcontinental railroad and the money that its builders were spending in San Francisco and Los Angeles. San Francisco's Nob Hill was becoming the finest address in the West, with the mansions of railroad barons rising there in the 1870s. Their houses were in many styles, although most of them reflected the fashionable mode of that decade, the Second Empire. They were not to be confused with their counterparts in the East; these palaces were more opulent and bombastic and were usually constructed of wood. Indeed, it was the wooden architecture of California that was to make it a center of domestic architectural experiments second only to the suburbs of Chicago at the turn of the century.

California was long dependent on Eastern sources for most of its architects and much of its interior decorations. When the Mark Hopkins house of 1878 was built on Nob Hill, its interiors were designed and executed by the famous manufacturers of art furniture in New York, Herter Brothers, who eventually sent Edward F. Searles to San Francisco as their representative. Searles married Hopkins's widow and later donated the mansion to the University of California, making possible the Mark Hopkins Institute of Art, which incorporated the California School of Design, founded as early as 1874.

At the World's Columbian Exposition in Chicago, 1893, California was represented by a large state pavilion with details adapted from its Franciscan missions, which were then being rediscovered. Also, there was a handsome booth set up by various California craftsmen with objects mostly of redwood. The following year, San Francisco's Golden Gate Park swelled with an echo of the Chicago extravaganza, the California Midwinter Exposition at which the agriculture, industries, and crafts of California were shown for the first time in a unified effort on the West coast.

Meanwhile the architecture of California had moved through its phase of the Queen Anne, and was now being bolstered by the arrival of younger designers from the East coast and Europe. The Englishman Ernest Coxhead, after a brief stay in Los Angeles, moved to San Francisco, where he helped establish a style of simple, shingle-clad domestic architecture. Coxhead was for a time assisted by Bernard Maybeck, the son of

a New York woodcarver, who brought to the hills of the San Francisco Bay an unusual combination of eccentricity and operatic sweep as well as a talent for doing fascinating things with limited budgets. For professors at the University of California and other sympathetic clients he dotted the landscape of Berkeley with shingled houses that fit perfectly into the contours of the hills. This method of building was propagated by the Berkeley Hillside Club, founded to encourage the well-being of local citizens through good fellowship and a healthy home life. In this vein there appeared in 1904 a small book, *The Simple Home,* written by Charles Keeler and dedicated to Maybeck, who had been its major inspiration. Keeler wrote: "The ideal home is one in which the family may be most completely sheltered to develop in love, graciousness and individuality, and which is at the same time most accessible to friends, toward whom hospitality is as unconscious and spontaneous as it is abundant." Keeler insisted that California was still the land of wooden houses and that interiors should be of natural wood, without the intrusion of wallpapers or too many printed fabrics.

Julia Morgan, the first woman to obtain an architectural license in California, was also a master of this kind of modest dwelling. Unlike Maybeck, however, she is not known to have designed furniture for her clients. Such appointments could be obtained from Lucia and Arthur F. Mathews, painters who designed furniture in their San Francisco shop, which they established after the 1906 earthquake and fire. This disaster had provided whole new careers for architects and designers in the area. One of those who benefited was Louis Christian Mullgardt from St. Louis, who, after spending a few years in London, came to San Francisco to stay. He lectured in January 1906 on "English Ways and Methods," and had some remarkable ideas about hillside bungalows which combined an awareness of the domestic work of such British designers as Charles F. A. Voysey, along with an enthusiasm for the architecture of the Orient which seemed almost native to the climate of the Golden State. Mullgardt was anxious to design furniture for his houses, but found only occasional opportunity to do so.

These accomplishments in architecture on the West coast were reported in *Architect and Engineer,* founded in October 1905 and published in San Francisco. Its interest was mainly focused on northern California, but gradually there was more awareness of what was happening in the southland. Irving Gill, a native of Syracuse, came to San Diego in 1893 after a short period in Louis Sullivan's office. That same year Charles and Henry Greene arrived in Pasadena and within a decade began designing the houses and furniture that made Pasadena famous as an architectural mecca before World War I.

In 1909, there appeared a single issue of the *Arroyo Craftsman,* published in Los Angeles and edited by George Wharton James of Pasadena. It was advertised as the quarterly organ of the Arroyo Guild, an amalgamation of architects and craftsmen who

sought commissions for houses in which all elements, including furniture and landscaping, would be handled as a total work of art. The magazine proclaimed that "California is destined to become the art center of the world." Inspiration for the publication was admitted to be the work of Gustav Stickley, the "American William Morris," for whom James had served as associate editor of the *Craftsman* five years before. The motto of the Arroyo Guild was "We can," a less humble variation of Stickley's "Als ik kan," borrowed from Jan Van Eyck.

In Santa Barbara (actually Montecito), Frederick Eaton headed a workshop specializing in metalwork and book illumination. His daughter, Elizabeth E. Burton, also had a studio there from 1903 to about 1910–11; lamps were her preoccupation. It was in Montecito that the first West coast work of Frank Lloyd Wright was built, the George C. Stewart house of 1909–10. It was not until after the First World War that Wright returned to do more houses in the Los Angeles area, where Rudolph Schindler and Richard Neutra now also worked. They had come from the Vienna of Otto Wagner, Josef Hoffmann, and the Wiener Werkstaette— via Wright's studio in Chicago. However, their work of the 1920s in California belongs to the period after the Arts and Crafts movement had passed.

In the Pacific Northwest there thrived a style of architecture comparable to that in the Bay Area, and which was somewhat dependent on it—although with some elements from the Prairie school, which was represented there by the firm of Andrew Willatsen and Barry Byrne from about 1908 to 1913. Also in Seattle was the Berry Shop, about which little is known, but which produced a noteworthy amount of copperware at about this time. The architect Ellsworth Storey, a native of Chicago who came to Seattle in 1903, designed fine wooden houses and curious Arts and Crafts furnishings, some of which were seen in the House of Hoo-Hoo at the Alaska-Yukon Exposition in 1909.

This Seattle fair is hardly remembered today, having been far outdone by California's two fairs held in 1915 to celebrate the opening of the Panama Canal. The Panama-Pacific International Exposition in San Francisco was a spectacular pageant, partly because of its ambitious Beaux-Arts scheme made more colorful than its predecessors in Chicago, Buffalo, and St. Louis by the adoption of Jules Guerin's exotic color scheme. The remnant of the exposition is, of course, Maybeck's Palace of Fine Arts, which contained paintings, sculpture, and graphics. Contemporary journals observed that the applied arts had been ignored until the last minute and then hastily given space in the Varied Industries Building at the opposite end of the exposition grounds.

The smaller San Diego fair of 1915 opened for a second season the following year. Its buildings, designed by Bertram Goodhue, heralded the Spanish Colonial revival of the next decade and hastened the decline in popularity of the architects and craftsmen who had been the protagonists of the Arts and Crafts movement on the West coast.

## Greene and Greene

Cincinnati, birthplace of the art pottery movement in the United States, also produced two architects whose work was surely a triumph of the American Arts and Crafts movement as it finally emerged in California. Charles Sumner Greene and Henry Mather Greene were born in 1868 and 1870 in Brighton Station, now a suburb of Cincinnati. They were raised in St. Louis, where their parents enrolled them in the Manual Training High School, which had been founded in 1877 by Calvin Woodward. Charles Greene wanted to be a painter, but his father insisted that he attend architectural school with his younger brother. After graduating from the Massachusetts Institute of Technology and working for various Boston architectural firms for a year or so, Charles and Henry traveled in 1893 to Pasadena, where their parents had since established residence. A few commissions came their way, and a practice was begun.

The first houses by the young firm of Greene and Greene were undistinguished—assorted attempts at Georgian and Queen Anne, sometimes clad with shingles and often suffering from brutal juxtapositions of elements and a lack of scale. However, after Charles Greene's wedding trip in 1901 to England, his wife's birthplace, a new phase of the Greenes' career was underway. There were houses with half-timbered exteriors, sometimes with a room or two appointed in the spirit of William Morris. Then came adaptions of the low-gabled Alpine chalet and the patio house of early California, and then the articulated structures of Japan. It was the architecture of the Orient in happy union with vestiges of the American shingle style that finally provided the base for the mature work of the Greenes.

The Greenes are best known for the four great houses designed by them during the short period of 1907 to 1909. It commenced with the large residence for Robert R. Blacker in Pasadena, 1907–09. Blacker was a retired lumberman from Michigan, who had commissioned a house in Mission revival style from Myron Hunt and Elmer Grey, refugees from Chicago now practicing in southern California. But sometime after the working drawings were completed, Blacker noticed the wooden architecture of the Greenes in "Little Switzerland," Charles's own neighborhood overlooking the Arroyo Seco, where the brothers had built or remodeled several houses in the heavy-timbered,

articulated mode that appealed to Blacker. The assignment was immediately changed, and the Greenes were the Blackers' architects henceforth, supplying not only the drawings for a huge wooden house, but also for furniture and extensive gardens. It was Charles Greene who did most of the designing; he was the dreamer and man of ideas who worked with the clients and sketched the original conceptions. Henry prepared the office drawings, giving his brother's work substance and continuity.

The next house of major consequence was that of 1907–09 for Mr. and Mrs. David B. Gamble, who were friends of the Blackers. Because it was a second home for winters away from Cincinnati, the Greenes were allowed to design much of the furniture—executed by Peter Hall, a local contractor and cabinetmaker who worked almost exclusively with the Greenes for several years. Then came the house for Charles M. Pratt in the Ojai Valley, 1908–09. This informal pavilion for an official of Standard Oil was also a winter retreat, and the Greenes, again, designed the furniture and the grounds.

The fourth of the Greenes' most famous houses constituted somewhat of an invasion of the territory of Bernard Maybeck, for in 1908 they were commissioned to design a house for the William R. Thorsens in Berkeley. Thorsen was a lumberman from Wisconsin. Mrs. Thorsen was the sister of Mrs. Blacker and had roomed with Mrs. Pratt at Vassar. She wanted a wooden house like her sister's in Pasadena, and her husband, who first balked at the expense, succumbed to the Greenes' expert use of wood and to the fact that his wife's inheritance was sufficient to pay the bills. Some furniture was designed by Charles Greene and was built in the Thorsen basement during a period of sixteen months by a Scandinavian craftsman sent from Peter Hall's workshops in Pasadena.

There was a word of caution written by a Thorsen relative who, having visited the Blacker house, hoped that in the Berkeley residence Charles Greene would not "let his fancy run riot in wood," for at the Blacker house she had "the feeling of a spider scrambling from one cigar box to another." Despite the "dim, religious light" emanating from wooden lanterns, "Mr. Greene's woodwork is a delight for the softness of its finish. It is like fresh butter or paste squeezed out of a tube—so soft are the surfaces and the corners." Regarding the Blacker furniture, the writer added

to the Thorsens, "It is all in keeping with the style of architecture and the wall fittings but there is not a deep, soft chair or sofa in the house. . . . It is studio furniture."

Beginning in June 1907, the *Craftsman* began to feature the work of the Greenes at regular intervals until May 1915. Stickley's writers praised the adaption of the Greenes' houses to their sites and the details of the interiors: "The living and dining rooms are heavily wainscoted and beamed, the solid ceiling beams of the construction being exposed in true CRAFTSMAN style." When Charles R. Ashbee visited southern California in 1909, he was delighted to meet Charles Greene, who showed him some of the buildings in progress, especially the Gamble house. Robert W. Winter has gleaned from Ashbee's memoirs some comments about what he saw: "I think C. Sumner Greene's work beautiful; among the best there is in this country. Like Lloyd Wright the spell of Japan is on him, he feels the beauty and makes magic out of the horizontal line, but there is in his work more tenderness, more subtlety, more self effacement than in Wright's work. It is more refined and has more repose. Perhaps it loses in strength, perhaps it is California that speaks rather than Illinois, anyway as work it is, so far as the interiors go, more sympathetic to me."

These comments can be related to Ashbee's enigmatic phrase in his introduction to the 1911 Wasmuth book of photographs of Wright's work: "There are features that give to the buildings of the Pacific coast a character quite distinct from the School of Chicago as the conditions are not the same, and I have been in homes on the Arroyo that appeal to me more than Frank Lloyd Wright's. . . ." Surprisingly, Wright also admitted having admiration for the work of the Greenes, and a telegram of March 1915 indicates that Wright had made several unsuccessful attempts to meet Charles Greene.

After 1910, few large commissions came the way of the Greene brothers, and almost none with the added request for custom furnishings. The California bungalow, whose forms and details they had helped to inspire, was now advertised by publishers of bungalow books and magazines, as well as by developers. In the summer of 1916, Charles Greene moved his family to Carmel, California, escaping, he said, the commercialism of his former environment. By 1918, he had decided not to return to southern California; Henry was practicing

under his own name within a few years. Charles Greene's last sizable undertaking was a house for D. L. James on the cliffs of Carmel Highlands. For inspiration he turned to the medieval ruins of Tintagel on the coast of Cornwall, which he had visited and painted during a second trip to England in 1909.

**107 Chest of drawers**
Designer: Charles Sumner Greene, 1908
Maker: Peter Hall
Walnut, with inlays of fruitwoods, ebony, and semi-precious stones
Height: 62", width: 37½", depth: 21"

Although the David B. Gamble house, 1907–09, was not the Greenes' most ambitious undertaking, it was one of their finest total schemes. The house, its furnishings, and the grounds are preserved today in almost perfect condition; the furniture in this exhibition was chosen from the master bedroom and living room. The bedroom pieces were made of walnut, with a limp floral design inlaid in fruitwoods and green stones. The superimposed rings of ebony seem to suggest oriental sword hilts, often collected and displayed at the time. The ebony pegs occasionally cover brass screws, but were usually intended as mere decoration. As in much of the Greenes' architecture, romanticized rationalism was the guiding principle.

Gamble House, Greene and Greene Library

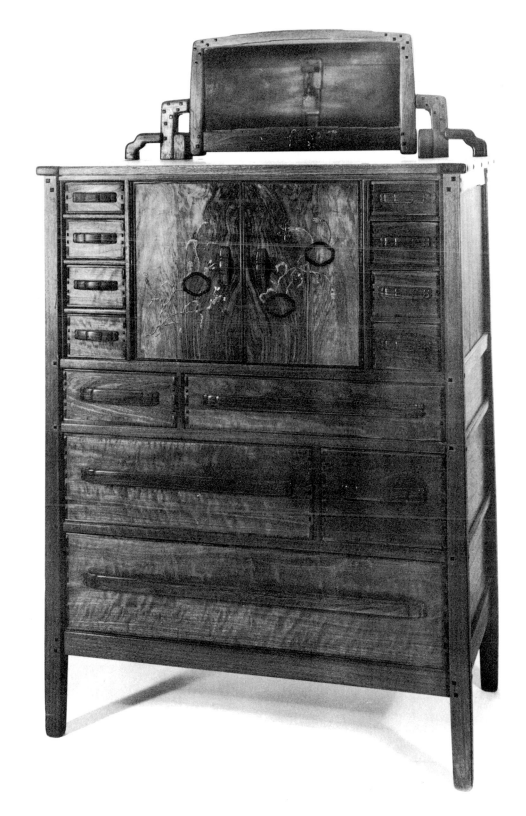

**116 Covered jar**
Furniture Shop, San Francisco, ca. 1906–20
Designer and decorator: Lucia K. Mathews
Wood, painted with various colors and gold leaf
Height: 11½"

In the continuous landscape are seen figures, trees, and a perspective toward a simple, whitewashed building. This jar, along with the desk in entry 115, were formerly in the Mathews residence in San Francisco.

Oakland Museum, gift of the Art Guild of the Oakland Museum Association

## Dirk Van Erp

According to the researches of Bonnie Mattison, Dirk Van Erp was a native of Leeuwarden, Holland. He came to this country in 1886, when he was twenty-six. After a sojourn in Merced, California, he moved to San Francisco, where he worked as a coppersmith in the shipyards. An unsuccessful venture as an independent businessman and a trip to Alaska followed, after which Van Erp returned to the shipyards. His hobby of making decorative objects from shell casings began to attract considerable attention, and eventually buyers, so Van Erp opened the Copper Shop in Oakland sometime in 1908. Two years later the shop was moved to San Francisco, where Van Erp remained for the rest of his life. In 1910 he was associated with Miss D'Arcy Gaw, whose name appeared above his on the new trademark, a windmill in outline. Later, Van Erp's two children, Agatha and William, were among the craftsmen in the workshop. Van Erp's metalwork was sold largely from his own premises, although some pieces were distributed to dealers elsewhere on the West coast. His oeuvre is remarkable for its consistency of style and quality of workmanship during the two decades of his professional activity.

**117 Table lamp**
Designer: Dirk Van Erp, ca. 1912
Copper, with mica inserts in shade
Height: 21½", diameter: 19¾"
Mark: *Dirk Van Erp,* below windmill, on base

This model with a flaring, riveted base was un-
doubtedly one of Van Erp's most popular designs,
for variations of it exist in larger quantity than
any other of his many styles of lamps. Its shape is
said to have been originally suggested by D'Arcy
Gaw, his onetime partner.

Ethel and Terence Leichti

**118 Table lamp**
Designer: Dirk Van Erp, 1920s
Copper, with mica inserts in shade
Height: 13", diameter: 12"
Mark: *Dirk Van Erp,* below windmill, on base

Although the broken border of the shopmark
indicates that this lamp was executed in the 1920s,
its design nevertheless relates to many that Van Erp
made prior to World War I. Its shape and color, as
well as the glow from the mica shade, were perfect

complements for the oak furniture and paneled
interiors of the American bungalow during the
mature phase of the Arts and Crafts movement
in this country.

Mr. and Mrs. Robert Mattison

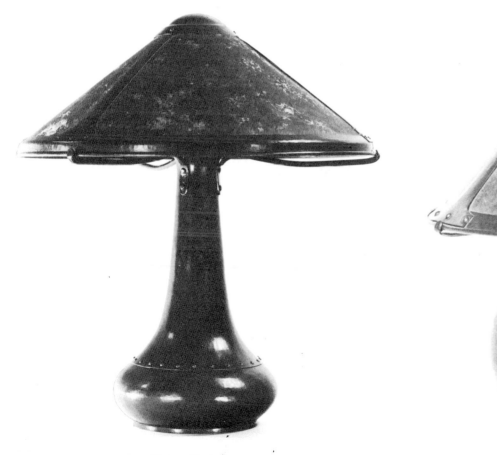

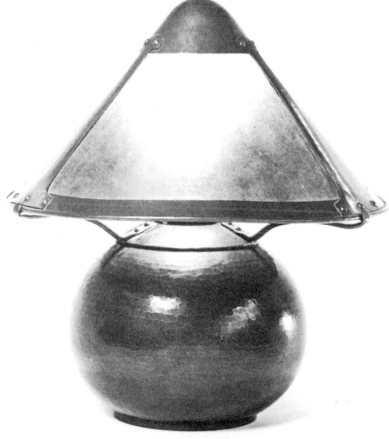

**119 Vase**
Designer: Dirk Van Erp
Copper
Height: 4½″
Mark: *Dirk Van Erp,* below windmill, on base

The robust, "warty" texture of this vase is quite unusual in Van Erp's limited production.

Mr. and Mrs. Robert Mattison

**120 Inkwell**
Designer: Dirk Van Erp, ca. 1914–15
Copper, with glass insert
Height: 2½″, width: 3⅝″, depth: 3¾″
Mark: *Dirk Van Erp,* below windmill, on base

The date is suggested by Van Erp's son, who recalls that his sister Agatha cut out the details of the lid.

Private collection

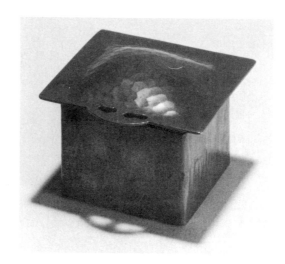

**121 Pen tray and letter opener**
Designer: Thomas McGlynn for Dirk Van Erp
Copper
Pen tray: length: 11", width: 2¾"
Letter opener: length: 7½"
Mark: *Dirk Van Erp,* below windmill

The motif of the oak tree was the work of Thomas McGlynn, who was also associated with Lucia and Arthur F. Mathews at the Furniture Shop in San Francisco. The actual execution of these pieces was probably by Agatha Van Erp.

Mr. and Mrs. Robert Mattison

# 4　The Arts and Crafts Book

## Susan Otis Thompson

Printing, like so much else in the nineteenth century, was blessed and cursed by mechanization. Increasing literacy called for more and cheaper books. This demand was met by the technological advances and commercial enterprise of the Industrial Revolution. Power presses, automatic typecasting and setting, photographic reproduction, new ways of mass producing cheap paper and bindings were important developments of the period. The concerns of Carlyle, Ruskin, and Morris regarding the degradation of both the workman and the product applied to printing as well as to other industries. And so toward the end of the century, the activities of the Arts and Crafts movement reached into the realm of bookmaking, with spectacular results.

Popular for approximately two decades, the Arts and Crafts style was a relatively short-lived but intense episode in printing history. There was no precedent for such a rapid explosion of admiration and emulation. In this period, when mechanical processes were taking over bookmaking and when Victorian eclecticism had begun to pall, the aspirations for fine printing were realized in the work of a man already famous as an artist and theoretician, William Morris, who founded the Kelmscott Press in 1890. His work reaffirmed the inspiration of the earliest Western printed books, and even of the Gothic manuscripts they copied. The Arts and Crafts book became a symbol for the values of hand production—quality and individuality. C. P. Rollins wrote in the September 1949 issue of *New Colophon*: "From 1890 to 1914 the spirit of adventure seized the printers . . . in no similar length of time was so much interesting and stimulating work issued from the American press."

Antecedents of the Arts and Crafts style in bookmaking are found in the early nineteenth century, such as the romantic movement's emphasis on decoration, including floral borders, and the Gothic revival's imitation of medieval manuscripts. In the eighties, a chapbook style appeared, most notably in the publications of the Leadenhall Press in London, which featured heavy type and woodcuts in the mode of the crude pamphlets that had been sold by itinerant peddlers. There was also a style for job work in the last quarter of the century (dubbed "Antique" by Vivian Ridler in the January 1948 issue of *Alphabet and Image*), which used models from the Gothic period through the seventeenth century. An example in book making is *An Antidote against Melancholy*, 1884, printed by T. L. De Vinne for the Pratt Manufacturing Company. Even

American homes than did any other enterprise. Their volumes featured chamois bindings, imported handmade paper, old-style type, hand-illuminated initials, bordered title pages, and colophons with press devices. Some of them are clumsy, but they generally merit more appreciation than they have received.

After the turn of the century, books in Kelmscott style became tiresome to many of the former leaders, who took new inspiration from the superbly printed, undecorated, sober books of Cobden-Sanderson's Doves Press in London. The most notable statement regarding this change was made by D. B. Updike and Bruce Rogers in their comments on modern book printing for the Boston Society of Printers' exhibition catalogue, *The Development of Printing as an Art,* in 1906: ". . . during the last few years the somewhat Gothic feeling of the Kelmscott Press books has been slowly abandoned for the lighter and more classical styles of type founded on Italian models of the fifteenth century,—a movement in which The Doves Press, London, has been chiefly instrumental."

Except for the efforts of John Henry Nash in San Francisco, this second wave of the American Arts and Crafts book also subsided by the First World War. But Arts and Crafts influence has continued in the sense of regarding printing as an art. The movement inspired by the Kelmscott Press has often been referred to as the "revival of fine printing" or the "Kelmscott revival." The ideals behind such a movement were already expressed during the eighties in the pages of Arthur B. Turnure's *Art Age* and were supported in the nineties by Joseph M. Bowles's *Modern Art* and by several journals solely devoted to printing. Morris's work has more often been described in terms of these ideals— the high standards of craftsmanship and artistry that he set—than in terms of his actual style. In any case, after people tired of this mode, the impetus toward fine printing continued. In the United States it is seen in the Printing House Craftsmen movement after the First World War, in the formation of the American Institute of Graphic Arts and its yearly exhibits of the fifty best-produced books, and in the success of attempts to sell fine books, such as the Limited Editions Club. Most important for this context, however, is the fact that the heroic generation of American typographers—Updike, Rogers, Bradley, Goudy, Cleland, Dwiggins, Rollins, Ransom, Nash—had its beginnings in the years of the Arts and Crafts movement.

**122 Knight Errant**
Volume I, number 1, April 1892
Elzevir Press, Boston
Border design: Bertram Grosvenor Goodhue,
dated 1891
Height: 12¾", width: 10"
Black and red
500 copies

This avant-garde periodical, edited by Goodhue and
Ralph Adams Cram and printed by Francis Watts
Lee, was one of the first milestones in the American
"revival of fine printing." Issued for four quarterly
numbers only, it was inspired, both physically and
intellectually, by the Century Guild's *Hobby Horse*
and the *Dial* of Charles Ricketts. Cram said in *My
Life in Architecture*: "What we aimed to do was to
take the English *Hobby Horse* and, in a manner
of speaking, go it one better. It was to be not only
an expression of the most advanced thought of
the time . . . but, as well, a model of perfect
typography and the printer's art."

Columbia University Libraries

**123 Craftsman**
Volume XXVI, number 5, August 1914
Blumenberg Press, New York
Height: 11", width: 8¼"
Black, red, and green on brown paper

During the fifteen years of its publication (October 1901 to December 1916), the *Craftsman* underwent at least eight changes in the format of its cover. In the first two volumes, a debt to Morris and the Kelmscott Press was obvious. Harvey Ellis was responsible for some distinctive covers in 1903, but the editor reverted to more simple designs after Ellis's death. The example shown here is typical of the style finally established in 1908, featuring a different design each month, printed as a block print, always on brown paper. The artists, who are unknown today, often signed their work with initials.

Private collection

**124 A Day at Laguerre's and Other Days Being Nine Sketches,** by F. Hopkinson Smith
Houghton Mifflin, Boston, 1892 (printed at the Riverside Press, Cambridge)
Book design: Daniel Berkeley Updike
Decorations: probably by J. E. Hill
Height: 7", width: 4½"
Black and red

Updike was one of the earliest leaders in American Arts and Crafts bookmaking, although he later rejected the style. In the first announcement, dated 1893, for his own office after leaving Houghton Mifflin's Riverside Press, Updike chose to mention only *A Day at Laguerre's* as an example of his previous designing. In it can clearly be seen the influence of the Kelmscott Press *Story of the Glittering Plain;* it may well be the first American example of such an influence.

Columbia University Libraries

**125 The Altar Book**
Merrymount Press, Boston, 1896 (presswork by the De Vinne Press, New York)
Book design: Daniel Berkeley Updike
Illustrations: Robert Anning Bell
Decorations: Bertram Grosvenor Goodhue
Height: 14¾", width: 11"
Black and red
350 copies

Updike's major production in the Kelmscott manner, issued from his own press after three years of labor, is the most monumental of all the American Arts and Crafts books. Goodhue designed the Merrymount type, modeled on William Morris's Golden font. The Larremores, in *The Marion Press,* have told how Updike in 1940 refused to sign a copy because he had tired of the book; but originally both he and the critics had been highly enthusiastic. The book's advertising brochure quoted the *New York Tribune:* "Never has a book issued from the hands of an American or an English publisher in nobler guise than this. . . . The perfect book is here."

Princeton University Library

**EASTER·DAY.** THE COLLECT.

ALMIGHTY God, who through thine only-begotten Son Jesus Christ hast overcome death, and opened unto us the gate of everlasting life; We humbly beseech thee that, as by thy special grace preventing us thou dost put into our minds good desires, so by thy continual help we may bring the same to good effect; through Jesus Christ our Lord, who liveth and reigneth with thee and the Holy Ghost ever, one God, world without end. Amen.

THE EPISTLE. Col. iii. 1.

IF ye then be risen with Christ, seek those things which are above, where Christ sitteth on the right hand of God. Set your affection on things above, not on things on the earth. For ye are dead, and your life is hid with Christ in God. When Christ, who is our life, shall appear, then shall ye also appear with him in glory. Mortify therefore your members which are upon the earth; fornication, uncleanness, inordinate affection, evil concupiscence, and covetousness, which is idolatry: for which things' sake the wrath of God cometh on the children of disobedience: in the which ye also walked some time, when ye lived in them.

THE GOSPEL. St. John xx. 1.

THE first day of the week cometh Mary Magdalene early, when it was yet dark, unto the sepulchre, and seeth the stone taken away from the sepulchre. Then she runneth, and cometh to Simon Peter, and to the other disciple, whom Jesus loved, and saith unto them, They have taken away the Lord out of the sepulchre, and we know not where they have laid him. Peter therefore went forth, and that other disciple, and came to the sepulchre. So they ran both together: and the other disciple did outrun Peter, and came first to the sepulchre.

**126 Esther: A Young Man's Tragedy: Together with the Love Sonnets of Proteus,** by Wilfrid Scawen Blunt
Copeland and Day, Boston, 1895 (printed at the University Press, Cambridge)
Design: Bertram Grosvenor Goodhue
Height: 7½", width: 5¾"
500 copies on Dutch paper and 50 on English

The second of Copeland and Day's four-volume English Love Sonnets Series, all designed by Goodhue, *Esther* shows that he could use traditional models as a point of departure for brilliantly original work. The type is Antique Old Style, later called Bookman, much used in Arts and Crafts work because of its heavy, uniform lines. Copeland and Day was the first of the small "literary publishers" of the nineties to emphasize this style of bookmaking.

Thomas L. Sloan

DEDICATION: TO THE BEST-BELOVED

NIGHT on our lives, ah me,
how surely has it fallen!
Be they who can deceived,
I dare not look before.
See, sad years, to your
own. Your little wealth
long hoarded,
How sore it was to win!
how soon it perished all!
Beauty, the one face loved, the pure eyes mine
so worshipped,
So true, so touching once, so tender in their dreams!
Find me that hour again, I yield the rest uncounted,
Urns for the dust of time, divine in her sole tears,
Unseen one! Unforgotten! oh, if your eyes be-
hold it,
By chance, this page revealed, which trembling
holds your name
Marged in the ultimate wreck of fame and
meaner joys,
Co-partner be with me in this my soul's last
sorrow,—
Pearl of my hidden life,—this grief that not again
Unspoiled love's rose shall blow, the dear love
which was ours.

ESTHER: A YOUNG MAN'S TRAGEDY:
TO THE HAND THAT HAS FORGOT-
TEN: THE EARS THAT CANNOT
HEAR: AND THE LIPS THAT SHALL
SPEAK OF LOVE NO MORE FOREVER

I

WHEN is life other than
a tragedy,
Whether it is played in tears
from the first scene,
In sable robes and grief's
mute pageantry,
For loves that died ere they
had ever been,
Or whether on the edge of
joys set keen,
While all the stage with laughter is agog,
Death stepping forward with an altered mien
Pulls off his mask, and speaks the epilogue?
Life is a play acted by dying men,
Where, if its heroes seem to foot it well
And go light-tongued without grimace of pain,
Death will be found anon. And who shall tell
Which part was saddest, or in youth or age,
When the tired actor stops and leaves the stage?

122

**127 Songs from Vagabondia,** by Bliss Carman and
Richard Hovey
Copeland and Day, Boston, 1894 (printed at the
University Press, Cambridge)
Design: Tom B. Meteyard
Height: 6¾", width: 4¼"
Black on tan paper

Decorative, and even illustrative, endpapers were
often found in fine books at the turn of the century,
although the inclusion of lettering, as in this ex-
ample, was unusual. The design is relatively inde-
pendent of historical models, but its bold lines are
clearly those of the Arts and Crafts aesthetic.

Columbia University Libraries

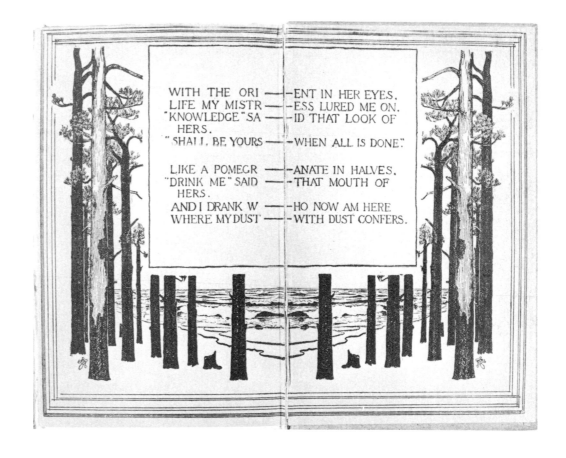

**128 Friar Jerome's Beautiful Book,** by Thomas
Bailey Aldrich
Houghton Mifflin, Boston, 1896 (printed at the
Riverside Press, Cambridge)
Design: William S. Hadaway
Height: 7¾", width: 4"
Black and red

The Arts and Crafts period included examples of
books more frankly Gothic in inspiration than the
Kelmscott volumes. Some of Goodhue's work falls
within this tradition, as does Hadaway's. However,
instead of a Gothic typeface, Clarendon, which
resembles Antique Old Style, is used here. This
book was produced at the Riverside Press in the
year Bruce Rogers began working there.

Joseph R. Dunlap

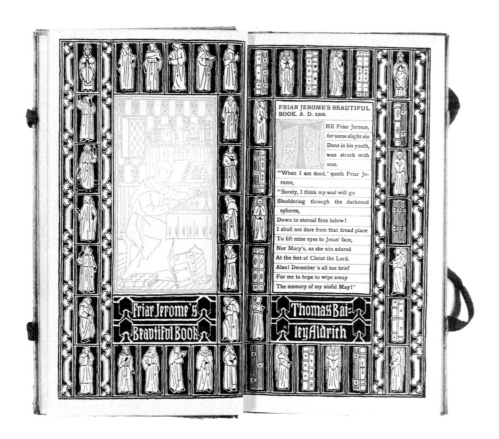

**129 Notes: Critical & Biographical: Collection of
W. T. Walters,** by R. B. Gruelle
Joseph M. Bowles, Indianapolis, 1895 (printed by
Carlon and Hollenbeck, Indianapolis)
Design: Bruce Rogers
Height: 9¼″, width: 6¼″
Black and red
975 copies on Michallet paper and 6 on Whatman
with hand-rubricated initials

Bowles made two major contributions to American
Arts and Crafts bookmaking: his periodical *Modern
Art* disseminated the philosophy, as well as the
style; and he helped Bruce Rogers to get a start.
Rogers, like Updike, later repudiated Arts and Crafts
tendencies, but his early work for Bowles shows
the strength of its influence, as do his designs for
*The Banquet of Plato,* published in 1895 by Way
and Williams of Chicago, and for the title page of
*Fadette,* published by T. Y. Crowell. Bowles wrote
in the September 1932 *Colophon* that *Notes:
Critical & Biographical* was sent to William Morris
for comment. He replied: "The ink is too pink."

Grolier Club

**130 The House Beautiful,** by William Channing Gannett
Auvergne Press, River Forest, Ill., 1897
Design: Frank Lloyd Wright
Height: 13½", width: 11"
Black and red
Number 22 (Avery) and number 45 (Ryerson) of 90 copies

After commissioning Wright to design his home in 1893, William Herman Winslow also charged him with the design of this book, which they printed together by hand. The text is a quintessential expression of Arts and Crafts philosophy, but the design, apart from its great emphasis on decoration, does not follow the usual Arts and Crafts lines. Rather it shows the innovative brilliance of Wright, ahead of his time in bookwork, just as he was giving the lead in architecture.

Avery Library, Columbia University (exhibited in Princeton and Washington)
Ryerson Library, The Art Institute of Chicago (exhibited in Chicago)

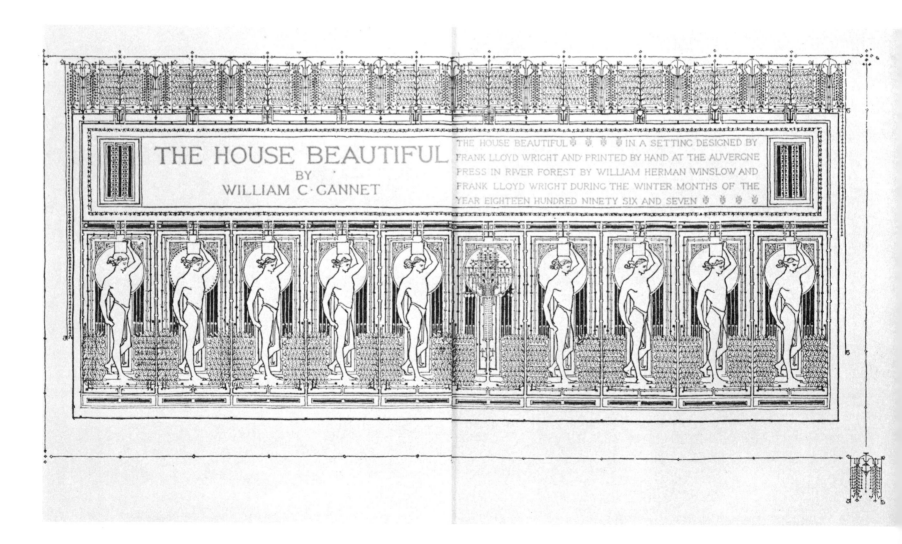

THE HOUSE BEAUTIFUL
BY
WILLIAM C·GANNET

THE HOUSE BEAUTIFUL IN A SETTING DESIGNED BY FRANK LLOYD WRIGHT AND PRINTED BY HAND AT THE AUVERGNE PRESS IN RIVER FOREST BY WILLIAM HERMAN WINSLOW AND FRANK LLOYD WRIGHT DURING THE WINTER MONTHS OF THE YEAR EIGHTEEN HUNDRED NINETY SIX AND SEVEN

**131 American Chap-Book,** October, November, 1904; July 1905
American Type Founders Company, Jersey City
Design: Will Bradley
Height: 7″, width: 4¼″
Black and red on various colors of paper

Bradley was one of the most influential of turn-of-the-century typographers. From totally traditional beginnings, his own style evolved through a Morris/Beardsley period and a Colonial/chapbook period, before culminating in a personal version of Arts and Crafts used primarily for periodicals and advertising. The *American Chap-Book,* which ran from September 1904 to August 1905, served not only to promote the wares of the American Type Founders Company, but was also intended as a teaching device for American printers. His reflection of the contemporary Arts and Crafts movement can be seen in the heavy, blunt, rounded lines; the close placement of elements, with little empty space; the use of repeated motifs; and the emphasis on decoration.

Ray Trautman

**132 In Russet and Silver,** by Edmund Gosse
Stone & Kimball, Chicago, 1894 (printed at the
University Press, Cambridge)
Binding design: Will Bradley
Height: 7", width: 4½"
Silver and brown on tan cloth

Bradley's small output of trade book designs in-
cludes some of the most brilliant work of the period.
This binding for Stone & Kimball stands out, even
at a time when cloth covers for books were receiv-
ing more artistic treatment than before or since.
The house of Stone & Kimball was the best known
of the ''literary publishers,'' but it issued few books
with Arts and Crafts influence.

Thomas L. Sloan

**133 Fringilla or Tales in Verse,** by Richard
Doddridge Blackmore
Burrows Brothers, Cleveland, 1895 (printed at the
University Press, Cambridge)
Design: Will Bradley
Height: 8¾", width: 6"
Black and red
Number 424 of 600 copies

Here the combined influence of Morris and
Beardsley is very evident and brings to mind the
1893 *Morte d'Arthur*, which Bradley must have
seen. The use of large black-and-white spaces in the
frontispiece drawing is typical of his work in this
period, as is the extremely close-knit texture of the
overall design. William Dana Orcutt, who became
head of the University Press the year this book was
published, wrote later in *The Kingdom of Books:*
"He repeated a fault of Morris' by having the
letters too near the decoration."

Campbell G. Paxton

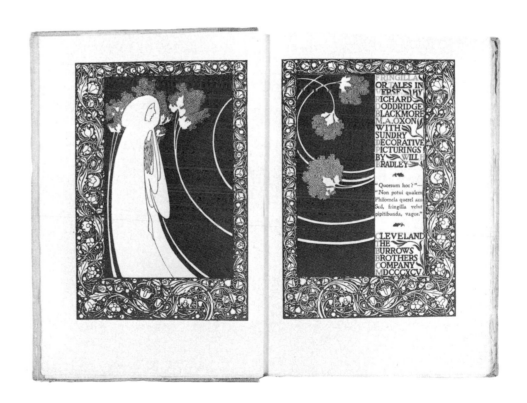

**134 War is Kind,** by Stephen Crane
Frederick A. Stokes, New York, 1899 (printed at the
University Press, Cambridge)
Design: Will Bradley
Height: 8¼", width: 5"
Black on dark gray paper

The influence of Beardsley is still apparent in what
is otherwise the most original of Bradley's book
designs. It is a gloomy, harsh masterpiece, created
at a time when Bradley himself was much disturbed
by the failure of his Wayside Press and its unsuc-
cessful merger with the University Press. Although
the Caslon type is too thin for the dark heavy paper,
the extremely black decorations are well suited to
it and produce a dramatic effect. In the July 1899
*Bookman,* however, John Curtis Underwood ended
a review of this Crane first edition with the words:
"The less said of Mr. Bradley's drawings the better."

Princeton University Library

**135 Epithalamion,** by Edmund Spenser
Dodd, Mead, New York, 1895 (printed at the
De Vinne Press, New York)
Design: George Wharton Edwards
Height: 8½", width: 5¼"
450 copies

Walter Crane's influence brought Arts and Crafts
ideas to American bookmaking as early as the
eighties, reflected most notably in the work of
Howard Pyle. George Wharton Edwards was another
who followed in Crane's footsteps. This book uses
Jenson type, based on Morris's Golden font, then
newly offered for sale by the American Type
Founders Company. Jenson rode the crest of the
"Kelmscott revival," becoming instantly popular
throughout the nation. It was especially useful as a
display face but also appeared in the texts of
some books.

Columbia University Libraries

Let no lamenting cryes, nor dolefull teares,
Be heard all night within, nor yet without:
Ne let false whispers, breeding hidden feares,
Breake gentle sleepe with misconceived dout.
Let no deluding dreames, nor dreadfull sights,
Make sudden sad affrights;
Ne let house-fyres, nor lightnings helpelesse harmes,
Ne let the Pouke, nor other evill sprights,
Ne let mischivous witches with theyr charmes,
Ne let hob Goblins, names whose sence we see not,
Fray us with things that be not:
Let not the shriech Oule nor the Storke be heard,
Nor the night Raven, that still deadly yels;
Nor damned ghosts, cald up with mighty spels,
Nor griesly vultures, make us once affeard:
Ne let th' unpleasant Quyre of Frogs still croking
Make us to wish theyr choking.
Let none of these theyr drery accents sing;
Ne let the woods them answer, nor theyr eccho
ring.

**136 Fancy's Following,** by Anodos [Mary Elizabeth Coleridge]
Thomas Bird Mosher, Portland, Maine, 1900
Height: 7½″, width: 4½″
Red and green on gray-blue wrappers over boards
450 copies on Kelmscott paper

Mosher, the famous "literary pirate" of English authors, began publishing in Portland in 1891; his well-produced, inexpensive books were widely disseminated through the English-speaking world. Two of his editions, Rossetti's *Hand and Soul,* 1899, and Arnold's *Empedocles on Etna,* 1900, are Kelmscott imitations, but his usual style was based on Renaissance models. He published many different series, with variations in format; but his books, on the whole, tend to be small, similar in appearance, and without much decoration. Occasionally, a welcome flourish makes a title stand out, as in the case of *Fancy's Following.* The bold lines of the floral decoration relate it to turn-of-the-century modes elsewhere.

Private collection

**137 Into the Light,** by Edward Robeson Taylor
D. P. Elder and Morgan Shepard, San Francisco,
1902 (printed at the Stanley-Taylor Company,
San Francisco)
Height: 8", width: 6"
Black and red

The floral borders of this book, repeated on every
page, show the emergence of Art Nouveau from the
earlier designs of Arts and Crafts borders. It is
possible that John Henry Nash had a hand in the
design, since he worked with Elder and Shepard
from 1901. In 1903 Elder and Nash formed the
Tomoyé Press, which they took to New York after
the 1906 earthquake, setting up an Arts and Crafts
Book Room in Elder's new bookstore there. Nash
became, after 1916, the most famous printer in
California, or, for that matter, the United States.
His monumental style was based on that of the
Doves Press.

Columbia University Libraries

**138 Pre-Raphaelite Ballads,** by William Morris
A. Wessels, New York, 1900
Design: H. M. O'Kane
Height: 8¼", width: 6¼"
Black and red
Number 170 of 250 on Imperial Japanese paper,
with 500 on "Old Stratford" paper

At the turn of the century, Helen Marguerite
O'Kane designed some of the most brilliant books
in America. Her style, which is her own kind of
Arts and Crafts enlivened with Art Nouveau, seems
to have come, like Bradley's, from both Morris and
Beardsley. This book, designed for a trade publisher,
uses Satanick type, the American Type Founders
Company version of Morris's Troy face. It is a
Romanized Gothic, just as Jenson could be called
a Gothicized Roman.

Joseph R. Dunlap

**139 Sonnets from the Portuguese,** by Elizabeth
Barrett Browning
Elston Press, New York, 1900
Design: H. M. O'Kane
Height: 10¼", width: 8"
Number 103 of 485 copies on Holland paper, with
60 on Imperial Japanese paper

This is the first book of Clarke Conwell's Elston
Press, one of the most successful of the many private
presses that sprang up at the turn of the century.
The work Helen O'Kane did for Conwell, her hus-
band, shows her at her most spectacular. Here the
extreme boldness of the design, complemented by
the heavy Satanick type, the impeccable presswork,
and the high quality of the ink and paper, result
in a complicated but masterful page. A broadside
laid in the book gives the information that due to
lack of skilled workmen, the printing was not done
entirely by hand, as had been intended.

Eleanor McDowell Thompson

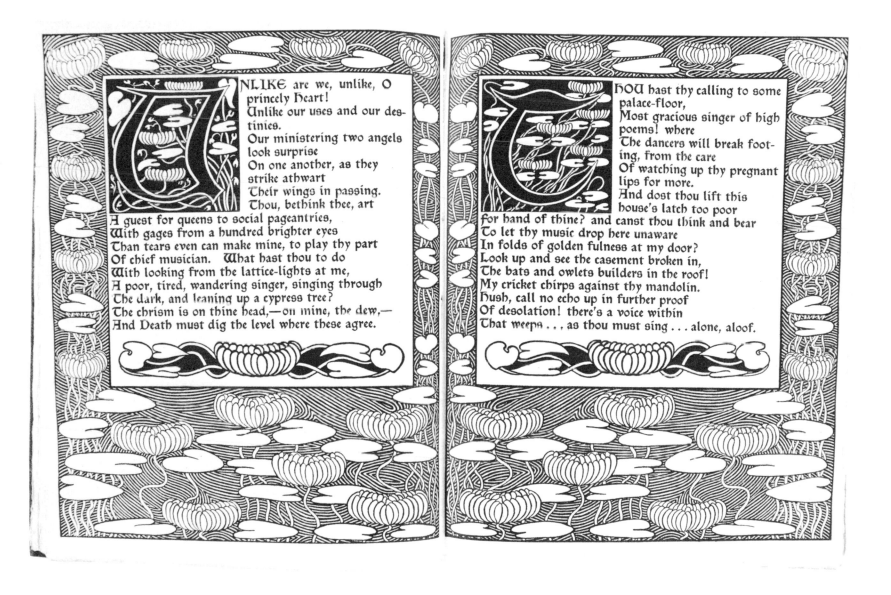

UNLIKE are we, unlike, O princely Heart!
Unlike our uses and our destinies.
Our ministering two angels look surprise
On one another, as they strike athwart
Their wings in passing. Thou, bethink thee, art
A guest for queens to social pageantries,
With gages from a hundred brighter eyes
Than tears even can make mine, to play thy part
Of chief musician. What hast thou to do
With looking from the lattice-lights at me,
A poor, tired, wandering singer, singing through
The dark, and leaning up a cypress tree?
The chrism is on thine head,—on mine, the dew,—
And Death must dig the level where these agree.

THOU hast thy calling to some palace-floor,
Most gracious singer of high poems! where
The dancers will break footing, from the care
Of watching up thy pregnant lips for more.
And dost thou lift this house's latch too poor
for hand of thine? and canst thou think and bear
To let thy music drop here unaware
In folds of golden fulness at my door?
Look up and see the casement broken in,
The bats and owlets builders in the roof!
My cricket chirps against thy mandolin.
Hush, call no echo up in further proof
Of desolation! there's a voice within
That weeps . . . as thou must sing . . . alone, aloof.

**140 The House of Life,** by Dante Gabriel Rossetti
Elston Press, New Rochelle, 1901
Design: H. M. O'Kane
Height: 10¼", width: 7¾"
Black on light gray paper
Number 9 of 310 copies

Another O'Kane-Elston masterpiece, produced after the press moved to New Rochelle, this book utilizes delicate lines that give an almost cobweb-like appearance. These fine lines would have seemed weak on white paper, so a soft gray was cleverly used. The type chosen is Jenson, less bold than the Satanick. Burne-Jones's influence can be seen in the facing illustration. The overall result is one of the most original and romantic books of the whole American Arts and Crafts period. Later Elston volumes were still impeccably printed, but became increasingly less decorated and less interesting.

Columbia University Libraries

THE HOUSE OF LIFE: A SONNET-SEQUENCE.

A SONNET is a moment's
monument,
Memorial from the Soul's
eternity
To one dead deathless hour.
Look that it be,
Whether for lustral rite
or dire portent,
Of its own arduous
fulness reverent:
Carve it in ivory or in ebony,
As Day or Night may rule; and let Time see
Its flowering crest impearled and orient.
A Sonnet is a coin: its face reveals
The soul,—its converse, to what Power 'tis due:—
Whether for tribute to the august appeals
Of Life, or dower in Love's high retinue,
It serve; or, 'mid the dark wharf's cavernous breath,
In Charon's palm it pay the toll to Death.

**141 Phryne and Cleopatra,** by Estelle Lambert
Matteson
Stiletto Publishing Company, New York, 1900
(printed at the Alwil Shop, Ridgewood, N.J.)
Design: Frank B. Rae, Jr.
Height: 8", width: 6¼"
Hand-colored in various shades of blue, with
touches of yellow
500 copies

Rae's Alwil Shop produced some of the most
charming books of the time, similar in appearance
to those of the Blue Sky Press in Chicago, for which
Rae also worked as a designer. An unusual feature of
the book on exhibit is that the borders of *Cleopatra,*
whether intentionally or not, seem to change from
a light to a dark blue as the book progresses. An-
other outstanding New Jersey press was the Hillside,
run by Frederic M. Burr in Englewood from 1906
to 1915. His materials and craftsmanship were excel-
lent, although his designs were often poor, with the
exception of those done for him by F. W. Goudy.

Columbia University Libraries

IN the purple lanes
Of her breasts' warm veins
Burns the flame of a quenchless fire;
And the splendid grace
Of a sovereign race
Enthrones all her royal desire.

THE sting and the stain
Of a pitiless pain
Are burned on her brow like a brand,
And the strenuous years
Of her hopes and fears
Are held as a leash in her hand.

**142 The Shrine of Death and the Shrine of Love,**
by Lady Dilke
Cornhill Press, Boston, 1901
Design: Thomas Maitland Cleland
Height: 7", width: 5½"
Black and red
Number 192 of 290 copies

Cleland began his career with four little books
printed in New York and Boston, of which this one
shows the greatest Arts and Crafts influence. It
also contains his first book illustrations, as opposed
to book decorations and advertisements. The
latter, such as the cut for the National Phonograph
Company in the May 1900 *Philistine,* are in the
chapbook style of Bradley, a debt acknowledged by
Cleland when he had become one of America's
leading designers. To those familiar with the
eighteenth-century mode he adopted later, his
Arts and Crafts beginnings afford an
amusing contrast.

Private collection

**143 The Dictes and Sayings of the Philosophers**
Cranbrook Press, Detroit, 1901
Design: George G. Booth
Height: 11", width: 8½"
Number 133 of 244 copies

Son-in-law of James E. Scripps, publisher of the *Detroit Evening News,* Booth had the money to set up a luxuriously appointed private press, with workmen to aid him. He saw that the best materials and craftsmanship were provided, but could do nothing about the frequent lack of artistry and taste in his own designs. The strapwork borders in the book on exhibit are typical of his best work, although not all pages are so bordered. The use of filler leaves to make the pages solidly set is a device not unusual for the period. The press ended in 1902, but Booth later endowed a large estate for public benefit in the spirit of the Arts and Crafts movement.

Columbia University Libraries

**144 The Hollow Land,** by William Morris
Village Press, Hingham, Mass., 1905
Design: Frederic W. Goudy
Height: 8½″, width: 6¾″
Black and red
220 copies

Goudy, who became the world's most prolific designer of types, began his Village Press in 1903 in Park Ridge, Illinois, outside of Chicago. *The Hollow Land* was the third book begun at the press that same year, but it was not finished until after the removal East, and only about eighty-five copies survived the 1908 fire in New York that temporarily destroyed the press. The type used is Goudy's Village font, based on Morris's Golden. (In 1902 another Chicago resident, Ralph Fletcher Seymour, also had cut a design of his own, named Alderbrink, which was based on Golden.) Cyrus Lauron Hooper, author of the printed and manuscript

notes, was Goudy's partner in the Booklet and Camelot Presses during the nineties. The partner in the founding of the Village Press was Will Ransom, who had had his own Handcraft Shop in Snohomish, Washington, and who was to become the leading bibliographer of American private presses.

Grolier Club

---

8  his own feeling of what romance might have been. The feuds fought, the revenges accomplished, the loves won, all in the picturesque setting of a time gay in the color of chivalry,—these were the things he saw in the light seen only by a poet. ❧ "The Hollow Land" was written when Morris was but 22 years of age, and was the beginning of his effort to work out a literary style with what power lay within him; a style he made what he did others in other arts, a thing of fullest beauty. The title, it has been suggested, was inspired by the passage in Rossetti's "Hand and Soul" where Chiaro is spoken of as "one just out of a dusk, hollow country, bewildered with echoes"—such a country as the poet's spirit delighted to wander in; a country whose shadowy hills he opens to us in the introduction to "The Earthly Paradise."

"Dreamer of dreams, born out of my due time,
    Why should I strive to set the crooked straight?
Let it suffice me that my murmuring rhyme
    Beats with light wing against the ivory gate,
    Telling a tale not too importunate
To those who in the sleepy region stay,
Lulled by the singer of an empty day."

C. L. H.

*I remember times when Goudy had good reason to be discouraged. But he wasn't.*
*Cyrus Lauron Hooper*
*Chicago, January 14, 1934*

# The Hollow Land

We find in ancient story wonders many told,
Of heroes in great glory, with spirit free and bold;
Of joyances and high-tides, of weeping and of woe,
Of noble recken striving, mote ye now wonders know.
Niebelungen Lied (See Carlyle's Miscellanies).

CHAPTER I—STRUGGLING IN THE WORLD

DO you know where it is—the Hollow Land? ❧I have been looking for it now so long, trying to find it again —the Hollow Land—for there I saw my love first. ❧I wish to tell you how I found it first of all; but I am old, my memory fails me: you must wait and let me think if I perchance can tell you how it happened. ❧Yea, in my ears is a confused noise of trumpet-blasts singing over desolate moors, in my ears and eyes a clashing and clanging of horse-hoofs, a ringing and glittering of steel;

b

**145 In A Balcony,** by Robert Browning
Blue Sky Press, Chicago, 1902
Design: Frederic W. Goudy and
William A. Dwiggins
Height: 9", width: 6"
Black and red
Number 98 of 400 copies, with 15 on Japan Vellum

Some of Goudy's best work was created for other
people, including the superb designs for *In A
Balcony,* jointly done with Dwiggins, whose later
highly original work gives no indication of his Arts
and Crafts beginnings. This is the most notable
production of A. G. Langworthy and T. W. Stevens's
Blue Sky Press, which turned out generally excel-
lent work, often with an Art Nouveau flavor and on
a less ambitious scale than Cranbrook or Elston.
Several other private presses flourished in and near
Chicago during this period; together with Bos-
ton, Chicago provided a focal point for American
Arts and Crafts bookmaking.

Joseph R. Dunlap

**146 The Rime of the Ancient Mariner,** by Samuel
Taylor Coleridge
Roycrofters, East Aurora, N.Y., 1899
Design: W. W. Denslow
Height: 8¾", width: 5½"
Black, red, and green

Printing was the first activity of Elbert Hubbard's
Roycrofters, and it remained their largest, most im-
portant occupation. Thousands of books in the
Arts and Crafts style went from East Aurora to the
parlor tables of middle-class Americans, bringing
a new awareness of the art of the book. Before
making his fortune with illustrations for *The Wizard
of Oz* in 1900, Will Denslow worked for Hubbard.
He is best known for his cartoons for the Roycroft
periodical, the *Philistine,* but he also designed
books. *The Ancient Mariner* is a Colonial pastiche
with paneled pages, a burlesque title page, and
Denslow's clever artwork.

Private collection

**147 The Last Ride,** by Robert Browning
Roycrofters, East Aurora, N.Y., 1900
Design: Samuel Warner
Height: 7¾", width: 5¾"
Number 664 of 940 copies, hand-illuminated by
Carrie Stewart and signed by Elbert Hubbard
Designs reused in different combinations for
Gray's *Elegy,* 1903

Less well known than Denslow, Samuel Warner
designed some of the finest Roycroft books. He
often worked from Kelmscott models, as in Ruskin's
*The Golden River,* 1900, or Tennyson's *Maud,*
1900. The latter is totally derivative in style, but the
superb quality of its material and craftsmanship
makes it outstanding. Beardsley's influence on
Warner is also apparent, as in *Aucassin & Nicolete,*
1899, or even the *Little Journey to the Home of
William Morris,* 1900. *The Last Ride,* however, owes
little to either source. Its beautiful borders are
Warner's own combination of Pre-Raphaelite im-
agery and Art Nouveau design.

Dr. and Mrs. Robert Koch

### VIII

AND you, great sculptor—so,
    you gave
A score of years to Art, her slave,
And that's your Venus, whence
    we turn
To yonder girl that fords the burn!
    You acquiesce, and shall I
        repine?
What, man of music, you grown
    gray
With notes & nothing else to say,
Is this your sole praise from a
        friend,
"Greatly his opera's strains in-
        tend,
But in music we know how
        fashions end!"
    I gave my youth; but we ride,
        in fine.

### IX

WHO knows what's fit for
    us? Had fate
Proposed bliss here should sub-
    limate
My being—had I signed the
    bond—
Still one must lead some life
    beyond,
    Have a bliss to die with, dim-
        descried.
This foot once planted on the goal,
This glory-garland round my soul,
Could I descry such? Try & test!
I sink back shuddering from
    the quest.
Earth being so good, would
    heaven seem best?
    Now, heaven and she are be-
        yond this ride.

**148 Justinian and Theodora,** by Elbert and Alice
Hubbard
Roycrofters, East Aurora, N.Y., 1906
Design: Dard Hunter
Height: 7¾", width: 5¾"
Black and orange
Decorations, not title page, reused for *The Doctors,*
1909

Dard Hunter was the last of Hubbard's three major
designers. He came to East Aurora as a young
apprentice, went on to study and work in Europe,
and finally became the world's leading authority
on handmade paper. He also carried the Arts and
Crafts traditions of handicraft and artistic unity
to their ultimate conclusions in making his famous
"one-man" books, for which he designed, cut,
cast, and set the types, made the paper, and printed
the sheets. He later looked with scorn on his early
designs for the Roycrofters, but today they appear
as wholly charming representatives of their time.

Private collection

**149 White Hyacinths,** by Elbert Hubbard
Roycrofters, East Aurora, N.Y., 1907
Design: Dard Hunter
Height: 7", width: 4½"
Black, green, and light red
Title page reused for *Pig Pen Pete,* 1914

Another of Hunter's best-known designs for
Hubbard, *White Hyacinths,* like *Justinian and
Theodora,* uses the small floral motifs he favored
in this period. Other examples are Emerson's
*Compensation,* 1904, possibly the first book he
designed in East Aurora, and the cover for
*The Motto Book,* 1909. Direct Kelmscott inspiration
can be found in the outline vine borders for
*Love, Life & Work,* 1906; but Hunter's leanings
toward the rectilinear, elongated forms of Glasgow
and Vienna can be seen even before his 1908 trip
to Europe. He recalled in *My Life with Paper* how
he studied the German and Austrian art journals
at the Roycroft shop.

Private collection

**150 Health and Wealth,** by Elbert Hubbard
Roycrofters, East Aurora, N.Y., 1908
Height: 7¾", width: 5"
Cover by Dard Hunter, reused from
*White Hyacinths,* 1907

The Roycrofters made a specialty of bindings. Although some books were issued in boards, the typical cover, like that of *Health and Wealth,* was soft chamois, known technically as "limp ooze" and disrespectfully as "window-cleaners" or "mouse skin." Silk doublures backed up these chamois covers. Much more expensive, hand-tooled bindings were also available.

Private collection

**151 The Doctors,** by Elbert Hubbard
Roycrofters, East Aurora, N.Y., 1909
Height: 8", width: 6"

The variety of Roycroft bindings extended as well to the classic Arts and Crafts format: limp vellum with silk ties. *The Last Ride,* for example, was thus available. The cover of *The Doctors* is Hubbard's amusing takeoff on such bindings. Instead of smooth vellum, he used rough, split calf; instead of silk, burlap ties. The title is blind stamped on the front, the Roycroft mark and date on the back.

Dr. and Mrs. Robert Koch

**152 The Dream of John Ball** and **A King's Lesson,**
by William Morris
Reeves and Turner, London, 1888
Cover design: Ellen Gates Starr, 1898
Pale olive green leather, with details in gold
Height: 7½", width: 6¼"
Mark: *E.G.S. 1898,* inside of back cover

Important to the history of the Arts and Crafts book was the art of making unique, finely tooled bookbindings, practiced only occasionally by the Roycrofters. This and the following binding were designed and executed by Ellen Gates Starr, a friend of Jane Addams and a major influence in the program of crafts at Hull House in Chicago. Miss Starr studied with T. J. Cobden-Sanderson in London, under whom this volume was done. In the back of the book is Cobden-Sanderson's signed statement, "Bound and tooled by Ellen Starr under my direction at Doves Bindery, 6 May 1898." RJC

Josephine S. Starr

**153 The Poems and Sonnets of Henry Constable**
Hacon & Ricketts, London, 1897
Cover design: Ellen Gates Starr, 1903
Blue leather, with details in gold, red, and olive
Height: 9", width: 5¾"
Mark: *E.G.S. 1903*, inside of back cover

Miss Starr showed several bindings similar to this one at the third public exhibition of the Society of Arts and Crafts in Minneapolis, held during January 1903. Some examples were featured in the *Craftsman*, March 1903.   RJC

Josephine S. Starr

**154 The Rime of the Ancient Mariner,** by S. T. Coleridge
Hacon & Ricketts, London, 1899
Cover design: Peter Verberg, 1903
Blue leather, with details in gold
Height: 7¾", width: 5"
Mark: *P.V. 1903,* inside of back cover

Peter Verberg was Ellen Gates Starr's favorite pupil. His design for the cover of Coleridge's ballad makes clever reference to the sea and sailing with simple but dynamic lines. Verberg later abandoned this craft to become superintendent of the printing plant of a music publisher in New York.   RJC

Josephine S. Starr

# 5 Art Pottery

# 5 Art Pottery
## Martin Eidelberg

### Early developments in Ohio

It was in Cincinnati that the American art pottery movement began. Its origins were inauspicious and, in fact, almost accidental. In 1871, Karl Langenbeck, a Cincinnati youth who was to become an important ceramic chemist, received a set of china painting colors from an uncle in Frankfurt. He was joined in his experiments by Maria Longworth Nichols, a wealthy young lady of Cincinnati whose family had long been associated with the arts there and who herself was to play a major role in this story. The following year Benn Pitman (brother of the inventor of the shorthand system) instituted a class in china painting for socially prominent women at the Cincinnati School of Art; among his pupils was Mary Louise McLaughlin, daughter of the city's leading architect. Enthusiasm for this new medium spread quickly in the city, for not only did it satisfy the ambitions of an age bent on culture, but also, in the words of Miss McLaughlin, "tidings of the veritable renaissance in England under the leadership of William Morris and his associates had reached this country."

The women were able to send a display of their overglaze decoration to the Centennial Exposition at Philadelphia in 1876, where it was favorably received. But even more important was the effect on them of the foreign ceramics at the Exposition. The display of oriental pottery, for example, heightened the admiration of Eastern wares which already existed in America just as it did in Europe. The second display which impressed them was that of French barbotine ware, a process of underglaze decoration with colored slips which had been developed several years before by Ernest Chaplet at Bourg-la-Reine and then used by him at the Haviland-Auteuil factory.

Miss McLaughlin later realized what was the technique behind this type of decoration while visiting the pottery of P. L. Coultry and Company in Cincinnati and, after various experiments, was able to produce satisfactory results. She exhibited in 1878 in her native city, New York, and even at the World's Fair in Paris that year, and began to attract considerable attention for her rediscovery of Limoges ware. "Cincinnati Limoges," as it became known, took the center of the stage and found many followers, so that a class was formed at the Coultry Pottery. In 1879 Miss McLaughlin organized the Women's Pottery Club with herself as president and Clara Chipman Newton as secretary. The invitation to Mrs. Nichols to join somehow never reached her and, offended by what she thought was a snub, Mrs. Nichols found her own working quarters at the Hamilton Road Pottery of Frederick Dallas. Ironically, the Women's Pottery Club then transferred its operations to the same place after discovering that Coultry had gone into partnership with Thomas J. Wheatley. Not only were the members' secrets being leaked, but Wheatley was also claiming that he had originated the method of underglaze decoration in New York in 1877.

In 1880 Mrs. Nichols succeeded, with her father's help, in establishing a private pottery of her own in an abandoned schoolhouse. She named it "Rookwood" after her family estate and also because, as she said, "it reminded one of Wedgwood." Her ambition was not only to continue her own experiments but also to put the pottery on a sound commercial basis. Moreover, she supplied greenware to members of the Women's Pottery Club and fired their work after it was decorated.

The growing interest in pottery in Cincinnati is shown by the ever increasing number of companies

seeking a share in what seemed to be a profitable industry. Wheatley broke off from Coultry and formed his own firm. In 1880 he secured a patent on underglaze decoration, thereby threatening to gain a monopoly on Limoges ware and stop all other private and commercial work; however, in 1882 he withdrew from the ceramic business. Other companies were started, such as the Cincinnati Art Pottery Company (1879–91) and the Matt Morgan Art Pottery (1883–85) but their operations were all short-lived. Karl Langenbeck, who worked for a brief while at Rookwood, started his own firm, the Avon Pottery, in 1886 but ceased operations after a year. Despite these competitors, the Rookwood Pottery flourished. In 1883 it closed its doors to the amateur members of the Women's Pottery Club, with whom its work was often confused. Thus it gained even greater dominance because the women, including Miss McLaughlin, now deprived of the advantages of Rookwood's facilities, were forced to fall back on the simpler method of overglaze painting on china.

Rookwood's style gradually emerged in the 1880s. The alternate forms of decoration which were tried—pressed geometric designs, printed transfer designs, carved and incised ware—were abandoned as the production of Limoges ware took precedence. There was also a decline in the use of Japanese motifs and gilding as the pottery turned to a simpler form of naturalistically rendered plants and animals. Moreover, the process of underglaze decoration was further refined. The painting, which at first was as coarse as the French ware, became suaver and more delicate. Most important was Laura Fry's introduction in 1883 of an atomizer to create smoother color transitions for the background. This ware, which was to become known as "Rookwood Standard," showed remarkably subtle changes from dark brown to orange to yellow and green, thus prompting the description of "Rembrandtesque tones."

What had begun as an essentially private venture became a commercially successful one. As early as 1881 Mrs. Nichols found that administrative work was absorbing all her time, and therefore entrusted Clara Chipman Newton, and then William

Taylor, with this responsibility. In 1881, too, Albert R. Valentien was hired as the first regularly employed member of the decorating staff, and thus began the change from independent studio work by amateurs to a professional staff of decorators. By 1889 the Rookwood firm had emerged with a cohesive style and purpose. Their early success was crowned by winning a gold medal at the World's Fair in Paris that year. It was at this time that the former Mrs. Nichols, who had been widowed and remarried to Bellamy Storer, assured of the success of her pottery, transferred her interests in the company to Taylor and withdrew.

The popularity of Rookwood's Standard ware can be gauged by the large number of companies that tried to imitate it. W. A. Long, a druggist in Steubenville, Ohio, was able to duplicate the underglaze process and began his own pottery, called Lonhuda, in 1892. S. A. Weller, a producer of commercial pottery in Zanesville, Ohio, bought the Lonhuda company in 1895 and introduced art pottery to Zanesville. This rapidly became the center for a number of Rookwood imitators and was often referred to as "Clay City." In 1896 J. B. Owens's factory there began producing the same type of ware, and in 1900 the Roseville Pottery followed suit. A number of other smaller companies worked in this vein as well.

As might be expected, there was a considerable time lag involved, and much of this work was being done at a point when Rookwood was already exploring newer avenues of decoration. As might also be expected, the work of these more commercially oriented factories rarely matched the quality achieved by Rookwood. The painting is often coarser, the forms are less pleasing, and inspiration is noticeably lacking.

**155 Plate**

M. Louise McLaughlin, Cincinnati, Ohio, ca. 1876–77

Ceramic, with painted underglaze decoration of cattails, flying birds, and tree branches in blue against a white background

Diameter: 8"

Marks: paper label with written legend, *First success in underglaze blue*

For her early experiments in underglaze work Miss McLaughlin obtained several porcelain blanks from the Union Porcelain Works in Greenpoint, New York, such as this one. As her label indicates, the plate represents her first success in the attempt to discover the secret of the Limoges technique, for the cobalt blue slip proved to be easier to work with than other colors. In the artist's brief memoirs ("Mary Louise McLaughlin," p. 218) she dates this phase of her work to 1876. E. A. Barber ("Cincinnati Women Art Workers," pp. 29–30) illustrates and discusses the plate; generally a reliable source of information, he errs in this instance by speaking of it as overglaze work done in 1875 on a stoneware blank from the Dallas Pottery.

Cincinnati Art Museum, gift of the Women's Art Museum Association

**156 Vase**

M. Louise McLaughlin, Cincinnati, Ohio, 1877–78

Pottery, with painted underglaze decoration of a branch with rose blossoms in tones of pink, black, and gray

Height: 10¼"

Marks: incised *L Mc L Cin'ti 1877*

According to E. A. Barber ("Cincinnati Women Art Workers," pp. 29–30), this was "the first entirely successful piece of underglaze slip work" and was executed late in 1877 by Miss McLaughlin. This is echoed in the artist's memoirs ("Mary Louise McLaughlin," p. 218) where, after talking about the very first though not totally successful piece of Limoges ware she executed, she wrote: "a later piece, a pilgrim bottle which came from the kilns in January, 1878, was more successful; this piece, now in the Cincinnati Museum, represents the first work of this kind done in Cincinnati." The vase was exhibited in the Cincinnati Women's display at the Chicago World's Fair of 1893.

Cincinnati Art Museum, gift of the Women's Art Museum Association

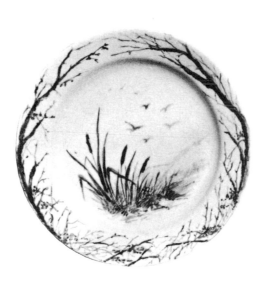

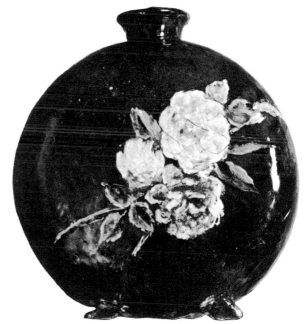

**157 Vase**
M. Louise McLaughlin, Cincinnati, Ohio, 1880
Pottery, with painted underglaze decoration of
Chinese hibiscus flowers in dull red and yellow
against a background shading from sage-green to
greenish white.
Height: 37¼"
Marks: painted on the side, *L.M.L. Cin^i 1880*

Known as the "Ali Baba" vase because of its size,
this vase was publicized as the largest made in
the United States. Actually, three were made from
the mold at the Dallas Pottery on Hamilton Road.
From the beginning the vase had a certain renown
and it was cited in 1881 by Mrs. A. F. Perry,
"Decorative Pottery of Cincinnati," p. 836. E. A.
Barber, *The Pottery and Porcelain of the United
States*, 1893, pp. 278–81, illustrates and discusses
the vase, calling it "one of the finest of her pieces."
An illustration of the display case with the Ali
Baba vase and other Cincinnati pottery at the
Chicago 1893 Exposition is found in *Frank Leslie's
Popular Monthly*, XLII (1896), p. 668.

Cincinnati Art Museum, gift of the Rookwood Pottery

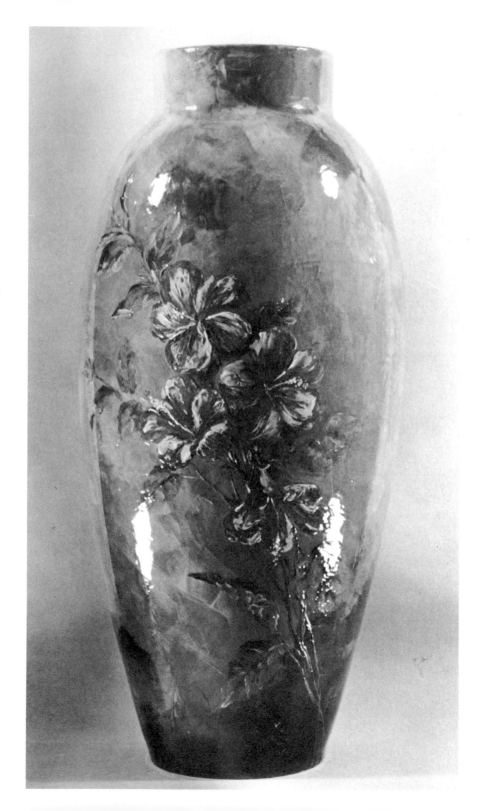

**158 Vase**
T. J. Wheatley and Company, Cincinnati, Ohio, 1879
Executed by John Rettig
Pottery, with painted underglaze decoration of a spray of wild roses against a blue ground
Height: 13⅛″
Marks: incised *T. J. Wheatley 1879;* painted on front side, *J. Rettig 79*

In execution and appearance this vase is obviously closely related to the work of Miss McLaughlin and the other exponents of Cincinnati Limoges. Although there was bitter rivalry between the different factions, the artists nonetheless frequently changed from one firm to another. John Rettig's younger brother, Martin, went to work at Rookwood a few years later.

Cincinnati Art Museum, gift of T. A. Langstroth

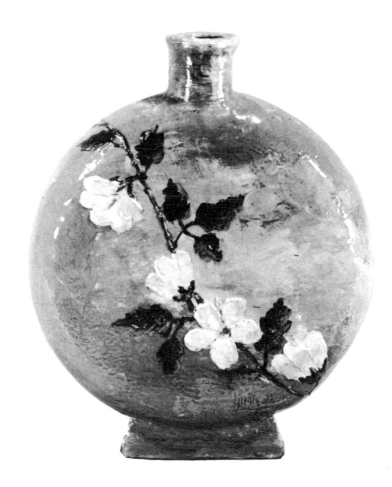

**159 Basket**
Rookwood Pottery, Cincinnati, Ohio, 1882
Executed by Maria Longworth Nichols
Pottery, with painted underglaze decoration of
spiders in a web; in tones of beige, black, and
white, with gilt overglaze
Height: 8¼", length: 20"
Marks: impressed *ROOKWOOD 1882*; painted,
*MLN*

As early as 1878, Mrs. Nichols's husband proph-
esied the importance of Japanese pottery and
decoration in his book, *Pottery, How It Is Made*,
for which Mrs. Nichols prepared several pages of

designs with motifs copied from Japanese sources.
It is not without significance that in the first of
them she included spiders, as well as dragonflies,
crabs, and other fauna. This particular piece of
pottery is typical of the free eclecticism of the
time; the Japanese decoration is applied to a very
unoriental basket with feet fashioned as lions'
heads (according to the Rookwood shape book,
this form was model number 45).

Cincinnati Art Museum, gift of Mrs. R. D.
Kercheval

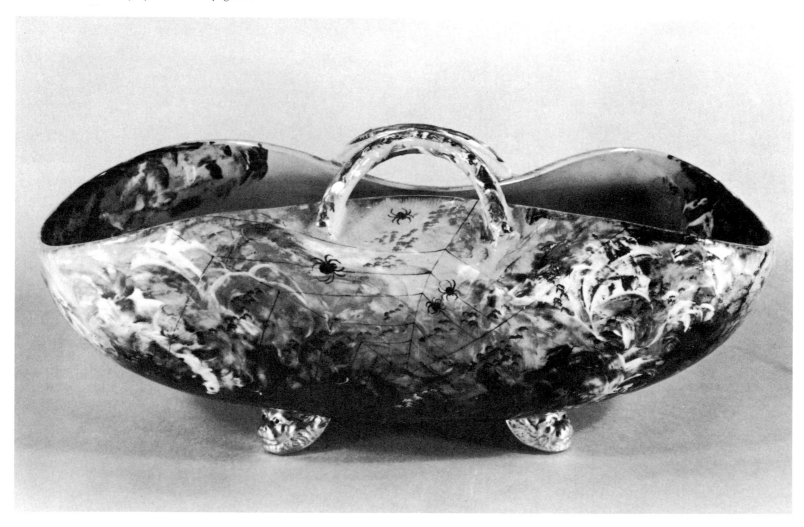

**160 Vase**
Mrs. C. A. Plimpton, Cincinnati, Ohio, 1881
Designer: L. F. Plimpton
Pottery, with pierced handles and inlaid with colored clays, with imitation Kufic script on one side with a scene of an Arabian city, and on the other with a man on a camel; in tones of cream, terra-cotta, brown, and black
Height: 16½"

Mrs. Plimpton was one of the leading members of the Cincinnati Pottery Club and her work, much of which was designed by her husband, was distinguished by a preference for Moorish and Egyptian shapes and for equally exotic scenes which decorated them. She employed an exacting technique of inlaying colored clays and, typical of local pride, could boast that all the clays on this vase were from Ohio, save for the black which came from Indiana. This piece was one of her most important creations. It was discussed and illustrated by E. A. Barber, *The Pottery and Porcelain of the United States*, 1893, pp. 281–83. The vase was exhibited at the Chicago Fair in 1893, where it reputedly attracted considerable attention.

Cincinnati Art Museum, gift of the Women's Art Museum Association

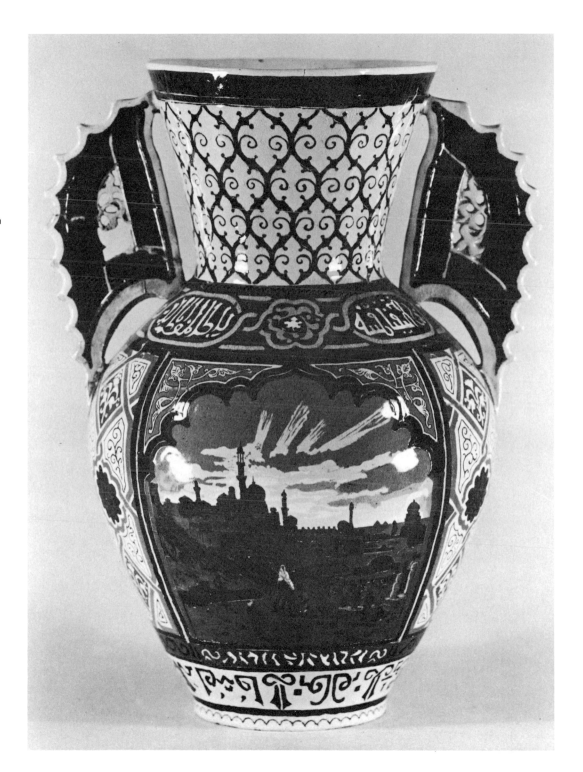

**161 Pitcher**
Laura A. Fry, Cincinnati, Ohio, 1881
Pottery, with incised decoration of ducks and water lilies picked out in blue glaze
Height: 8⅝″
Marks: incised cypher of conjoined *LAF, 1881, Cin. Pottery Club.*

Miss Fry was simultaneously a member of the Pottery Club and an employee at Rookwood, and this pitcher typifies the confusing interrelation between the two operations. The markings indicate that it was one of Miss Fry's independent works, yet the ceramic form itself was made by the Rookwood Pottery (model number 133, according to the company's shape book). In fact, part of the company notation about this shape reads "Sales for decoration to ladies good, to trade poor." Miss Fry's incised decoration imitates the type of stoneware then being produced with great success at the Doulton factory by women decorators such as Hannah Barlow. Moreover, the very shape of the pitcher was, also according to the Rookwood Pottery's records, based on a model by the same British artist. This piece is discussed and illustrated by E. A. Barber, *The Pottery and Porcelain of the United States,* 1893, pp. 282–83, and by K. E. Smith, "Laura Anne Fry," pp. 369–70, 372.

Cincinnati Art Museum, gift of the Women's Art Museum Association

**162 Pitcher**
Rookwood Pottery, Cincinnati, Ohio, 1882
Executed by Clara Chipman Newton
Pottery, with painted underglaze decoration of dragonflies on one side and bamboo branches on the other; in tones of brown, black, blue, and white, with gilt overglaze
Height: 6½″
Marks: impressed *ROOKWOOD 1882, 116, R;* incised *C.C.N.*

Miss Newton, who had been a schoolmate of Mrs. Nichols, was active in the Women's Pottery Club and, when the Rookwood Pottery began, served as its secretary, besides continuing her own decorating work. This vase, although obviously Japanese in intent, also has strong affinities with the faience made by Emile Gallé at Nancy, with which Mrs. Nichols and the Rookwood decorators were familiar. They even recorded some forms as borrowed from Gallé (Rookwood model nurmbers 102, 110, 115), although this "Horn Pitcher" is not one of them.

Brooklyn Museum, gift of Miss J. Ethel Brown

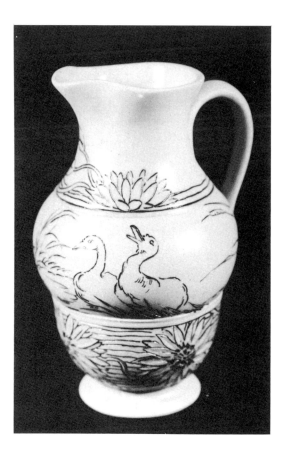

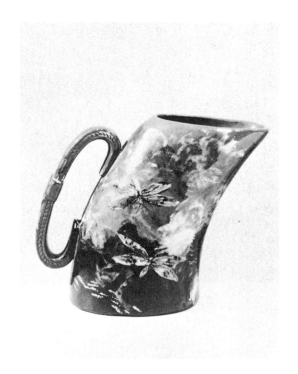

**163 Plate**

Rookwood Pottery, Cincinnati, Ohio, 1885
Executed by William P. McDonald
Pottery, with painted underglaze decoration of a
turtle and leafy branch; in tones of brown and
aqua
Diameter: 6¼"
Marks: impressed *ROOKWOOD 1885 212;*
painted, *WM$^c$D*

From 1882 until the end of his life, William
McDonald was one of the major decorators at
Rookwood. Like the other motifs of this plate,
the undulating pattern of the stream is taken
from Japanese art and it is this type of stylized,
fluid line which ultimately became the basis of
the "wavy line" of Art Nouveau.

National Museum of History and Technology,
Smithsonian Institution, gift of Mrs. Page Kirk

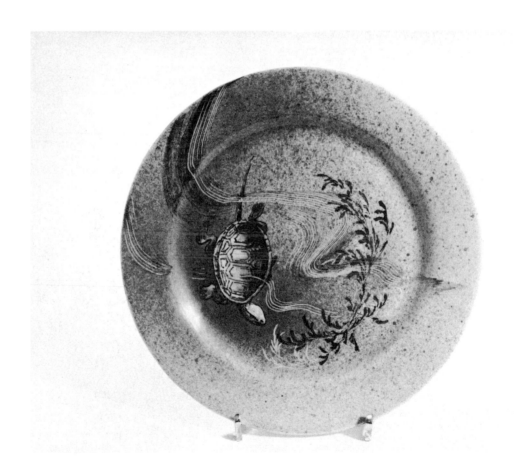

**164 Vase**
Rookwood Pottery, Cincinnati, Ohio, ca. 1885–95
Pottery, with painted underglaze decoration of a
bird flying over waves; in tones of black and dark
brown
Height: 8⁷⁄₁₆"
Marks: original paper labels, *ROOKWOOD/POT-
TERY/CINCINNATI/USA* a kiln with the letters
*SP U/UNIVERSAL/EXPOSITION/P[ARIS]; ROOK-
WOOD POTTERY/CINCINNATI USA/* cypher of
conjoined *RP/PAN AMERICAN/EXPOSITION/
BUFFALO USA; ROOKWOOD POTTERY/CINCIN-
NATI USA/1904/LOUISANA PURCHASE/EX-
POSITION ST. LOUIS*

When viewed at close hand and under certain
lighting, cascades of golden crystals are to be seen
embedded within the glaze. This effect first ap-
peared, quite unexpectedly, on some of the Rook-
wood pieces fired in 1884 and was named "Tiger
Eye." It was greatly prized by the pottery but
though they tried for several years to duplicate it,
they could not master the secret. Its appearance on
vases remained sporadic and not within their con-
trol. The Rookwood Pottery obviously considered
this vase to be a prime example of Tiger Eye and
exhibited it at the three major expositions of
Paris (1900), Buffalo (1901), and St. Louis (1904).

Cooper-Hewitt Museum of Decorative Arts and
Design, Smithsonian Institution, gift of J. Lion-
berger Davis (whose family bought the vase at the
St. Louis Exposition)

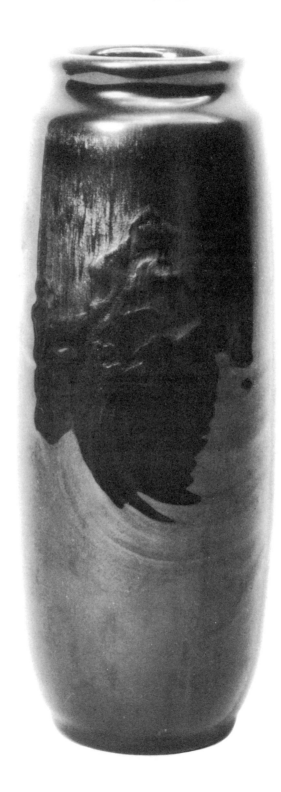

**165 Vase**
Rookwood Pottery, Cincinnati, Ohio, 1892
Executed by Caroline Steinle
Pottery, with painted underglaze decoration of
strawberries and leaves; in tones of yellow, brown,
orange, and green
Height: 6"
Marks: impressed cypher of conjoined *RP* sur-
mounted by seven flames, *304, W;* incised *CS/L;*
original paper label, *ROOKWOOD POTTERY/
Cincinnati U.S.A./WORLD'S COLUMBIAN/ EX-
POSITION 1893* and emblem of kiln with a crow
at either side

The bright and luminous color of this vase shows
the progress Rookwood had made by the early
1890s. According to the records of the pottery, its
shape was designed by William Watts Taylor, who
was then director of the firm.

National Museum of History and Technology,
Smithsonian Institution, gift of Mrs. Charlotte Ellis
Danforth

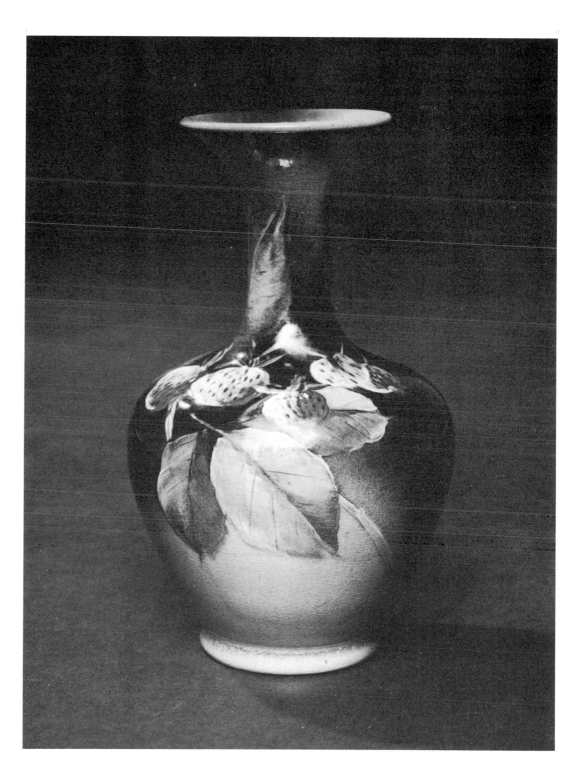

161

**166 Mug**
Rookwood Pottery, Cincinnati, Ohio, 1899
Executed by Sara Sax
Pottery, with painted underglaze decoration of gooseberries and leaves; in tones of orange, brown, and green
Height: 6¼"
Marks: impressed cypher of conjoined *RP* surmounted by thirteen flames, *659 C;* incised cypher of conjoined *SAX*

A contemporary illustration of another example of this shape (R. Kingsley, "Rookwood Pottery," p. 345) labels it a "Cyder Jug." According to the pottery's shape book, the form was designed by William Watts Taylor.

National Museum of History and Technology, Smithsonian Institution, gift of Mrs. Page Kirk

**167 Pitcher**
Lonhuda Pottery, Steubenville, Ohio, 1893
Executed by Sarah R. McLaughlin
Pottery, with painted underglaze decoration of pansies; in tones of yellow, orange, brown, and green
Height: 6⅝"
Marks: impressed *194, LONHUDA,* emblem of Indian's head (full face), *1893* and cypher formed from company's monogram; incised cypher formed from *SL*

According to Barber *(Marks of American Potters,* p. 130), the Indian-head mark on this pitcher "was used on shapes adapted from aboriginal American pottery forms." If so, the adaptation was obviously thoroughgoing since this sort of ewer with handles and trilobed mouth is wholly in accord with the fancy shapes favored in the late nineteenth century.

Macklowe Gallery

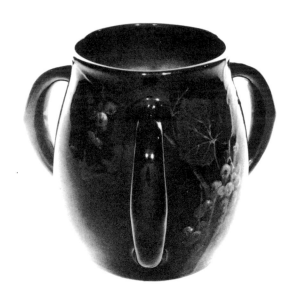

## Other early developments

Contemporary with the experiments in underglaze decoration in Cincinnati, but nonetheless independent of them, was the work of Charles Volkmar. While studying painting in Paris he became interested in pottery, and as it happened there was a small pottery near his studio at Montigny-sur-Loing. A number of French painters were doing underglaze decoration at this time and their work undoubtedly influenced Volkmar to some degree. Eugène Carrière, in fact, proposed setting up a kiln in partnership with Volkmar. Volkmar returned to this country in 1879 and established a pottery at Greenpoint, Long Island, where he continued his work in underglaze decoration. His technique was closer to that practiced in France in that his slips were made from clay which had been fired and pulverized. It is interesting that the underglaze technique did not gain the type of popularity on the East coast that it did in the Midwest.

More far-reaching in importance for the history of American art pottery is the work of the Robertson family. A firm was begun in Chelsea, a small town outside of Boston, as far back as 1866 with production centering on common brown ware and the like. Alexander W. Robertson, joined by his father James, and his brother Hugh C., began to produce art pottery in an enlarged plant under the name of Chelsea Keramic Art Works in 1872. Much of their work was done in a chaste Greek style but by the 1880s they had developed more elaborate techniques: incising, impressing, hammering, and carving were employed with great bravado. They executed designs of birds and flowers sprigged on in extremely high relief. Often, compositions of such well-known artists as Gustave Doré and Hans Makart were copied in toto on plaques and vases.

A major change in the direction of their work took place when Hugh Robertson went to the Centennial Exposition at Philadelphia in 1876. Like others he was intrigued by the display of French Limoges underglaze which he then began to make, calling his ware "Bourg-la-Reine" in honor of the French town where the art had been revived. More important, he was deeply influenced

163

by the display of oriental pottery; not only did this give him a whole new repertoire of motifs, but it also led him to experiment with glazes in an attempt to match those of the East.

The orientalizing trend in Robertson's work gradually took precedence over every other aspect. In 1880 his father died, and in 1884 his brother Alexander went to California, leaving Hugh in control of the firm. He became totally absorbed in his experiments; a four-year search began for the oriental *sang-de-boeuf,* or dragon's blood glaze. When he found a spot of the desired color the size of a pea on one of his vases, his determination only increased. The story goes that he spent long nights watching his kiln, dozing on piles of wood scraps. In the four years of work many pieces were glazed and fired but only three hundred with the dragon's blood glaze were deemed acceptable. So absorbed was Robertson in his quest that he neglected the management of his company; in 1888, for lack of money even for firing the kilns, operations had to cease.

In 1891, with the financial help of a group of Boston men, a new company called the Chelsea Pottery was formed with Hugh Robertson as manager. Although he was encouraged to pursue his art, he was enjoined from further research on the elusive *sang-de-boeuf* glaze. His experiments led him to another type of oriental glaze, namely a crackled one. Here, he had success and this ware ultimately proved to be the mainstay of the company's production. Eventually, it was decided to move the pottery, since dampness in the soil at Chelsea permeated the kiln causing steam to form during the firing. The new site, in Dedham, to the southwest of Boston, saw the resumption of work in 1896 under the name of Dedham Pottery. Much of Robertson's work consisted of the crackle glaze and high-fired bleeding glazes, sometimes with rough, craterous surfaces which gave such work the name volcanic. The company also made dinnerware with painted border designs in the new crackle glaze.

Robertson's success was crowned when he received one of the three highest awards at the St. Louis World's Fair in 1904. He died four years later, in 1908. His son William continued the business, but since he had been severely burned in a kiln explosion he could not work at the wheel. Thus, for the next thirty-five years until the pottery was closed in 1943, only the dinnerware and a few novelty items were produced, without, it should be added, any diminution of quality.

The J. and J. G. Low Art Tile Works can be considered as an offshoot of the Chelsea Keramic Art Works. It was founded in 1878 by John G. Low, one of the leading decorators for the Robertsons, and his father John Low. Moreover, George W. Robertson, brother of Alexander and Hugh, worked for them. The tiles produced by the Low company, like those of the Chelsea Keramic Art Works, have designs which frequently reflect European tiles of the 1860s and 1870s, whether in floral or more geometric patterns. Because of the transparency of the glaze, the high points of the design show through, heightening the effect of the relief. While most of their work was destined for architectural use, certain pieces were meant solely for artistic display; some have metal frames (made by the company itself) so that they could be hung on the wall like pictures.

Paralleling the later experiments of Hugh C. Robertson is the work of Mrs. Bellamy Storer (the former Mrs. Nichols). Although she had withdrawn from active participation in the Rookwood Pottery, she maintained a studio there in order to continue her private work. In this she focused more and more on rich, copper-red glazes with lusterous surfaces. Although dragons and other Eastern motifs still appear, either carved in the sides of her vases or else in the metal supports she fashioned for them, her interest in oriental pottery changed, just as had Robertson's. She no longer saw it merely as a repertoire of painted motifs; instead she developed a more sophisticated feeling for the intrinsic value of colors and textures. However, Mrs. Storer's pottery work was limited by the rising political career of her husband, whom she accompanied to Europe when, from 1897 onward, he served as ambassador in turn to Belgium, Spain, and the Austro-Hungarian Empire.

The work of Theophilus A. Brouwer, Jr., follows a similar development. Like Volkmar, he began as a painter but gradually turned his attention to pottery. About 1893 he set up a studio in East Hampton, Long Island, called the Middle Lane Pottery, and started experimenting in luster glazes and the employment of gold leaf under the glaze. These glowing effects were used at first to enrich vases decorated with flowers and butterflies, but gradually the glazes were allowed to stand by themselves. Although he knew little of chemistry and not much more of pottery, or perhaps just because of this, Brouwer was able to work without preconception. He developed a series of rich, iridescent glazes with various textures and even with elusive suggestions of imagery. He spoke of his work as "fire painting" in which he controlled the desired effects through the manipulation of the kiln. Not only were his glazes unique, but his process of transferring the pieces from one hot kiln to another was totally unorthodox (the only roughly comparable mode is the Japanese *raku* and it seems unlikely that Brouwer would have known this tradition). Although the majority of his vases were of simple shapes, he did some with animal and vegetal forms. Ultimately, around 1910, Brouwer forsook pottery altogether—taking up instead sculpture executed in concrete.

Another bold experimenter was George Ohr of Biloxi, Mississippi. His history is still somewhat unclear. Although we know that he was exhibiting as far back as 1885, our knowledge of his work does not begin until 1899. By then he had perfected a tour-de-force technique of throwing vessels with walls as thin as eggshell porcelain. Ohr then squeezed, folded, and collapsed these walls into bizarre shapes. Their irregularity was further emphasized by strangely curved handles. With the same sense of experimentation, Ohr glazed his "mud fixings" with interesting combinations of colors giving unusual nuances. Ohr has been associated with an emerging Art Nouveau style, but it would perhaps be more appropriate to connect the work of the "mad genius of Biloxi" with the inventive drive of the latter part of the nineteenth century, which was seeking a distinctively original style to claim as its own.

**168 Vase**
Charles Volkmar, Greenpoint, N.Y., ca. 1879–81
Pottery, with painted underglaze decoration of
cows in a meadow; in tones of brown, blue,
green, white, and pink
Height: 12⅝"
Marks: painted on side of vase, *Chas. Volkmar;*
fragment of original paper label, . . . *MA* . . .

This is one of a pair of vases which, according to
the artist's son, was made soon after his father's
return from Paris. The underglaze slips used to
decorate this vase were made from ground-up
porcelain obtained from the nearby Union Porce-
lain Works. As a painter turned potter, Volkmar's
work reveals very much the same sort of subject
matter and mood as his paintings, which were
inspired by the Barbizon school. A vase of
similar classical shape made by the Chelsea
Keramic Art Works in 1872 is illustrated by L. E.
Hawes, *The Dedham Pottery,* p. 51.

Brooklyn Museum, gift of Leon Volkmar

**169 Vase**
Chelsea Keramic Art Works, Chelsea, Mass., ca.
1875–80
Executed by Hugh C. Robertson
Pottery, decorated in low relief with scene of
trumpeting horseman in a landscape; blue and
speckled blue-green glazes
Height: 8¾"
Marks: impressed CHELSEA KERAMIC/ [ART W]
OR[KS]/ ROBERTSON & SONS; incised on front
side, cypher of conjoined HCR, After Kelly

The same shape of flask vase by Robertson is
illustrated in Jennie Young, *The Ceramic Art,* New
York, 1879, p. 470. The scene that decorates our
example is probably based on an engraving by
James Edward Kelly, a popular illustrator and
sculptor of the time. This vase was in the collection
of Dr. Marcus Benjamin who, on behalf of the
United States Congress, made a tour of American
potteries in 1905, to research a paper on the
state of art pottery in this country. He obtained
samples at each factory and his findings were pub-
lished in *Glass and Pottery World* (this vase is
illustrated in volume XV, p. 29), as well as in the
*Congressional Record,* and in his privately printed
book.

National Museum of History and Technology,
Smithsonian Institution, gift of Dr. Marcus
Benjamin

**170 Vase**
Chelsea Keramic Art Works, Chelsea, Mass., 1879
Designer: Isaac E. Scott
Pottery, decorated in high relief with two birds
on the branch of a plum tree, a third bird ap-
proaching, and an inscription *Two's Company . . . ;*
green glaze
Height. 8⅝"
Marks: impressed *CHELSEA KERAMIC/ . . . /ROB-
ERTSON & SONS;* incised on front, *SCOTT . . . /79*

This is one of four vases designed by Isaac Scott
that were executed at the Chelsea Keramic Art
Works and that were owned by the John J.
Glessner family of Chicago, for whom Scott also
designed furniture (see entries 1 and 2). The
stylization of the palmettes at the neck and of
the plum blossoms, and the curling forms of the
letters are a good indication of the date of this
vase. The homely motto is not unusual in English
and American products, but it is a far cry from
the symbolist quality of Gallé's poetic phrases in
France during the next decade.

Chicago School of Architecture Foundation

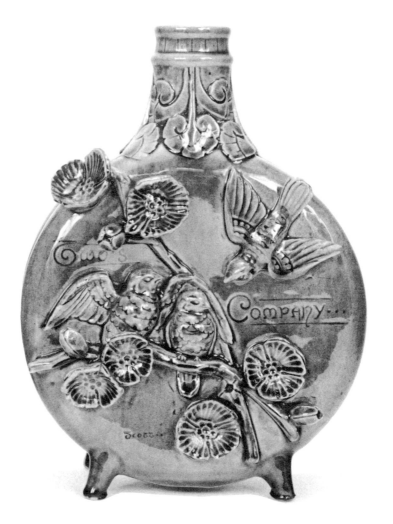

**171 Vase**

Chelsea Keramic Art Works, Chelsea, Mass., ca. 1888
Executed by Hugh C. Robertson
Stoneware, with a *sang-de-boeuf* glaze of transparent ruby color
Height: 6⅝"
Mark: impressed *CKAW*

This and another vase now in the Museum of Fine Arts, Boston, are known as "the twin stars of Chelsea." Although they are not at all identical, they are considered the two finest examples of dragon's blood glaze that Robertson achieved. They are illustrated together by M. M. Swan, "The Dedham Pottery," p. 120.

Museum of Fine Arts, Boston, gift of Eleanor M. Hearn

**172 Vase**

Chelsea Keramic Art Works, Chelsea, Mass., ca. 1887–89
Stoneware, with blue painted design of a flying bird on one side and on the other a bird perched on a branch, over a gray-white crackle glaze
Height: 7½"
Mark: impressed *CKAW*

Robertson's crackle glaze was celebrated as the first of its kind produced outside the Orient. Here the use of such glazes is still combined with painted motifs, a combination found in his oriental prototypes. But already visible is the artist's interest in the heavy, molten quality of the glaze itself.

Paul F. Evans

**173 Plate**
Dedham Pottery, Dedham, Mass., after 1895
Designers: Alice and Joseph Lindon Smith
Pottery, with blue painted border of alternating
rabbits and plants over a white crackled glaze
Diameter: 8½"
Marks: painted stencil, *DEDHAM POTTERY,* em-
blem of rabbit in profile facing right

Although it was relatively easy to obtain a crackle
glaze on vertical surfaces, it proved at first much
more difficult to get the same effect on flat surfaces.
This design of rabbits nibbling at what are re-
putedly Brussels sprouts was created in 1891 by the
director of the Boston Museum of Fine Arts and
his wife; for an example dated 15 November 1891,
see L. E. Hawes, "Hugh Cornwall Robertson,"
p. 413.

Private collection

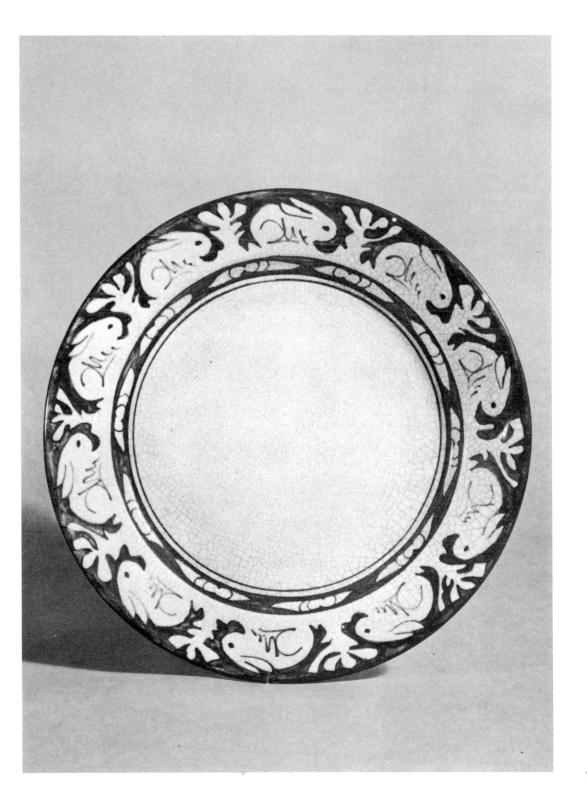

**174 Vase**
Dedham Pottery, Dedham, Mass., ca. 1899–1908
Executed by Hugh C. Robertson
Stoneware, with splashed crimson, orange-red,
gray, and green glazes, slight iridescent effects
Height: 8"
Marks: incised *Dedham Pottery*, cypher of con-
joined *HCR*

The glazes of Robertson's last phase show the
boldest sense of color and texture and, in a
sense, mark the beginning of twentieth-century
developments.

Private collection

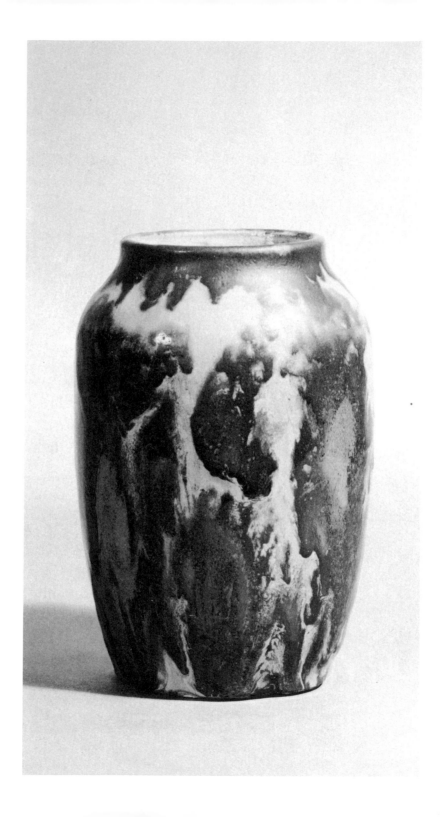

**175 Vase**
Dedham Pottery, Dedham, Mass., ca. 1899–1908
Executed by Hugh C. Robertson
Stoneware, with flowing white, brown, and olive
glazes
Height: 8⅝"
Marks: incised *Dedham Pottery*, cypher of con-
joined *HCR*; painted, *T·DP71B, C89/TP*

Private collection

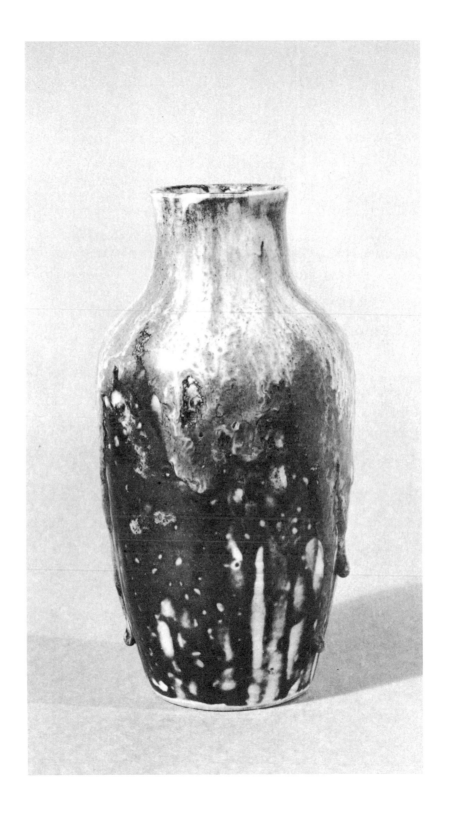

**176 Tile**
J. and J. G. Low Art Tile Works, Chelsea, Mass.,
ca. 1881–90
Pottery, with molded relief of overlapping pat-
terned disks; green glaze
Height: 2⅛", length: 6"
Marks: impressed *J. & J. G. LOW/PATENT ART
TILE WORKS/ CHELSEA, MASS., U.S.A./COPY-
RIGHT 1881 by J. & J. G. LOW*

This pattern is obviously Japanese inspired. It is
illustrated as model X25 ("The strips for belts and
borders have the prefix *X . . .*") in the 1884
catalogue issued by the company; the price is
listed as thirty cents per tile.

Private collection

**177 Tile**
J. G. and J. F. Low Art Tile Works, Chelsea, Mass.,
ca. 1883–90
Pottery, with molded relief of conventionalized
flowers and leaves; pinkish brown glaze
Height: 4¼", width: 4¼"
Marks: impressed *J. & J. G. LOW/ PATENT ART
TILE/ WORKS/ CHELSEA/ MASS./ U.S.A./
COPYRIGHT 1883 by J. G. & J. F. LOW*

In 1883 the name of the firm changed with the
retirement of John Low. According to the 1884
catalogue issued by the company, this size tile
was "used for hearths, mantel facings, mural
decorations, etc." While the pattern is not
illustrated in the 1884 catalogue, a closely related
one called "Amaranth" is (plate VIII). Each tile
of this size cost thirty cents.

Private collection

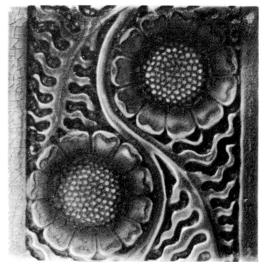

**178 Tile**
J. and J. G. Low Art Tile Works, Chelsea, Mass., ca. 1880–85
Executed by Arthur Osborne
Pottery, modeled in low relief with the head of an aged man and the motto *SEMPER FIDELIS;* yellow-green glaze
Height: 11", width: 7"
Mark: incised on the front side, *AO*

Arthur Osborne was the chief modeler for the Low company. This type of art work, which went beyond the demands of commercial tile, was known as a "plastic sketch."

National Museum of History and Technology, Smithsonian Institution, gift of E. Stanley Wires

**179 Vase**
Maria Longworth Nichols Storer, Cincinnati, Ohio, 1897
Pottery, with modeled decoration of three sea-horses in relief; dark red glaze with slight iridescence
Height: 7"
Mark: painted, *M.L.S. 1897*

Cincinnati Art Museum, gift of Dr. H. Schroer

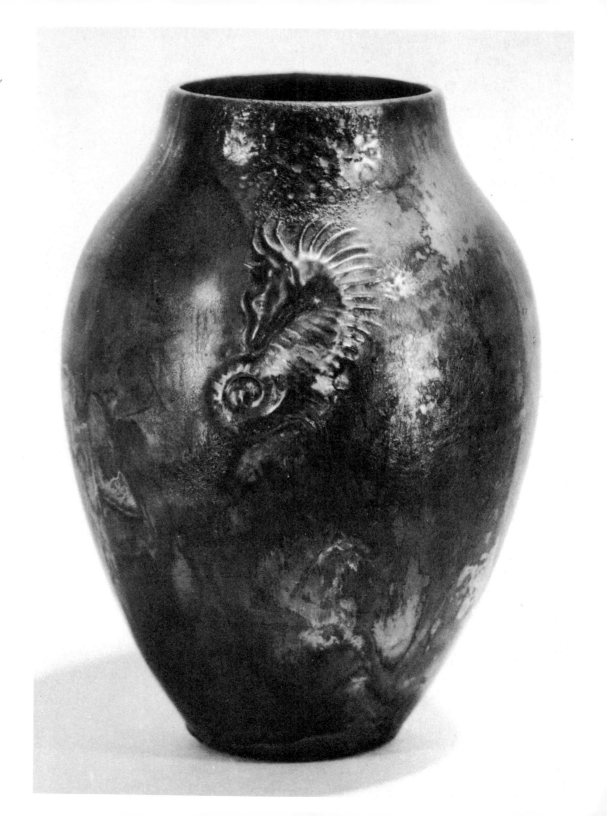

**180 Vase**
Middle Lane Pottery, East Hampton, N.Y., ca.
1898–1903
Executed by Theophilus A. Brouwer, Jr.
Pottery, with black and purple iridescent glaze
over a lighter green
Height: 7¼"
Marks: impressed M under whalebone arch

It would seem that Brouwer, like Tiffany, was
intrigued by the lusterous quality of long-buried,
ancient objects, for the roughened texture and
iridescent, metallic effects of this vase suggest
those of a corroded, antique bronze vessel. Typical
of the picturesque tastes of that era, the jawbone of
a whale that had washed up on the beach was used
as a gateway to Brouwer's seaside home, and he
chose that as the emblem of his pottery.

National Museum of History and Technology,
Smithsonian Institution, gift of Mrs. Julia H.
Chadwick

**181 Vase**
Brouwer Pottery, West Hampton, N.Y., after 1903
Executed by Theophilus A. Brouwer, Jr.
Pottery, decorated in high relief with mouse peer-
ing into hole; lusterous brown and yellow glaze
Height: 3½"
Marks: incised M under a whalebone arch, B

The humorous motif of the mouse was probably
inspired by an example of Japanese pottery or
netsuke.

National Museum of History and Technology,
Smithsonian Institution, gift of Mrs. Julia H.
Chadwick

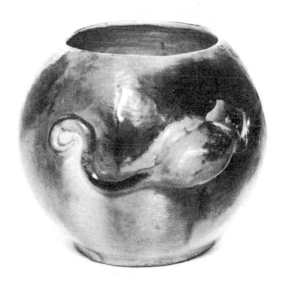

175

**182 Vase**
Brouwer Pottery, West Hampton, N.Y., ca. 1903–10
Executed by Theophilus A. Brouwer, Jr.
Pottery, with fiery orange-yellow and brown glaze, and iridescent effects
Height: 7¼″
Marks: incised *M* under a whalebone arch, *Brouwer, 1*

This vase was kept by the artist until 1925 when he sent it as an example of his "stuff" to the editor of *Adventure,* hoping that the latter would use his magazine to praise the benefits of country living. Brouwer felt strongly that his career as an artist would never have been possible had he remained in New York City.

Private collection

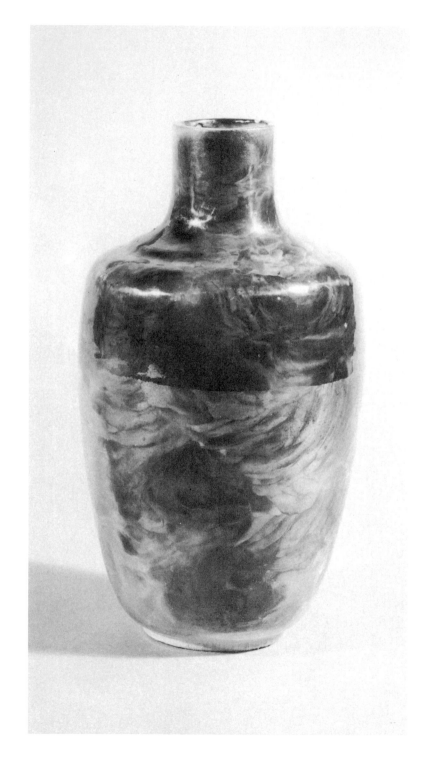

**183 Vase**
George E. Ohr, Biloxi, Miss., ca. 1900
Pottery, with green and plum-colored glaze
Height: 8½"
Mark: impressed *G. E. OHR Biloxi, Miss.*

The bizarre forms of Ohr's pieces did not guarantee success. As Barber put it: "they are twisted, crushed, folded, dented and crinkled into grotesque and occasionally artistic shapes . . ." *(Marks of American Potters,* p. 155).

National Museum of History and Technology, Smithsonian Institution, gift of George F. Ohr

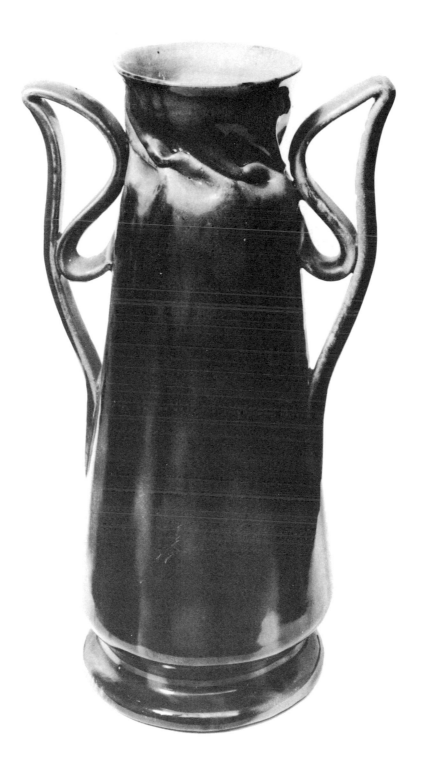

## Grueby

A major change in American pottery around the turn of the century was the introduction of mat glazes, and the person most responsible for this was William H. Grueby. Grueby learned the art of ceramics at the J. and J. G. Low Art Tile Works in Chelsea. In his first venture, the firm of Atwood and Grueby, which specialized in architectural faience, Grueby's particular responsibility was, as it would remain throughout his career, with the glazes.

The firm was short-lived and in 1894 Grueby set out again, forming the Grueby Faience Company. (The date of 1897, which traditionally but wrongly has been cited as the starting point for the company, marks instead the year in which it was reorganized and incorporated.) At first, work was in a variety of historical styles with, for example, Moorish and Chinese tiles, and plaques after the Della Robbias. It was at this time that the production of vases began; actually, a principal reason seems to have been the utilization of what otherwise would have been wasted space in the kilns. About 1898, Grueby began to use a new mat glaze that he had been working on ever since he had seen the displays of French pottery—particularly those of Delaherche and Chaplet—at the Chicago World's Fair of 1893. The glaze is a dense, generally dark green which breaks unevenly in veins of a slightly lighter green, thus giving an effect which was likened to the rind of a watermelon. In addition, he developed mat glazes in other shades of green, as well as yellows, browns, blues, and occasionally red.

At this point, shortly before the turn of the century, a consistent style emerged with which the name of Grueby soon became synonomous and which remained relatively unchanged throughout the firm's existence. The vases were designed at first by George P. Kendrick, one of the directors of the firm. While some are left plain or with simple geometric designs, most are decorated with vegetal forms in low relief. The leaves may be long or short, pointed or blunted, set in single, double, or even triple rows; often they are separated by long-stemmed buds or flowers. The inspiration for this came from certain vases by Delaherche that Grueby had seen at Chicago. But in the end this is of little consequence for, unlike the French prototypes, Grueby vases have a heaviness of form and the treatment of the decoration tends to be either botanically specific or else very severe.

Architectural faience continued to be a major aspect of the company's work. Here, too, floral motifs were frequently used but a wider range was introduced. In addition to geometric patterns, there were often animals, forest scenes, medieval knights, and illustrations from Kipling and Carroll. Although a predominant number of commissions came from the Boston area itself, Grueby tiles were used throughout the country in homes, hotels, churches, stores, colleges, railroad stations, and even zoos.

In many ways Grueby is an ideal representative of the Arts and Crafts movement, for his business was conceived as a "happy merger of mercantile principles and the high ideals of art." Despite the relatively large production and the staff of over one hundred people, work was done essentially by hand. The vases were thrown on a wheel and were then decorated by one of the young women following the designer's patterns. Similarly, most of the tile work—particularly the decoration—was done by hand, although some molds may have been used. The sobriety of Grueby designs and coloring complements the work of Gustav Stickley, and it is to be noted how often their products were associated. Not only did they exhibit together at the Buffalo Pan-American Exposition of 1901, but Stickley also used Grueby tiles in his Craftsman houses and Grueby vases for interior decoration, as can be seen in many of the illustrations in the *Craftsman* magazine.

In 1899 the company began to use the name "Grueby Pottery" to designate that section of its operation that produced vases and other art wares, and in 1907 this was incorporated as a separate entity. However, the dividing line between the two firms is less than clear, for they were housed in the same factory, and the vases were glazed and fired by the Grueby Faience Com-pany. Conversely, many of the designs for the department of architectural faience were prepared by Grueby Pottery. To add to the confusion, some vases bear both designations and some tiles have the Grueby Pottery label.

Despite the many awards and favorable reviews of the companies' work, they were beset by financial problems. The Grueby Faience Company was declared bankrupt in 1908, but through legal maneuvers a new firm, named Grueby Faience and Tile Company, was set up to continue the department of architectural faience. No vases were exhibited after this period and production of them seems to have essentially stopped by 1911, although some may have been made during the next two years. The business of making tiles continued relatively unchanged until 1919 when the C. Pardee Works of Perth Amboy, New Jersey, acquired the firm. Operations were transferred to the Pardee factory and, even after Grueby's death in 1925, continued until at least the end of the decade.

**184 Vase**
Grueby Faience Company, Boston, Mass., ca. 1898–1902
Executed by Wilhemina Post
Pottery, with modeled decoration of three-pointed leaves separated by long-stemmed buds; dark green mat glaze
Height: 7⅞"
Marks: impressed in a circle, *GRUEBY FAIENCE CO. BOSTON. U.S.A.;* incised *W. P., 7* or *L*

Private collection

**185 Vase**
Grueby Faience Company, Boston, Mass., ca. 1898–1902
Designer: George P. Kendrick
Pottery, with decoration of modeled leaves; dark green mat glaze
Height: 11⅛"
Mark: impressed in a circle, *GRUEBY FAIENCE CO. BOSTON. U.S.A., 35*

This is one of the earliest models, illustrated in 1898 by A. Russell ("Grueby Pottery," p. 5) and again in *L'Art décoratif,* III (1901), p. 203. The form of the vase, particularly the way the handles flare out at their lower terminals, suggests analogies with Delaherche's work; cf. *Studio,* XII (1898), pp. 114, 116. Grueby's wide-mouthed vases were often used as the bases for oil lamps by firms such as Tiffany Studios, Duffner and Kimberly, Bigelow and Kinnard; illustrated in *Brush and Pencil,* IX (January 1902), p. 240, and *Glass and Pottery World,* XVII (June 1908), p. 19.

Private collection

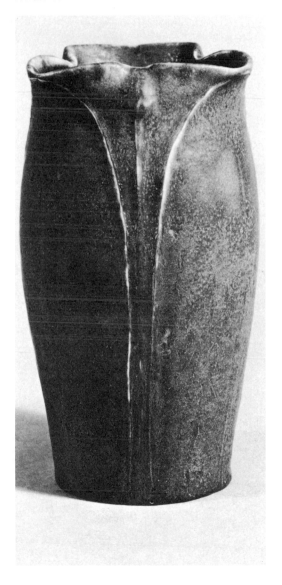

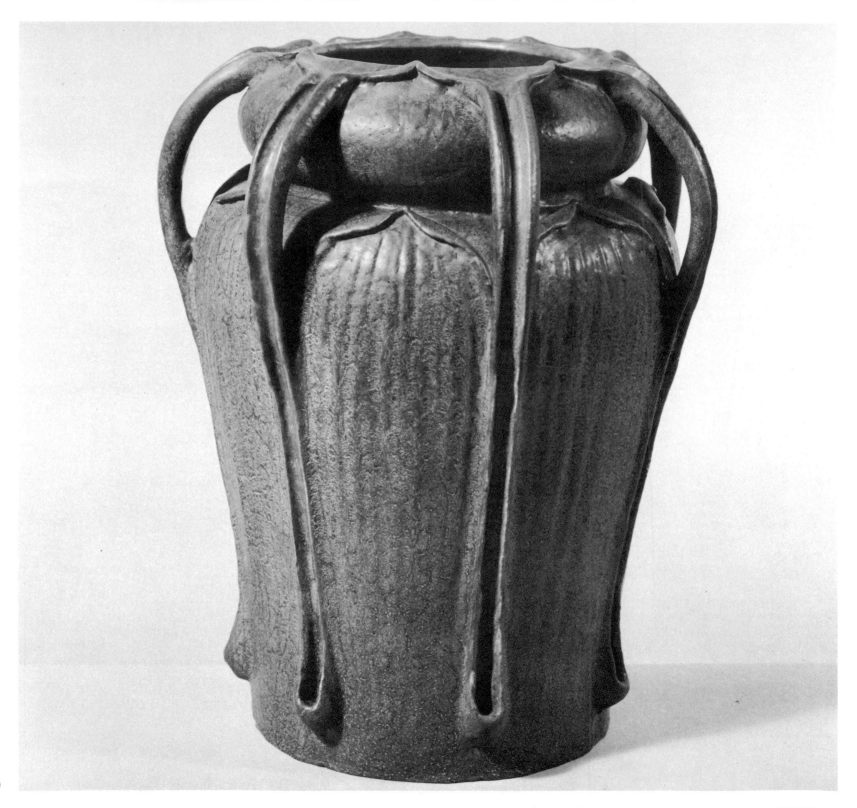

**186 Vase**
Grueby Faience Company, Boston, Mass., ca. 1898–1902
Pottery, with decoration of five modeled leaves separated by long-stemmed buds; pale blue mat glaze
Height: 7¾₁₆"
Marks: impressed in a circle around a stylized lotus flower, *GRUEBY FAIENCE CO. BOSTON. U.S.A.*

According to the records of the Newark Museum, the retail price for this vase at the time of acquisition (1910) was fifteen dollars.

Newark Museum

**187 Vase**
Grueby Faience Company, Boston, Mass., ca. 1898–1902
Pottery, with decoration of modeled leaves; dark green mat glaze
Height: 8⅛"
Marks: impressed in a circle around a stylized lotus flower, *GRUEBY FAIENCE CO. BOSTON. U.S.A.;* original paper label, in circles around a stylized lotus flower, *GRUEBY · POTTERY · BOSTON · U·S·A/REGISTERED TRADE MARK;* original paper label, in a circle around a stylized lotus flower, *WORLD'S · FAIR · ST. · LOUIS · 1904*

A closely related model was exhibited at the Paris World's Fair, 1900, as illustrated by Bowdoin, "The Grueby Pottery," p. 137. There is another illustration in *Glass and Pottery World,* XVI (June 1908), p. 13.

Private collection

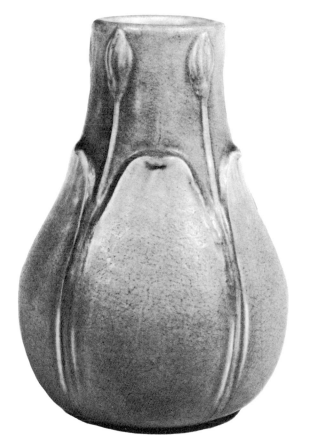

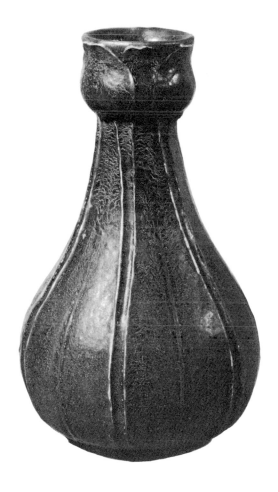

**188 Vase**
Grueby Faience Company, Boston, Mass., ca. 1898–1902
Pottery, with decoration of modeled leaves; mat yellow glaze
Height: 9⅜"
Marks: impressed in a circle, *GRUEBY FAIENCE CO. BOSTON. U.S.A.*

Private collection

**189 Vase**
Grueby Faience Company, Boston, Mass., ca. 1898–1902
Pottery, with decoration of geometric patterns in yellow, ocher, and white mat glazes
Height: 7½"
Marks: impressed in a circle, *GRUEBY FAIENCE CO. BOSTON. U.S.A.*; original paper label, in circles around a stylized lotus flower, *GRUEBY POTTERY · BOSTON · U.S.A./REGISTERED TRADE MARK*; original price sticker, *GRUEBY POTTERY./ PRICE $18./ No.B.*

The design of this vase is an unusual departure for the Grueby company. The technique of building cloisonné walls of slip clay to contain the flow of the various glazes was rarely used by Grueby for vases but regularly employed for tiles.

Newark Museum

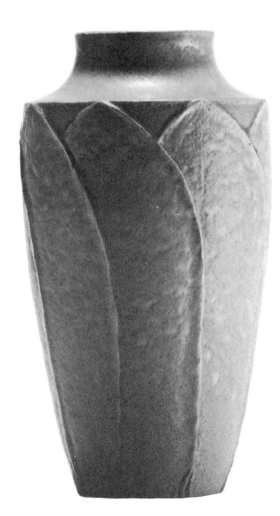

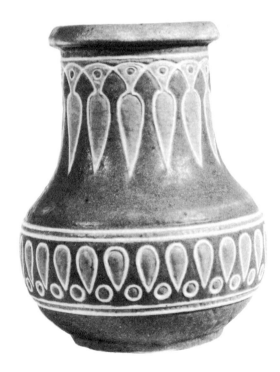

**190 Vase**
Grueby Faience Company, Boston, Mass., ca. 1898–1903
Pottery, with decoration of modeled leaves and long-stemmed buds; green mat glaze
Height: 21⅞"
Marks: paper label with written legend, *Grueby Museum/$50.⁰⁰/ 9542.*

This vase was acquired by The Art Museum, Princeton University in 1903. The model was exhibited at the Paris World's Fair, 1900, and illustrated the same year by Bowdoin, "The Grueby Pottery," p. 137.

The Art Museum, Princeton University

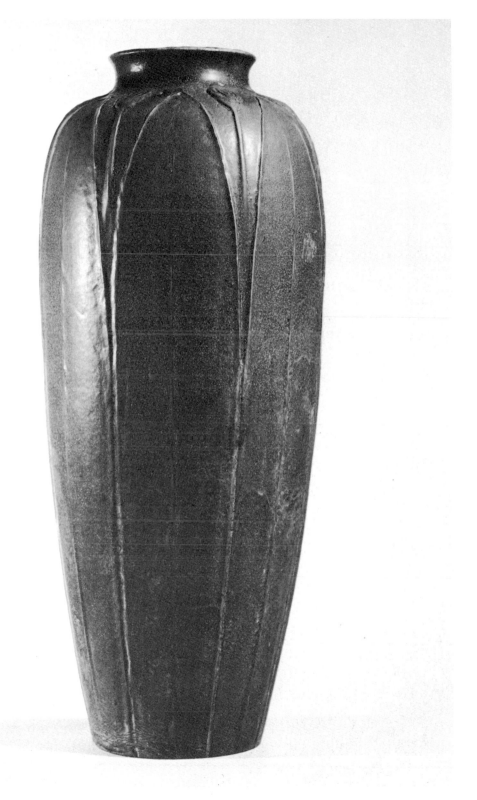

183

**191 Vase**
Grueby Pottery, Boston, Mass., ca. 1899–1910
Executed by Ruth Erickson
Pottery, with decoration of five modeled leaves
and handles; light green mat glaze with tones of
ocher
Height: 10⅝"
Marks: impressed in a circle around a stylized
lotus flower, GRUEBY · POTTERY · BOSTON ·
U·S·A, 172; incised cypher of conjoined RE

This model was exhibited at the Paris World's
Fair, 1900, and illustrated by Bowdoin, "The
Grueby Pottery," p. 138. Another example, but
with a yellow mat glaze, is in the Metropolitan
Museum. According to the records of the Newark
Museum, the retail price for this vase at the time
of acquisition (1910) was fifty dollars.

Newark Museum

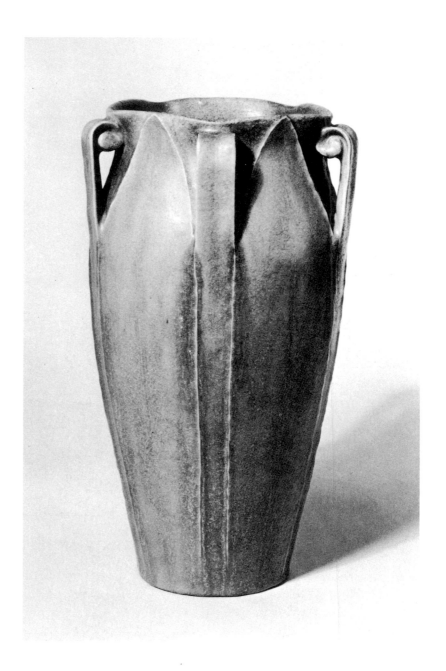

**192 Vase**
Grueby Pottery, Boston, Mass. ca. 1899–1910
Probably executed by Annie V. Lingley
Pottery, with decoration of modeled leaves and
conventionalized flower buds; dark green and
yellow mat glazes
Height: 12″
Marks: impressed in a circle around a stylized lotus
flower, GRUEBY · POTTERY · BOSTON · U·S·A, 20;
incised AL

Delaherche designed a vase with similar long
stemmed, trefoil buds above rows of leaves, illus-
trated in the *Studio,* XII (1898), p. 117.

Private collection

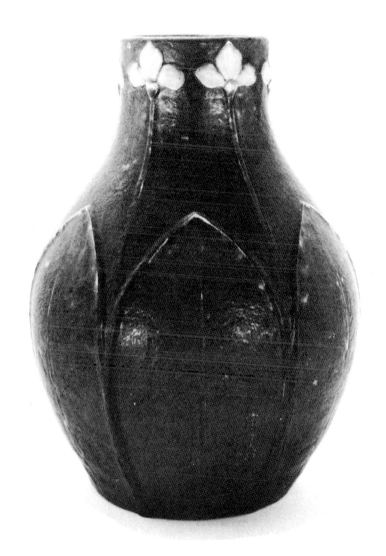

**193 Vase**
Grueby Pottery, Boston, Mass., ca. 1899–1910
Pottery, with modeled decoration of tulip leaves
and flowers; green and yellow mat glazes
Height: 8⅝"
Marks: impressed in a circle, *GRUEBY · POTTERY ·
BOSTON · U·S·A*; incised cypher of conjoined
*MCJ*, [?] *36*; painted, *X*

Private collection

**194 Tobacco jar**
Grueby Pottery, Boston, Mass., 1907
Executed by Wilhelmina Post
Pottery, with decoration of modeled tobacco
flowers; light green and white mat glazes
Height: 7¾"
Marks: impressed in a circle, *GRUEBY · POTTERY ·
BOSTON · U·S·A*; incised *W.P., 1/14/7*; painted,
*X*

In December 1906 at The Art Institute of Chicago,
the Grueby Pottery exhibited two different models
of tobacco jars designed by Julia H. Bradley. Al-
though this example does not correspond to the
one described in *International Studio*, XXX (Febru-
ary 1907), p. cvi, it is of the same series. Miss
Bradley was the third major designer of vases,
succeeding George Kendrick who left in 1901 and
Addison B. LeBoutillier who after several years
restricted himself to designing tiles. Although most
of the firm's decorators were women, Miss Bradley
seems to have been the only one to have held a
post of such importance.

Private collection

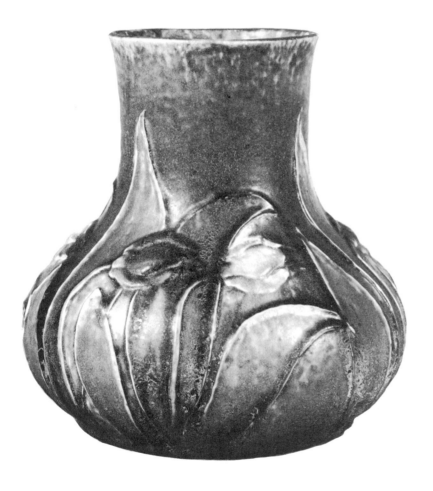

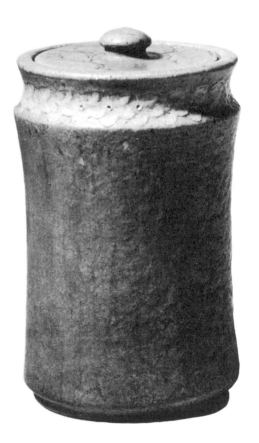

## 195 Vase

Grueby Pottery, Boston, Mass., 1910
Pottery, decorated with three repeating landscape
panels; green, yellow, ocher, and white mat
glazes
Height: 6½"
Marks: impressed in a circle, *GRUEBY • POTTERY •
BOSTON • U•S•A;* incised *10/10*

As noted before (entry 189) this cloisonné techni-
que is unusual for Grueby vases. There is another
example of the model in the National Museum of
History and Technology, Smithsonian Institution.
The date of *10/10* incised on the bottom raises the
question of exactly when Grueby's vase making
operations ceased. Taken with the date of *11/12*
incised on another vase in a private collection, it
suggests that production continued, even if on a
reduced basis, for a greater length of time than
has previously been thought.

Private collection

## 196 Tile

Grueby Faience Company, Boston, Mass., ca. 1900–
05
Executed by an artist with the initials *ET*
Pottery, with a design of a conventionalized tulip
and leaves in light and dark green, and yellow
mat glazes
Height: 6", width: 6"
Marks: painted, *ET;* original paper label on side,
in circles around a stylized lotus flower, *GRUEBY •
POTTERY • BOSTON • U•S•A/ REGISTERED TRADE
MARK*

Grueby tiles with tulip designs were exhibited at
the 1902 exhibition of the Architectural League of
New York (number 332 in its catalogue). An illustra-
tion of this model mounted in bronze by Tiffany
Studios for use as a tea tile is given by L. Henzke,
*American Art Pottery,* p. 196.

Ethel and Terence Leichti

**197 Tile**
Grueby Faience Company, Boston, Mass., ca. 1906
Pottery, with a painted design of conventionalized
trees; with green, blue, lavender, ocher, and brown
mat glazes
Height: 13", width: 13"

This design is closely related in style and theme
to a frieze of Grueby tiles called *The Pines,* which
was designed by Addison B. LeBoutillier, exhibited
in 1906, and illustrated in the *Brickbuilder,* XV
(1906), p. 107.

National Museum of History and Technology,
Smithsonian Institution, gift of E. Stanley Wires

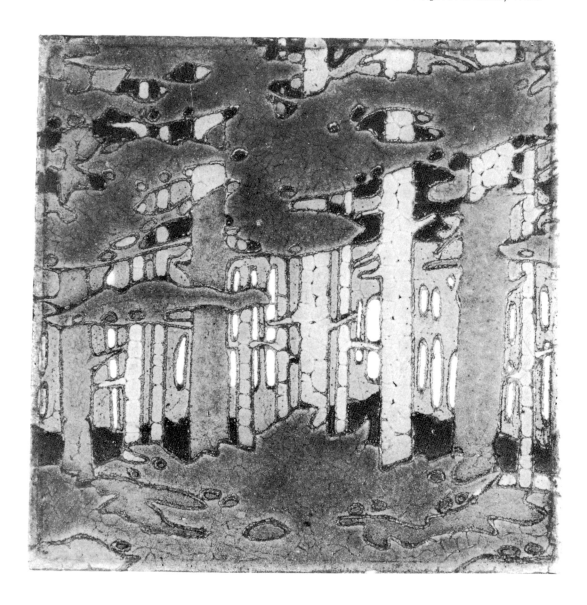

**198 Tile**

Grueby Faience Company, Boston, Mass., ca. 1906
Pottery, with relief emblem of Saint Luke (a winged
ox with a book) in glossy green and dark blue
glazes
Height: 7½", width: 7½"

In the first exhibition of the National Society of
Craftsmen, held in New York in December 1906,
Grueby exhibited the *Four Gospels:* "four tiles
forming a square, each holding the symbol of one
of the Gospels traced in blue shades," *International
Studio,* XXX (1907), p. lxx. It should be remembered
that at the time many major commissions came
from ecclesiastical sources.

National Museum of History and Technology,
Smithsonian Institution, gift of E. Stanley Wires

**199 Paperweight**

Grueby Faience Company, Boston, Mass., after 1903
Pottery, with molded relief design of scarab;
dark mottled green, semi-mat glaze
Length: 3⅞"
Marks: impressed in a circle around a stylized
lotus flower, *GRUEBY FAIENCE CO. BOSTON U.S.A.*

The scarab paperweight was a novelty introduced
by Grueby at the St. Louis World's Fair in 1904;
see *Keramic Studio,* VI (1904), p. 217. Except for
such scarabs and, of course, the lotus flower
which Grueby adopted as his trademark, he made
no outright borrowings from Egyptian art. An
admiration for the strength and solemnity of
Egyptian architectural decoration is nevertheless
manifest in his vases.

Paul Morrissey

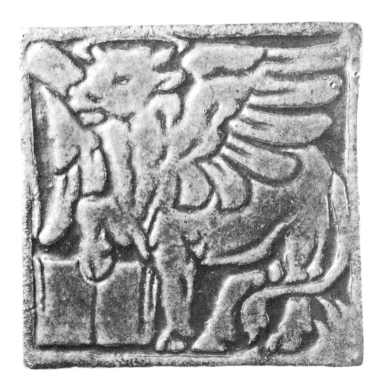

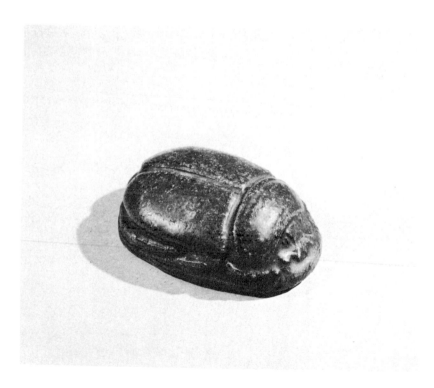

**200 Tile**
Grueby Faience and Tile Company, Boston, Mass.,
after 1908
Pottery, with painted design of candlestick and the
words *GRUEBY/TILE*; light and dark green, black,
and yellow mat glazes
Height: 6", width: 4"

This is a tile meant for advertising or display purposes. The words *GRUEBY TILE* are an abbreviation of the name of the firm which was incorporated in September 1909, after the former Grueby Faience Company had gone bankrupt and into receivership.

Ethel and Terence Leichti

## Newcomb College

The Newcomb Pottery of New Orleans typifies the Arts and Crafts movement at the turn of the century. The idea of training young women in a craft which would allow them to make an honorable living is one that occurs frequently at this time, whether in connection with the Kensington School of Art Needlework in London or the New York Society of Decorative Art. In New Orleans the idea was promoted by William Woodward, an instructor of painting and drawing at Tulane University. He led a group of women who ran the Baronne Street Pottery and who decorated ceramics much as did their counterparts in Cincinnati. In 1895 it was decided to start a pottery at Newcomb College (the women's division of Tulane) and Ellsworth Woodward, brother of William, was made its director. He called upon Mary G. Sheerer, an already skilled painter of china, as instructor of design. The beginnings of the pottery were, of necessity, modest. Some of the materials were obtained from an abandoned porcelain factory, a suitable clay was found in nearby Biloxi, and the potter built a simple kiln in part of a boiler room.

The first years saw a variety of work being done. From the beginning it was understood that the girls would decorate the pottery but would not have to perform the heavier task of making the vessels themselves. This was left to a professional and a succession of men was found to throw on the wheel. The third of those hired, an Alsatian named Joseph Meyer, had previously worked for the Baronne Street Pottery; until his retirement in 1925, this potter patiently threw almost all the Newcomb vases. At first, an attempt was made to imitate the Rookwood style of underglaze decoration but this had to be abandoned owing to technical difficulties. In its place evolved a simpler system of painting the low-fired bisque ware with designs of conventionalized forms in varied tones of blue and green derived from cobalt and chromium oxides. Frequently, to strengthen the conventionalized effect, the outlines of the design were first carved into the body. Much was made of the fact that the motifs used were of plants and animals indige-

nous to the South; thus, the repertoire included magnolia, live oak, palm trees, and wisteria. As Miss Scheerer put it, "The whole thing was to be a southern product, made of southern clays, by southern artists, decorated with southern subjects."

In addition to serving as a training function of the college, the pottery also provided a means of employment for those who chose to stay on after graduation. The work accordingly varies in quality from a professional to a purely amateurish level, although supposedly the Newcomb College mark was obliterated from any piece that did not meet the pottery's standards. The aesthetic of the pottery was abreast of the times in its general insistence upon conventionalization of forms and an essentially two-dimensional sense of surface pattern. It thus parallels the more advanced designs shown in magazines such as *Keramic Studio* which were used nationwide by the home decorators of china. Although the designs occasionally have a rhythmic excitement associable with Art Nouveau, most are more sober. This quality is reinforced by the very simple shapes of the vases (most of which were designed by Miss Scheerer) and by the insistent, horizontal bands of color which constrain the patterns on so many of the pieces.

The work of the pottery proceeded with little change during the first decade of this century. About 1910, however, an innovation marks the second major phase of Newcomb's production. At that time Paul Cox, a graduate of Binns's courses at Alfred University, was called in as technician and, following the lead of so many other American potteries, he developed a mat glaze for Newcomb. Along with the new softer textures and colors, the decoration relaxed into a kind of gentle naturalism with light modeling suggestive of a third dimension. Although vases continued to bear the paper label announcing that "Designs are not duplicated," the later products of the pottery, which continued in operation until 1930, often tend to be repetitive.

**201 Vase**
Newcomb College Pottery, New Orleans, La., ca.
1898
Executed by Mary Sheerer
Pottery incised and painted with decoration of iris
flowers and leaves in tones of blue, cream, pink,
and yellow; glossy glaze
Height: 10¼"
Marks: impressed *NEWCOMB COLLEGE*, incised *O*

Miss Sheerer had studied at the Cincinnati Art
Academy, which may have prompted her gift to
this museum in 1898. Besides the actual date of
donation, the earliness of the vase is attested to
by the unusual patterned treatment of the back-
ground and by the rare signature with the pottery's
name fully written out. At this time ceramic and
glass vases were frequently displayed on the same
carved stands as were used to display oriental vases;
for this particular vase Miss Sheerer made a blue
glazed pottery stand (not exhibited).

Cincinnati Art Museum, gift of Mary G. Sheerer

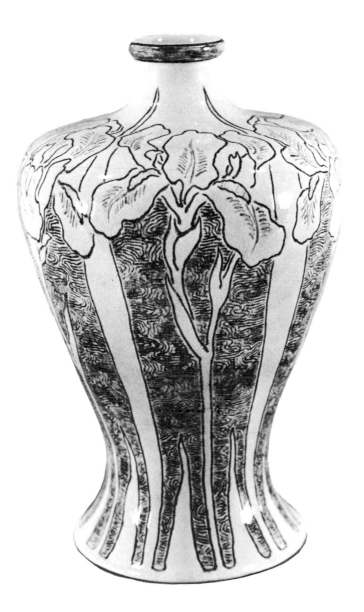

**202 Vase**
Newcomb College Pottery, New Orleans, La., 1904
Executed by Mazie T. Ryan (Joseph Meyer, potter)
Pottery, incised and painted with design of wisteria blossoms in tones of blue and blue-green; glossy glaze
Height: 8¾"
Marks: impressed cypher of N within a C, cypher of conjoined JM; incised M T RYAN 1904; original paper label NEWCOMB POTTERY/Subject Westeria [sic]/Designs are not duplicated./NEW ORLEANS.; original price sticker, 0077 $12⁰⁰ [the price partially effaced]

Many of the motifs favored by the Newcomb Pottery are dialects of an international language; although wisteria was one of the plants claimed as indigenous to the South, it had already been firmly established as a popular motif in European and American decorative art.

Mr. and Mrs. Julius Gold

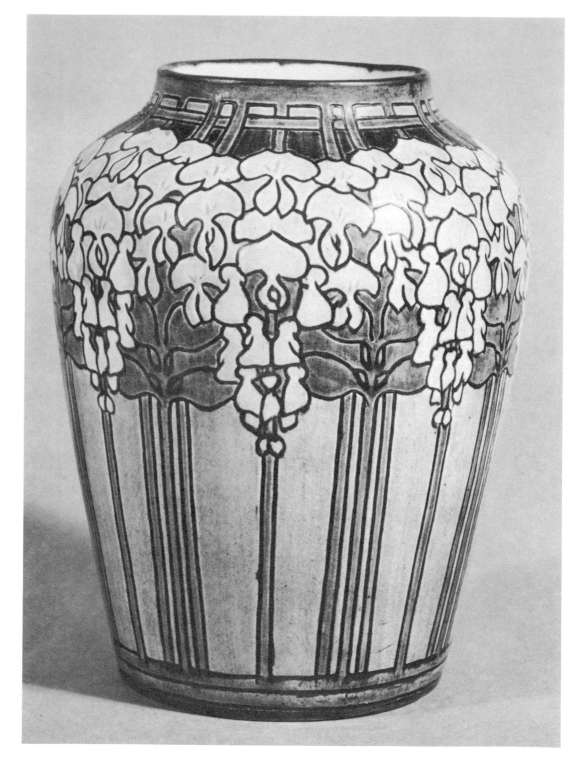

**203 Vase**
Newcomb College Pottery, New Orleans, La., ca.
1900–10
Executed by Mazie T. Ryan (Joseph Meyer, potter)
Pottery, incised and painted with design of wild
tomatoes in tones of blue, blue-green, yellow, and
buff; glossy glaze
Height: 11¾"
Marks: impressed cypher of N within a C, cypher
of conjoined MTR, cypher of conjoined JM; painted,
AT 84; original paper label, NEWCOMB POTTERY/
Subject Wild Tomato/ Designs are not duplicated./
NEW ORLEANS.

This vase is illustrated by R. W. Blasberg, "New-
comb Pottery," p. 76, where it is described as
having a semi-mat glaze and is therefore dated
circa 1910–18. However, the glaze is the normal
glossy one used in the first decade of this century.

National Museum of History and Technology,
Smithsonian Institution, gift of Tulane University

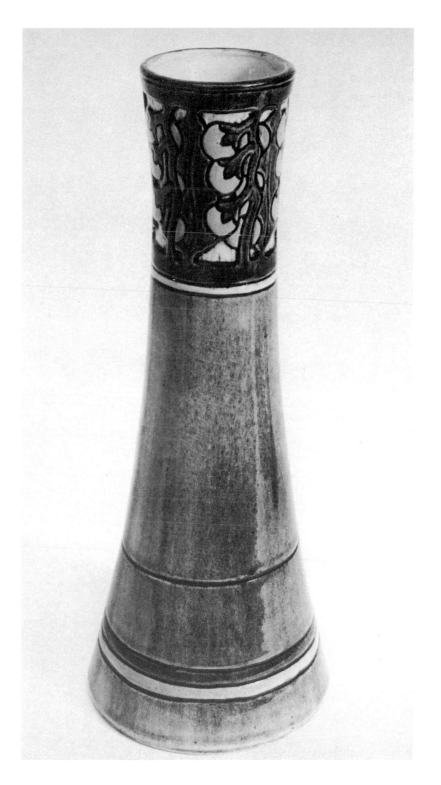

**204 Vase**
Newcomb College Pottery, New Orleans, La., ca. 1900–10
Executed by Amalie Roman (Joseph Meyer, potter)
Pottery, with painted abstract vegetal design in tones of green, and light and dark blue; glossy glaze
Height: 3⅜″
Marks: impressed cypher of N within a C, cypher of conjoined JM, U; painted artist's cypher of AR within a rectangle, 1 within a shield

Private collection

**205 Vase**
Newcomb College Pottery, New Orleans, La., ca. 1900–10
Executed by Leona Nicholson (Joseph Meyer, potter)
Pottery, incised and painted with design of stylized flowers in tones of blue, green, yellow, and white; glossy glaze
Height: 5½″
Marks: impressed cypher of N within a C, LN, cypher of conjoined JM; painted, BZ–72; original price sticker, BZ-72 3⁵⁰

Newark Museum

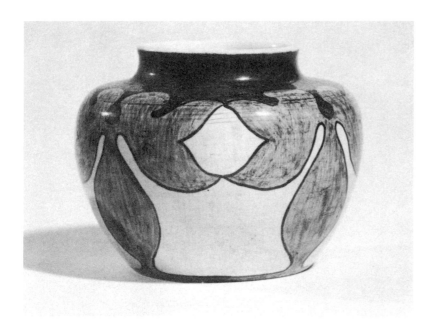

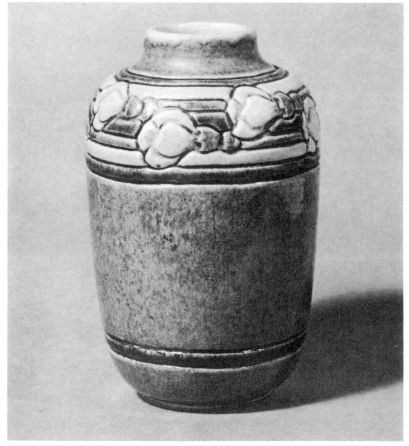

**206 Mug**
Newcomb College Pottery, New Orleans, La., ca. 1900–10
Executed by Marie Hoe-LeBlanc (Joseph Meyer, potter)
Pottery, painted with repeating landscape scene of trees and winding road in tones of blue and blue-green; glossy glaze
Height: 5½"
Marks: impressed cypher of N within a C, cypher of conjoined JM; incised cypher of conjoined MHL; painted cypher of conjoined EMHL, J21X

Private collection

**207 Vase**
Newcomb College Pottery, New Orleans, La., ca. 1900–10
Executed by Maria Hoe-LeBlanc (Joseph Meyer, potter)
Pottery, incised and painted with a border decoration of china ball trees in tones of blue and yellow; glossy glaze
Height: 5⁷⁄₁₆"
Marks: impressed cypher of N within a C, cypher of conjoined JM, cypher of conjoined MHLᵉB; painted, CJ-56; original paper label, NEWCOMB POTTERY/Subject China Ball Tree/Designs are not duplicated./NEW ORLEANS.; original price sticker, CJ-56/5⁰⁰

Newark Museum

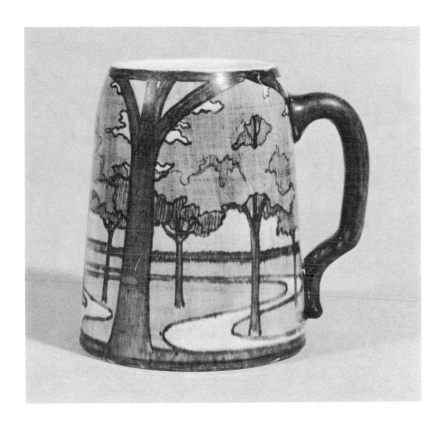

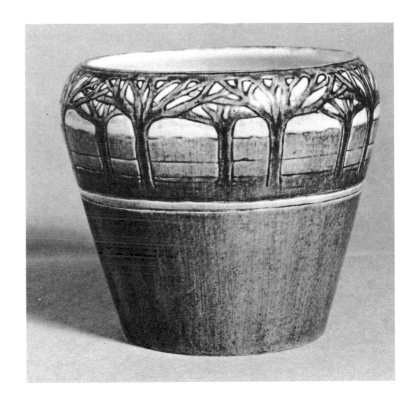

195

**208 Vase**
Newcomb College Pottery, New Orleans, La., ca. 1904–10
Executed by Henrietta Bailey (Joseph Meyer, potter)
Pottery, incised and painted with border decoration of cherries and leaves in tones of blue and blue-green; glossy glaze
Height: 9"
Marks: impressed cypher (appearing twice) of *N* within a *C*, cypher of conjoined *JM*, cypher of conjoined *HB*, *W*; painted, *AE 74*

Henrietta Bailey's name is not listed in Barber's *Marks of American Potters* (1904) and so it seems reasonable to assume that she joined the decorating staff slightly later. According to P. E. Cox ("Newcomb Pottery," p. 142), she "never gave all of her time to pottery decoration but more of her ware went into prize-winning shows than her general average of work would predict."

Private collection

**209 Vase**
Newcomb College Pottery, New Orleans, La., ca. 1900–10
Executed by C. Payne (Joseph Meyer, potter)
Pottery, painted with design of conventionalized flowers in tones of blue and blue-green; glossy glaze
Height: 6½"
Marks: impressed cypher of *N* within a *C*, cypher of conjoined *JM*; incised *C. Payne*, *U*; painted cypher of conjoined *CP*, *Y 79*

Private collection

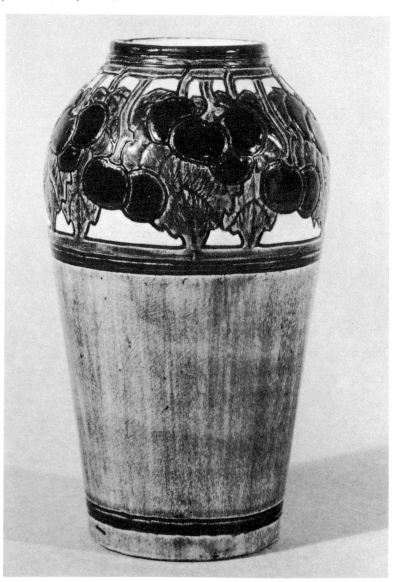

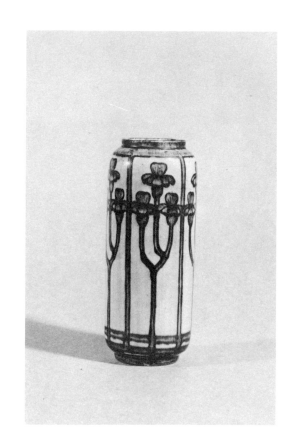

**210 Vase**
Newcomb College Pottery, New Orleans, La., ca. 1904–10
Pottery, painted with design of iris flowers in tones of blue and blue-green; glossy glaze
Executed by Anna Frances Simpson (Joseph Meyer, potter)
Height: 12³⁄₁₆"
Marks: impressed cypher of *N* within a *C*, cypher of conjoined *JM, K*; painted, *AFS, DI, DO-15.*

According to P. E. Cox ("Newcomb Pottery," p. 142), Miss Simpson was "a prolific but less inspired designer" than Sadie Irvine. Neither of these artists is listed in Barber's *Marks of American Potters* (1904), thus suggesting that they joined the decorating staff somewhat later. The prolific nature of both artists' work is shown by the frequency with which their initials appear on the later products of the Newcomb Pottery.

Private collection

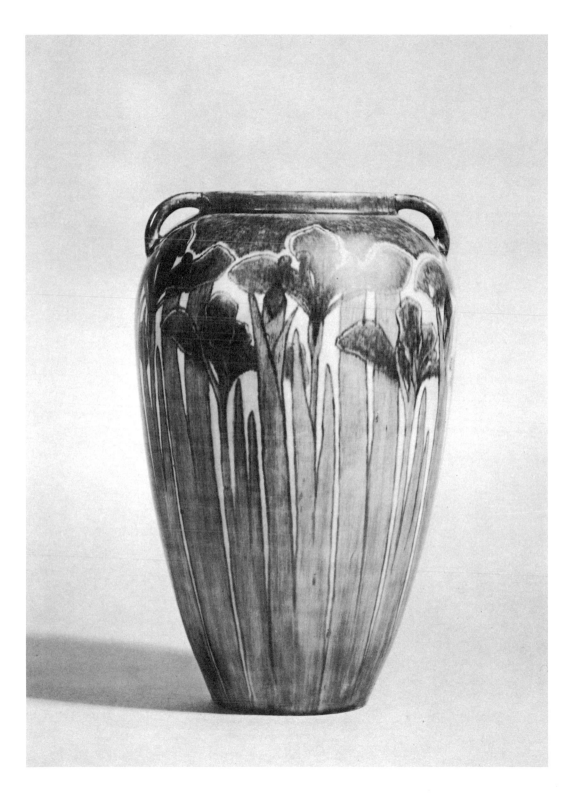

**211 Mug**
Newcomb College Pottery, New Orleans, La., ca. 1900–10
Pottery, painted with decoration of highly conventionalized seed pods in tones of green and buff; glossy glaze
Height: 6¼"
Marks: impressed cypher of *N* within a *C*, cypher of conjoined *JM*; incised *W*; painted cypher of conjoined *WL*, *D'34X*, *1* within a shield

This type of three-handled mug or tyg was not an uncommon shape for Newcomb; cf. *Craftsman*, III (1902), p. 197.

The Art Museum, Princeton University

**212 Vase**
Newcomb College Pottery, New Orleans, La., ca. 1900–10
Executed by Sewells (Joseph Meyer, potter)
Pottery, incised and painted with design of a conventionalized magnolia blossom in tones of green and white; glossy glaze
Height: 12"
Marks: impressed cypher of *N* within a *C*, cypher of conjoined *JM*, *W*; incised *Sewells*

Brooklyn Museum, Dick S. Ramsay Fund

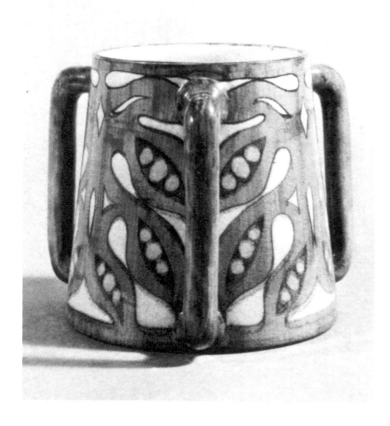

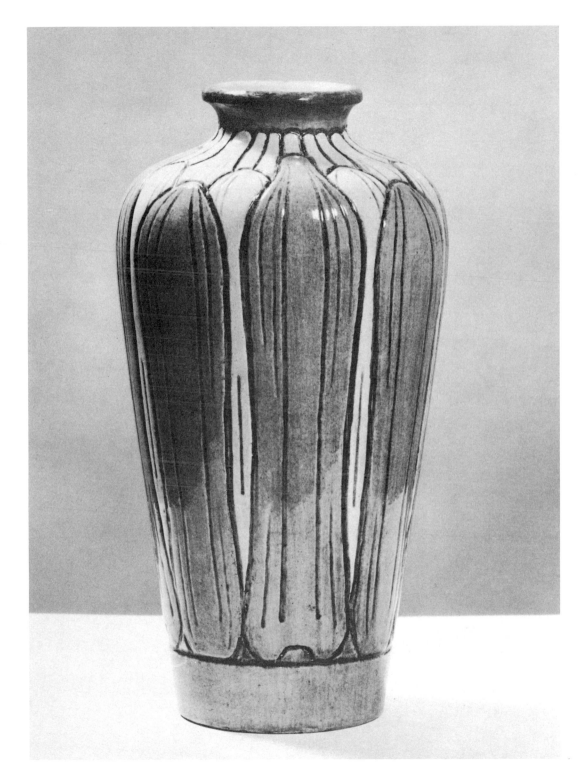

**213 Vase**
Newcomb College Pottery, New Orleans, La., probably after 1910
Executed by Sadie Irvine
Pottery, incised and decorated with a design of stylized blossoms in tones of blue and gray; semi-mat glaze
Height: 6⅞"
Marks: impressed cypher of *N* within a *C*; incised cypher of conjoined *SI, KS, UQ88*; original paper label, *NEWCOMB COLLEGE DESIGNS ARE NOT DUPLICATED/ Subject _____/ No. UQ88 Price $6⁰⁰/ NEW ORLEANS.*

According to Miss Irvine, she joined the decorating staff of the pottery sometime between 1910 and 1912. As mentioned above (entry 210), she is one of the better-known decorators from Newcomb's later phase and is particularly noted for her scenes of bayous with a moon appearing through trees laden with Spanish moss. Kenneth Smith, who may have potted the vase, was employed by Newcomb as chief ceramist.

Cincinnati Art Museum, gift of Mary G. Sheerer

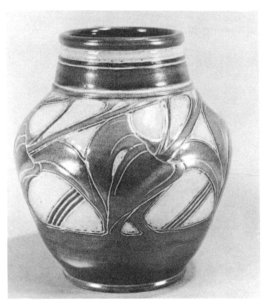

**214 Vase**
Newcomb College Pottery, New Orleans, La., after 1910
Executed by an artist with the initials *CL* or *LC* (Joseph Meyer, potter)
Pottery, incised and painted with decoration of pine trees in tones of blue and green; mat glaze
Height: 9"
Marks: impressed cypher of *N* within a *C*, cypher of conjoined *CL*, *C* within a circle, *68;* painted, *Q014*

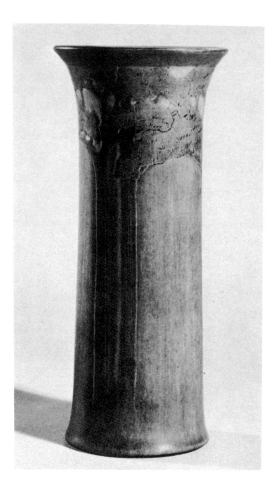

Although it is difficult to date the later work of Newcomb College with any exactitude, the vase seems to be a relatively early example of their mat-glazed ware. This is suggested by the way that some of the marks are reinforced with blue in accordance with the practice seen on the glossy glazed ware, as well as by the fact that the work is still finely executed and the trees have a firm, rectilinear quality.

Private collection

## Ohio pottery after 1900

Pottery produced in Ohio after the turn of the century showed ingenuity and diversity in dealing with the question of a modern style. Leading the way, as before, was the Rookwood Pottery. While not completely abandoning the "Standard" underglaze decoration, it enlarged the color range. As far back as 1894, it had developed what were called "Iris," "Sea Green," and "Aerial Blue" lines, that is, underglaze decorations in color ranges of light blue-gray, green, and blue respectively. The gradual change from dark, Rembrandtesque effects to lighter, clearer tones paralleled contemporary developments in the art of easel painting, and was also to be found in European pottery of the time.

Of greater consequence, perhaps, was the experimentation with mat glazes, an idea that had been suggested by Artus Van Briggle, a young decorator about whom more is said later in this catalogue. The mat glazes were used not only for painting designs but also to cover modeled forms, an innovation for which Van Briggle may again have been responsible.

Besides the wider variety of techniques, Rookwood also began to experiment with the stylization of decoration. Under the leadership of Van Briggle and W. P. McDonald, both of whom had recently been in Europe, there was a gradual intrusion of Art Nouveau elements, such as plants stylized in rhythmically repeating curves, and women with swirling hair. Also, after the turn of the century, they began using a simpler and what might almost be considered a more American form of conventionalization, in which the decorative motifs are abstracted in a rigid, more mathematical way. Rookwood also used incised designs based on American Indian pottery—an interest that was shared by a great many other craftsmen. By about 1910 one can see a gradual cohesion of style in favor of the new lighter colors and mat finishes on vases of simple shape decorated with a kind of gentle naturalism or simple, more conventionalized border decorations.

Although the commercial factories of Zanesville aimed at making "art pottery" at cheap prices for

commercial profit, they nonetheless produced wares in the first decade of this century that are worthy of attention. Being so close to Cincinnati, they were naturally tempted to imitate Rookwood's latest developments. For example, in response to that pottery's Iris glaze, Owens had a "Lotus" line, Weller produced an "Eocean" ware, and Roseville countered with "Rozane Royal Light."

The Zanesville firms were equally open to ideas from the East coast and from Europe. Aware of the great popularity of iridescent pottery in Europe and of iridescent glass, Weller in 1901 hired Jacques Sicard, a French ceramist who had worked with Clement Massier and had learned his master's secrets of iridescent glaze. The resulting "Sicardo" ware proved to be a great critical success. Sometimes the results of Continental emulation were less than satisfactory, as in the case of Weller's "L'Art Nouveau" line. As the name suggests, it was created in what was believed to be modern French style; but neither the actual designs—such as women enframed by arabesques of leaves and flowers—nor the bisque pink and gray finish had any artistic merit. On the other hand, about the same time Weller introduced a series with modeled animal forms and interesting mat glazes which, though it was given less publicity, nonetheless shows great ingenuity. There was an almost bewildering array of new lines and a staggering volume of production. Weller's factory, which he claimed was the largest in the world, spread over three hundred thousand feet of floor space and had six hundred employees.

One of the progressive forces in Zanesville was Frederick Hurten Rhead who, having just come from England, brought with him a more certain sense of modern design. He began working for Weller in 1902 and created various lines, such as "Jap Birdimal" in which natural forms were brilliantly conventionalized. At the same time Rhead wrote articles on design for *Keramic Studio,* one of the country's leading craft journals. Rhead left Weller in 1904 to become art director for the Roseville Pottery, where he remained for the next four years. Again, he developed a number of creative new lines, such as the misnamed "Della Robbia"

and "Aztec" with conventionalized decoration excised or applied to the shapes. But for a truer picture of the times, it should be remembered that Rhead also developed an "Olympic" line for Roseville which consisted of pastiches of classical figures. In all these potteries cost was an essential consideration. Whereas Rookwood had developed a distinguished product and could maintain the tradition of hand-worked ceramics, more commercial concerns like Weller and Roseville had to forsake the luxury of complicated designs and techniques introduced by Rhead in favor of simple molded and printed wares, thus leading to the artistic decline of the Zanesville potteries after World War I.

The production of tiles was quite as important to the Ohio pottery industry as vases. Ceramic decoration of buildings was extremely popular during this period, for architects at the turn of the century were particularly fond of the enriching effects of colored tiles. One of the new major companies in this field was the Mosaic Tile Company of Zanesville, which was founded in 1894 by Karl Langenbeck, the noted ceramic chemist, Herman Mueller, a sculptor, and William Shinnick. As the name of their company implies, one of its first products was an inexpensive tile simulating mosaic. However, under the influence of Grueby, whose main business was architectural faience, the tile industry followed suit and began producing mat-glazed tiles. Even Rookwood opened a department of architectural faience in 1902. Mueller and Langenbeck left the Mosaic Tile Company in 1903. Mueller went to work for a while at the Robertson Art Tile Company in Pennsylvania, a firm founded by George W. Robertson, brother of Hugh C. Robertson. In 1908 Mueller established his own firm, called the Mosaic Tile Company, in Trenton, New Jersey, while in the same year Langenbeck went to the Grueby Faience Company in Boston.

### 215 Vase

Rookwood Pottery, Cincinnati, Ohio, 1899
Executed by William P. McDonald
Pottery, incised and painted with a design of conventionalized cyclamen plants in tones of brown, yellow-green, and dark green; glossy glaze
Height: 5⅜"
Marks: impressed cypher of conjoined *RP* surmounted by thirteen flames, *S1546;* incised *WMcD*

In 1898 the artist was given two hundred dollars by the Rookwood company for a trip to Europe, and was also granted a leave of absence with pay for seventeen weeks. As is evident from this vase, he seems to have been deeply influenced by the Art Nouveau style emerging on the Continent. The whiplash energy of the stems and leaves, and even the choice of the flower motif—the cyclamen—parallels avant-garde French work.

Cincinnati Art Museum, gift of Walter Schott, Margaret Schott, Charles Williams, Lawrence Kyte

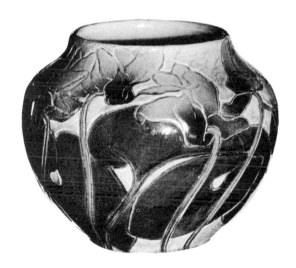

**216 Vase**
Rookwood Pottery, Cincinnati, Ohio, 1900
Designer: William P. McDonald
Pottery, with molded design of a woman; mat
white and light blue glazes
Height: 5½"
Marks: impressed cypher of conjoined *RP* sur-
mounted by fourteen flames, *T1228;* incised cypher
of conjoined *WMcD*

Although it is Van Briggle's name that is primarily
associated with the introduction of modeled de-
signs at Rookwood, William McDonald seems
to have been equally interested in such work.
Actually, there may have been an interchange
between them, especially since McDonald was the
more recent visitor to Europe. Whatever the
situation, Van Briggle's departure for Colorado in
1899 left McDonald to create a series of designs
for Rookwood with women in flowing, diaphanous
veils or modeled so that they merged fluidly
into the wall of the vessel. Some closely paralleled
Van Briggle's designs executed at the same time
in Colorado. The *T* prefix for the model number
of this particular vase indicates that it was a trial
piece; it is not certain that the design was put
into regular production.

Private collection

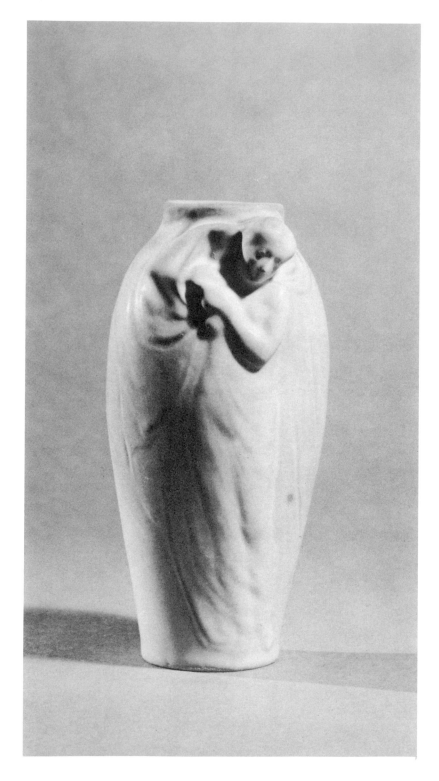

**217 Vase**
Rookwood Pottery, Cincinnati, Ohio, 1901
Executed by Kataro Shirayamadani
Pottery, with modeled and painted decoration of
geese; mat green, white, and tan glazes
Height: 10½"
Marks: impressed cypher of conjoined *RP* sur-
mounted by fourteen flames, *I, 892B;* incised signa-
ture of artist in Japanese characters

The vase, with its delicate carving and bright
coloring, is an example of the interesting experi-
ments being carried out at Rookwood at the turn
of the century. This type of carved ware (not to
be confused with cast, relief designs) was never
pursued, presumably because of the labor and ex-
pense involved. Whereas the graceful, long-necked
swan was a popular motif among the British
aesthetes and Continental Art Nouveau designers,
the homely and humorous goose was a more
popular subject at Rookwood; a vase somewhat
similar to this had been made around 1898, when
it was illustrated by J. Valentine, "Rookwood
Pottery," p. 121.

*Private collection*

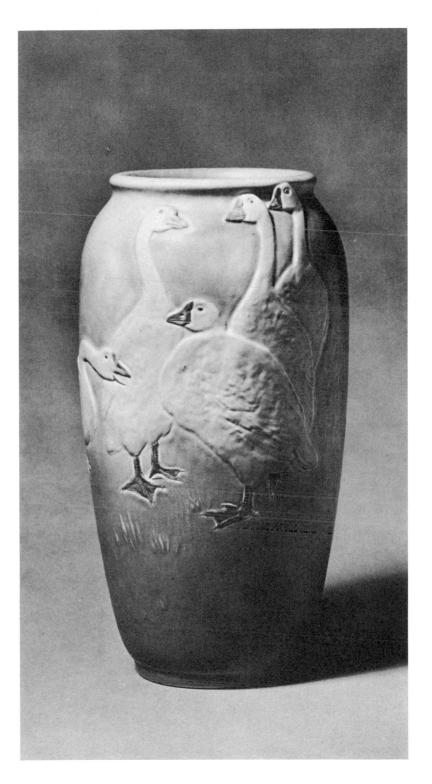

**218 Vase**
Rookwood Pottery, Cincinnati, Ohio, 1901
Executed by Mary Nourse
Pottery, with painted decoration of daffodils; mat
blue, white, yellow, and ocher glazes
Height: 5⅜"
Marks: impressed cypher of conjoined *RP* sur-
mounted by fourteen flames, *I, 31DZ;* painted,
*MN;* original paper label, *ROOKWOOD/
POTTERY/* cypher of conjoined *RP/ PAN AMERI-
CAN/ EXPOSITION/ BUFFALO 1901*

It was at the Pan-American Exposition in Buffalo
that Rookwood officially introduced its new line of
decorated, mat-glazed vases. The mat glazes
they had previously developed could not be suffi-
ciently controlled to allow the painting of fine
details. This drive toward mat surfaces was likened,
interestingly enough, to a preference in photog-
raphy for mat prints as against glossy ones.

Museum of Modern Art, New York

**219 Vase**
Rookwood Pottery, Cincinnati, Ohio, 1901
Executed by John D. Wareham
Pottery, with modeled and painted decoration of
poppy seed pods; green, red, purple mat glazes
Height: 7½"
Marks: impressed cypher of conjoined *RP* sur-
mounted by fourteen flames, *I, 905 D;* incised *JDW*

The development of a type of glaze did not neces-
sarily govern its use. Both this and the preceding
vase are examples of the new mat ware; but
Miss Nourse was continuing with the more tradi-
tional, naturalistic approach at the same time
that John D. Wareham was working in a purely

Art Nouveau vein. Like William McDonald, with
whom he was friendly, Wareham had been
granted two hundred and fifty dollars in 1898 to
travel to Europe, and his designs in the following
years are among the most striking at Rookwood.
In 1902 he was appointed head of the decorating
department, and ultimately he became president of
the Rookwood Pottery.

Museum of Modern Art, New York

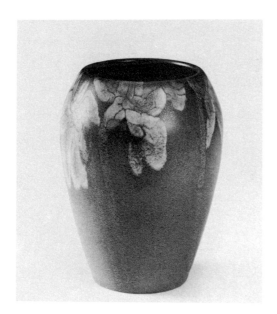

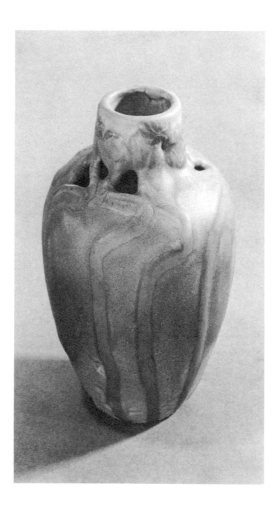

**220 Vase**
Rookwood Pottery, Cincinnati, Ohio, 1904
Executed by Charles Schmidt
Pottery, with painted underglaze decoration of
peacock feathers in tones of blue, green, yellow,
and black
Height: 10¾"
Marks: impressed cypher of conjoined *RP* sur-
mounted by fourteen flames, *IV, 940C, W;* incised
cypher of conjoined *CS* within a circle; original
paper label, *ROOKWOOD POTTERY/ CINCINNATI
USA/ 1904/ LOUISIANA PURCHASE/ EXPOSITION.
ST. LOUIS*

Underglaze painting continued to be a favored
mode at the Rookwood factory, although with
the coming of a lighter palette, the Iris and Sea
Green lines gradually superseded the Standard
ware. This vase was probably classified as "Dark
Iris," a distinction maintained for only a few years.
The treatment was similar to the Iris ware but,
as the name implies, the background color was
darker, often going to a luminous black. Although
the peacock feather was another of the pervasive
motifs of the Art Nouveau movement and offered
great possibilities for stylization, it is presented
here in a relatively naturalistic way—reminding us
once again of conservative tastes at Rookwood
and, even more, in America at large.

Cooper-Hewitt Museum of Decorative Arts and
Design, Smithsonian Institution, gift of J. Lionberger
Davis (whose family bought the vase at the St.
Louis Exposition)

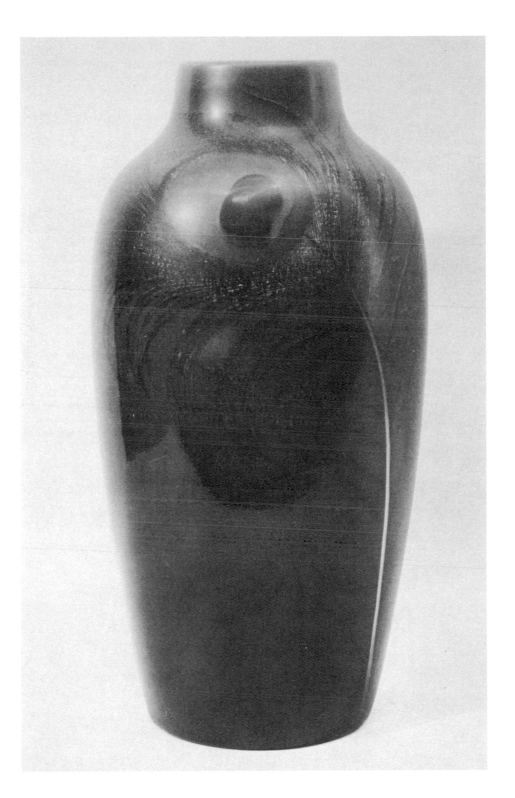

**221 Inkwell and pen tray**
Rookwood Pottery, Cincinnati, Ohio, 1906
Designer: Kataro Shirayamadani
Pottery, with molded design in form of a conventionalized water lily blossom and pad; green and blue-green mat glazes
Height: 3", length: 7¾₆"
Marks: impressed cypher of conjoined *RP* surmounted by fourteen flames, *VI, 1208*

The name of the designer is recorded in the Rookwood shape book.

Mr. and Mrs. Julius Gold

**222 Vase**
Rookwood Pottery, Cincinnati, Ohio, 1911
Executed by Sara Sax
Pottery, with painted underglaze decoration of conventionalized peacock feathers in varied tones of brown, yellow, orange, green, and brown; mat glaze
Height: 7¾₆"
Marks: impressed cypher of conjoined *RP* surmounted by fourteen flames, *XI, 939D, V;* incised cypher of conjoined *SAX;* original price sticker, cypher of conjoined *RP/ REMOVE/ ONLY WHEN/ SOLD/ $15*

Another new type of glaze developed by Rookwood was the "Vellum." The Vellum line was actually underglaze painting covered with a transparent, mat glaze. This offered the benefit of fine detail possible only with underglaze painting, as well as the highly desired effect of a soft, mat surface. Unlike the preceding vase, the peacock feather here is a rigid conventionalized design which is consistent with developments in America at the end of the first decade of the century. It could be compared, for example, with the style of Marblehead pottery.

Newark Museum

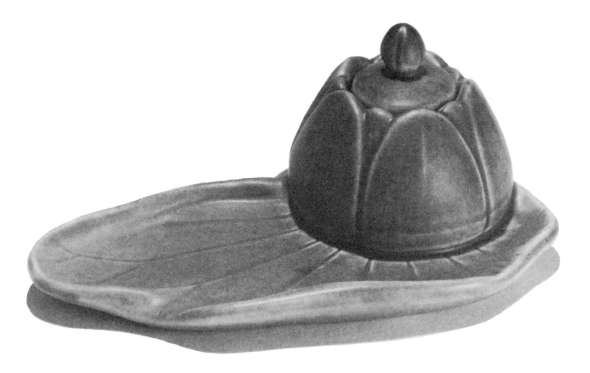

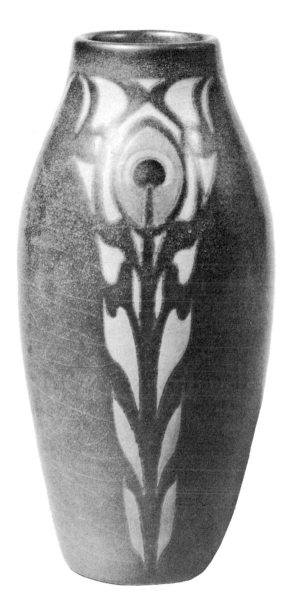

**223 Tea tile**
Rookwood Pottery, Cincinnati, Ohio, 1910
Pottery, with molded design of a sailing ship;
green, blue-green, brown, and ocher mat glazes
Width: 6⅞", length: 6⅞"
Marks: impressed cypher of conjoined *RP* sur-
mounted by fourteen flames, *X,* in an oval
*I.M.&T.D.A./ CHICAGO 1910/ COMPLIMENTS OF
THE/ ROOKWOOD POTTERY CO.*

Sailing ships were a popular motif in British and
American art, perhaps because they recalled that
wholesome era before industrialization that the
Arts and Crafts movement sought to revive.

Private collection

**224 Tile**
Rookwood Pottery, Cincinnati, Ohio, ca. 1910–11
Pottery, with molded and painted decoration of a crow on a tree branch, and the word *ROOK-WOOD*; blue, brown, green, and tan mat glazes
Height: 4½", width: 8¾"
Marks: original price sticker, cypher of conjoined *RP/ REMOVE/ ONLY WHEN/ SOLD/ $3*

Although this tile, acquired by the Newark Museum in 1911, was obviously intended for display or advertising, it nonetheless was sold independently. The crow, also called a rook, was the symbol of the firm.

Newark Museum

**225 Vase**
S. A. Weller, Zanesville, Ohio, ca. 1901–07
Executed by Jacques Sicard
Pottery, with molded decoration of leaves and painted design of honeysuckle blossoms; iridescent glaze in tones of gold, purple, and green
Height: 5½"
Marks: impressed *WELLER*; incised *53*

In Zanesville, Sicard worked with an assistant, Henri Gellie. As the legend goes, they spoke to each other in Swiss French to maintain the secret of the iridescent glaze formula, thus preventing Weller from producing it on his own. The forms of the vases, however, were those developed by the company. For example, this model, but without the crimped top, was also used for Weller's "Etched-Matt" line (illustrated by L. Henzke, *American Art Pottery*, p. 95).

Private collection

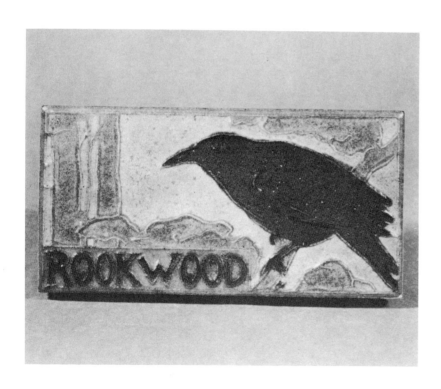

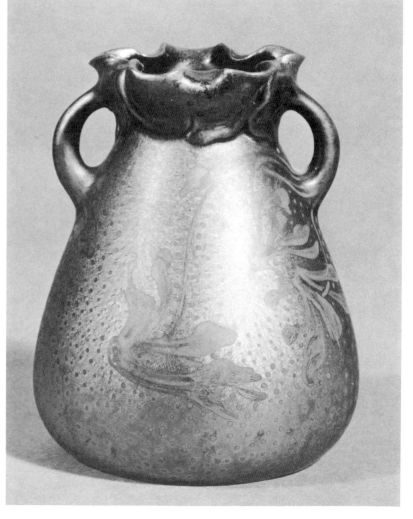

**226 Plaque**
S. A. Weller, Zanesville, Ohio, ca. 1902–04
Designer: Frederick H. Rhead
Pottery, with painted underglaze decoration of
conventionalized poppy flowers and seed pods in
tones of brown, green, blue, and white; glossy
glaze
Diameter: 10½"
Marks: incised *Weller Faience;* incised sgraffito on
front side, *Rhead*

The technical process here is essentially the
Standard underglaze method save that the white
contour lines are in slip applied with a squeeze
bag. Typical of the compromises that had to be
made at commercial factories producing art
pottery, the decoration was done by hand but
production was not restricted to one example.
Moreover, this striking Art Nouveau design was
adapted for other items such as mugs and condi-
ment sets.

Private collection

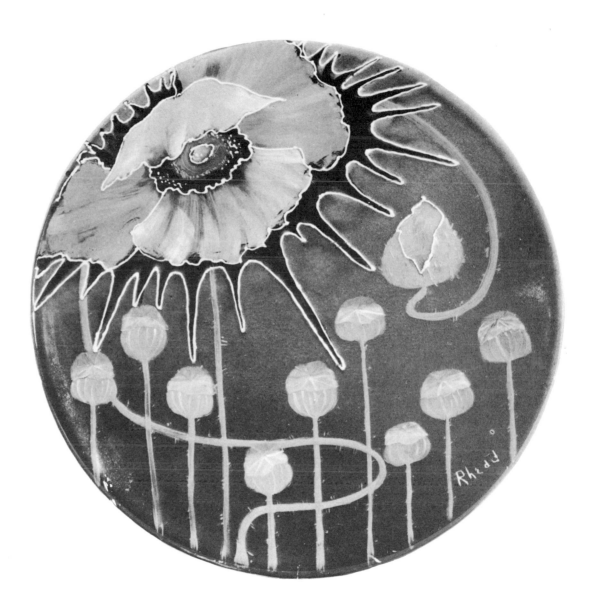

**227 Vase**
S. A. Weller, Zanesville, Ohio, ca. 1905
Pottery, with a molded design of a curling snake
and a frog; light green mat glaze
Height: 7¾"
Mark: impressed *WELLER*

This example of Weller's excursion into the field
of molded design was obtained by Marcus
Benjamin on his visit to the factory in 1905 and is
illustrated in his report in *Glass and Pottery World,*
March 1907, p. 13.

National Museum of History and Technology,
Smithsonian Institution, gift of Dr.
Marcus Benjamin

**228 Vase**
S. A. Weller, Zanesville, Ohio, ca. 1905
Pottery, with a molded design of conventionalized
leaves and beetles; blue-gray and brown mat glazes
Height: 5"
Marks: impressed *WELLER*

Their appearance in Japanese art made insects
a popular motif with French Art Nouveau designers
such as Gaillard and Verneuil. Although they are
used successfully here, they were less common in
American designs. When the editors of *Keramic
Studio* presented an up-to-date pattern of conven-
tionalized insects for home decorators to follow,
an irate subscriber complained that she would
no more decorate plates with insects than she
would eat food containing them.

Private collection

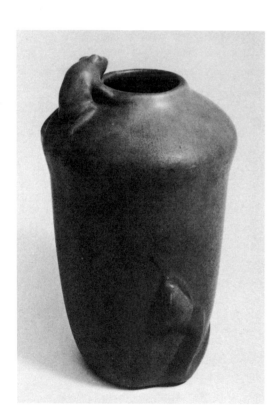

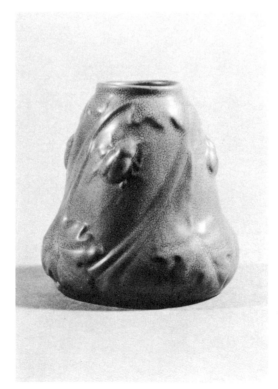

**229 Vase**
Roseville Pottery Company, Zanesville, Ohio, ca. 1906–08
Designer: Frederick H. Rhead
Executed by W. Meyers
Pottery, with incised and painted underglaze decoration of conventionalized flowers and leaves in tones of blue, green, yellow, and orange; glossy glaze
Height: 11"
Marks: raised disk with *ROZANE WARE* in relief; incised *W.M.;* incised on side of vase, *W.M.*

This is an example of Rhead's Della Robbia line. The association with the famous Renaissance family of ceramic sculptors, barely justified by qualities of texture and colors, certainly does not apply to the Art Nouveau design. The model is illustrated in the 1906 catalogue of the Roseville Pottery Company where it is listed as "No. 6. 11½ inches high. $16.00 each."

Private collection

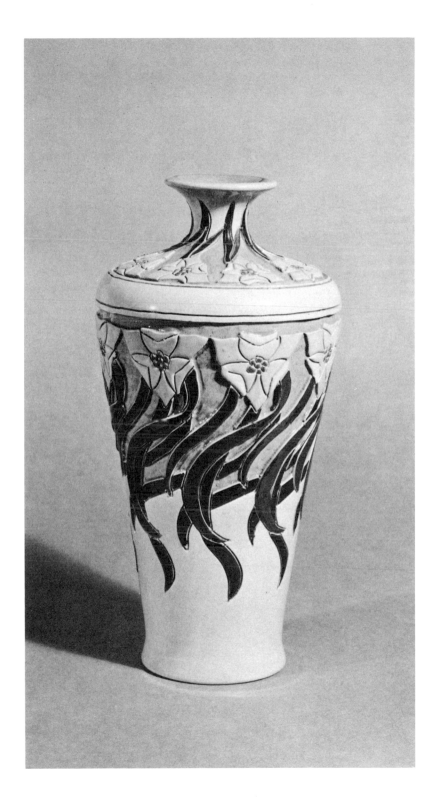

**230 Vase**
Roseville Pottery Company, Zanesville, Ohio, ca. 1906–08
Designer: Frederick H. Rhead
Executed by an artist with the initials *C.H.*
Pottery, with incised and painted underglaze decoration of conventionalized cypress trees in tones of brown and buff; glossy glaze
Height: 10½″
Marks: raised disk with *ROZANE WARE* in relief; incised on side of vase, *C.H.*

This design was created prior to the inception of Roseville's Della Robbia line; it appeared in an article by Rhead and W. P. Jervis in *Keramic Studio,* VI (December 1904), p. 166.

Private collection

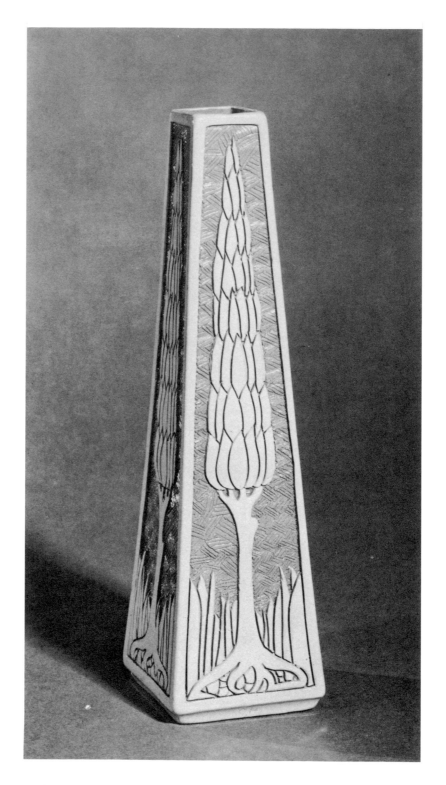

**231 Tile**
Mosaic Tile Company, Zanesville, Ohio, ca.
1905–15
Pottery, with molded design of elephant standing
on a ball containing the company monogram
of conjoined *MTC*; beige, blue, black, brown, and
green mat and semi-mat glazes
Height: 5″, width: 5″
Mark: impressed cypher of conjoined *MTC* in a
circle

Carol Ferranti Antiques

**232 Waterspout**
Mueller Mosaic Tile Company, Trenton, N.J., ca.
1910
Pottery, a molded turtle with brown and green
mat glazes
Width: 6″, length: 6″, height: 3½″

National Museum of History and Technology,
Smithsonian Institution, gift of E. Stanley Wires

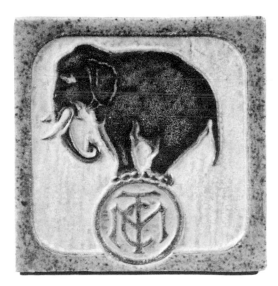

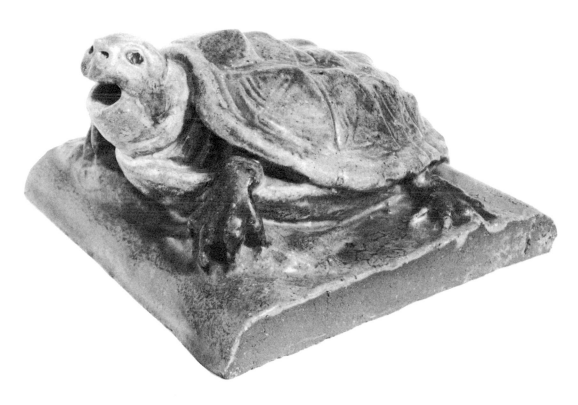

## Van Briggle

The work of Artus Van Briggle (1869–1904) marks a high point of the Art Nouveau style in American pottery. Born and raised in Felicity, Ohio, the son of a maker of wooden stirrups, Van Briggle decided on a career as a painter, thereby reverting to a family tradition (he claimed descent from none other than Pieter Bruegel the Elder). At the age of seventeen he went to study at the Academy of Art in Cincinnati. To support himself, he found odd jobs, first painting dolls' heads and, then, vases at the newly founded Avon Pottery. He thus entered the world of ceramics almost accidentally. With the closing of the Avon Pottery (1887) and the growing success of the Rookwood Pottery, it was only natural that he should go to work for the latter firm. Little distinguishes his work in these years from that of the other decorators working for Rookwood; most of the pieces have the floral underglaze decoration associable with the company at the time. Van Briggle did not give up his aspirations for a career as a painter and, in fact, one of his paintings was exhibited at the Chicago World's Fair in 1893. This success encouraged Mrs. Storer and the Rookwood Pottery to grant him a scholarship for two years' study in Paris.

Thus, in the latter part of 1893, in Paris, he enrolled in the institution beloved of all aspiring American artists, the Académie Julian. While he won prizes for his drawings and paintings, we are more interested to know that he took courses in sculpture that involved modeling in clay. The Paris experience was of importance in other ways as well; apparently Van Briggle was deeply impressed with the oriental glazes he saw at the Musée des Arts Décoratifs and at the Sèvres Museum. We must also presume that he was fully aware of the Art Nouveau idiom just then flourishing in the French decorative arts.

Van Briggle's scholarship was extended for a third year, so it was not until 1896 that he returned to Cincinnati. By then he was engaged to another American student he had met in Paris, Anne Louise Gregory. He resumed a busy schedule as a painter and as a Rookwood decorator. He also continued his personal experiments at home with a small kiln that Mrs. Storer had given him. Although his official work for Rookwood was in underglaze painting, in both the Standard and the newly developed Iris glaze, his private experiments centered on recapturing the secret of Chinese "dead" or mat glazes. By the fall of 1898 he had achieved some success. His decorative effects also began to change with the introduction of painted figures in which there are recollections of the modern style that he had seen in Paris. He is reputed to have modeled one vase on which the figure of a woman gradually merged into the surface in the French mode.

Much of Van Briggle's achievements during this time foreshadows developments at Rookwood after the turn of the century, so that in one way Rookwood Pottery had a good return for the money it had invested in him. On the other hand, they must have felt disappointment when, owing to failing health, he resigned in March 1899, a scant three years after his return from Paris.

Van Briggle was suffering from tuberculosis and it had been suggested to him that the air and climate of Colorado would be beneficial. Once there he resumed his experiments, now utilizing local clays and minerals. He was assisted by Professor Strieby, the head of the Department of Chemistry and Metallurgy at the University of Colorado. By 1901 Van Briggle had established his own small studio and some three hundred vases were ready for the commercial market by Christmas of that year. By the spring of the following year a stock company was formed and work proceeded on an enlarged scale.

From this point on Van Briggle's work shows the unmistakable influence of European Art Nouveau design. Not only are the floral and animal motifs conventionalized but they are often arranged with flaring curves and charged with dynamic rhythm. He frequently incorporated the human figure, male and female, in his designs and while contemporary critics likened this to the work of Rodin, it should also be seen as a reflection of Continental Art Nouveau design. An important aspect of his work is the way that the decoration is not simply applied to the vessel but is subtly sculpted as an integral part of it. His glazes are in a variety of soft, bleeding colors, often with refined and delicate commingling of tones. Of course, others besides Van Briggle, including his wife whom he married in 1902, designed the models, but his own work was unquestionably the most outstanding. Unlike so many other art potteries of the time which emphasized the handmade quality of each piece, Van Briggle cast his models in many examples, "the repetition of a fine, slowly-developed model being regarded by Mr. Van Briggle as far preferable to the execution in each case of a new idea which often entails careless and inartistic work."

By the fall of 1902 the first important shipment of pieces to Eastern cities had been greeted with critical and commercial success. In the following year Van Briggle began exhibiting at, for example, the Craftsman Building in Syracuse and the Salon des Artistes Françaises in Paris. The latter exhibit, slightly enlarged, was sent on to St. Louis in 1904 for the Louisiana Purchase International Exposition. There, the Van Briggle Pottery was awarded many medals. But the announcement of the awards in the latter part of 1904 came too late to reach Van Briggle, whose health had steadily deteriorated and who had died on July fourth of that year. The company continued production under the direction of his wife and, because of its growing success, a new and larger plant was built in 1907. The company is still in operation today and, in fact, continues to produce some of the original models.

**233 Vase**
Van Briggle Pottery Company, Colorado Springs,
Colo., 1902
Designer: Artus Van Briggle
Pottery, with molded relief of conventionalized
narcissi; light green mat glaze
Height: 10½"
Marks: incised cypher of conjoined *AA* within a
trapezoid, *VAN BRIGGLE, 1902, III*

Van Briggle's work in Colorado is all highly Art
Nouveau in style, yet his designs of 1901 have
more complicated rhythms and a deeper sculp-
tural approach than his work of a year or two later.
This vase was executed in 1902 but its rich design
was created the previous year, when it was
illustrated by G. Galloway, "The Van Briggle Pot-
tery," p. 2.

National Museum of History and Technology,
Smithsonian Institution, gift of the Van Briggle
Pottery Company

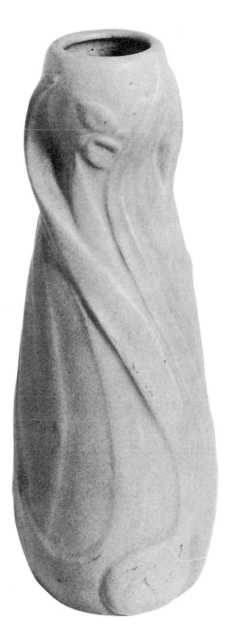

**234 Vase**
Van Briggle Pottery Company, Colorado Springs,
Colo., 1902
Designer: Artus Van Briggle
Pottery, with molded relief of conventionalized
iris plants; dark blue and green mottled mat glazes
Height: 4½"
Marks: incised cypher of conjoined *AA* within a
rectangle, *1902, III;* impressed *26*

Private collection

**235 Plate**
Van Briggle Pottery Company, Colorado Springs,
Colo., 1902
Designer: Artus Van Briggle
Pottery, with molded design of conventionalized
poppy flowers and leaves; light green mat glaze
Diameter: 8⅝"
Marks: incised cypher of conjoined *AA* within a
rectangle, *1902, III;* impressed *20*

Private collection

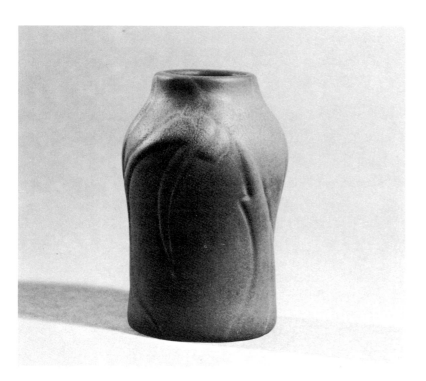

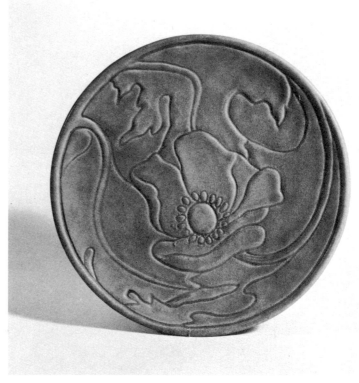

**236 Vase**
Van Briggle Pottery Company, Colorado Springs, Colo., 1903
Designer: Artus Van Briggle
Pottery, with molded relief design of conventionalized daffodils; yellow, aqua, and magenta mat glazes
Height: 9½"
Marks: incised cypher of conjoined *AA* within a rectangle, *VAN BRIGGLE, 1903, III;* incised *161;* original paper label, *N° 5308/ $12* [partially effaced], *$8.°°/ P 161*

This model was illustrated in 1903 by I. Sargent, "Chinese Pots and Modern Faience," opp. p. 415.

National Museum of History and Technology, Smithsonian Institution, gift of the Van Briggle Pottery Company

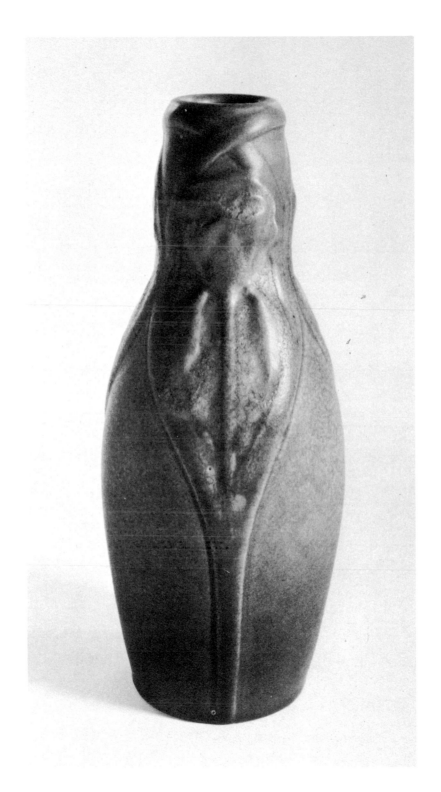

**237 Vase**
Van Briggle Pottery Company, Colorado Springs,
Colo., 1903
Designer: Artus Van Briggle
Pottery, with molded design of conventionalized
convolvulus flowers and leaves; yellow mat glaze
Height: 12″
Marks: incised cypher of conjoined *AA* within a
rectangle, *VAN BRIGGLE, 1903, III*

Private collection

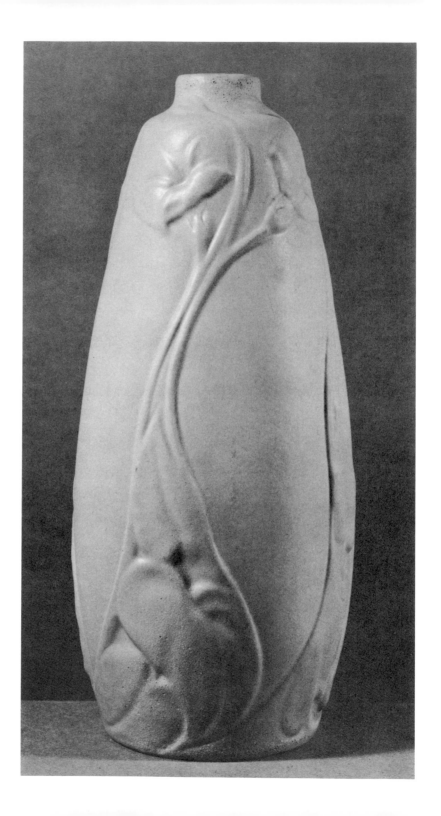

**238 Vase**
Van Briggle Pottery Company, Colorado Springs,
Colo., 1903
Designer: Artus Van Briggle
Pottery, with molded design of conventionalized
flowers and leaves; green and red mat glazes
Height: 11⅚₁₆″
Marks: incised cypher of conjoined *AA* within a
rectangle, *VAN BRIGGLE, 1903, III*; impressed *233*

Newark Museum, from the estate of
John Cotton Dana

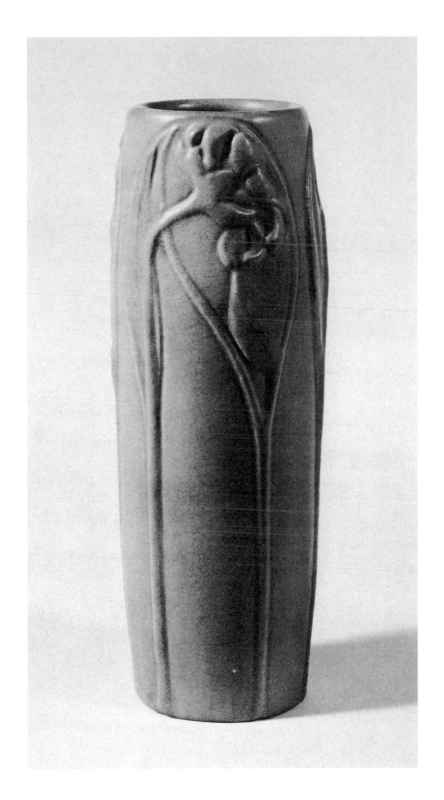

**239 Vase**
Van Briggle Pottery Company, Colorado Springs, Colo., 1903
Designer: Artus Van Briggle
Pottery, with molded design of conventionalized swans' heads; yellow-green and light blue mat glazes
Height: 7¼"
Marks: incised cypher of conjoined *AA* within a rectangle, *VAN BRIGGLE, 1903, III;* impressed *5B*

This vase is believed to have come from the collection of Elbert Hubbard. It, or at least one of the same model, was exhibited at the Syracuse Arts and Crafts Exhibition in the spring of 1903 and was illustrated that year by I. Sargent, "Chinese Pots and Modern Faience," opp. p. 414, and by W. G. Bowdoin, "Some American Pottery Forms," p. 88. The design was already in production in 1902; see *Du,* XXXI (June 1971), p. 456, and R. E. Bayer, "Van Briggle Pottery," *Western Collector,* VII (1969), p. 113.

Macklowe Gallery

**240 Vase**
Van Briggle Pottery Company, Colorado Springs, Colo., 1903
Designer: Artus Van Briggle
Pottery, with molded relief of conventionalized flowers and buds; lavender semi-mat glaze
Height: 10"
Marks: incised cypher of conjoined *AA* within a rectangle, *VAN BRIGGLE, 1903, III;* impressed *135;* painted, *II*

Private collection

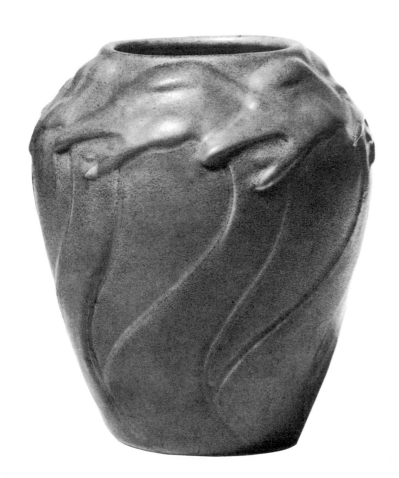

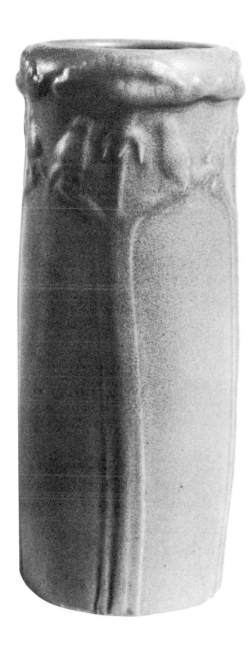

**241 Vase**
Van Briggle Pottery Company, Colorado Springs, Colo., 1903
Designer: Artus Van Briggle
Pottery, with molded relief of conventionalized flowers and leaves; mottled red semi-gloss glaze
Height: 5⅞"
Marks: incised cypher of conjoined *AA* within a rectangle, *VAN BRIGGLE, 1903, III;* impressed *95;* painted, *VIII*

Private collection

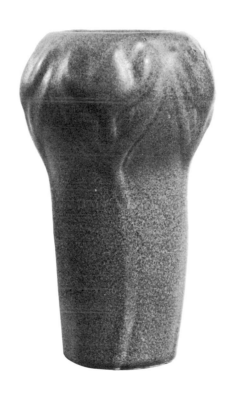

**242 Vase**

Van Briggle Pottery Company, Colorado Springs, Colo., 1904
Pottery, with molded decoration of conventionalized leaves; dark and mottled light green mat glazes
Height: 15"
Marks: incised cypher of conjoined *AA* within a rectangle, *VAN BRIGGLE, 1904;* impressed *106;* original paper label, *5915/ $50°°* [partially effaced]/ *P106;* paper label, *20°°*

This model was illustrated in a report on the 1903 Arts and Crafts exhibit at the Craftsman Building in Syracuse, *Keramic Studio,* V (June 1903), p. 37, and also by I. Sargent, "Chinese Pots and Modern Faience," opp. p. 415.

National Museum of History and Technology, Smithsonian Institution, gift of the Van Briggle Pottery Company

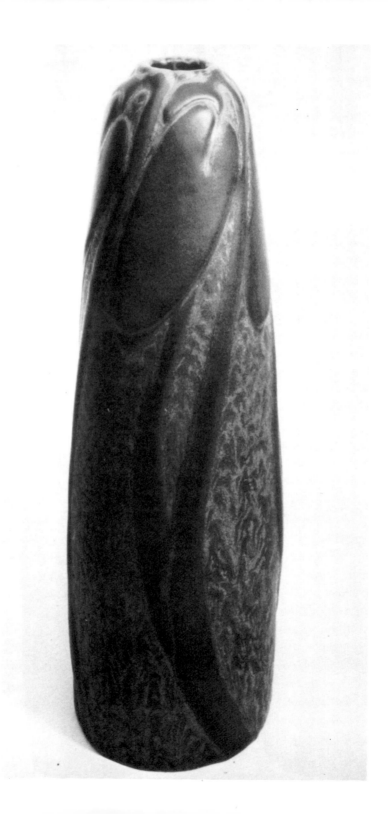

**243 Vase**

Van Briggle Pottery Company, Colorado Springs, Colo., 1904
Pottery, with aqua mat glaze; bronze mounting of conventionalized mistletoe with seed pearl berries
Height: 8½"
Marks: incised cypher of conjoined *AA* within a rectangle, *VAN BRIGGLE, 1904, V*; impressed *275*

As was noted by Clara Ruge in 1906, "His [Van Briggle's] studies in France also led him to introduce a novelty to America—the combination of pottery and metal work. Whenever he felt that a touch of jewellery would add to the beauty of his creation, he adorned his potteries with the precious and semi-precious stones of Colorado" ("American Ceramics—A Brief Review of Progress," p. xxvii).

Private collection

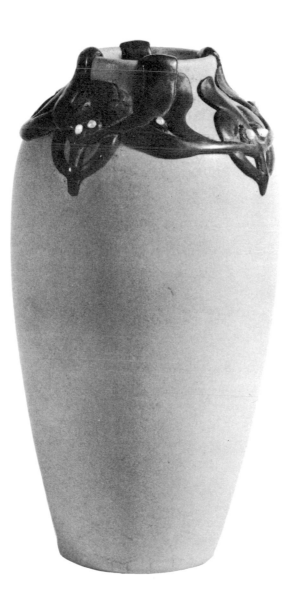

**244 Vase**

Van Briggle Pottery Company, Colorado Springs, Colo., 1905
Pottery, with molded relief of conventionalized pendant leaves; greenish yellow semi-mat glaze over a brown clay body
Height: 7½"
Marks: incised cypher of conjoined *AA* within a rectangle, *VAN BRIGGLE, 1905, V*; impressed *95*

Whereas Van Briggle's work centered on glazes covering the entire surface of the piece, there was a new departure after his death. A dark brown clay was used and the glaze only partially covered the body, enriching the color contrasts.

Private collection

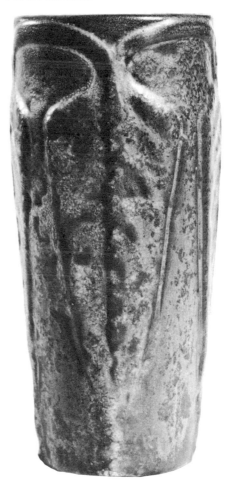

223

**245 Vase**
Van Briggle Pottery Company, Colorado Springs, Colo., 1906
Designer: Artus Van Briggle
Pottery, with molded decoration of two conventionalized women in flowing gowns; green mat glaze
Height: 7¾"
Marks: incised cypher of conjoined *AA* within a rectangle, *VAN BRIGGLE, COLORADO SPRINGS, 1906*

The model was illustrated in 1903 by W. G. Bowdoin ("Some American Pottery Forms," p. 88). The designer is presumably Artus Van Briggle, as he seems to have been the only one at the pottery to be concerned with the human figure.

Private collection

**246 Vase**
Van Briggle Pottery Company, Colorado Springs, Colo., ca. 1905–07
Pottery, with molded design of conventionalized natural forms; yellow and ocher semi-mat glazes
Height: 6½"
Marks: original paper label, cypher of conjoined *AA*, printed over with *N° 1946/$—/P 650*

Private collection

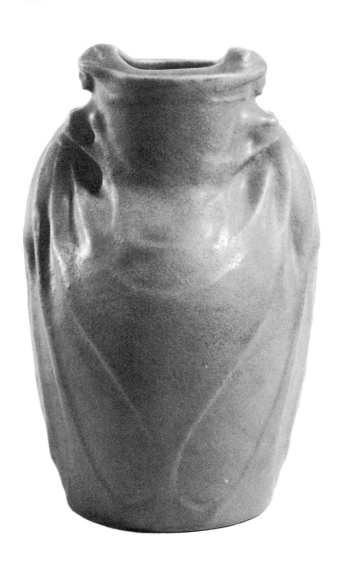

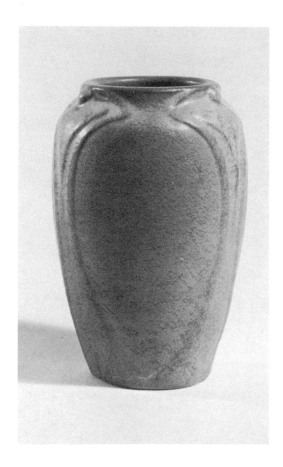

**247 Vase**

Van Briggle Pottery Company, Colorado Springs, Colo., 1907
Pottery, with molded relief of conventionalized poppy seed pods; light blue mat glaze over a dark brown clay body
Height: 5¼"
Marks: incised cypher of conjoined *AA, VAN BRIGGLE, COLO SPRINGS 1907*; impressed *5* [other numerals obscured by glaze]

Private collection

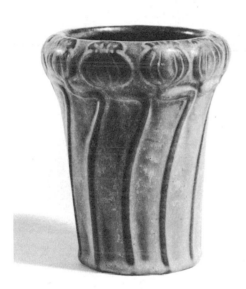

## Losanti, Tiffany, and Robineau

There was a flurry of interest and activity in pottery around 1900, unequalled since that which had been seen two decades earlier. Louise McLaughlin was forced to abandon her work in pottery in 1883 when the facilities at Rookwood were closed to amateurs, but she never lost her interest in the crafts movement. She continued to work in overglaze decoration and to write about it for various publications; she also did decorative etching on metal, for which she received a silver medal at the Paris World's Fair of 1889. Moreover, she was proficient as an artist in oils and watercolors, as an illuminator, embroiderer, lace maker, as well as author. In many ways, she was the fulfillment of William Morris's ideal.

Always seeking a new challenge, Miss McLaughlin tackled the problem of making her own porcelain vases in 1898. As she later realized, she began with only the faintest inkling of the difficulties in store for her. At the time there were no technical treatises on the subject and so, armed only with the formula for the paste used at the Sèvres factory and a kiln in her back yard (which greatly annoyed her neighbors), she began to experiment. She set herself one problem after another, always seeking new and more complex techniques such as inlaying designs by painting them in colored slip on the interior walls of the mold, or the unusual feat of maturing the body and the glaze in a single firing.

She began work on her Losanti ware, so called in honor of Cincinnati's early name of L'Osantiville, in 1898 but it was several years before she had a successful porcelain body. Reflecting general developments in the world of ceramics, her work changed from painted to carved decoration around 1901. The stylized floral forms with their whiplash curves and the intricate pierced work show an awareness of European Art Nouveau, as might be expected at this point in time, especially since her nephew by marriage, Edward Colonna, was one of its leading exponents in Paris. If anything is noteworthy, it is the restraint with which she adopted the new style. It is generally restricted

to the patterned design while the shape of the vessel retains a classical silhouette. Her technical accomplishments were warmly received by the critics. Her first major exhibition of Losanti ware was at the Pan-American Exposition in Buffalo in 1901, then the Turin Exposition the following year, the Syracuse Arts and Crafts Exhibition in 1903, and the St. Louis World's Fair in 1904. But once success was in hand, the challenge to continue seems to have been lost and Miss McLaughlin turned to other endeavors.

Louis C. Tiffany, the acknowledged leader in American decorative arts at the turn of the century, was equally intrigued by the possibilities of ceramics, especially after he had seen the displays of pottery at the Paris World's Fair of 1900. Unlike Miss McLaughlin, however, he had far greater financial and technical resources to draw upon, and so experiments were carried out privately for the next few years. His pottery did not make its official debut until the opening of the St. Louis World's Fair in 1904, and it was not released commercially until the latter part of the following year.

We know very little about the individuals who created his ceramics, for the craftsmen at Tiffany Studios remained relatively anonymous under the cloak of the master's name. This is probably as it should have been because the guiding genius of Tiffany is to be felt everywhere. The pottery has the sophistication of form, color, and material which, as with all the creations of Tiffany Studios, reflects Tiffany's own sensibilities.

Although the pottery went under Tiffany's trade name of "Favrile," that is, handmade, only some of it was thrown on the wheel. The majority of the decorated pieces, even delicate vases with pierced work and high relief, were cast. Of course, the "mass production" methods did not at all lower the quality of the work. While there was some experimentation with the clays used, by and large almost all pieces were made of a fine, white semiporcelainous clay fired at a high temperature.

Tiffany pottery has remarkably subtle effects of color which, in their own right, equal those of

his more celebrated Favrile glass. To a large extent, this is Tiffany's response to the rich glazes of oriental ceramics, of which he owned a large collection. While such effects tend to appear on vases of simple shape, the more distinctive and typical pieces are those decorated with plants and animals which, treated like sculpture, create the shape of the vase itself—the rounded and scalloped edges of flowers or leaves, for instance, forming the lip. Tiffany particularly delighted in such humble motifs as field ferns, Queen Anne's lace, toadstools, and frogs. Most often the quality of design is introduced not so much through stylization as through the positioning of the motif, although occasionally there are marvelously abstracted forms. The glazes that were developed are as important as the decoration itself. Two glazes were particularly favored, one a splotched green resembling moss, and another ranging from light yellow to black, suggesting old ivory. Not only are there subtle diversities within a tonal range but also the glazes run or well up in the relief as a natural consequence of the firing, often resulting in a heightening of the lines of the design—an effect very much sought after by Tiffany.

Despite the high quality and beauty of Tiffany pottery, it received little attention in its day, overshadowed by the already well-established Favrile glass and lamps. Nevertheless, it quietly continued in production until 1919 when Tiffany withdrew from the Tiffany Studios operation.

A third major personality is Adelaide Alsop Robineau. She was born in Middletown, Connecticut, in 1865. For a while she taught china painting in Minnesota. Then she returned east to New York where she continued to teach while studying painting with William Merritt Chase and exhibiting as a wartercolorist and miniaturist. In 1899 she married Samuel E. Robineau. The same year she, her husband, and George Clark bought a magazine, the China Decorator, and began publication in Syracuse under the new name of Keramic Studio. Through the editorship of this magazine she came to national prominence.

Her work at this point in her career, both in terms of the china she decorated herself and the patterns she prepared for the use of amateurs, was strongly Beaux-Arts in character, consisting of naturalistic and historical styles often openly adapted from European publications. After 1900, however, there was a growing recognition of the Art Nouveau style. To please her subscribers she continued to publish naturalistic flower studies but her own designs and her editorials emphasized the value of conventionalized forms. It was an uphill struggle, and one which she was still making a decade later.

The most important change in her career came about in 1903. Through his French contacts, her husband had obtained a series of articles on porcelain by Taxile Doat, the celebrated artist of the Sèvres manufactory. Mrs. Robineau was thus inspired to try her hand at the making of porcelain; after several weeks of classes with Charles Binns at Alfred University, she began to experiment. Encouraged by her first successes, and by her husband who helped with the glazes and presided over the firings, she decided to start a commercial venture. In order to allow for a large quantity, the pieces were cast; they were then decorated with simple geometric carvings or else they were given more elaborate decoration such as pâte-sur-pâte. The project turned out to be no more successful commercially than it was stimulating artistically, and so it was abandoned in favor of the creation of a very limited number of individual pieces. At this time Mrs. Robineau began the practice of excising the decoration—a difficult task given the nonplastic nature of porcelain clay. Indeed, finely perforated ware was to become a hallmark of her work. Further enhancing the jewel-like quality of her ceramics were the delicate mat and crystalline glazes. She showed unusual patience, not only in the carving but also in the firing where a piece sometimes had to be fired as many as seven times until the desired result was obtained.

In 1910 Mrs. Robineau became associated with the ceramic school at University City, Missouri. She taught there for a year and then returned to Syracuse. Perhaps her greatest triumph occurred in 1911 when her display of fifty-five pieces at the International Exposition of Decorative Art in Turin received a Grand Prize, the highest award possible.

After 1910 the Art Nouveau motifs in her work, such as dragonflies and wisteria, become drier and also less frequent. In their place one often finds a concentration on color effects, or the use of Chinese and Mayan motifs.

**248 Vase**

M. Louise McLaughlin, Cincinnati, Ohio, ca.
1901–04
Porcelain, with modeled decoration of conventionalized grape leaves; gray glaze
Height: 5½"
Marks: incised cypher of conjoined *MCL*; painted,
*LOSANTI*

The gentle stylization of these plant forms reveals
the impact of Art Nouveau on Miss McLaughlin
and the restraint with which she used it. As
she wrote: "The movement known as 'l'Art
Nouveau' will and must have influence, but it cannot be followed without reason or moderation,
except to the detriment and degradation of the
Beautiful."

Cincinnati Art Museum, gift of the Porcelain
League of Cincinnati

**249 Vase**

M. Louise McLaughlin, Cincinnati, Ohio, ca.
1901–04
Porcelain, with modeled decoration of conventionalized leaves; dull red and pale green glaze
Height: 4¾"
Marks: incised cypher of conjoined *MCL,X, 326*;
painted, *Losanti*

Here again, though the rhythmical sweep of the
design is Art Nouveau, the actual decorative motif
is closer to the tendrils of a Renaissance arabesque.
Other Losanti vases with similar decoration were
illustrated by Mrs. Monachesi in 1902 ("Miss M.
Louise McLaughlin and Her New 'Losanti Ware,'"
p. 11).

National Museum of History and Technology,
Smithsonian Institution

**250 Vase**

M. Louise McLaughlin, Cincinnati, Ohio, 1901–04
Porcelain, with modeled decoration of conventionalized leaves; gray glaze
Height: 5⅛"
Marks: incised cypher of conjoined *MCL, 163*;
painted, *LOSANTI*

Cincinnati Art Museum, gift of Theodore
Langstroth

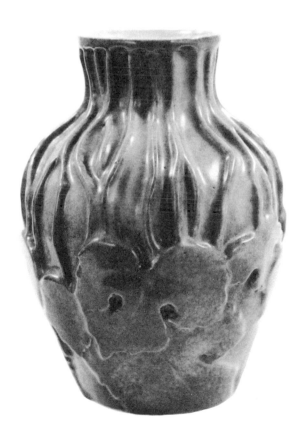

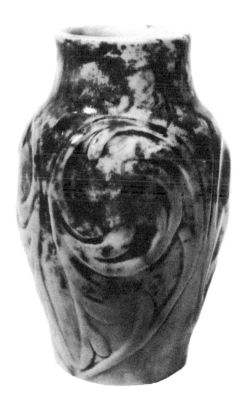

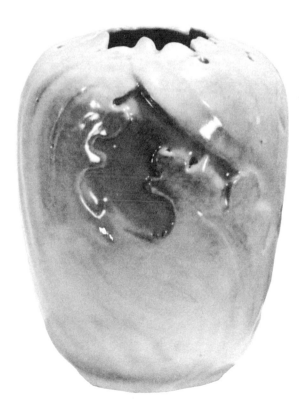

**251 Vase**
Tiffany Studios, New York, ca. 1905–19
Pottery, with molded decoration of fern fronds;
semigloss glaze, ivory shading to black
Height: 9⅞"
Marks: incised cypher of conjoined *LCT, 7*; etched
*P485 L.C. Tiffany-Pottery, 9089*

Another example of this model was illustrated in
1906 by C. Ruge ("Amerikanische Keramik," p.
172). Many of the shapes used for Tiffany's pottery
were first designed for execution in enamel on
copper repoussé. This particular design of fern
fronds is found on an enamel and copper vase in
the collection of Dr. and Mrs. Alick Osofsky. The
enamel version is, as always in such cases,
larger (11½" high), suggesting that the ceramic
model may have been cast from it.

Private collection

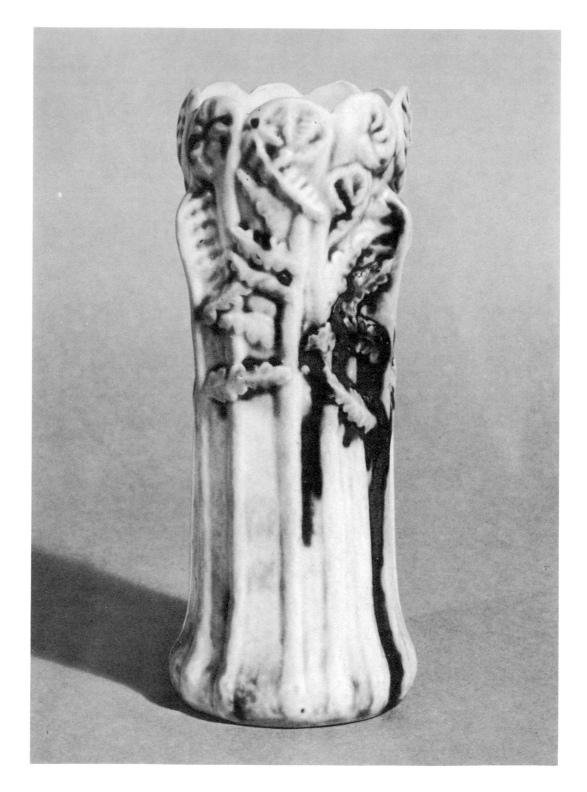

**252 Vase**
Tiffany Studios, New York, ca. 1905–19
Pottery, with molded decoration of conventionalized tulips; mottled green semigloss glazes
Height: 11"
Marks: incised cypher of conjoined *LCT, 7;* etched *P1341 L.C. Tiffany-Favrile Pottery*

The harmonious disposition of the tulip motif, from the alternately open and closed flowers at the top of the vase down to the bulbs encircling its base, owes much to an appreciation of the Art Nouveau movement. Yet we rarely find in Tiffany's work the fully stated rhythms and stylizations of Art Nouveau, as we so often do in that of Van Briggle. (Compare Van Briggle's vase with the narcissus motif, entry 233, in which a single whiplash descends from the flower through the fluid stem to the stylized bulb at the bottom.)

Private collection

**253 Vase**
Tiffany Studios, New York, ca. 1905–19
Pottery, with molded decoration of conventionalized leaves; semigloss glaze, ivory shading to black
Height: 6¼"
Marks: incised *1,* cypher of conjoined *LCT, 7;* etched *P146 Tiffany-Favrile Pottery*

Private collection

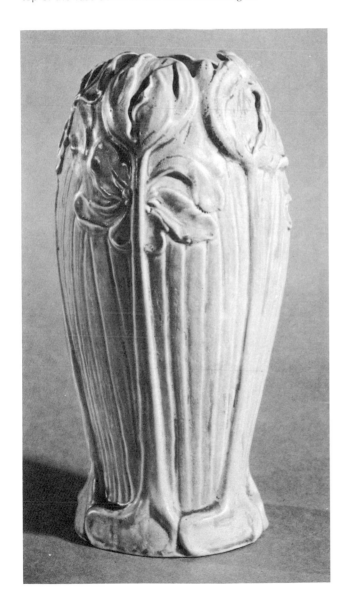

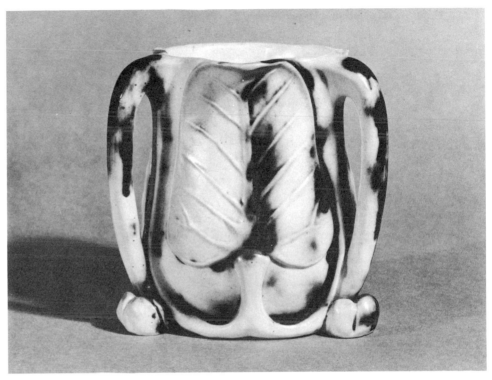

### 254 Vase

Tiffany Studios, New York, ca. 1905–19
Pottery, with molded decoration of pendant seed pods; green semigloss and orange-ocher mat glazes
Height: 5⅛"
Marks: incised cypher of conjoined *LCT, 7*

The flared lower part of this vase is fairly common in Tiffany pottery, and yet it is not a natural form for work in clay. Rather, it is taken from enamel vases where such a flanged shape was necessary for the attachment of the bottom metal plate to the cylinder of the vase itself. Thus it seems likely that this particular vase copies one in enamel.

Private collection

### 255 Vase

Tiffany Studios, New York, ca. 1905–19
Pottery, with purple and russet green glazes
Height: 4¾"
Mark: incised cypher of conjoined *LCT*

Responding to Tiffany's color sensibilities, his workmen were able to achieve remarkable effects regardless of medium, be it glass, enamel, or pottery. The strong colors of this vase evoke the sumptuous shades of a peacock feather or a dragonfly.

Museum of Modern Art, New York, gift of Joseph H. Heil

### 256 Vase

Tiffany Studios, New York, ca. 1905–19
Pottery, with molded design of conventionalized artichoke blossom; mottled green semigloss glaze
Height: 11"
Marks: incised cypher of conjoined LCT; etched *P952, L.C. Tiffany-Favrile Pottery*

One is always tempted to believe that the artists worked directly from natural motifs and, indeed, there are posed photographs of Rookwood decorators doing just that. Yet this generally was not the case. We know that Tiffany maintained a large library of books devoted to plants and animals that his designers consulted for an unending variety of motifs.

Philadelphia Museum of Art, gift of Mr. and Mrs. Thomas E. Shipley, Jr.

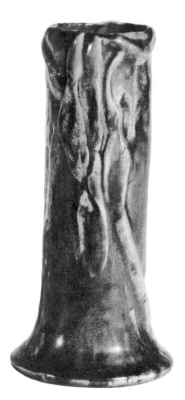

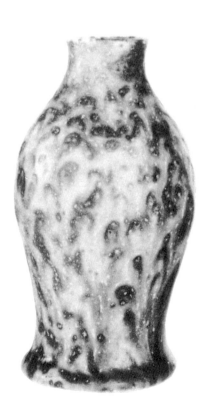

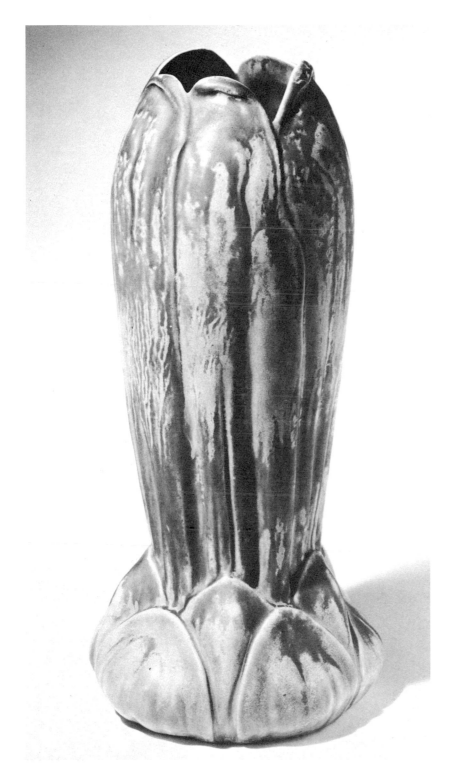

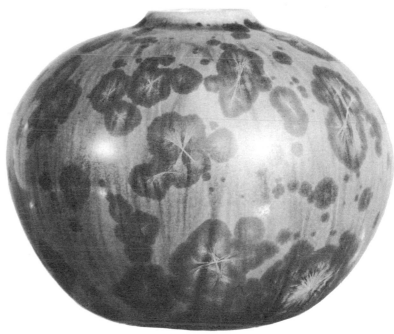

**257 Vase**
Adelaide Alsop Robineau, Syracuse, N.Y., 1905
Porcelain, streaked orange-brown glaze with large brown and silver crystals
Height: 3¾″
Marks: incised *RP* within a rectangle, *214*, *'5*, cypher of conjoined *AAR*

Private collection

**258 Vase**
Adelaide Alsop Robineau, Syracuse, N.Y., 1905
Porcelain, with blue crystalline glaze
Height: 7"
Marks: incised cypher of conjoined *AR* in a circle,
*230, '5*

When Mrs. Robineau prepared her exhibit for the
Society of Keramic Arts in 1905 she included
this vase, as shown in *International Studio,* XXV

(1905), lxxxii. She considered it a very rare
example of crystallizations of titanium and illus-
trated it in *Keramic Studio,* X (1909), p. 258. The
vase is probably to be identified with one exhibited
at the Panama-Pacific International Exposition,
San Francisco, 1915, number 87 (offered for sale
at forty dollars).

Everson Museum of Art

**259 Bowl**
Adelaide Alsop Robineau, Syracuse, N.Y., 1905
Porcelain, with excised geometric decoration and
knobs with a pattern of conventionalized crabs;
brown mat glaze on the exterior, green crystalline
glaze on the interior
Diameter: 9½"
Marks: incised cypher of conjoined *AR* in a
rectangle, *'5, 282*

The firing of crystalline glazes on the interior of
a bowl proved very difficult and Mrs. Robineau,
always concerned with the technical problems
of her art, noted that she did not succeed in firing
a larger bowl with interior crystallizations for
another decade. This bowl was exhibited at Turin
in 1911, in Paris at the Musée des Arts Décoratifs
and the Spring Salon of 1912, and at the Panama-
Pacific International Exposition in San Francisco,
1915, where it was listed as number 54 (offered for
sale at eighty dollars).

Everson Museum of Art

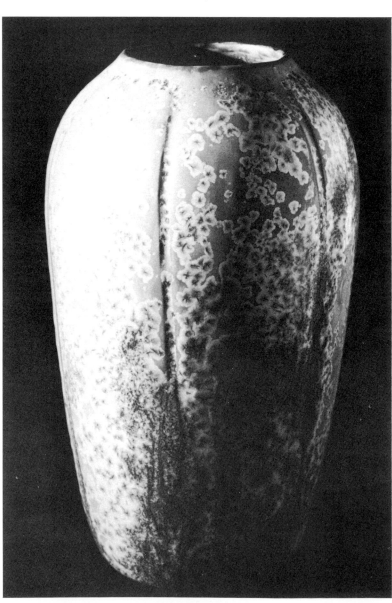

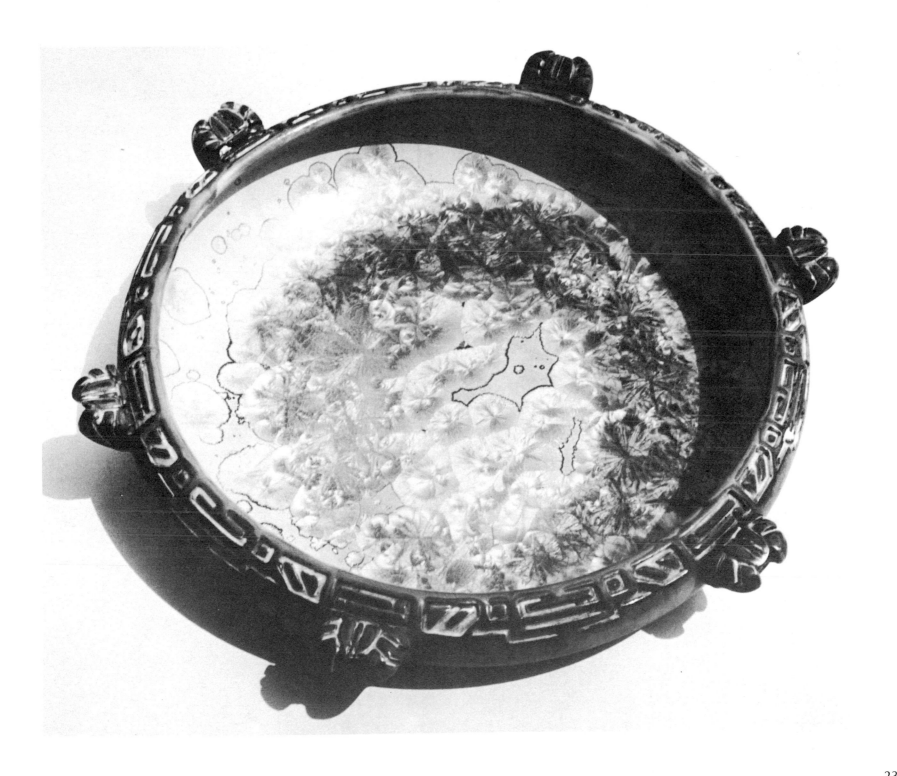

233

**260 Vase**

Adelaide Alsop Robineau, Syracuse, N.Y., 1905
Porcelain, with excised decoration of Viking ships
and perforated porcelain ring base of the same
motif; blue, green, and brown mat and semi-mat
glazes
Height: 7¼"
Marks: excised cypher of conjoined *AR* in a circle;
incised *570;* inside the ring, incised cypher of
conjoined *AR* within a rectangle

Known as the "Viking" vase, this and a closely
related one called the "Crab" vase are two of the
high points of Mrs. Robineau's early career. It
is typical of her painstaking work that it should be
the second of two attempts—the first having pre-
sumably met with an accident in its making. (The
Crab vase required four versions.) The slender,
elegant shape, tapering at the bottom, demanded
a stand or support which Mrs. Robineau supplied
in the form of a separate ring decorated with
the same Viking motif. Undoubtedly she knew of
comparable models from Sèvres where, however,
the support ring was made of bronze doré; see
*Art et décoration,* XIV (1903), opp. p. 340. The
decorative motif of Viking ships is not at all French,
but rather more English in origin. From the begin-
ning, this was one of Mrs. Robineau's prime
show pieces and it was illustrated in *The
Sketch Book,* V (January 1906), p. 232. The
vase was exhibited at the 1911 International
Exposition in Turin, illustrated in *Keramic Studio,*
XIII (1911), p. 83; in Paris at the Musée des Arts
Décoratifs and the Spring Salon of 1912; and at the
Panama-Pacific International Exposition, San
Francisco, 1915, number 2 (offered for sale at
seventy-five dollars).

Everson Museum of Art

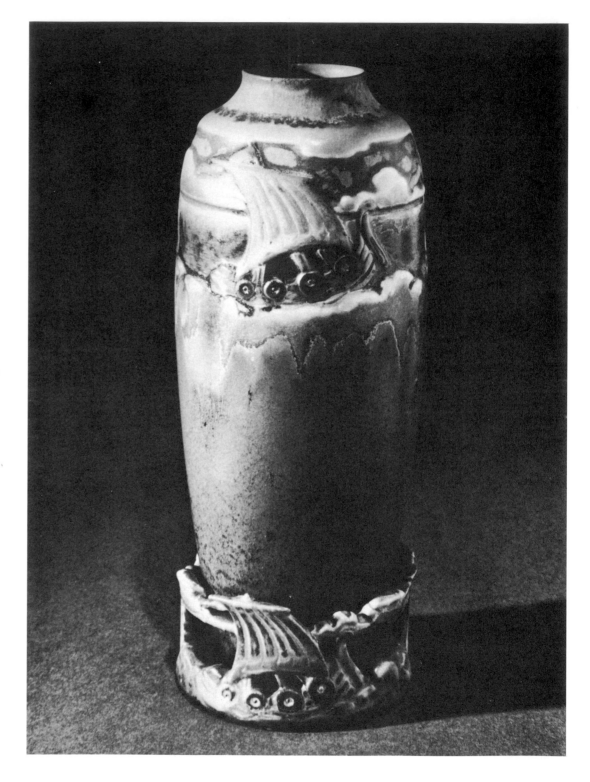

**261 Vase**
Adelaide Alsop Robineau, Syracuse, N.Y., 1910
Porcelain, with incised decoration of convention-
alized water lilies and geometric pattern; pink
crystalline and mat brown glazes
Height: 11⅜"

The works that Mrs. Robineau executed at Uni-
versity City, such as this and her famous "Scarab"
vase, became the property of that institution, but
she was later able to recover her pieces when
the Woman's League foundered. The vase was
exhibited at the 1911 Exposition in Turin, illus-
trated in *Keramic Studio,* XIII (1911), p. 83. It then
went on, as did the other vases, to Paris, to the
Musée des Arts Décoratifs and the Spring Salon of
1912. It was shown the following year at the Arts
and Crafts Exhibition at The Art Institute of Chi-
cago, see *Keramic Studio,* XIV (1913), p. 197,
and in 1915 at the Panama-Pacific International
Exposition, San Francisco, number 38 (offered for
sale at fifty dollars).

Everson Museum of Art

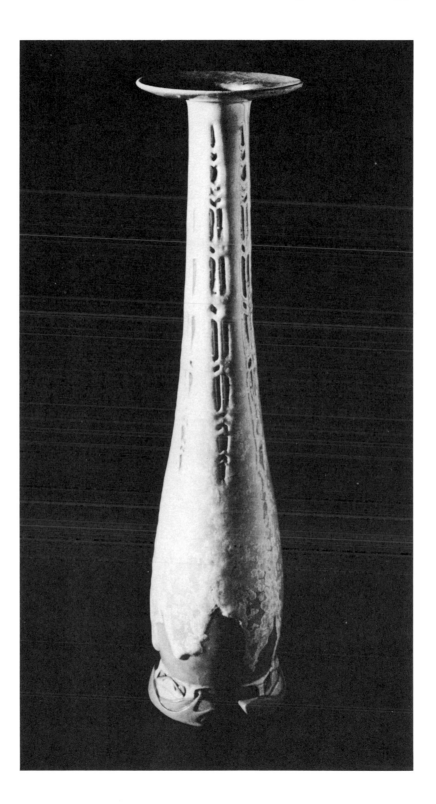

**262 Covered vase**
Adelaide Alsop Robineau, Syracuse, N.Y., 1913
Porcelain, with green crystalline glaze; cover with
incised geometric pattern, green glaze
Height: 4¼"
Marks: excised cypher of conjoined *AR* in a circle;
incised *1913*

Metropolitan Museum of Art

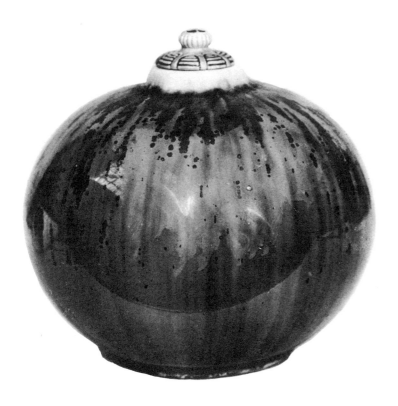

## Crystalline and iridescent glazes

Another of the women who led the art pottery
movement in America was Mary Chase Perry.
Born and raised in Michigan, she went to art
school in Cincinnati and New York. She had
turned from clay sculpture to china painting, a
profession which, as we have seen, was considered
proper and promising for aspiring women artists,
and in Detroit she became associated with a neigh-
bor, Horace Caulkins, whose kilns for baking dental
enamels had made him a fortune. She used his kiln
to fire her china and eventually the two of them
created a new, gas-fired pottery kiln that they
marketed under the name of "Revelation Kilns."

Like Mrs. Robineau, Miss Perry now made the
important change from china painter to ceramist. It
was a step from talented lady painter (with its
implied dilettantism) to professional craftsman—a
challenge to which only a few rose. Her decision
must have been prompted, at least in part, by her
acquaintance with Charles L. Freer, the Detroit
millionaire who had one of the country's richest
collections of oriental pottery (now housed in the
Freer Gallery in Washington). His extraordinary re-
finement of taste and his extensive collection
proved to be continuing sources of inspiration to
Miss Perry. Another formative influence was
Charles Binns, with whom she had been associated
for a short while at Alfred University.

Miss Perry's work went under the name of
Revelation Kilns but in about 1903 she founded
the Pewabic Pottery, calling it after a Michigan
river whose name in Chippewa signified "clay
in copper color." It was at first a small under-
taking in which she was assisted by Mr. Caulkins
and a man who threw the vases. As might be
expected, her early pieces were decorated with
relief forms of conventionalized leaves and plants,
and covered with dull, mat glazes. She was much
inspired by the work of Grueby; in fact, it was she
who had championed Grueby when he was ac-
cused of plagiarizing Delaherche's work. Miss
Perry was also affected by European Art Nouveau
design and by stimuli closer to home, such as the
work of Louis C. Tiffany.

In the course of time, her interests veered

more and more toward the effects of glazes and, predictably, the shapes of her vases came to be very simple—mere vehicles for the display of the rich glazes. The final, major phase of her work, one which continued until her death at the age of ninety-four in 1961 and the closing of the Pewabic Pottery, was the exploration of iridescent and luster glazes. Her palette was augmented by deep blues rivaling those of ancient Egyptian and Persian wares, as well as ones of burning gold. The resulting vases with their subtle overlays of dripping glazes and their sparkling iridescence were more than enough to secure a place of prominence for Miss Perry in the world of pottery.

At the turn of the century Fulper Pottery of Flemington, New Jersey, was already the oldest pottery in the country, having been established in 1805. They had produced a wide variety of utilitarian wares in the nineteenth century and it was not until around 1910 that they joined the art pottery movement with their so-called Vase–Kraft line. Here too, as with a number of other potters, the inspiration both for their glazes and their shapes came from Chinese pottery. One of their efforts, for example, was a "Famille Rose" line in which Chinese prototypes were closely copied. Fulper quickly developed a wide range of glazes, including the popular mat varieties, as well as a high gloss one called "Mirror Glaze"; their crystalline glazes were termed the "modern ceramic curios." One Fulper glaze was described by the firm as "blue of the sky, seen between clouds after rain." Another, "Mission Matte," was interpreted by the company as a "brown black glaze resembling the finish of fumed oaks or Mission furniture." Although this latter name referred only to a particular Fulper color, it reminds us of the very close connection between Fulper and the American trend toward simplicity of form. The vase shapes which Fulper evolved frequently have an angular, geometric quality and, while they are often successful, many Fulper designs suffer from the same heaviness of form that can be encountered in so-called Mission furniture.

The extent and popularity of the art pottery movement in the United States is indicated by the development that took place at University City near St. Louis. Behind the whole concept stood Edward J. Lewis, a businessman with varied banking, publishing, and educational interests. In 1907 he founded the American Woman's League, with a program for educating women and enhancing their opportunities in general. It was to be conducted largely through correspondence courses in such subjects as business, language, journalism, and photography. Mr. Lewis's personal interest in ceramics was due principally to the translation of Taxile Doat's book Grand Feu Ceramics, prepared by Mr. Robineau. Naturally enough, classes in ceramics were among the first to be instituted at University City. The project was ambitious: no less a person than Taxile Doat was brought to University City in 1909. Mrs. Robineau moved there with her husband in 1910 and, besides her teaching and personal work, took up the editorship of Palette and Bench, a new magazine published by Lewis. Frederick Rhead was also associated with the group as an instructor in pottery, and during his stay wrote a manual called Studio Pottery. The first kiln was fired in 1910.

Most of the work still consisted of overglaze painting on china. For this there were over three hundred "correspondence pupils," while some twenty or thirty of the more gifted students did their work at University City. By contrast, the ceramic department was very small with no more than thirty correspondence pupils and about ten studying at University City. The work was highly sophisticated, as might be expected given the presence of Taxile Doat and his European assistants as well as the gifted Mrs. Robineau. Using native clays, they produced high-fired porcelain with extraordinary flambé and crystalline glazes. While some of the vase shapes were those that Doat had developed in France, a number of new, simple forms were devised. All the while, of course, the teachers pursued their own, separate work projects.

Unfortunately, this program at University City, which might have been of great significance for the practice of china painting and ceramic making by women in the United States, was short-lived.

Lewis's various activities brought him into conflict with the government and, as a result, the American Woman's League foundered in 1911. Rhead and the Robineaus left but production was continued from 1912 to 1914. Lewis's move to California and the subsequent transfer of the pottery equipment brought the University City operations to an end.

**263 Vase**
Pewabic Pottery, Detroit, Mich., ca. 1903–05
Executed by Mary Chase Perry
Pottery, with modeled decoration of convention-
alized tulip leaves and blossoms; green mat glaze
Height: 10½"
Marks: impressed *PEWABIC* in an arc surmounted
by five flames or leaves.

Occasionally, as here, Miss Perry's interpretation
of Art Nouveau produced a restless energy in the
decorative forms. Her early mat-glazed pieces were
inevitably likened to Grueby's, which is justifiable
since he had been her chief inspiration. Yet, like
those produced by other Grueby imitators such as
the Hampshire Pottery, J. B. Owens, Roseville,
and the Gates Pottery, her glazes have a curiously
drier and duller aspect.

Private collection

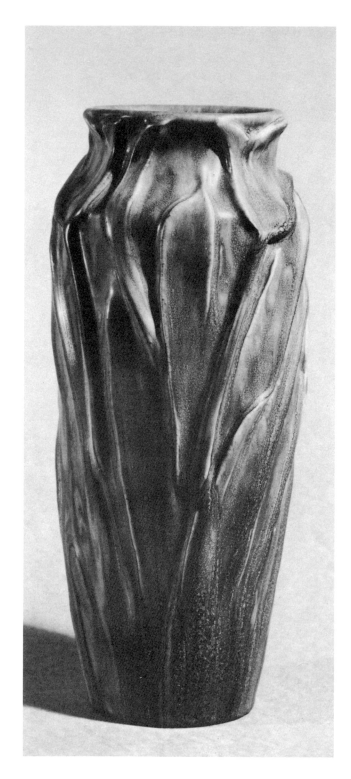

**264 Vase**
Pewabic Pottery, Detroit, Mich., ca. 1910–12
Executed by Mary Chase Perry
Pottery, with thick, iridescent gold glaze over blue glaze
Height: 18¾"

Charles Freer was a firm supporter of Miss Perry's work and this is one of three Pewabic vases that he selected for presentation to the Detroit Institute of Arts in 1912. It was also he who prophesied that, long after Detroit's fame as an industrial center had been forgotten, it would still be renowned as the home of the Pewabic Pottery.

Detroit Institute of Arts, gift of Charles L. Freer

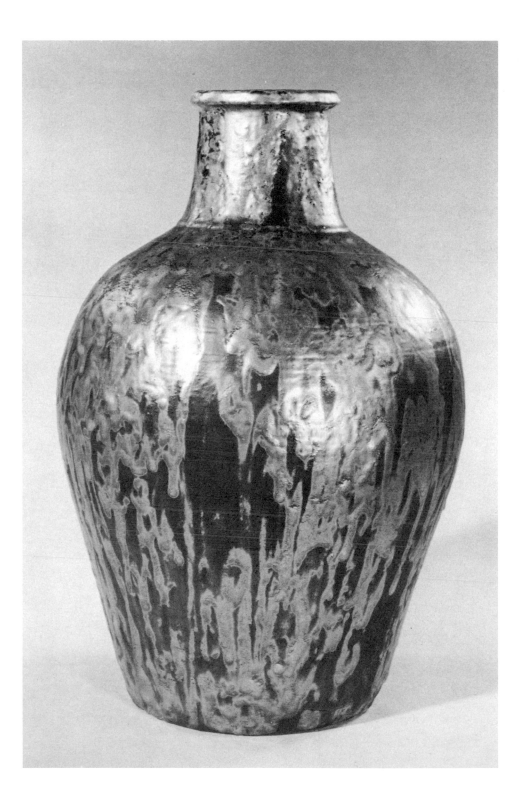

**265 Vase**
Pewabic Pottery, Detroit, Mich., ca. 1910–15
Executed by Mary Chase Perry
Pottery, with incised decoration of wavy lines; iridescent glaze in tones of green, yellow, brown, and blue
Height: 4½"
Marks: impressed *PEWABIC* twice

Private collection

**266 Vase**
Pewabic Pottery, Detroit, Mich., ca. 1914
Pottery, with iridescent glaze in tones of gold, purple, gray, and green
Height: 10"

The vase was acquired by the Newark Museum in 1914.

Newark Museum

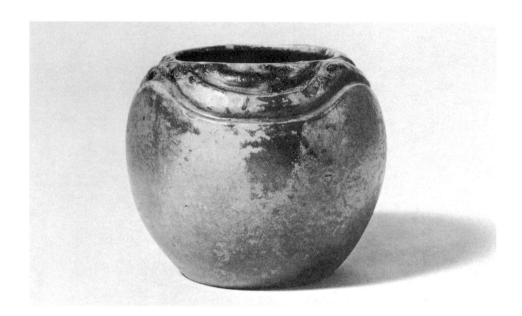

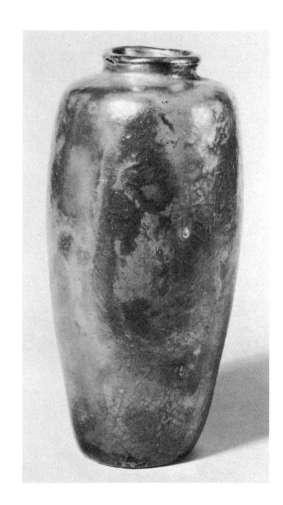

**267 Vase**
Fulper Pottery Company, Flemington, N. J., ca. 1910–14
Pottery, with dark green and black glazes, silver crystalline formations
Height: 8⅛"
Marks: printed *FULPER* in a vertical rectangle; original paper label, *Vasekraft/ Med. double Ori-/ form Cucumber Green/ $4.40 VASEKRAFT/* emblem of a potter/ *FULPER 1905*

The vase was acquired by the Newark Museum in 1914.

Newark Museum

**268 Vase**
Fulper Pottery Company, Flemington, N. J., ca. 1910–14
Pottery, with brown and olive glazes, black and gray crystals with light centers
Height: 5½"
Marks: original paper label, *Vasekraft/ Slender Ovoid/ Leopard Skin $1.00/VASEKRAFT/* emblem of a potter/ *FULPER 1905*

Among the unusual types of crystalline glazes developed at the Fulper Pottery was this "Leopard Skin" glaze with square crystals. Vases of this shape were illustrated in *Pottery and Glass,* VI (April 1911), p. 8. The piece was acquired by the Newark Museum in 1914.

Newark Museum

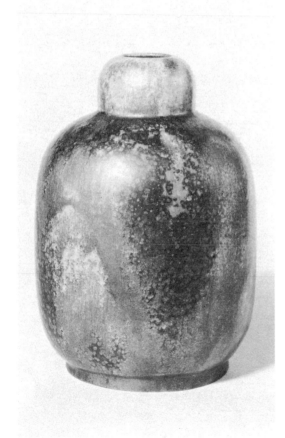

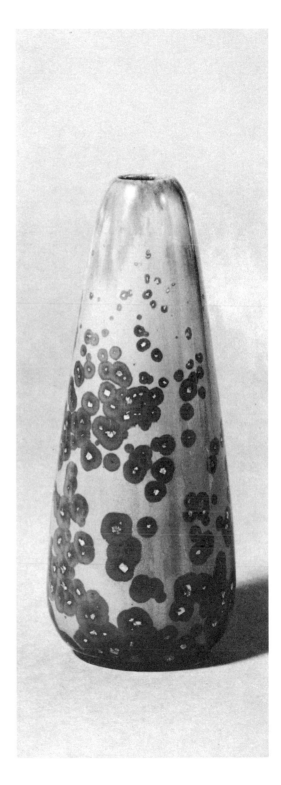

**269 Vase**
Fulper Pottery Company, Flemington, N. J., ca. 1910–14
Pottery, with green crystalline glaze
Height: 6⅞"
Marks: stamped *FULPER* in a vertical rectangle; original paper label, *Vasekraft/ Med. Globular Bottle, Leopard skin/ crystal $4.40/ VASEKRAFT/* emblem of a potter/ *FULPER 1904*

A Fulper vase of this shape is illustrated in *Pottery and Glass,* VI (April 1911), p. 8. This one was acquired by the Newark Museum in 1914.

Newark Museum

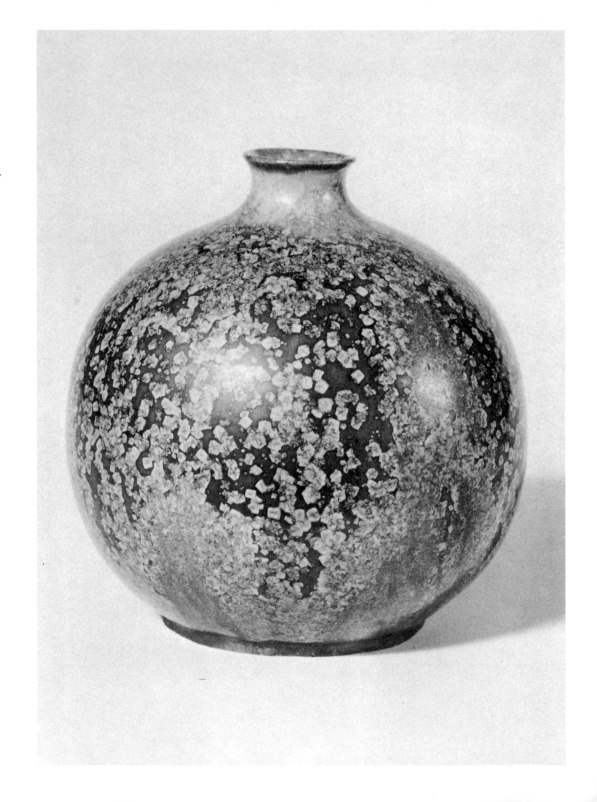

**270 Vase**
Fulper Pottery Company, Flemington, N. J., ca. 1915
Pottery, light and dark green crystalline glazes
Height: 11"
Marks: printed *FULPER* in vertical rectangle; original paper label on side of vase, *PANAMA-PACIFIC INTERNATIONAL EXPOSITION SAN FRANCISCO 1915 HIGHEST AWARD TO FULPER Pottery*

A vase of this modern shape was illustrated in *Pottery and Glass*, V (August 1910), p. 43, where it is listed for sale at two dollars fifty cents. After winning an award at the Panama-Pacific International Exposition, 1915, the pottery affixed labels of the type seen on this vase to its products.

National Museum of History and Technology, Smithsonian Institution, gift of Robert Blasberg

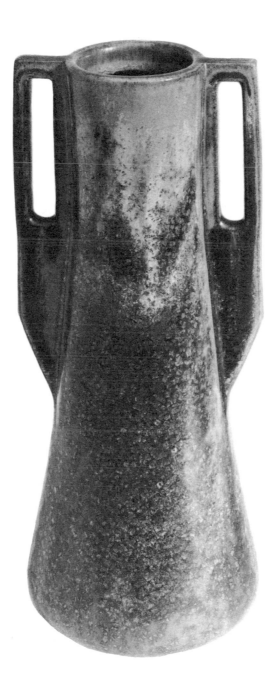

**271 Lamp**
Fulper Pottery Company, Flemington, N. J., ca. 1911–15
Pottery with leaded glass; blue and gunmetal glossy glazes, green, yellow, and blue glass
Height: 19"
Mark: printed *FULPER* in a vertical rectangle

Fulper's Vase-Kraft lamps were introduced at Christmas 1910, and were publicized as "Art pottery put to practical uses." Part of the distinctiveness of the lamps was that both the base and the shade were of the same material; it was claimed that the bulbs were hidden and the switch was small and inconspicuous so that, in effect, the viewer saw only beautiful pottery. The glaze on this lamp is extremely glossy and is of the type that the company referred to as Mirror Glaze. This model, but with a different pattern of inset glass, was illustrated in the August 1911 issue of *Pottery and Glass*, and was advertised in the November 1911 issues of the *Craftsman* and *House Beautiful* as the "clean stem mushroom" with a price of forty-five dollars.

Carol Ferranti Antiques

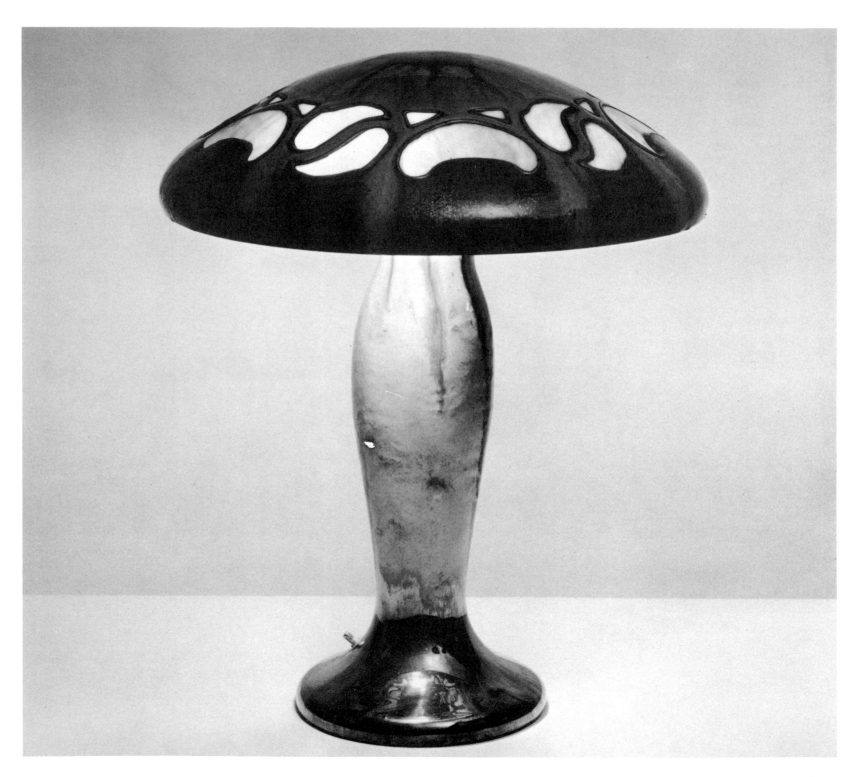

**272 Vase**
University City Pottery, University City, Mo., 1910
Executed by Emile Diffloth
Porcelain, beige glaze with green crystalline spots,
slight lustered effect
Height: 5"
Marks: printed circular mark, *The American
Woman's League UC 1910;* painted cypher of con-
joined *ED, 116*

Emile Diffloth was one of the technical experts
who came with Doat from Europe. Diffloth had
been the art director at the Boch Frères pottery at
La Louvière, Belgium

Private collection, from the estate of E. G. Lewis

**273 Vase**
University City Pottery, University City, Mo., ca.
1910–14
Porcelain, molded gourd shape with blue crystal-
line, white, and yellow glazes
Height: 6¾"

Taxile Doat had created a series of gourd-shaped
vases such as this one in 1900. In all probability he
brought the molds with him when he came to the
United States. Those produced at University City

are slightly smaller than the French examples,
which may be due to the greater shrinkage of
American clay. The vases made in France generally
have coloring more like that of a natural gourd,
whereas those done at University City have exotic
flambé and crystalline effects. From the beginning
Doat left the white porcelain showing at the lip as
a means of emphasizing the intrinsic quality of the
body.

Private collection, from the estate of E. G. Lewis

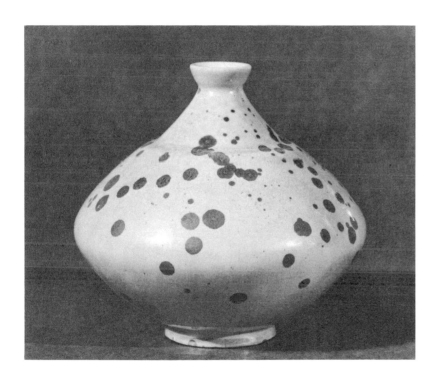

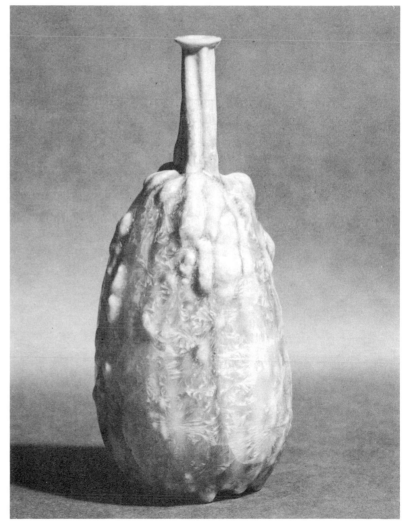

245

**274 Vase**
University City Pottery, University City, Mo., ca. 1910–14
Porcelain, with incised and perforated geometric decoration at the base; beige, brown, and green crystalline glazes
Height: 5⅜"

The conception of this bowl and its base is due to Taxile Doat in whose original model, however, the two parts were made separately and joined with a metal bolt. The irregularities of modeling suggest that this piece was done by a student.

Private collection, from the estate of E. G. Lewis

**275 Bowl**
University City Pottery, University City, Mo., ca. 1910–14
Pottery, with incised and painted decoration; light blue, cream, and pink glazes
Diameter: 4¼"
Marks: incised cypher of conjoined *UC* containing a second cypher, *5105*

While the porcelain work done at University City was dominated by the styles of Taxile Doat and Mrs. Robineau, the pottery was treated with greater freedom and, as in this small bowl, shows an inventive, modern sense of conventionalized decoration which may be due to Rhead's teaching.

Private collection, from the estate of E. G. Lewis

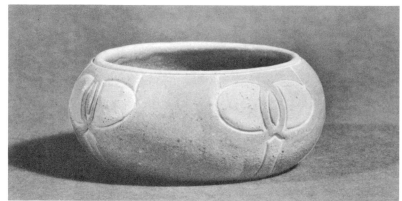

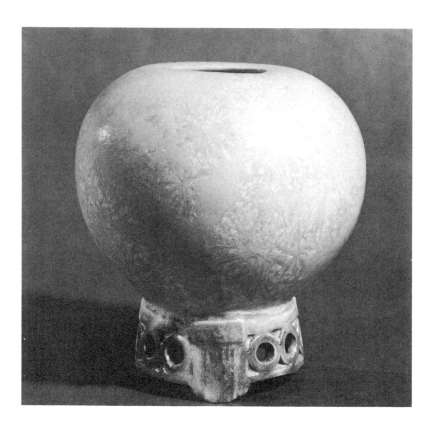

**276 Vase**
University City Pottery, University City, Mo., 1912
Porcelain, with café-au-lait and green crystalline glazes
Height: 8⅝"
Marks: incised *UC, 1912*; painted, *7*

Private collection, from the estate of E. G. Lewis

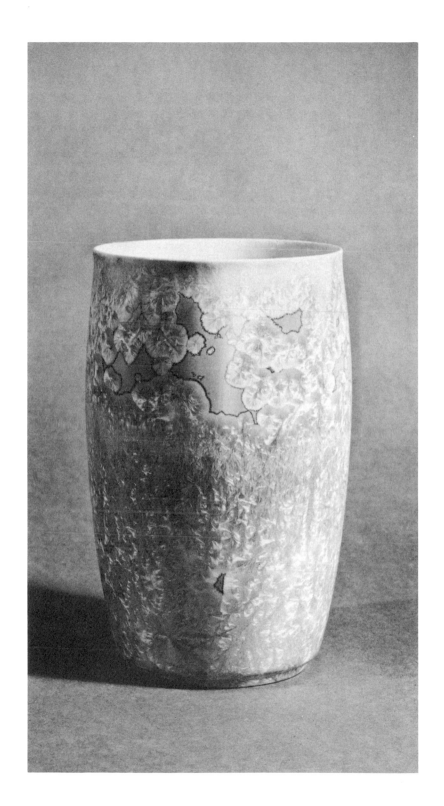

**277 Vase**
University City Pottery, University City, Mo., 1914
Porcelain, with cream-colored glaze having forma-
tions of yellow crystals edged in rose
Height: 7½″
Marks: painted, *UC, 1914,* cypher of conjoined *TD*

Taxile Doat's monogram on this vase means only
that he designed its form.

Carol Ferranti Antiques, from the estate of
E. G. Lewis

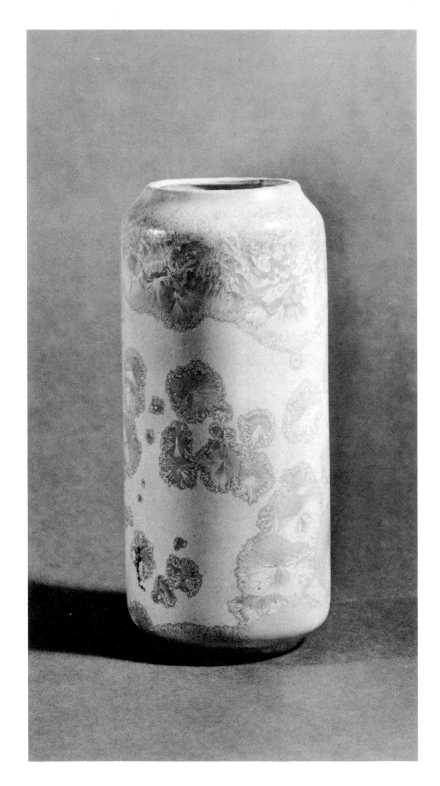

## Later mat glazes and conventionalized decoration

By and large, there was no single style which a ceramist followed from beginning to end of his career; his work after 1900 would be very different from what it had been in the 1880s. Charles Volkmar's pottery, for example, shows the adoption of newer modes. As we have seen, he had been one of the early practitioners of the Haviland underglaze technique; later, he radically reduced the pictorial design and used underglaze painting only to contour his much-simplified forms of conventionalized flowers and flying ducks. He was also very much influenced by oriental pottery. Like Robertson, he attempted to create a peachblow glaze, but had more success with his blues and greens. By the turn of the century Volkmar was following the general tendency towards mat or dull glazes although he seems, curiously, not to have been entirely happy with this development. Volkmar's importance in the New York area is due to the fact that, besides exhibiting widely, he also taught classes at his pottery, first in Corona, Long Island and, from 1903, in Metuchen, New Jersey. He was assisted in his work by his son Leon, who was an instructor at the Pennsylvania School of Industrial Art, the same institution with which Edward A. Barber, the noted historian of American ceramics, was associated.

The new aesthetic of simplicity is clearly evident in the work of Arthur E. Baggs and the Marblehead Pottery. Situated in the Massachusetts coastal town of Marblehead, the pottery was begun in 1905 as part of Dr. Herbert J. Hall's program to create a series of workshops in his sanitarium where "his nervously worn out patients" could have "the blessing and privilege of quiet manual work." To this end he engaged the services of Arthur Baggs, who had been a leading student of Charles Binns at Alfred University. The technical requirements of the pottery proved so demanding, however, that it was made a separate entity. (A similar idea was tried later in California when the Arequipa Pottery was set up in a sanitarium for tubercular girls under the direction of Frederick Rhead.)

Marblehead pottery, which was introduced to the public about 1908, is very much a product of its time in its restraint and understatement. Essential to the sobriety of its aesthetic are the simple, frequently straight-sided shapes and the muted, mat colors which are often so closely related in tone that it is hard to discern them. In addition to the predictable animal and floral motifs, we also find a good many, such as seaweed, fish, and sailing ships, which are related to the New England seacoast. More important than the motif, however, is its treatment: the design is conventionalized into flat, abstract patterns. There is often an insistence on a rigid, vertical stem, and many of the patterns are purely geometrical.

Comparable in style is the work of Frederick Walrath, a potter who was well received at the time but who has since fallen into obscurity. Like Baggs, Walrath had learned the art of ceramics from Binns's classes at Alfred University, and he won a bronze medal at the St. Louis World's Fair in 1904, where his work was displayed with that of his fellow students. Walrath taught at the Mechanics Institute in Rochester, New York, and at Columbia University in New York City. His work became well known through annual exhibitions, and it consistently received favorable reviews. Much of his attention was directed toward abstracted designs executed in mat glazes with an emphasis on rigid, vertical lines and large, conventionalized floral forms, not unlike the trend at the Marblehead Pottery. Walrath was also interested in flowing mat and crystalline glazes over simple shapes, again responding to the general development of modern ceramics. It is interesting to note that at the end of his relatively short life he was technical ceramist for two years at the Newcomb College Pottery, where he died about 1920.

The attempt to relate the creation of art pottery to social needs was not unique to the Marblehead Pottery. With the Paul Revere Pottery, so named because it lay in the shadow of the Old North Church at Boston made famous by Paul Revere, the effort was successful. This pottery not only furthered the artistic training of its young workers, but also used its financial rewards to complement their education in other areas. The girls came from poor, mainly immigrant families living in Boston's North End and, though they called themselves the "Saturday Evening Girls' Club," they actually worked eight hours a day. They worked, of course, from pre-established patterns; we know little of who may have been responsible for the original designs or the glazes. Like the previously mentioned potteries, the decoration of Paul Revere ware shows a kind of vertical rigidity and a constraint within border areas, thus preserving a certain sense of simplicity. A great deal of the production consisted of bowls and dishes—functional rather than ornamental items. Moreover, the dishes were intended not as formal dinnerware but rather as breakfast and nursery sets, where the naiveté of design and the rusticity of material would be deemed acceptable.

Another interesting experiment was the Moravian Pottery and Tile Works of Doylestown, Pennsylvania, which was established in 1900 by Dr. Henry C. Mercer. Here again the craftsman idea is evident in the pottery's reliance upon "honest," unsophisticated designs, using at first local Pennsylvania Dutch decorations and, later, medieval motifs. This firm employed a very wide variety of techniques including colored glazes, sgraffito, and opus sectile. Whatever the technique, though, the firm studiously sought to achieve a rough, handcrafted effect.

**278 Vase**
Volkmar Kilns, Metuchen, N.J., ca. 1910
Executed by Charles Volkmar
Pottery, with green mat glaze having a wrinkled
texture
Height: 6″
Mark: incised *V*

This vase was acquired by the Newark Museum in
1910. Volkmar had been experimenting with sim-
ple, undecorated shapes and flowing glazes at
least as far back as the turn of the century, as is
seen in a group of vases from his Corona workshop,
illustrated in *International Studio*, XII (1900–01),
p. xiii.

Newark Museum

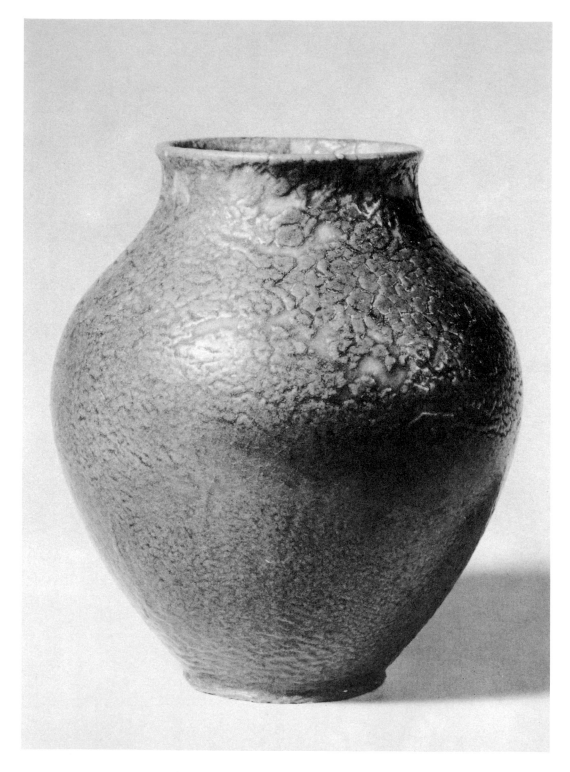

**279 Bowl**
Volkmar Kilns, Metuchen, N.J., ca. 1903–10
Pottery, with excised motto *ART IS THE CHILD OF NATURE;* brown and green mat glazes
Diameter: 10"
Marks: incised *V, G*

Dr. and Mrs. Ernest Kafka

**280 Tile**
Volkmar Kilns, Metuchen, N.J., ca. 1910
Executed by Charles Volkmar
Pottery, with painted landscape of birch trees; green, brown, and blue semi-mat glazes
Height: 7¾", width: 7¾"
Marks: ink-stamped, *VOLKMAR KILNS/ METUCHEN, N. J.;* painted on the front side, *V*

Volkmar was making landscape tiles before the turn of the century, thus paralleling, if not preceding, Rookwood, whose work in this genre is better known. The soft, mat glazes, well suited to the poetic mood of the scene, reveal his development away from his earlier, underglaze work (see entry 168). Similar landscape tiles by Volkmar are illustrated in *Keramic Studio,* XI (1909), p. 41. This one was acquired by the Newark Museum in 1911.

Newark Museum

**281 Vase**
Marblehead Pottery, Marblehead, Mass., after 1908
Executed by Hanna Tutt
Pottery, with incised and painted geometric pattern; black and speckled blue-green glazes
Height: 3¾"
Marks: impressed *M*, emblem of a sailing ship, *P*; incised *HT*

The Marblehead Pottery, like so many other handicraft ventures of that era, showed a compromise between hand labor and industrialization. The vases were all hand-thrown and hand-decorated, but according to pre-established patterns set by the designers. The catalogue issued by the pottery in 1919 gives this shape as model number 1—number 1A when decorated. To gauge by the revised 1920 price list, where 1A is three dollars and sixty cents, the prices were modest indeed.

Private collection

**282 Vase**
Marblehead Pottery, Marblehead, Mass., after 1908
Pottery, with painted geometric pattern; speckled mustard, brown, green, orange, and blue mat glaze
Height: 3¾"
Marks: impressed *M*, emblem of a sailing ship, *P*

National Museum of History and Technology, Smithsonian Institution, gift of Mrs. Page Kirk

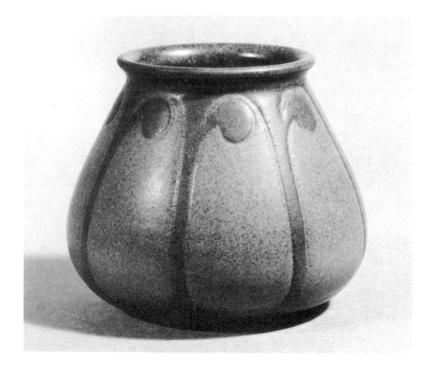

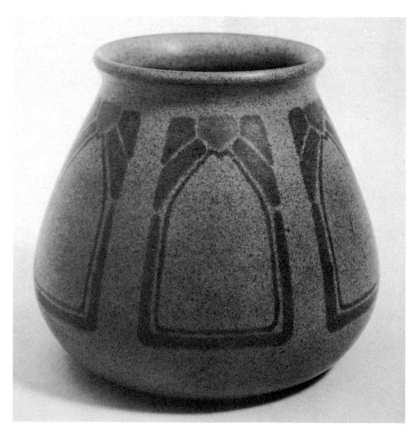

**283 Vase**
Marblehead Pottery, Marblehead, Mass., after 1908
Executed by Hanna Tutt
Pottery, with incised and painted geometric pattern; green and black-green mat glazes
Height: 8⁹⁄₁₆″
Marks: impressed *M*, emblem of a sailing ship, *P*; incised *H*

This type of strong, simple geometric decoration which so handsomely complements the shape of the vase goes back to Binns's teaching and to illustrations that Baggs may have made for him; see *Keramic Studio,* V (June 1903), pp. 46–47. Although there was a marked uniformity to the Marblehead style, there were a number of designers, notably Baggs himself, Arthur I. Hennessey, and Maude Milner.

Private collection

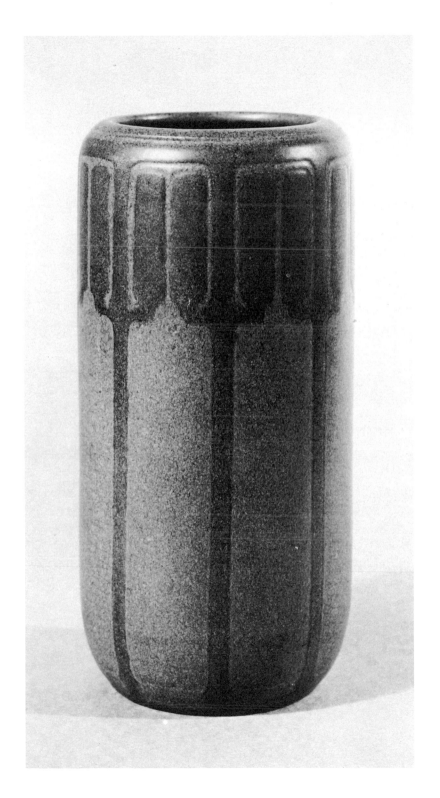

**284 Vase**
Marblehead Pottery, Marblehead, Mass., after 1908
Executed by Hanna Tutt
Pottery, with incised and painted decoration of
conventionalized dragonflies; brown and green mat
glazes
Height: 6"
Marks: impressed *M,* emblem of a sailing ship, *P;*
incised *HT*

A somewhat similar and equally rigid schematiza-
tion of dragonflies appears on a Marblehead vase
illustrated in *Keramic Studio,* XI (1909), p. 40.

Private collection

**285 Bowl**
Marblehead Pottery, Marblehead, Mass., after 1908
Pottery, with incised and painted decoration of
stylized floral motifs; green, brown, and orange
mat glazes
Height: 3¼"
Marks: impressed *M,* emblem of a sailing ship, *P;*
incised conjoined *AB, T*

The Marblehead Pottery was well aware of the com-
patibility of its sturdy designs with the heaviness
of its clay body. Even when curving motifs were
used, such as this stylized floral pattern with its dis-
tant echo of Art Nouveau, the treatment is strin-
gent and sparse. Yet when the pottery began mak-
ing majolica around 1912, the finer quality of the
material prompted experimentation with more com-
plicated and rhythmic designs.

Private collection

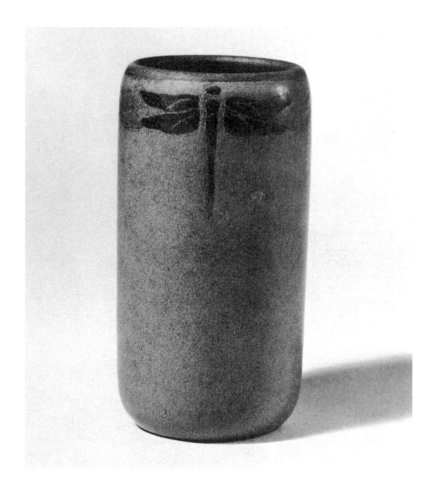

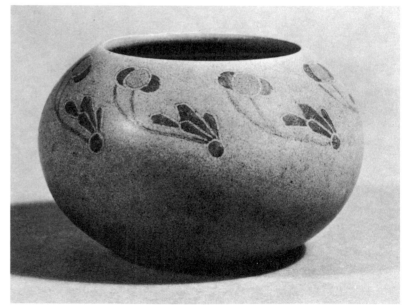

**286 Vase**
Marblehead Pottery, Marblehead, Mass., ca. 1908–10
Executed by Hanna Tutt
Pottery, with modeled and painted decoration of
conventionalized flowers; green, brown, black, and
yellow mat glazes
Height: 7″
Marks: impressed *M*, emblem of a sailing ship, *P*,
incised *HT*; original paper label, *MARBLEHEAD/
A-5/ POTTERY*

The Newark Museum acquired this vase in 1910.

Newark Museum

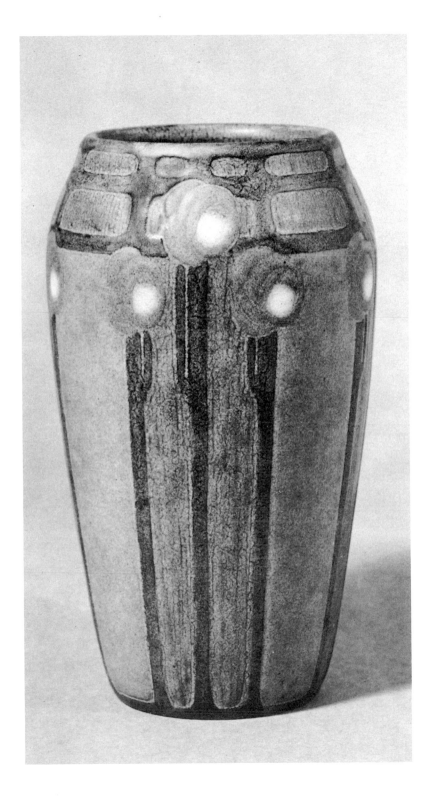

**287 Vase**
Walrath Pottery, Rochester, N.Y., ca. 1910
Executed by Frederick E. Walrath
Pottery, with painted design of conventionalized
iris; brown, purple, yellow-green, and green mat
glazes
Height: 9"
Marks: incised *Walrath Pottery* and device of four
conjoined arrows; original price sticker, *18/6.00*

When this vase was bought by the Newark Museum
in 1910, it sold for a modest six dollars. According
to a contemporary reviewer in the *Craftsman,* XXI
(February 1912), p. 567: "The price of the pottery,
with all its satisfactory beauty and usefulness, was
such as to place it within the means of the busy,
intelligent working people of this country. There is
no reason in the world why those who care for
such things should not have many household de-
tails for which this pottery is suited, made beautiful
in place of the types of things which are usually
considered necessarily ugly and to be purchased
only from the stores handling machine products."

Newark Museum

**288 Tobacco jar**
Walrath Pottery, Rochester, N.Y., ca. 1910
Executed by Frederick E. Walrath
Pottery, with painted design of a conventionalized
floral motif; speckled blue-brown and orange mat
glazes
Height: 6¾"
Marks: incised *Walrath Pottery* and device of four
conjoined arrows; original price sticker, *11/4.00*

The jar was acquired by the Newark Museum in
1910.

Newark Museum

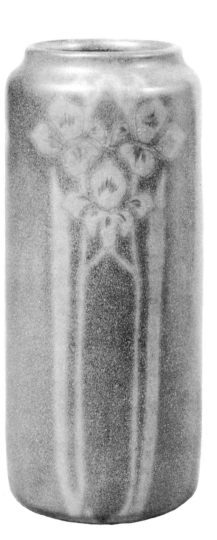

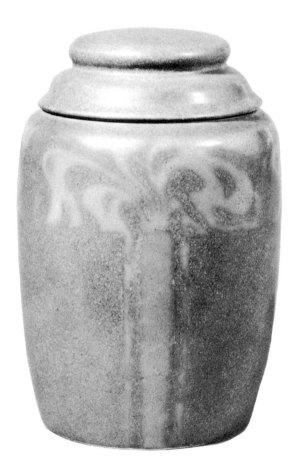

**289 Vase**

Walrath Pottery, Rochester, N.Y., ca. 1910
Executed by Frederick E. Walrath
Pottery, with painted design of a conventionalized floral motif; speckled brown, yellow, and green mat glazes
Height: 7"
Marks: incised *Walrath Pottery* and device of four conjoined arrows

Mr. and Mrs. James M. Marrin

**290 Bowl**

Paul Revere Pottery, Boston, Mass., 1910
Executed by an artist with the initials *CG*
Pottery, with an incised and painted design of heraldically paired roosters and the motto *EARLY·TO·BED·&·EARLY·&·EARLY·TO·RISE·MAKES·A·CHILD·HEALTHY·&·WISE;* yellow, white, and black mat glazes
Diameter: 5½"
Marks: painted, . . . *1.10, CG* within a vertical rectangle; portion of original paper label, . . . *WL SHOP/ S·E·G* within the emblem of a bowl/ . . . *ULL·ST/* . . . *ON·MASS/* . . . *2.50*

A toilet set with the same design of heraldic roosters, but with different mottoes, is illustrated in the *Craftsman*, XXI (February 1912), p. 567.

Newark Museum

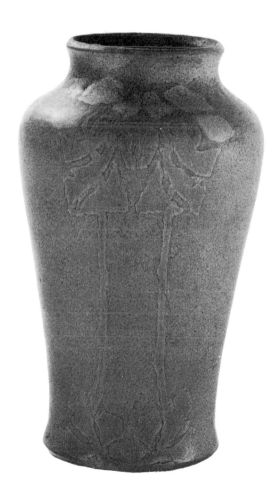

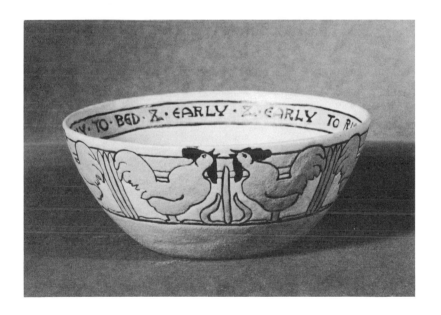

**291 Plate**
Paul Revere Pottery, Boston, Mass., 1910
Executed by an artist with the initials *EL*
Pottery, with a painted design of conventionalized flowers; blue-gray, black, and white mat glazes; white crackle glaze
Diameter: 7¾"
Marks: painted . . . *11-10, C·O, EL* within a rectangle; original paper label, *BOWL SHOP/S·E·G* within the emblem of a bowl/ *18 HULL·ST/ BOSTON· MASS/ PRICE 2.50*

This model is illustrated in the *Craftsman*, XXI (February 1912), p. 566. Its color scheme, its use of a crackle glaze, and its conventionalized floral motif are all quite close to the Dedham Pottery dinnerware, particularly to the latter's "Magnolia" pattern.

Newark Museum

**292 Vase**
Paul Revere Pottery, Boston, Mass., ca. 1910
Executed by an artist with the initials *AM*
Pottery, with an incised and painted design of conventionalized daffodils; blue, yellow, and green semi-mat glazes
Height: 5¹¹⁄₁₆"
Mark: painted, *AM/S.E.G.*

Private collection

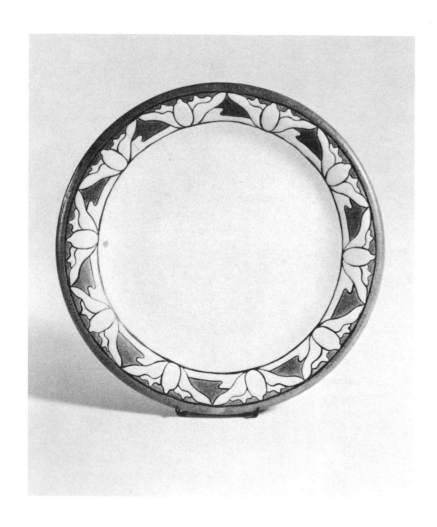

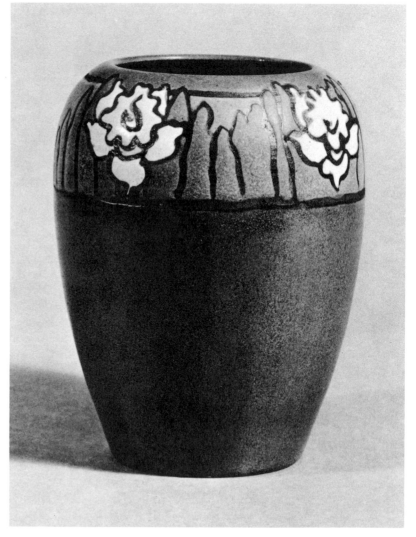

**293 Tile**
Moravian Pottery and Tile Works, Doylestown, Pa.,
ca. 1910
Pottery, with relief pattern of an armored knight on
a charging horse; glossy ocher and blue glazes
Height: 4¹¹⁄₁₆″, width: 7⁵⁄₁₆″

According to the records of the Newark Museum,
which acquired the tile in 1910, this pattern was
called "Knight of Margam" and was based on an
old tile in Margam Abbey.

Newark Museum

**294 Tile**
Moravian Pottery and Tile Works, Doylestown, Pa.,
ca. 1910
Pottery, with relief pattern of a conventionalized
lion; blue-green, tan, and buff glazes
Height: 5⁵⁄₁₆″, width: 5⁵⁄₁₆″

This pattern was called the "Etin" and was a copy
of an ancient British tile in the Frank Collection,
according to the records of the Newark Museum.
The museum acquired the tile in 1910.

Newark Museum

**295 Tile**
Moravian Pottery and Tile Works, Doylestown, Pa.,
ca. 1910
Pottery, with intaglio pattern of conventionalized
dragon; blue and yellowish tan glazes.
Height: 3¾", width: 3½"

According to the records of the Newark Museum,
which acquired the tile in 1910, this pattern, called
"Scaled Dragon," was copied from an old tile in
Castle Acre Priory, Norfolk, England.

Newark Museum

# Selected Bibliography

## General

"The Arts and Crafts Movement at Home and Abroad," *Brush and Pencil,* VI (June 1900), 110–21.

Bing, Samuel. *La Culture artistique en Amérique.* Paris, 1895. (Translation published in *Artistic America, Tiffany Glass, and Art Nouveau,* by Samuel Bing. Cambridge, Mass.: M.I.T. Press, 1970.)

Binns, Charles F. "The Arts and Crafts Movement in America: Prize Essay," *Craftsman,* XIV (June 1908), 275–79.

Binstead, Herbert E. *The Furniture Styles.* Chicago: Trade Periodical Co., 1909.

Coulter, Mary J. "History of the Art Crafts Movement in America," *California's Magazine,* II (1916), 169–78.

Covell, Alwyn T. "The Real Place of Mission Furniture," *Good Furniture,* IV (March 1915), 359–68.

Davidson, Marshall B., ed. *The American Heritage History of Antiques from the Civil War to World War I.* New York: American Heritage Publishing Co., 69.

———, ed. *The American Heritage History of Notable American Houses.* New York: American Heritage Publishing Co., 1971.

Dickason, David Howard. *The Daring Young Men: The Story of the American Pre-Raphaelites.* Bloomington: Indiana University Press, 1953.

Gebhard, David. "C. F. A. Voysey—To and From America," *Journal of the Society of Architectural Historians,* XXX (December 1971), 304–12.

Jordy, William H. *American Buildings and their Architects.* Vol. III, *Progressive and Academic Ideals at the Turn of the Twentieth Century.* Garden City, N.Y.: Doubleday and Co., 1972.

Keith, M. L. *Interiors Beautiful and Their Decoration.* 3d ed. Minneapolis, [ca. 1911].

Kornwolf, James D. *M. H. Baillie Scott and the Arts and Crafts Movement.* Baltimore: Johns Hopkins Press, 1972.

Lancaster, Clay. *The Japanese Influence in America.* New York: Walton H. Rawls, 1963.

———. "Taste at the Philadelphia Centennial," *Magazine of Art,* XLIII (January 1950), 293–97, 308.

Lynes, Russell. *The Tastemakers.* New York: Harper and Brothers, 1955.

Macomber, H. Percy. "The Future of the Handicrafts," *American Magazine of Art,* IX (March 1918), 192–95.

Naylor, Gillian. *The Arts and Crafts Movement.* London: Studio Vista, 1971.

*19th-Century America: Furniture and Other Decorative Arts.* New York: Metropolitan Museum of Art, 1970.

Otto, Celia Jackson. *American Furniture of the Nineteenth Century.* New York: Viking, 1965.

Priestman, Mabel Tuke. "History of the Arts and Crafts Movement in America," *House Beautiful,* XX (October 1906), 15–16; (November 1906), 14–16.

Robie, Virginia. "Mission Furniture: What It Is and Is Not," *House Beautiful,* XXVII (May 1910), 162–63, 175.

Ruge, Clara. "Kunst und Kunstgewerbe auf der Weltausstellung zu St. Louis," *Kunst und Kunsthandwerk,* VII (December 1904), 597–649.

———. "Das Kunstgewerbe Amerikas," *Kunst und Kunsthandwerk,* V (March 1902), 126–48.

Sargent, Irene. "William Morris," *Craftsman,* I (October 1901), 1–14.

Stein, Roger B. *John Ruskin and Aesthetic Thought in America, 1840–1900.* Cambridge, Mass.: Harvard University Press, 1967.

Triggs, Oscar Lovell. *Chapters in the History of the Arts and Crafts Movement.* Chicago: Bohemia Guild of the Industrial Art League, 1902.

Twyman, Joseph. "The Art and Influence of William Morris," *Inland Architect and News Record,* XLII (January 1904), 43–45.

Whiting, Fredric Allen. "The Arts and Crafts at the

Louisiana Purchase Exposition," *International Studio*, XXIII (October 1904), ccclxxxiv–ccclxxxix.

Winter, Robert W. "American Sheaves from 'C. R. A.' and Janet Ashbee," *Journal of the Society of Architectural Historians*, XXX (December 1971), 317–22.

Zueblin, Rho Fisk. "The Arts and Crafts Movement," *Chautauquan*, XXXVI and XXXVII (October 1902–June 1903).

## The Eastern seaboard

"Ein amerikanischer Moebel-Kuenstler: Charles Rohlfs, Buffalo," *Dekorative Kunst*, IV (October 1900), 74–79.

Balch, David Arnold. *Elbert Hubbard: Genius of Roycroft*. New York: F. A. Stokes Co., 1940.

Beisner, Robert L. " 'Commune' in East Aurora," *American Heritage*, XXII (February 1971), 72–77, 106–9.

Berlepsch-Valendas, H. E. "Will Bradley, ein amerikanischer Wohnungskuenstler," *Moderne Bauformen*, V (1906), 110–15.

Blasberg, Robert W. "The Old Oaken Mark," *Spinning Wheel*, XXVII (October 1971), 10–13.

"The Boston Society of Arts and Crafts," *Craftsman*, II (August 1902), 258–59.

*Bradley: American Artist and Craftsman*. New York: Metropolitan Museum of Art, 1972.

Bragdon, Claude. "Harvey Ellis: A Portrait Sketch," *Architectural Review* (Boston), XV (December 1908), 173–83.

Caruthers, J. Wade. "Elbert Hubbard: A Case of Re-Interpretation," *Connecticut Review*, I (October 1967), 67–77.

Champney, Freeman. *Art and Glory: The Story of Elbert Hubbard*. New York: Crown Publishers, 1968.

de Kay, Charles. *The Art Work of Louis C. Tiffany*. New York: Doubleday, Page and Co., 1914.

Denison, Lindsay. "Elbert Hubbard's Shop: An American William Morris at Work in East Aurora," *New York Sun*, 29 October 1899, 6.

Early, Marcia Andrea. "*The Craftsman* (1901–1916) as the Principal Spokesman of the Craftsman Movement in America, With a Short Study of the Craftsman House Projects." Master's thesis, Institute of Fine Arts, New York University, 1963.

Edgewood, Margaret. "Some Sensible Furniture," *House Beautiful*, VIII (October 1900), 653–55.

Ellis, Harvey. "An Adirondack Camp," *Craftsman*, IV (July 1903), 281–84.

———. "A Craftsman House Design," *Craftsman*, IV (July 1903), 269–77.

———. "A Note of Color," *Craftsman*, V (November 1903), 153–63.

———. "A Summer Chapel," *Craftsman*, IV (September 1903), 401–14.

———. "An Urban House," *Craftsman*, IV (August 1903), 313–27.

Farrar, Francis, and Farrar, Abigail. *The Book of the Roycrofters*. East Aurora, N.Y.: Roycrofters, 1907.

Freeman, John Crosby. *The Forgotten Rebel: Gustav Stickley and His Craftsman Mission Furniture*. Watkins Glen, N.Y.: Century House, 1966.

Garden, Hugh M. G. "Harvey Ellis, Designer and Draughtsman," *Architectural Review* (Boston), XV (December 1908), 184–86.

Hamilton, Charles F. *Little Journeys to the Homes of Roycrofters*. East Aurora, N.Y.: S-G Press, 1963.

Howe, Samuel. "A Visit to the Workshops of the United Crafts," *Craftsman*, III (October 1902), 59–64.

Hubbard, Elbert. *The Roycroft Shop: Being a History*. East Aurora, N.Y.: Roycrofters, 1908.

Hunter, Dard. *My Life with Paper*. New York: Alfred A. Knopf, 1958.

Kaufmann, Edgar, jr. "At Home with Louis C. Tiffany," *Interiors*, XVII (December 1957), 118–24.

———. "Some American Architectural Ornament of the Arts and Crafts Era," *Journal of the Society of Architectural Historians*, XXIV (December 1965), 285–91.

Kennedy, Roger G. "Long Dark Corridors: Harvey Ellis," *Prairie School Review*, V (First and Second Quarter 1968), 5–18.

———. "The Long Shadow of Harvey Ellis," *Minnesota History*, XL (Fall 1966), 97–108.

Koch, Robert. "Elbert Hubbard's Roycrofters as Artist-Craftsmen," *Winterthur Portfolio*, III (1967), 67–82.

———. *Louis C. Tiffany, Rebel in Glass*. New York: Crown Publishers, 1964.

———. *Louis C. Tiffany's Glass—Bronzes—Lamps*. New York: Crown Publishers, 1971.

———. "Will Bradley," *Art in America*, L (Fall 1962), 78–83.

Lipscomb, Mary Elizabeth. "The Architecture of Harvey Ellis in Rochester, New York." Master's thesis, University of Rochester, 1969.

*Louis Comfort Tiffany, 1848–1933*. New York: Museum of Contemporary Crafts, 1958.

Manning, Eileen. "The Architectural Designs of Harvey Ellis." Master's thesis, University of Minnesota, 1953.

Moffitt, Charlotte. "The Rohlfs Furniture," *House Beautiful*, VII (January 1900), 81–85.

"New Designs in Silver," *House Beautiful*, VII (December 1899), 55–58.

Pond, Theodore Hanford. "The Arts and Crafts Exhibition at the Providence Art Club," *House Beautiful*, X (June 1901), 98–101.

Randall, Richard H., Jr. *The Furniture of H. H. Richardson*. Boston: Musem of Fine Arts, 1962.

"A Revival of Pen and Ink Rendering: The Work of Harvey Ellis," *Western Architect*, XVIII (March 1912), 31–37.

Roberts, Mary Fanton. "One Man's Story," *Craftsman*, XXX (May, 1916), 188–200.

Rohlfs, Charles. "My Adventures in Wood-Carving," *Arts Journal*, October 1925, 21–22.

———. "The Grain of Wood," *House Beautiful*, IX (February 1901), 147–48.

Sargent, Irene. "A Recent Arts and Crafts Exhibition," *Craftsman*, IV (May 1903), 69–83.

Shay, Felix. *Elbert Hubbard of East Aurora*. New York: Wise and Co., 1926.

"Some Recent Examples of Gorham Silverware," *Craftsman*, VII (January 1905), 447–59.

Stern, Madeleine B. "An American Woman First in Textiles and Decoration: Candace Wheeler." In *We the Women*. New York: Schulte Publishing Co., 1963, 273–303.

Stickley, Gustav. *Chips from the Craftsman Workshops*. New York: Kalkhoff Co., 1907.

———. *Craftsman Homes*. New York: Craftsman Publishing Co., 1909.

———. "The Craftsman Movement: Its Origin and Growth," *Craftsman*, XXV (October 1913), 17–26.

———. *The Craftsman's Story*. Syracuse: Mason Press, [1905].

———. *More Craftsman Homes*. New York: Craftsman Publishing Co., 1912.

———. "The Structural Style in Cabinet-Making," *House Beautiful*, XV (December 1903), 19–23.

———. *What is Wrought in the Craftsman Workshops*. Syracuse, 1904.

"Structure and Ornament in the Craftsman Workshops," *Craftsman*, V (January 1904), 391–96.

Swales, Francis S. "Master Draftsmen, III: Harvey Ellis," *Pencil Points*, V (July 1924), 49–55, 79.

Townsend, Horace. "American and French Applied Art at the Grafton Gallery," *Studio*, XVII (June 1899), 39–44.

Van Zanten, David T. "H. H. Richardson's Glessner House, Chicago, 1886–1887," *Journal of the Society of Architectural Historians,* XXIII (May 1964), 107–11.

Vidler, Virginia. "Hubbard's Roycroft," *Antiques Journal,* XXIV (July 1969), 10–12.

Weinberg, Helene Barbara. "The Decorative Work of John La Farge." Ph.D. dissertation, Columbia University, 1972.

Wheeler, Candace. *Principles of Home Decoration.* New York: Doubleday, Page and Co., 1903.

———. *Yesterdays in a Busy Life.* New York: Harper and Brothers, 1918.

*Will Bradley, His Work: An Exhibition.* San Marino, Calif.: Henry E. Huntington Library and Art Gallery, 1951.

## Chicago and the Midwest

Adams, Mary. "The Chicago Arts and Crafts Society," *House Beautiful,* IX (January 1901), 96–101.

"An Appreciation of the Work of Robert Jarvie," *Craftsman,* V (December 1903), 271–76.

*The Architecture of Purcell and Elmslie.* Introduction by David Gebhard. Park Forest, Ill.: Prairie School Press, 1965. (Reprint of sections from *Western Architect,* January 1913, January 1915, and July 1915.)

Brooks, H. Allen. "Chicago Architecture: Its Debt to the Arts and Crafts," *Journal of the Society of Architectural Historians,* XXX (December 1971), 312–17.

———. *The Prairie School: Frank Lloyd Wright and His Midwest Contemporaries.* Toronto: University of Toronto Press, 1972.

———. "Steinway Hall, Architects and Dreams," *Journal of the Society of Architectural Historians,* XXII (October 1963), 171–75.

Caye, Roger. "Paul Revere, Silversmith, and Modern Emulators: The Handwrought Silverwork of Robert Jarvie, Craftsman," *Arts and Decoration,* IV (August 1914), 385–86.

Committee of Architectural Heritage. *Frank Lloyd Wright: Vision and Legacy.* Urbana: University of Illinois, 1966.

Eaton, Leonard K. *Two Chicago Architects and Their Clients: Frank Lloyd Wright and Howard Van Doren Shaw.* Cambridge, Mass.: M.I.T. Press, 1969.

Gebhard, David. "Louis Sullivan and George Grant Elmslie," *Journal of the Society of Architectural Historians,* XIX (May 1960), 62–68.

———. "William Gray Purcell and George Grant Elmslie and the Early Progressive Movement in American Architecture from 1900 to 1920." Ph.D. dissertation, University of Minnesota, 1957.

"George W. Maher—A Democrat in Architecture," *Western Architect,* XX (March 1914), 25–29.

Granger, Alfred H. "An Architect's Studio," *House Beautiful,* VII (December 1899), 36–45.

Hitchcock, Henry-Russell. *In the Nature of Materials, 1887–1941: The Buildings of Frank Lloyd Wright.* New York: Duell, Sloan and Pierce, 1942.

Illinois Art League. *Arts and Crafts: Circular of Information.* Chicago: University of Chicago Press, 1899.

Kalec, Donald. "The Prairie School Furniture," *Prairie School Review,* I (Fourth Quarter 1964), 5–21.

Key, Mabel. "A Review of the Recent Exhibition of the Chicago Arts and Crafts Society," *House Beautiful,* VI (June 1899), 3–12.

Licht, Ira. "The Stained Glass Panels of Frank Lloyd Wright," *Arts Magazine,* XLIII (November 1968), 34–35.

Maher, George W. "An Architecture of Ideas," *Arts and Decoration,* I (June 1911), 329–31, 355.

Manson, Grant Carpenter. *Frank Lloyd Wright to 1910: The First Golden Age.* New York: Reinhold Publishing Co., 1958.

Price, C. Matlack. "Secessionist Architecture in America," *Arts and Decoration,* III (December 1912), 51–53.

Rudd, J. William. "George W. Maher, Architect of the Prairie School," *Prairie School Review,* I (First Quarter 1964), 5–10.

Smith, Katherine Louise. "An Arts and Crafts Exhibition at Minneapolis," *Craftsman,* III (March 1903), 373–77.

Spencer, Robert C., Jr. "The Work of Frank Lloyd Wright," *Architectural Review* (Boston), VII (June 1900), 61–72.

Stuart, Evelyn Marie. "A Contribution to Artistic Handicraft," *Fine Arts Journal,* XXV (August 1911), 375–78.

Tallmadge, Thomas E. "The 'Chicago School,'" *Architectural Review* (Boston), XV (April 1908), 69–74.

Triggs, Oscar Lovell. *About Tobey Handmade Furniture.* Chicago: Press of Metcalf, 1906.

Wight, Peter B. "Country House Architecture in the Middle West," *Architectural Record,* XXXVIII (October 1915), 385–421.

Wright, Frank Lloyd. *Ausgefuehrte Bauten und Entwuerfe.* Berlin: Ernst Wasmuth, 1910.

———. *Frank Lloyd Wright: Ausgefuehrte Bauten.* Berlin: Ernst Wasmuth, 1911.

———. "In the Cause of Architecture," *Architectural Record,* XXIII (March 1908), 155–221.

## The Pacific coast

Allman, Paul R. "Arthur and Lucia Mathews," *Art Gallery,* XV (May 1972), 33–35, 90–91.

Bangs, Jean Murray. "Bernard Ralph Maybeck, Architect, Comes into His Own," *Architectural Record,* CIII (January 1948), 72–79.

———. "Greene and Greene," *Architectural Forum,* LXXXIX (October 1948), 81–89.

Batchelder, Ernest. *Design in Theory and Practice.* New York: Macmillan Co., 1910.

———. *The Principles of Design.* Chicago: Inland Printer Co., 1904.

"Bernard Maybeck: A Parting Salute to a Great Romantic," *House and Home,* XII (December 1957), 124–29.

"California's Contribution to a National Architecture: Its Significance and Beauty as Shown in the Work of Greene and Greene, Architects," *Craftsman,* XXII (August 1912), 532–47.

Croly, Herbert D. "The Country House in California," *Architectural Record,* XXXIV (December 1913), 483–519.

"The Gamble House, Pasadena: Design and Craftsmanship, 1907–1910," *Source Book,* XVII (September 1969), 30–33.

Keeler, Charles. *The Simple Home.* San Francisco: Paul Elder and Co., 1904.

———. "Thoughts on Homebuilding in California," *Architect and Engineer,* II (October 1905), 19–28.

Lancaster, Clay. "My Interviews with Greene and Greene," *Journal of the American Institute of Architects,* XXVIII (July 1957), 202–6.

McCoy, Esther. *Five California Architects.* New York: Reinhold Publishing Corp., 1960.

Makinson, Randell L. "Greene and Greene: The Gamble House," *Prairie School Review,* V (Fourth Quarter, 1968), 5–23.

Maloney, John. "The Rediscovered California Decorative Style of Arthur and Lucia Mathews," *Gallery,* III (May-June 1972), 1, 20–21, 36.

"Parting Salute to the Fathers of the California Style," *House and Home*, XII (August 1957), 84–95.

*Roots of California Contemporary Architecture.* Los Angeles: Los Angeles Art Commission, 1956.

Thompson, Elizabeth Kendall. "The Early Domestic Architecture of the San Francisco Bay Region," *Journal of the Society of Architectural Historians*, X (October 1951), 15–21.

Winter, Robert W. "Southern California Architecture & Crafts: Early 20th-Century Works," *Historic Preservation*, XXIV (April–June 1972), 12–15.

Yost, L. Morgan. "Greene and Greene of Pasadena," *Journal of the Society of Architectural Historians*, IX (March and May 1950), 11–19.

## The Arts and Crafts book

[*Note: This section does not include material, much of it very valuable, on individual people or presses, but is selected from the general literature.*]

*American Dictionary of Printing and Bookmaking.* New York: Howard Lockwood and Co., 1894.

Bowles, Joseph M. "Thoughts on Printing: Practical and Impractical," *Modern Art*, II (Summer 1894), unpaged.

Bullen, Henry Lewis. "William Morris, Regenerator of the Typographic Art," *Inland Printer*, LXIX (June 1922), 369–74.

Cave, Roderick. *The Private Press.* London: Faber and Faber, 1971.

De Vinne, Theodore Low. *The Practice of Typography.* 4 vols. New York: Century, 1900–04.

Goudy, Frederic W. "William Morris: His Influence on American Printing," *Philobiblon*, VII (1934), 185–91.

Grannis, Ruth Shepard. "Modern Fine Printing." In *A History of the Printed Book: Being the Third Number of the Dolphin*, edited by Lawrence C. Wroth. New York: Limited Editions Club, 1938, 269–93.

Houghton Library, Department of Printing and Graphic Arts. *The Turn of a Century, 1885–1910: Art Nouveau-Jugendstil Books.* Cambridge, Mass.: Harvard University, 1970.

Koch, Robert. "Artistic Books, Periodicals and Posters in the 'Gay Nineties,' " *Art Quarterly*, XXV (Winter 1962), 370–83.

Lehmann-Haupt, Hellmut. *The Book in America.* 2d ed. New York: R. R. Bowker Co., 1952.

Lewis, John N. C. *The Twentieth Century Book.* New York: Reinhold Publishing Corp., 1967.

McLean, Ruari. *Modern Book Design from William Morris to the Present Day.* London: Faber and Faber, 1958.

Nash, Ray. *Printing as an Art: A History of the Society of Printers, Boston, 1905–1955.* Cambridge, Mass.: Harvard University Press, 1955.

Orcutt, William Dana. "The Art of the Book in America." In *The Art of the Book*, edited by Charles Holme. London: The Studio, 1914, 259–76.

Ransom, Will. *Private Presses and Their Books.* New York: R. R. Bowker Co., 1929.

Rollins, Carl Purington. "The Golden Age of American Printing," *New Colophon*, II (September 1949), 299–303.

Schmidt-Kuensemueller, F. A. *William Morris und die neuere Buchkunst.* Wiesbaden: Harrassowitz, 1955.

Symons, A. J. A. "An Unacknowledged Movement in Fine Printing: The Typography of the Eighteen-Nineties," *Fleuron*, VII (1930), 83–119.

Taylor, John Russell. *The Art Nouveau Book in Britain.* London: Metheun, 1966.

Thompson, Susan Otis. "Kelmscott Influence on American Book Design." D.L.S. dissertation, School of Library Service, Columbia University, 1972.

Weinstein, Fredric D. "Walter Crane and the American Book Arts, 1880–1915." D.L.S. dissertation, School of Library Service, Columbia University, 1970.

Wells, James M. "Book Typography in the United States of America." In *Book Typography 1815–1965 in Europe and the United States*, edited by Kenneth Day. London: Benn, 1966, 325–70.

## Art pottery

"Adelaide Alsop Robineau, A Significant American," *Design*, XXXVII (December 1935), 20–22, 41.

Baggs, Arthur E. "The Story of a Potter," *The Handicrafter*, I (April–May 1929), 8–10.

Barber, Edwin A. "Cincinnati Women Art Workers," *Art Interchange*, XXXVI (February 1896), 29–30.

———. *The Pottery and Porcelain of the United States.* New York: G. P. Putnam's Sons, 1893 (3d and rev. ed. 1909).

———. *Marks of American Potters.* Philadelphia: Patterson and White, 1904.

———. "Recent Progress of American Potters," *Clay-Worker*, XXIII (1895), 580.

Benjamin, Marcus. "American Art Pottery," *Glass and Pottery World*, XV (February 1907), 28–31; (March 1907), 13–18; (April 1907), 35–40; (May 1907), 35–39.

Blackall, C. H. "The Grueby Faience," *Brickbuilder*, VII (August 1898), 162–63.

Blasberg, Robert W. "Grueby Art Pottery," *Antiques*, C (August 1971), 246–49.

———. "Moravian Tiles: Fairy Tales in Colored Clay," *Spinning Wheel*, XXVII (June 1971), 16–19.

———. "Newcomb Pottery," *Antiques*, XCIV (July 1968), 73–77.

———. "The Sadie Irvine Letters," *Antiques*, C August 1971), 250–51.

Bogue, Dorothy McGraw. *The Van Briggle Story.* Colorado Springs, 1968.

Bopp, H. F. "Art and Science in the Development of Rookwood Pottery," *American Ceramic Society Bulletin*, XV (1936), 443–45.

"Boston's Art Product—Grueby Ware," *Crockery and Glass Journal*, LIV (December 1901), 131–35.

Bowdoin, W. G. "The Grueby Pottery," *Art Interchange*, XLV (December 1900), 137–38.

———. "Some American Pottery Forms," *Art Interchange*, L (April 1903), 87–90.

Boulden, Jane L. "Rookwood," *Art Interchange*, XLVI (June 1901), 129–31.

"Clara Chipman Newton, Pioneer Secretary, Rookwood Pottery Company," *American Ceramic Society Bulletin*, XVIII (1939), 443–46.

Cox, Paul E. "Newcomb Pottery Active in New Orleans," *American Ceramic Society Bulletin*, XII (1933), 140–42.

Crane, Anne W. "The Middle Lane Pottery," *Art Interchange*, XLV (August 1900), 32–33.

"Dedham Pottery Distinctively Different," *Glass and Pottery World*, XVI (October 1908), 15–16.

Dole, Nathan Haskell. "The Best American Pottery," *House Beautiful*, II (September 1897), 87–94.

Eidelberg, Martin. "Tiffany Favrile Pottery," *Connoisseur*, CLXIX (September 1968), 57–61.

"Ellsworth Woodward," *American Ceramic Society Bulletin*, XVIII (1939), 179–80.

Emerson, Gertrude. "Marblehead Pottery," *Craftsman*, XXIX (March 1916), 671–73.

Evans, Paul F. "American Art Porcelain: The Work

of the University City Pottery," *Spinning Wheel*, XXVII (December 1971), 24–26.

———. "America's Finest Pottery," *Yankee*, June 1968, 93–95, 168–70.

Foster, Edith D. "William A. Robertson, Master Potter," *International Studio*, LI (November 1913), xcv–xcvi.

*Forms from the Earth: 1,000 Years of Pottery in America*. New York: Museum of Contemporary Crafts, 1962.

Galloway, George D. "The Van Briggle Pottery," *Brush and Pencil*, IX (October 1901), 1–11.

"Good Green Ware Gave Fame to Grueby Name," *Glass and Pottery World*, XVI (June 1908), 13–14.

Gray, Walter Ellsworth. "Latter-Day Developments in American Pottery," *Brush and Pencil*, IX (January 1902), 236–43.

Hall, Herbert J. "Marblehead Pottery," *Keramic Studio*, X (1908), 30–31.

Hawes, Lloyd E. *Dedham Pottery and the Earlier Robertson's Chelsea Potteries*. Dedham, Mass., 1968.

———. "Hugh Cornwall Robertson and the Chelsea Period," *Antiques*, LXXXIX (March 1966), 409–13.

Henzke, Lucile. *American Art Pottery*. Camden, N.J.: Thomas Nelson, 1970.

Hitchcock, Ripley. "The Western Art Movement," *Century Illustrated Monthly Magazine*, XXXII (August 1886), 576–93.

Hull, William. "Some Notes on Early Robineau Porcelains," *Everson Museum of Art Bulletin*, XXII (1960), 1–6.

Jervis, W. P. *A Pottery Primer*. New York: O'Gorman Publishing Co., 1911.

Kingsley, Rose. "Rookwood Pottery," *Art Journal* (London), XXIII (1897), 341–46.

"Louisiana Purchase Exposition Ceramics," *Keramic Studio*, VI (1904), 193–94, 216–19, 251–52; VII (1905), 7–8.

Low, J. G. and J. F. Art Tile Works. *Illustrated Catalogue of Art Tiles*. Chelsea, Mass., 1884.

McLaughlin, M. Louise. "Losanti Ware," *Craftsman*, III (December 1902), 186–87.

MacSwiggan, Amelia E. "The Marblehead Pottery," *Spinning Wheel*, XXVIII (March 1972), 20–21.

*Marblehead Pottery*. Marblehead, Mass.: Marblehead Potteries, 1919.

"Mary Louise McLaughlin," *American Ceramic Society Bulletin*, XVII (1938), 217–25.

Meline, Elva. "Art Tile in California: The Work of E. A. Batchelder," *Spinning Wheel*, XXVII (November 1971), 8–10, 65.

Mendenhall, Lawrence. "Mud, Mind and Modellers," *Frank Leslie's Popular Monthly*, XLII (December 1896), 667–74.

"Michigan State University Revives Pewabic Pottery," *Impresario*, February-March 1968, 16–17, 55–56.

Monachesi, Mrs. "Miss M. Louise McLaughlin and her New 'Losanti' Ware," *Art Interchange*, XLVIII (January 1902), 11.

"Necrology: Mrs. Bellamy Storer," *American Ceramic Society Bulletin*, XI (1932), 157–59.

Nelson, Marion J. "Art Nouveau in American Ceramics," *Art Quarterly*, XXVI (1963), 441–59.

———. "Indigenous Characteristics in American Art Pottery," *Antiques*, LXXXIX (June 1966), 846–50.

Nichols, George Ward. *Pottery: How it is Made, Its Shape and Decoration*. New York: G. P. Putnam's Sons, 1878.

Northend, Mary H. "Paul Revere Pottery," *House Beautiful*, XXXVI (August 1914), 82–83.

Ohr, George E. "Some Facts in the History of a Unique Personality," *Crockery and Glass Journal*, LIV (December 1901), 123–25.

Peck, Herbert. *The Book of Rookwood Pottery*. New York: Crown Publishers, 1968.

———, ed. *Catalog of Rookwood Art Pottery Shapes*. Kingston, N.Y., 1971.

———. "Rookwood Pottery and Foreign Museum Collections," *Connoisseur*, CLXXII (September 1969), 43–49.

———. "Some Early Collections of Rookwood Pottery," *Auction*, III (September 1969), 20–23.

Perry, Mary Chase. "Grueby Potteries," *Keramic Studio*, II (1900), 250–52.

Perry, Mrs. Aaron. "Decorative Pottery of Cincinnati," *Harper's New Monthly Magazine*, LXII (May 1881), 834–45.

Plumb, Helen. "The Pewabic Pottery," *Art and Progress*, II (January 1911), 63–67.

Purviance, Louise; Purviance, Evan; and Schneider, Norris F. *Roseville Art Pottery in Color*. Des Moines: Wallace-Homestead Book Co., 1970.

———. *Zanesville Art Pottery in Color*. Leon, Iowa: Mid-American Book Co., 1968.

Robineau, Adelaide. "Porcelains," *Keramic Studio*, IX (1907), 178–80.

Robineau, Samuel. "Adelaide Alsop Robineau," *Design*, XXX (April 1929), 201–6.

[——— ?] *High Fire Porcelains*. 1915.

[——— ?] *Porcelains from the Robineau Pottery*.

[ca. 1910].

———. "The Robineau Porcelains," *Keramic Studio*, XII (1911), 80–84.

"Rookwood at the Pan-American," *Keramic Studio*, III (1901), 146–48.

Roseville Pottery. *Rozane Ware Catalog*. Zanesville, Ohio, 1906 (reprint 1970).

Ruge, Clara. "Amerikanische Keramik," *Dekorative Kunst*, IX (January 1906), 167–76.

———. "American Ceramics—A Brief Review of Progress," *International Studio*, XXVIII (March 1906), xxi–xxviii.

Russell, Arthur. "Grueby Pottery," *House Beautiful*, V (December 1898), 3–9.

Sargent, Irene. "Chinese Pots and Modern Faience," *Craftsman*, IV (September 1903), 415–25.

———. "Some Potters and Their Products," *Craftsman*, IV (August 1903), 328–37.

Saunier, Charles. "Poteries de la Cie Grueby (Boston)," *L'Art décoratif*, III (August 1901), 203–8.

Schneider, Norris F. *Zanesville Art Pottery*. Zanesville, Ohio, 1963.

Sheerer, Mary G. "Newcomb Pottery," *Keramic Studio*, I (1899), 151–52.

Smith, Kenneth E. "Laura Anne Fry: Originator of Atomizing Process for Application of Underglaze Color," *American Ceramic Society Bulletin*, XVIII (1938), 368–72.

———. "The Origin, Development, and Present Status of Newcomb Pottery," *American Ceramic Society Bulletin*, XVII (1938), 257–59.

"A Social and Business Experiment in the Making of Pottery," *Handicraft*, III (1911), 411–16.

"The Story of Paul Revere Pottery," *Craftsman*, XXV (November 1913), 205–7.

Swan, Mabel M. "The Dedham Pottery," *Antiques*, X (August 1926), 116–21.

Townsend, Everett. "Development of the Tile Industry in the United States," *American Ceramic Society Bulletin*, XXII (May 1943), 126–52.

"A True Porcelain Art Pottery," *Glass and Pottery World*, XVII (March 1909), 11–13.

Valentine, John. "Rookwood Pottery," *House Beautiful*, IV (September 1898), 120–29.

"Van Briggle Name Adds to Colorado's Fame," *Glass and Pottery World*, XVI (April 1908), 15–16.

"Volkmar Art Pottery," *Crockery and Glass Journal*, LIV (December 1901), 147–49.

Walton, William. "Charles Volkmar, Potter," *International Studio*, XXXVI (January 1909), lxxv–lxxxi.

## Additional Bibliography, 1972–1991

**1972**

France, Jean R., et al. *A Rediscovery—Harvey Ellis: Artist, Architect.* Rochester: Memorial Art Gallery of the University of Rochester and Margaret Woodbury Strong Museum, 1972.

Schwartz, Marvin. "Arts and Crafts Movement, 1876–1916" (review), *Craft Horizons,* XXXII (December 1972), 46–51, 74–76.

**1973**

Eidelberg, Martin. "The Ceramic Art of William H. Grueby," *Connoisseur,* CLXXXIV (September 1973), 47–54.

Frangiamore, Catherine Lynn. "A Half-Century of Decorative Arts" (review), *Smithsonian Magazine,* IV (May 1973), 38–41.

Hamilton, Charles F. *As Bees in Honey Drown: Elbert Hubbard and the Roycrofters.* New York: A. S. Barnes and Co., 1973.

Shelton, Stanhope. "The Arts and Crafts Movement in America, 1876–1916" (review), *Journal of the Royal Society of Arts* (September 1973), 690–91.

**1974**

Andersen, Timothy J., Eudorah M. Moore, and Robert W. Winter, eds. *California Design 1910.* Pasadena: California Design Publications, 1974.

Current, William R., and Karen Current. *Greene and Greene, Architects in the Residential Style.* Fort Worth: Amon Carter Museum of Western Art, 1974.

Evans, Paul. *Art Pottery of the United States: An Encyclopedia of Producers and their Marks.* New York: Charles Scribner's Sons, 1974.

Hanks, David A. *Isaac E. Scott: Reform Furniture in Chicago, John Jacob Glessner House.* Chicago: Chicago School of Architecture Foundation, 1974.

Johnson, Marilynn. "The Arts and Crafts Movement in America, 1876–1916" (review), *Prairie School Review,* XI (1974), 20–23.

Sokol, David M. "The Arts and Crafts Movement in America, 1876–1916" (review), *Art Journal,* XXXIV (Fall 1974), 88.

**1975**

Arnest, Barbara M., ed. *Van Briggle Pottery: The Early Years.* Colorado Springs: Colorado Springs Fine Arts Center, 1975.

Clark, Robert Judson, ed. "Aspects of the Arts and Crafts Movement in America" (symposium), *Record of the Art Museum, Princeton University,* XXXIV/2 (1975), entire issue.

**1976**

Colby, Joy Hakanson, et al. *Arts and Crafts in Detroit 1906–1976: The Movement, the Society, the School.* Detroit: Detroit Institute of Arts, 1976.

Leighton, Margaretha Gebelein. *George Christian Gebelein, Boston Silversmith, 1878–1945; A Biographical Sketch.* Boston, 1976.

Macht, Carol, et al. *The Ladies, God Bless 'Em: The Women's Art Movement in Cincinnati in the Nineteenth Century.* Cincinnati: Cincinnati Art Museum, 1976.

**1977**

Cardwell, Kenneth H. *Bernard Maybeck, Artisan, Architect, Artist.* Salt Lake City: Peregrine Smith, 1977.

Darling, Sharon S., with Gail Farr Casterline. *Chicago Metalsmiths: An Illustrated History.* Chicago: Chicago Historical Society, 1977.

Koch, Robert. *Louis C. Tiffany's Art Glass.* New York: Crown Publishers, 1977.

Makinson, Randell L. *Greene & Greene: Architecture as a Fine Art.* Salt Lake City: Peregrine Smith, 1977.

Thompson, Susan Otis. *American Book Design and William Morris.* New York: R. R. Bowker Co., 1977.

Weinberg, Barbara. "The Decorative Work of John LaFarge." Ph.D. dissertation, Columbia University, 1972 (New York: Garland Publishing, 1977).

**1978**

Anscombe, Isabelle, and Charlotte Gere. *Arts and Crafts in Britain and America.* London: Academy Editions, 1978.

Keen, Kirsten Hoving. *American Art Pottery, 1875–1930.* Wilmington: Delaware Art Museum, 1978.

**1979**

Blasberg, Robert W., with Carol L. Bohdan. *Fulper Art Pottery: An Aesthetic Appreciation, 1909–1929.* New York: Jordan-Volpe Gallery, 1979.

Bohdan, Carol. "Arts and Crafts Copperware," *American Art and Antiques,* II (March–April 1979), 108–15.

Bruhn, Thomas P. *American Decorative Tiles, 1870–1930.* Storrs, Conn.: William Benton Museum of Art, 1979.

Callen, Anthea. *Women Artists of the Arts and Crafts Movement, 1870–1914.* New York: Pantheon Books, 1979.

Clark, Garth, and Margie Hughto. *A Century of Ceramics in the United States, 1878–1978.* New York: E. P. Dutton, 1979.

Darling, Sharon S. *Chicago Ceramics and Glass: An Illustrated History from 1871 to 1933.* Chicago: Chicago Historical Society, 1979.

Hanks, David A. *The Decorative Designs of Frank Lloyd Wright.* New York: E. P. Dutton, 1979.

Johnson, Diane Chalmers. *American Art Nouveau.* New York: Harry N. Abrams, 1979.

Linch, Mark David. "The Ward Willits House by Frank Lloyd Wright," *Frank Lloyd Wright Newsletter,* II/3 (1979), 1–5.

Makinson, Randell L. *Greene & Greene: Furniture and Related Designs.* Salt Lake City: Peregrine Smith, 1979.

Sanders, Barry. "Gustav Stickley: A Craftsman's Furniture," *American Art and Antiques,* II (July–August 1979), 46–53.

**1980**

Bohdan, Carol. "The Roycrofters of East Aurora: An Episode in American Arts and Crafts." *Connoisseur,* CCIII (March 1980), 209–16.

Bray, Hazel V. *The Potter's Art in California, 1885–1955.* Oakland: Oakland Museum, 1980.

Clark, Robert Judson. "Good Design and Simple Beauty: American Arts and Crafts Furniture," *Antiques World,* II (Summer 1980), 38–43.

Davey, Peter. *Arts and Crafts Architecture: The Search for Earthly Paradise.* London: Architectural Press, 1980.

Lambourne, Lionel. *Utopian Craftsmen: The Arts and Crafts Movement from the Cotswolds to Chicago.* London: Astragal Books, 1980.

Trapp, Kenneth R. *Ode to Nature: Flowers and Landscapes of the Rookwood Pottery, 1880–1940.* New York: Jordan-Volpe Gallery, 1980.

Winter, Robert. *The California Bungalow.* Los Angeles: Hennessey & Ingalls, 1980.

Wright, Gwendolyn. *Moralism and the Model Home: Domestic Architecture and Cultural Conflict in Chicago, 1873–1913.* Chicago: University of Chicago Press, 1980.

**1981**

Blasberg, Robert W. *Grueby.* Syracuse, N.Y.: Everson Museum of Art, 1981.

Cathers, David M. *Furniture of the American Arts and Crafts Movement: Stickley and Roycroft Mission Oak.* New York: New American Library, 1981.

———. *Genius in the Shadows: The Furniture Designs of Harvey Ellis.* New York: Jordan-Volpe Gallery, 1981.

Edwards, Robert. "The Roycrofters: Their Furniture and Crafts," *Art & Antiques,* IV (November–December 1981), 80–87.

Lears, T. J. Jackson. *No Place of Grace: Antimodernism and the Transformation of American Culture, 1880–1920.* New York: Pantheon Books, 1981.

Sanders, Barry. "Harvey Ellis: Architect, Painter, Furniture Designer," *Art & Antiques*, IV (January–February 1981), 59–67.

Stover, Donald L. *The Art of Louis Comfort Tiffany.* San Francisco: Fine Arts Museums of San Francisco, 1981.

Úlehla, Karen Evans, ed. *The Society of Arts and Crafts, Boston: Exhibition Record, 1897–1927.* Boston: Boston Public Library, 1981.

Weiss, Peg, ed. *Adelaide Alsop Robineau: Glory in Porcelain.* Syracuse, N.Y.: Syracuse University Press, 1981.

### 1982

Ayres, William S. "The Constructional Theory of Furniture Making: More Honored in the Breach than in the Observance," *Tiller: A Bimonthly Devoted to the Arts and Crafts Movement*, I (September–October 1982), 21–30.

Bavaro, Joseph J., and Thomas L. Mossman. *The Furniture of Gustav Stickley: History, Techniques, Projects.* New York: Van Nostrand Reinhold Co., 1982.

Kaufmann, Edgar, jr. *Frank Lloyd Wright at the Metropolitan Museum of Art.* New York: Metropolitan Museum of Art, 1982.

Robertson, Cheryl. *The Domestic Scene (1897–1927): George M. Niedecken, Interior Architect.* Milwaukee: Milwaukee Art Museum, 1982.

Smith, Mary Ann. "The Craftsman Interior," *Tiller*, I (September–October 1982), 31–41.

Thompson, Neville. "Addison B. Le Boutellier: Developer of Grueby Tiles," *Tiller*, I (November–December 1982), 21–30.

### 1983

Ayres, William, et al. *A Poor Sort of Heaven, A Good Sort of Earth: The Rose Valley Arts and Crafts Experiment.* Chadds Ford, Pa.: Brandywine River Museum, 1983.

Balmori, Diana. "The Arts and Crafts Garden," *Tiller*, I (July–August 1983), 18–27.

Brandt, Beverly. "The Essential Link: Boston Architects and the Society of Arts and Crafts, 1897–1917," *Tiller*, II (September–October 1983), 7–32.

Hollander, Gary. "Rockledge: A Summer House Designed by George W. Maher," *Tiller*, I (July–August 1983), 10–16.

Kahler, Bruce R. "Contexts and Challenges: Intellectual Historians and the American Arts and Crafts Movement," *Tiller*, I (May–June 1983), 7–15.

Kinsey, Sally. "The Arts and Crafts Attitude in American Costume: 'Let Nature Play Her Part'," *Tiller*, II (November–December 1983), 30–49.

Ludwig, Coy L. *The Arts and Crafts Movement in New York State, 1890s–1920s.* Hamilton, N.Y.: Gallery Association of New York State, 1983.

Smith, Mary Ann. *Gustav Stickley, The Craftsman.* Syracuse, N.Y.: Syracuse University Press, 1983.

Stradling, Diana. "Teco Pottery and the Green Phenomenon," *Tiller*, I (March–April 1983), 9–36.

Robertson, Cheryl. "Mural Painting and the New Art: Domestic Decorations by George M. Niedecken, 1897–1917," *Tiller*, I (March–April 1983), 49–72.

### 1984

Brooks, H. Allen. *Frank Lloyd Wright and the Prairie School.* New York: George Braziller, 1984.

Connors, Joseph. *The Robie House of Frank Lloyd Wright.* Chicago: University of Chicago Press, 1984.

Darling, Sharon. *Chicago Furniture: Art, Craft & Industry, 1833–1983.* Chicago: Chicago Historical Society, 1984.

Dietz, Ulysses G. *The Newark Museum Collection of American Art Pottery.* Newark, N.J.: Newark Museum, 1984.

Dunn, Roger T. *On the Threshold of Modern Design: The Arts and Crafts Movement in America*, Framingham, Mass.: Danforth Museum of Art, 1984.

Edwards, Robert, and Jane Perkins Claney. *The Byrdcliffe Arts and Crafts Colony: Life by Design.* Wilmington: Delaware Art Museum, 1984.

Hoffmann, Donald. *Frank Lloyd Wright's Robie House: The Illustrated Story of an Architectural Masterpiece.* New York: Dover Publications, 1984.

Makinson, Randell L., and Yukio Futagawa. *Greene and Greene: David B. Gamble House, Pasadena, California, 1908.* Tokyo: A.D.A. Edita Tokyo Co., 1984.

Poesch, Jessie, et al. *Newcomb Pottery: An Enterprise for Southern Women, 1895–1940.* Exton, Pa.: Schiffer Publishing, 1984.

### 1985

Brandt, Beverly Kay. " 'Mutually Helpful Relations': Architects, Craftsmen and The Society of Arts and Crafts, Boston, 1897–1917." Ph.D. dissertation, Boston University, 1985 (University Microfilms International, 1986).

———. " 'Sobriety and Restraint': The Search for an Arts and Crafts Style in Boston, 1897–1917," *Tiller*, II/5 (1985), 26–73.

Finlay, Nancy. *Artists of the Book in Boston, 1890–1910.* Cambridge, Mass.: Houghton Library, Harvard University, 1985.

Lancaster, Clay. *The American Bungalow, 1880–1930.* New York: Abbeville Press, 1985.

Phillips, Lisa, et al. *High Styles: Twentieth-Century American Design.* New York: Whitney Museum of American Art, 1985.

Shi, David E. *The Simple Life: Plain Living and High Thinking in American Culture.* New York: Oxford University Press, 1985.

Trapp, Kenneth R. "The Shop of the Crafters at Cincinnati, 1904–1920," *Tiller*, II/5 (1985), 8–25.

### 1986

Boris, Eileen. *Art and Labor: Ruskin, Morris and the Craftsman Ideal in America.* Philadelphia: Temple University Press, 1986.

Burke, Doreen Bolger, et al. *In Pursuit of Beauty: Americans and the Aesthetic Movement.* New York: Metropolitan Museum of Art, 1986.

Dale, Sharon. *Frederick Hurten Rhead: An English Potter in America.* Erie, Pa.: Erie Art Museum, 1986.

Doumato, Lamia. *Gustav Stickley.* Monticello, Ill.: Vance Bibliographies, 1986.

Kahler, Bruce Robert. "Art and Life: The Arts and Crafts Movement in Chicago, 1897–1910." Ph.D. dissertation, Purdue University, 1986 (University Microfilms International, 1987).

### 1987

Adams, Henry, et al. *John La Farge.* New York: Abbeville Press, 1987.

Adams, Steven. *The Arts and Crafts Movement.* London: Quintet Publishing Limited, 1987.

Eidelberg, Martin, ed. *From Our Native Clay: Art Pottery from the Collections of the American Ceramic Arts Society.* New York: Turn of the Century Editions, 1987.

James, Michael. "The Philosophy of Charles Rohlfs: An Introduction," *Arts & Crafts Quarterly*, I/3 (1987), 1, 14–18.

Johnson, Bruce E. *The Collector's Guide to Arts & Crafts Shopmarks.* Durham, N.C.: Knock on Wood Publications, 1987.

Kaplan, Wendy, et al. *The Art That Is Life: The Arts and Crafts Movement in America, 1875–1920.* Boston: Museum of Fine Arts, 1987.

Marek, Don. *Arts and Crafts Furniture Design: The Grand Rapids Contribution, 1895–1915.* Grand Rapids: Grand Rapids Art Museum, 1987.

Mundy, James. *Rookwood Pottery and the Arts and Crafts Movement, 1880–1915.* Milwaukee: Milwaukee Art Museum, 1987.

Pearce, Clark, and Neville Thompson. *Addison B. Le*

Boutillier, *Andover Artist and Craftsman*. Andover, Mass.: Andover Historical Society, 1987.

Reed, Cleota. *Henry Chapman Mercer and the Moravian Pottery and Tile Works*. Philadelphia: University of Pennsylvania Press, 1987.

Scully, Vincent, et al. *The Meyer May House, Grand Rapids, Michigan*. Grand Rapids: Steelcase, 1987.

Trapp, Kenneth R., and Vance A. Koehler. *American Art Pottery*. New York: Cooper-Hewitt Museum, Smithsonian Institution, 1987.

**1988**

Abernathy, Ann. *The Oak Park Home and Studio of Frank Lloyd Wright*. Oak Park, Ill.: Frank Lloyd Wright Home and Studio Foundation, 1988.

Bolon, Carol R., Robert S. Nelson, and Linda Seidel, eds. *The Nature of Frank Lloyd Wright*. Chicago: University of Chicago Press, 1988.

Brandt, Beverly K. "Worthy and Carefully Selected: American Arts and Crafts at the Louisiana Purchase Exposition, 1904," *Archives of American Art Journal*, XXVIII/1 (1988), 2–16.

Mainzer, Janet C. "The Relation Between the Crafts and the Fine Arts in the United States from 1876 to 1980." Ph.D. dissertation, New York University, 1988 (University Microfilms International, 1990).

Smeaton, Suzanne. *The Art of the Frame: An Exhibition Focusing on American Frames of the Arts and Crafts Movement, 1870–1920*. New York: Eli Wilner and Co., 1988.

Volpe, Tod M., and Beth Cathers. *Treasures of the American Arts and Crafts Movement, 1890–1920*. New York: Harry N. Abrams, 1988.

**1989**

Benjamin, James Elliott. "C. R. Ashbee in America: An Englishman's Observations on the Arts and Crafts Movement, Architecture and Culture 1896–1916." M. A. thesis, Cornell University, 1989.

Clark, Garth, Robert A. Ellison, Jr., and Eugene Hecht. *The Mad Potter of Biloxi: The Art and Life of George E. Ohr*. New York: Abbeville Press, 1989.

Darling, Sharon S. *Teco: Art Pottery of the Prairie School*. Erie, Pa.: Erie Art Museum, 1989.

Davidoff, Donald A. "Sophisticated Design: The Mature Work of L. and J. G. Stickley," *Antiques and Fine Art*, VII (December 1989), 85–91.

Duncan, Alastair, Martin Eidelberg, and Neil Harris. *Masterworks of Louis Comfort Tiffany*. New York: Harry N. Abrams, 1989.

Gengarelly, W. Anthony, et al. *The Prendergasts & the Arts & Crafts Movement: The Art of American Decoration & Design, 1890–1920*. Williamstown, Mass.:

Williams College Museum of Art, 1989.

Kaufmann, Edgar, jr. *Nine Commentaries on Frank Lloyd Wright*. New York: Architectural History Foundation, 1989.

Lamoureux, Dorothy. *The Arts and Crafts Studio of Dirk van Erp*. San Francisco: San Francisco Craft and Folk Art Museum, 1989.

Naylor, Gillian, et al. *The Encyclopedia of Arts and Crafts: The International Arts Movement, 1850–1920*. New York: E. P. Dutton, 1989.

Parry, Linda. *William Morris and the Arts and Crafts Movement*. New York: Portland House, 1989.

Stankiewicz, Mary Ann. "Art at Hull House, 1889–1901: Jane Addams and Ellen Gates Starr," *Woman's Art Journal*, X (Spring/Summer 1989), 35–39.

Wilson, Richard Guy, et al. *From Architecture to Object: Masterworks of the American Arts and Crafts Movement*. New York: Hirschl & Adler Galleries, 1989.

**1990**

Bowman, Leslie Greene. *American Arts and Crafts: Virtue in Design*. Los Angeles: Los Angeles County Museum of Art, 1990.

Harris, Dianne. "Maybeck's Landscapes: Creations of the San Francisco Bay Area Architect," *Journal of Garden History*, X (July/September 1990), 145–61.

Miller, R. Craig. *Modern Design in the Metropolitan Museum of Art, 1890–1990*. New York: Harry N. Abrams, 1990.

**1991**

Anscombe, Isabelle. *Arts & Crafts Style*. New York: Rizzoli International Publications, 1991.

Cumming, Elizabeth, and Wendy Kaplan. *The Arts and Crafts Movement*. New York: Thames and Hudson, 1991.

Hines, Thomas S. "Antiques: Vintage California Design; West Coast Exemplars of the Arts and Crafts Movement," *Architectural Digest*, XLVIII (May 1991), 174–79, 212, 215, 218.

Lynn, Catherine. "A Movement's Foundation: Centenary Project Begins," *American Craft*, LI (February/March 1991), 10–14.

McCarter, Robert, ed. *Frank Lloyd Wright: A Primer on Architectural Principles*. New York: Princeton Architectural Press, 1991.

## Contributors

Contributions by persons other than
those listed as authors of the respective
sections are indicated by the following
initials:

RJC    Robert Judson Clark

ME     Martin Eidelberg

MLG    Mary Laura Gibbs

KLG    Karen L. Graham

DAH    David A. Hanks

HJI    Howard John Iber

TLS    Thomas L. Sloan

SOT    Susan Otis Thompson

RWW    Roberta W. Wong

# Photography Credits

[Numbers refer to entry numbers]

Albright-Knox Art Gallery, 88, 89
The Art Institute of Chicago, 1, 2, 4, 18, 21, 39,
    42, 57, 68, 74–76, 78–83, 85–87, 90–98,
    102–4, 170, 192
Donald H. Bennett, 115, 116, 118, 119, 172
Paul Birnbaum, 5
Simeon Braunstein, 54, 62
Brooklyn Museum, 162, 168
Cincinnati Art Museum, 155–61, 179, 201, 213, 215,
    248, 250
Columbia University Libraries, 130
Gabriel Cooney, 152–54
Cooper-Hewitt Museum of Decorative Arts and
    Design, Smithsonian Institution, 164, 220
William R. Current, 40, 41, 43, 45, 46, 53, 60, 70,
    73, 99–101, 106–10, 112, 113, 117, 121, 196,
    200, 289
Detroit Institute of Arts, 264
Everson Museum of Art, 258–61
Philip Evola, 30–35
David H. Geyer, 50, 51, 55, 56, 59, 61, 63, 64
Harris-Davis, Inc., 23
Leonard H. Kane, 12, 122–29, 131–51
Roger G. Kennedy, 36
Robert Koch, 13, 52
Library Photographic Service, University of Cali-
    fornia, Berkeley, 111
Robert Matthews, 120, 188, 221
Metropolitan Museum of Art, 7, 8, 15, 16, 77,
    84, 262
Minotaur Studios, 6 (© Hugh F. McKean)
Museum of Fine Arts, Boston, 171
Museum of Modern Art, New York, 218, 255
National Museum of History and Technology,
    Smithsonian Institution, 163, 165, 166, 169, 178,
    180, 181, 183, 197, 198, 203, 232, 233, 236, 242,
    249, 270, 282
Philadelphia Museum of Art, 9, 65, 256
Thurman Rotan, 22

Taylor and Dull, Inc., 3, 10, 11, 14, 17, 19, 20,
    24–29, 37, 38, 44, 47–49, 66, 67, 69, 71, 72, 105,
    114, 167, 173–77, 182, 184–87, 189–91, 193–95,
    199, 202, 204–12, 214, 216, 217, 222–31, 234, 235,
    237–41, 243, 244–47, 251–54, 257, 263, 265–69,
    271–81, 283–88, 290–95
Malcolm Varon, 219
Winterthur, 58

This project is supported by a grant from the
National endowment for the Arts in Washington,
D.C., a Federal agency.